Creative
Figure
Drawing

Creative
Figure
Drawing

Art from Life
Life from Art

Milton Hirschl
Pierce College

Prentice-Hall, Englewood Cliffs, New Jersey 07632

Library of Congress Cataloging-in-Publication Data

Hirschl, Milton, (Date)
 Creative figure drawing.

 Bibliography: p.
 Includes index.
 1. Figure drawing—Technique. I. Title.
NC765.H57 1986 743'.4 86-9434
ISBN 0-13-189572-9

Editorial/production supervision and
 interior design: Joseph O'Donnell, Jr.
Cover design: Lundgren Graphics, Ltd.
Manufacturing buyer: Harry P. Baisley
Page layout: Richard Dombrowski

On the cover:
Michelangelo.
Detail from the *Last Judgment*.
Sistine Chapel, Rome.

Prentice-Hall International (UK) Limited, *London*
Prentice-Hall of Australia Pty. Limited, *Sydney*
Prentice-Hall Canada Inc., *Toronto*
Prentice-Hall Hispanoamericana, S.A., *Mexico*
Prentice-Hall of India Private Limited, *New Delhi*
Prentice-Hall of Japan, Inc., *Tokyo*
Prentice-Hall of Southeast Asia Pte. Ltd., *Singapore*
Editora Prentice-Hall do Brasil, Ltda., *Rio de Janeiro*

For my wife, Sylvie,
and my daughter, Karin

Contents

CHAPTER FOUR
Perceptual Awareness 47

CHAPTER FIVE
Gesture, Memory, and Movement 62

CHAPTER SIX
Basics of Figure Construction 78

CHAPTER SEVEN
The Building Elements 102

CHAPTER EIGHT
Principles 122

CHAPTER NINE
Multifigure Composition: From One to Many 142

CHAPTER TEN
Originality and Influence 156

CHAPTER ELEVEN
Two Major Currents 166

CHAPTER TWELVE
Clarity and Definition: Seeing by the Edge 174

CHAPTER THIRTEEN
Indeterminacy: Seeing by Masses, Blurring and Dimming, and Incompletion 187

CHAPTER NINETEEN
Reality and Fantasy 260

CHAPTER TWENTY
Some Challenging Questions,
Some Tentative Conclusions 275

Bibliography 280

Index 283

Creative
Figure
Drawing

Preface

AN INTEGRATIVE VIEW

Although many people still hang on doggedly to the notion that figure drawing is basically imitation and technique, others have swung to the opposite goal of self-expression without discipline. The recent trend in books on drawing reflects the fragmentation of the art scene. There is a proliferation of material dealing with narrower and narrower channels: specialized texts on the female figure, male figure, children, heads, hands, and so on. Although these may be helpful, my own objective is to present an integrative view, combining explorations in perception, awareness of the role of discipline, freedom and imagination in pictorial expression, and a command of basic techniques. My goal is to combine the craft of figure drawing with the art of figure composition.

NEED FOR BASIC SKILLS AND TECHNIQUES

When focusing on the human form as subject matter, it is essential to develop basic skills in drawing the figure: to construct forms and to control tools and techniques. It is also most important to learn to see in relationships and to express oneself as one learns, evolving, in time, a personal style congruent with one's world view.

OBSERVATION

But before such skills are developed, the beginning artist needs to become aware of the primary importance of observation. It is essential in the creative experience in figure drawing, even when the drawing represents a conscious departure from realism.

INDIVIDUAL APPROACH AND GROUP INVOLVEMENT

This book is so structured that an individual may read it and do the exercises without necessarily following the sequence, although doing so may be easier. Working with a group can be helpful and stimulating: Not only is there feedback, but also the possibilities for a greater variety of art experiences are expanded.

EXPLORATIONS

We must make something new of tradition.
Kenzo Tange

But what is really new? What I have learned after much searching is that the old can be the seed for the new; I continually stumble over treasures that I

had previously bypassed, and I have learned that the new often lies hidden amid old byways, where it is least expected.

Perhaps it is not so much the new per se that matters but also the creative way in which we perceive both old and new things and the multiple combinations, mutations, and metamorphoses that put them in new and fresh relationships and give rise to further insights and renewed imagery.

Although the process starts and ends with the individual artist and his or her particular esthetic sensitivity and originality, I believe that a carefully nurtured creative environment—offering multiple physical and psychological choices—activates a free and vigorous current of creative energy, which then flows from the environment to the artist, to the model, to the instructor, and back again to the artist, contributing greatly to the process of creative vision and expression.

NEED
FOR CREATIVE ENVIRONMENT

As a creative environment, the conventional studio seems somewhat limited; therefore a different concept is presented, in which the qualities of a small theater are combined with those of the art studio, with controlled lighting and sound playing a significant role.

CHANGING FRAMES
OF REFERENCE

In order to challenge the overly familiar ways of seeing and depicting the figure, it is important to find ways and means of presenting the figure in different contexts. This means altering the conditions of perception: changes in eye levels and exposure time, value contrasts, instantaneous flashings in the dark, emphasis on negative space, changing the pose from stationary to moving, or monocular to multiview, using visual observation or recall, and so on. In addition to the nude model, an array of costumes and body wrappings are used, often accompanied by props to enhance the mood. Light can be changed for subtle contrasting effects, and for color pattern immersion.

The new physical setup and the atmosphere it seems to generate is particularly conducive to involvement and interaction and tends to act as a leavening agent, one that stimulates the creative imagination. Additional paraphernalia such as

translucent screens, projectors, ladders, and climbing ropes may also be used.

Although the suggested materials can be very helpful, they are certainly not essential. Simpler means can often achieve similar objectives. The physical devices are only means to an end; their function is to help the participant to see more creatively. They are to be considered and used as occasional aids, not as crutches. In the end, the problem always remains the artist, the model, the paper, and the tool.

CHANGES

Many materials and techniques, both traditional and nontraditional, are introduced as a means not only of expanding the technical range of beginning artists but also to sensitize them to the relationship among concept, materials, technique, and expression. A number of working procedures are also introduced: working directly from the figure or from slides, sometimes from both; using the modified photograph as part of the drawing process; and using the accidental as well as the purposeful and concerted approach. Participants are encouraged to explore a wide range of concepts, both perceptual and imaginative, thereby discovering to which experiences and techniques they respond most instinctively, so as eventually to develop a personal style.

A COMPASS
FOR THE JOURNEY

In order to offer the participant some perspective and guidance in modern art idioms, this book will focus on two main concepts in visualizing and drawing the figure: the hard edge linear and the indeterminacy of merging masses. From these two basic approaches, a number of "realities" will be introduced: realism, expressionism, abstraction, and fantasy. In each case, exercises will provide opportunities for personal investigations and discoveries.

A large variety of drawing experiences is offered, from the quick gestural sketch to the detailed contour or modeled drawing, from the observed analytical study to the interpretation of themes, from the single figure to multiple figure composition. Photography, printmaking, dance, sculpture, and theater play important roles as sources of inspiration for these experiences, so that

the boundaries between various disciplines begin to slip away and the artist becomes aware of the close interrelationships and pervading unity of these allied arts.

AFTER ALL IS SAID AND DONE

It would take many days and nights of unremitting toil to carry out all the preparations described in this book: the environments, costumes, setups, lighting effects—activities only tangential to the drawing act and only meant to activate, reactivate, or facilitate creative perception.

It is a rich diet—overly rich, perhaps. It may well be argued that art should be created by simpler means, that patient, intensive, and probing search in one given pictorial vein is the most authentic answer. But it may also be true that the paths are many, and that although the pure and ascetic way is the most effective for some, a dramatic juggling of approaches, concepts, and even physical devices may be a way to help unlock perception and creativity for others.

It would be short-sighted of anyone to assume that any creative activity can be reduced to a series of formulas and techniques. The most that can be done is to help produce a creative climate or environment; disturb the complacency of those who depend on conventional methods and solutions; and raise esthetic questions that can only be solved through personal involvement, constant work, and constant reevaluation. The studio experience, when it is positive, can be a shortcut in coming to grips with the various problems of art expression.

ART FROM LIFE

I am unable to distinguish between the feeling I have for life and my way of expressing it.
Henri Matisse

It is my passionate belief that for the serious artist, there is a close connection between life and art and that the work of art is an ever recurring affirmation of the bond between the two. The urge behind the work of art is to create form endowed with life, form that reconciles contradictions and paradoxes and that is imbued with a pulsation and rhythm echoing those of nature and life in one grand orchestration of energy. I am convinced that the search for form and esthetic validity is part and parcel of the search for the meaning, order, and equilibrium that we would like to find in life. It is likely that art gives life new meanings indeed and provides us with images and symbols to help us sort, understand, and come to terms with our everchanging objective and subjective realities even beyond the studio walls.

The figure remains an inexhaustible source of inspiration for the artist. It can be observed, analyzed, re-created, transformed, and metamorphosed. It can be drawn as a single form or as a complex multifigured configuration. It can be recorded objectively, emotionally, conceptually, or symbolically. It can be combined with other elements; it can partake of the drawing and the photograph; it can be hybrid; it can be immediately and objectively recognizable or it can be merely suggested.

In a book devoted to the study of the human figure, the relationship of art to life should certainly be obvious. The study of the human figure is related to a search for understanding and effectively expressing the human component through a visual statement that combines form and meaning; and the more personal, the more authentic the statement is, the more universal it may be. It is to be hoped that artists find a personal style that is their "signature," so that their depictions and interpretations become their own "letter to the world." Few artists may be endowed with the talent and power to renew the representation of the human figure with indelible images and revelations, but the search itself is invested with meaning and nobility.

GOALS

The immediate objective of this book, then, is to teach the artist to draw the figure with some degree of control and to help the beginner gain an understanding of pictorial organization and of various concepts or art expression.

The long-term objective is to act as a catalyst in helping participants liberate themselves from the constraints of prefabricated precepts, to be free to create and express an inner personal vision—remembering that the art experience is not confined to the art studio but should extend beyond it so that, in the end, as life generates art, so does art, in turn, enhance life.

ACKNOWLEDGMENTS

I owe a debt to many people: my former and present students, my colleagues, family, friends, models, artists and art collectors, whose cooperation, encouragement, patience, and interest contributed to the elaboration of this book. I also wish to thank the museums and curators who helped me secure permissions to reproduce works in their collections.

In addition to the inspiration and encouragement I have received from my students through the years, I have appreciated their active participation as models and improvizers of imaginative set-ups.

I have always been grateful to the models who have been willing to get involved creatively in some of my set-ups; I could not name all the models, but I would like to single out Susan Kreitz for her sensitive understanding of what I was trying to achieve and for her patience in helping me to realize it.

Among the many people who helped shape the book, I wish to thank particularly Irene Nye, for constructing our wonderful mannequin "Adam" and the armor and for solving many of the designing and sewing problems related to body coverings and costumes; Sara Fisher and Marian Leon also contributed to the realization of the costumes and body coverings.

I also want to thank Doris Gunn, Arlene Gould, Ron Rafaelli, and Saul Blackman, who took the photographs of student work and of studio set-ups, Leon Kotkofsky, who, through the years, offered visual materials, useful references, and suggestions, and Karin and Russell Wolvek, who helped whenever help was needed. My thanks also go to Norwell F. Therien Jr. and Joe O'Donnell Jr. of Prentice Hall, for their patience and discrete guidance in realizing this project.

As for Sylvie, my wife, she has worked with me on all phases of the project, serving as helper, critic, morale booster, typist, proofreader, and permission hunter as the need of the moment required. I regard her assistance as crucial to the realization of this book, from its inception to its completion.

CHAPTER ONE

Setting the Stage:
The Drawing Studio
and Theater Combined

WHAT IS DRAWING?
A TENTATIVE DEFINITION

The Most Revealing

Seemingly the most easy of all crafts, drawing is the one which reveals most tellingly our incapacity to sustain true vision and our acquiescence to the ready made.

<div align="right">Rico Lebrun</div>

A Provoker of Consequences

I shun drawing which is too easily formulated. It does not seem fertilized enough to produce consequences, and a drawing should be a provoker of consequences.

<div align="right">Rico Lebrun</div>

Before we can seriously deal with the substance of the first chapter, there are three questions that should be considered: What is drawing? Can drawing really be taught? What is the role of the art teacher? The answers can, perhaps, provide a basis for choosing the kind of environment that would be the most effective in the development of creative drawing.

Drawing is the process of shaping forms on a two-dimensional surface. It can be anything from a scrawl to a fully rendered series of forms. It is not only an art but also a craft, in which one must become aware of the tools and techniques. It must above all be considered an art, in which one deals with concepts, perception, expression, and imagination. It is one of the simplest of all media, yet the one that often conveys most directly the naked thoughts and feelings of the artist. Seeing is an essential ingredient in drawing—whether through the eye or through the mind's eye. Drawing, in turn, helps one to see more clearly. Even though seeing is the most important sense to the draftsperson, the other senses are called into play at least indirectly. Drawing can also be thought of as a kind of universal visual language, whereby it is possible to communicate on a generalized level through the elements of line, value, texture, point, and sometimes color. It is also a form of visual thinking, by means of which ideas and concepts can be conveyed precisely or poetically.

CAN DRAWING BE TAUGHT?

Anyone who is involved in art—as an artist, teacher, student, or all three—must question whether drawing can really be taught. If we mean the craft and techniques that are essential ingredients of the process, the answer would obviously be yes; we can study or teach many aspects of drawing: proportion, foreshortening, light and shade, different technical approaches, even composition. But if we mean the *art* of drawing or painting, the special and unique factor that imbues the best of great artists' works, then I'm afraid that the answer would be no, for that is something that

students must have or find for themselves. In short, when it comes to that precious and mysterious element, the student artist, in the final analysis, is his or her own best teacher.

Formal Training and the Personal Search

Artists without any training often remain primitives—maybe even gifted primitives—or naive painters with large gaps in knowledge, experience, and practice; they are usually unable to change their style even if they wish to do so. In these cases, what passes for personal vision is, with a few brilliant exceptions, nothing more than the repetition of certain early, pleasing results.

On the other hand, if student artists depend *totally* on a formal class for their drawing experience, they may become too psychologically dependent on a teacher, on ready-made problems and exterior stimulation. For most artists, the solution seems to lie between the two approaches, with a period of formal training enriched by the study of the masters and art books in general, and with a parallel series of independent drawing experiences that go on during and after the period of formal training has ended, and which become the personal search for form and meaning that is the artist's life-long commitment. Because I strongly believe that parallel independent drawing experiences are of paramount importance in the art student's artistic growth, I like the concept of free-choice problems in addition to those proposed by a teacher or a book.

The Role of the Art Teacher

Passion as Discipline

In teaching, we neglect to sponsor passion as a discipline. The only discipline we teach is that of the deadly diagram supposedly to be fertilized later by personal experience. Later is too late.

Rico Lebrun

What then, is the function and role of the art teacher, art class, or art book, besides providing guidance and practice in the mastery of skills and techniques? Perhaps exposure to the arts of the past and present cultures as a source of study and discussion provides a partial answer. But I think that inspired and enthusiastic art teachers and writers have always nurtured a more ambitious goal: that of serving as facilitators and guides in the creative process by offering a rich array of meaningful, imaginative, visual, and perceptual experiences and problems in a stimulating physical environment. Inspired art teachers and motivated students are a creatively volatile group, and it takes only a small hint or suggestion to set off a chain reaction of creative ideas, one begetting another, almost ad infinitum. Each problem presented can spark a number of variations and transformations in a self-generating string of creative problems and personal solutions.

SETTING THE STAGE

If these are valid objectives, how does one create the necessary stimulating environment and climate? There are many possible answers, depending on the personality and background of the teacher or writer.

A personal solution to this query presented itself to me gradually through multiple trial and error but crystallized as I was watching a performance of a contemporary experimental dance group a number of years ago. My hunch was that a flexible, changeable environment, as used on the stage, could multiply the ways in which the figure could be perceived and drawn. This approach would help to break down some of the sterotyped imagery that encumbers the beginning student. What I wanted was a physical environment that could easily be transformed, and in turn, would transform the viewer's perception of the model: in short, a combination drawing studio and small horseshoe theater with controlled lighting. The setup could be extremely simple or complex, depending on the needs and resources of the moment, but it would be structured to encourage group participation and involvement. It would be flexible enough to allow for the quiet, reflective, traditional stationary drawing, as well as complex setups, with movements, special lighting effects, and multifigure choreographic poses: in short, an environment where the figure could be presented in as many visual and psychological contexts as possible. (See Figs. 1-1 and 1-2)

When considering the physical work environment, the student has a number of options available, each one presenting advantages and disadvantages and each better suited to the needs of some participants than others, depending on such factors as one's level of experience and disposition at a given time.

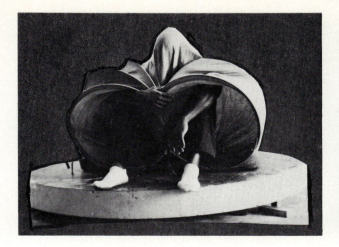

Figure 1–1.
Photograph.
Positioning the model inside a child's crawl-through tunnel creates strange and intriguing images. The beginning student often raises the question: What does it mean? It does not always have to have a clear or obvious meaning if the configuration is imaginative and open to individual interpretation.

Figure 1–2.
ELIZABETH TOKAR, student.
Charcoal drawing from setup shown in Figure 1–1.

The Average Art School Studio

The average art school studio consists of a large, well-lit room, with a supply of drawing benches, easels, a few movable spotlights, a model stand, some simple props, a small heater for the model, a screen for films and slides, and perhaps a record player. It presents the advantages of simplicity, the availability of a teacher, regular instruction, a professional model, and contact with fellow students for discussion and sharing. Its major disadvantages are its lack of visibility, flexibility, controlled lighting, and adequate storage.

The Bare-Bones Operation

The garage or den is usually the setting for a makeshift studio for a group of artists or advanced art students who wish to have a workshop—where they pool their resources and share the expense of the model—so that they can work more independently. The setup is usually very modest, with a few easels, a few chairs, a few simple props, and a couple of clamp-on spotlights.

This setup is particularly good for the students who wish to wean themselves from the more formal class, but they must be careful that the

arrangement does not fall into the usual set format: a few quick sketches, then some intermediate ones, followed by a sustained pose. This can easily develop into a dull, unimaginative approach in which individual needs are deferred to the established routine.

The Loner

The advanced student or full-fledged artist eventually needs to set up his own studio or workroom where he can work independently and at his own tempo, setting his own problems and evaluations and surrounding himself with the art books and reproductions that are meaningful to him at a given time. Usually, members of the family or friends are prevailed on to serve as models. At this particular point, the artist may also work from his own previous drawings or from imagination. These options are not mutually exclusive, and often various combinations are tried, according to the need of the moment.

DRAWING AS THEATER

As I have mentioned previously, my concept of an ideal setup for the formal study of figure drawing and composition is a combination art studio and theater, with provisions made for controlled lighting and sound. The following are some basic considerations.

Visibility

A major consideration is an arrangement that permits good visibility of the model from any part of the studio-theater; adjustable, safe risers are a workable solution, with adjustable drawing tables on three levels. The fact that the benches can be relatively flat makes it feasible to produce controlled wash drawings, which is vitually impossible on an upright easel.

A most practical feature is a powered rotating model stand, which permits full-circuit viewing of any setup; the participants can study the different views of a pose from a single vantage point. Two slightly lower model stands can flank the rotating stand for added posing space and greater flexibility in group poses.

Flexibility

Flexibility is a particularly important factor, since the whole idea of a studio-theater revolves on the possibility of creating various temporary physical setups as one would on a stage. To this end, props should be light and easily dismantled to allow the studio to be used by other classes in whatever format is needed.

Large screens attached to the wall behind the model stand can be used for various types of projections: slides, films, special lighting, and opaque and overhead projections. When the screens are rolled up and not in use, parts of the wall can serve as a display area for art reproductions and student work.

A projection counter for the projectors and phonograph located behind the students and slightly above the highest riser is a valuable feature.

Controlled Lighting

Controlled lighting is probably one of the major features of the setup, and the one that best dramatizes or transforms the model and thus reorients the viewer's perception. A variety of light sources and effects, such as overhead, side, back, and top lighting, sculpt and dramatize the model through different light and shade patterns. Moods can be created and changed with a blend of stage lights, colored spotlights, flickering lights, and dimmers. Provisions for lighting each individual work area with a narrow shaft of light should be made; if this cannot be done from the ceiling, gooseneck flashlights with long-lasting batteries

affixed to the easels are a workable alternative. The lights over the individual work areas are used when the problem requires that the studio be darkened while the model is illuminated with spotlights.

Additional Paraphernalia: Optional

A few additional implements can add to the flexibility of the setup and increase the varieties of ways of viewing the model:

A skeleton
A life-size muscle figure made of plaster
Strong hooks in the ceiling over the model stands to support rope ladders, swings, or climbing nets
Window mannekins
A sturdy ladder with railings and a safety platform
A few stage flats
Sturdy cubes of various sizes
Drapes and pillows

Storage

A well-designed storage area is a tremendous help in keeping props and costumes easily available; it also avoids unnecessary, dangerous, irritating clutter.

Safety and Ventilation

The safety factor and proper ventilation cannot be overemphasized. The circuitry and extension cords should be regularly checked for safety. So should ceiling hooks used for rope ladders or other hanging props. All paraphernalia should be sturdy, simple, and well secured.

Because the room must be occasionally darkened, ventilation becomes important. Some good wire-enclosed electric fans strategically placed are helpful, especially in hot weather. A heater for the model during the cold season is an absolute must.

If one has the good fortune to have a technical assistant, this person is invaluable in expediting the setups and the general management and care of the equipment and props.

A Rationale for Staging

It must be acknowledged that creative figure drawing can be and has been done with the simplest means and without resorting to staging techniques. In fact, the danger with staging tech-

niques is that they may become gimmicky, leading to showy, superficial effects rather than to a slowly gained personal expression. However, if the staging is introduced with caution and with an awareness of some of its inherent dangers, it can allow the beginning artist to gain a quicker and deeper comprehension of various concepts. The translation of a three-dimensional setup that includes space-defining props, for example, can help the student to grasp principles of spatial relationships faster. Actually seeing the models in an abstract setup and in abstract costumes brings the concept to life and may thus be more effective in fostering a visceral understanding of some aspects of abstraction and fantasy than a theoretical explanation would. For me, the most effective setup is one in which the designed environment so meshes with the figure or figures that, together, they become a larger organic configuration.

It may seem like a paradox, but it has been my experience that such direct contact with the models in what may be termed contrived settings encourages the art novice to probe the concepts further. I will repeat now—and certainly will repeat again—that all extraneous devices must be used judiciously, so as to avoid gratuitous artificiality. Sometimes, they are an intrinsic part of the project; in those cases, one must use them unabashedly as theatrical setups. At other times, they are means to an end; in those cases, when the given concept has been apprehended and internalized, the devices should be laid aside and the artist should continue his or her investigations in a more private and unaided manner, following the direction that feels most authentically expressive to the individual.

SUGGESTED EXERCISES: ENVIRONMENTS

The following is a list of environments that can be easily constructed with one basic material. Later, a number of materials can be combined in one setup. The important thing to remember is to choose materials that are commonly found and are inexpensive. Lighting is an important ingredient and so are sound effects. These can be put together by the students themselves, using their own tapes and snatches from records. The list offered here will probably become more meaningful when used in connection with figure compositions in subsequent chapters.

Exposed corrugated cardboard: towers and walls. Exposed corrugated cardboard is particularly useful because it can easily be formed into conical towers and curving walls as well as offering rich surfaces that can be used to cover cubes, cylinders, and so on (Fig. 1-3).

Old Tires. Lash old tires together and suspend them from the ceiling or otherwise secure them so

Figure 1–3.
Towers and walls of exposed corrugated cardboard.

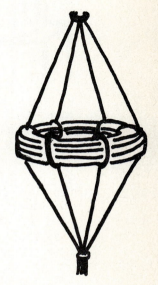

Figure 1–4.
A space-breaking geometric shape obtained with a discarded tire and heavy rope.

that they can be used by a gymnastic model for interesting poses (Fig. 1-4).

Giant tinkertoys. Use an old set of giant Tinkertoys to create interesting sculptural forms as a backdrop.

TV antennas. Use a collection of old TV antennas to create an exciting contemporary environment, which could be photographed as a slide and later projected on a rear screen.

String environments. Stretch strings, yarns, or cords of various colors from easel to easel and from the wall to the floor and back again to form an exciting web or network of crisscrossing colored lines, against which or behind which the figures are posed.

Figure 1–5.
Construction of slotted cardboard rectangles.

Figure 1–6.
Cardboard box figure: à la Marisol.

Figure 1–7.
Amorphous cardboard sculpture: à la Nogochi.

Figure 1–8.
Cloth-covered amorphous forms.

Figure 1–9.
Totem of geometric flat shapes made of carboard.

Cardboard rectangles. Use covered corrugated or plasticized cardboard rectangles with slots on all four sides to install free-standing planes. These could be painted and decorated. Cardboard boxes can often be found in supermarkets (Fig. 1-5).

Cardboard box columns: Marisol's presences. Pile up cardboard boxes to form columns. They could be designed in the manner of Marisol's *Presences* (Fig. 1-6) with a wig head placed on top. The sides of each box could be decorated with symbols, draw-

ings, photos, or even caricatures. The top box could have references to the upper torso, the next box to the lower torso, and the last two to the legs.

Amorphous cardboard sculpture. Design and slot amorphous cardboard forms so that they form abstract, free-standing sculpture in the manner of the contemporary sculptor Noguchi (Figs. 1-7 and 1-14).

Cloth-covered amorphous forms. Stretch and sew cloth over irregular wire or wood structures, forming bonelike shapes that can be suspended from the ceiling. This works best when stretch material is used (Fig. 1-8).

Totems of geometric planes and hanging things. Cut cardboard into geometric shapes of the same scale—circles, semicircles, diamond shapes, equilateral triangles, squares, and rectangles. These can be brightly painted or covered with metallic foil and

then attached to wooden dowels. They can serve as space breakers (Fig. 1-9).

A variation is to design a series of equally sized cardboard rectangles in patterns of bright colors. These could be attached together in columns to sturdy cords and then suspended from the ceiling (Fig. 1-10).

Still another means of breaking space is with hanging beads or knotted string, which has the advantage of the see-through effect.

Styrofoam environments. Styrofoam is often used in the packing and shipping of appliances and can be found in throwaway bins. It comes in interesting three-dimensional shapes, which can easily be slotted or adhered to.

Old bed sheets. Hang old bed sheets at various depths. Perforate them with holes of varying sizes, and sew on patches in overlapping forms. You could also shred them into vertical strips in certain areas (Fig. 1-11).

Figure 1–10.
Banners and hangings.

Figure 1–11.
Bedsheets can be modified by patching, perforating, and so on.

Circular base and poles. Drill an old circular table top with holes so that bamboo poles can be inserted. Lash them together to form space dividers and backdrops for the models (Figs. 1-12 and 1-13).

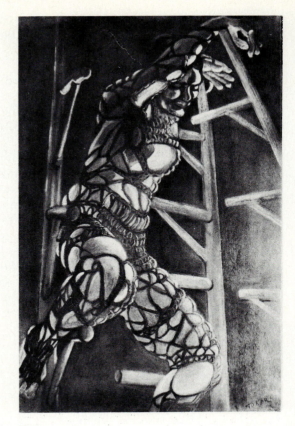

Figure 1–13.
ELIZABETH TOKAR, student.
Pastel.

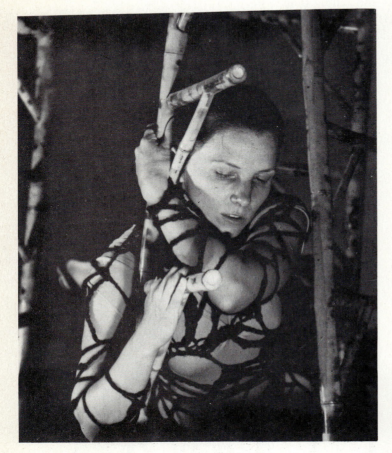

Figure 1–12.
Photograph.
Posing the model in a bamboo pole enclosure and clothing the figure in an irregular mesh outfit that resembles a web evokes an image of captivity. While serving as anchors to support the body, the poles also help break up the space dynamically.

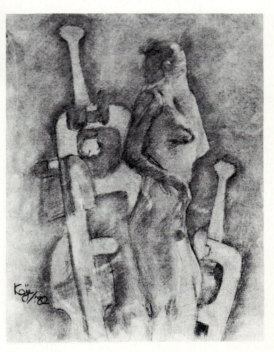

Figure 1–14.
KOJI SONODA, student.
Charcoal.
The human figure is combined with abstract props to form a provocative, imaginative configuration, delicately depicted as a soft focus, a soft contrast unit.

CHAPTER TWO

Artists and Models

THE NAKED TRUTH

The Human Condition

To see the human condition in the old woman, in the child, in the model on the stand, in that particular human being, and to let the hand trace it, this act of adoration is called "drawing from life."

Frederick Franck

The nude model is and has been a traditional subject for artists; each culture and each period within a culture has used it to re-create its own image. In an artist's development, the nude model fulfills a number of purposes: It is a means of studying the structure and anatomy of the human figure, and it is a subject for composition and artistic expression. But over and beyond these primary purposes, it provides the artist with the opportunity to study the body stripped of the coverings and shams that protect, correct, and disguise; it may even foster a greater acceptance and appreciation of the human image in its vulnerability and frequent imperfections, while it confirms a sense of wonder at its inherent beauty in its different stages, from youth to old age. In a larger sense, working with the nude model plays its part in coming to grips with the human condition.

Expressive rendition of the average nude model requires understanding, skill, tempera-ment, and style, which few beginners possess. The beginning artist feels psychologically most comfortable in translating the subject into an idealized, stereotyped drawing, which is a slick, insipid version of calendar art or a weak version of the classical mold without the grace and sensitivity of the better classical drawings. At best, the results are careful, harmonious, even competent draw-ings, which too often are lifeless and indistinguish-able one from the other.

This may be why it is easier, at first, to draw expressively from models whom we euphemisti-cally call "interesting," that is, those whose bodies do not conform to the standard norms of attrac-tiveness. Eventually the skills gained in drawing these naturally more expressive nonclassical fi-gures are carried over to drawing the standard figure with insight and sensitivity.

Because figure drawing deals almost exclu-sively with live models, nude or clothed, it is very important to select professional models carefully. When artists respond positively to a model, the drawings almost invariably reflect it. Professional models fall into all physical types: tall, short, thin, stocky, average, young, middle-aged, old; like the rest of us, they can be classified as attractive, exciting, average, or nondescript. It is advisable to have access to models of all body types and age groups (Figs. 2-1 through 2-4).

Figure 2–1.
Student work.

Figure 2–2.
IVANA ALVAREZ, student.

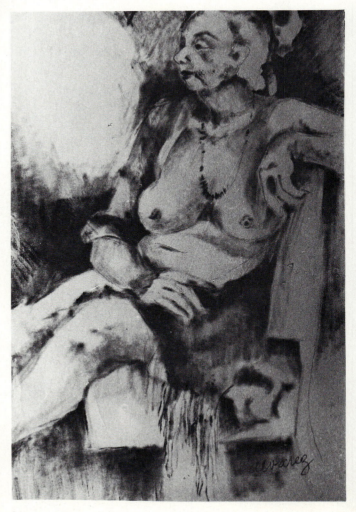

14

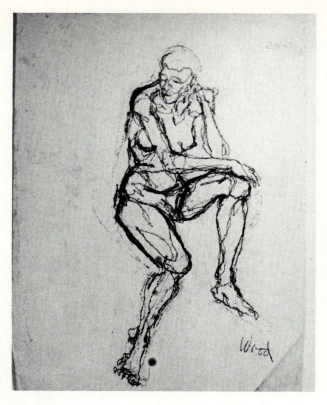

Figure 2–3.
M. WOOD, student.

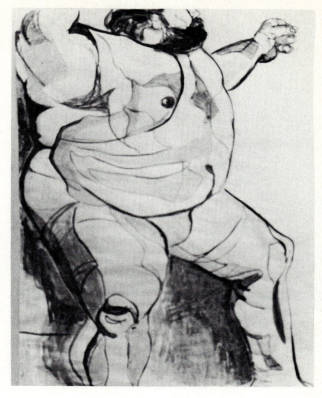

Figure 2–4.
RUTH DINKEN, student.

ADVANTAGES AND DISADVANTAGES OF PROFESSIONAL MODELS

The obvious advantage of using a professional model rather than an amateur is that the former usually has a wide range of poses and knows how to remain still. A possible drawback to the exclusive use of professional models is the cost, especially for the artist who wishes to work independently. This is one of the reasons why many artists pool their resources to have a workshop and hire a model.

Although the use of models is a sine qua non of the life-drawing studio, there is a subtle disadvantage in using the professional model with unswerving regularity; after a while, a kind of deadly routine and sequence of work may set in: a few quick warm-up exercises, two twenty-five minute poses, and the rest of the session devoted to one long pose. The routine is certainly valid enough and offers the opportunity for at least three varieties of drawing experience, but by adhering rigidly to it in all drawing sessions, many opportunities are lost to work with other frames of

reference: slides, study of the masters, memory, imagination, or spontaneous and unusual poses or groupings by nonprofessionals. It may, therefore, be a good idea to use professional models for most of the sessions but to reserve a few sessions, perhaps every third or fourth one, for freer and more spontaneous work with or without models.

THE INVOLVED MODEL

It is helpful to find models who take an interest in the art process and understand their role as a catalyst. Some models take their work seriously enough to have studied the poses of the figures in well-known masterpieces, and they are able to duplicate these poses if the artist or the group so wishes. Others have an art, theater, or dance background and are cooperative and creative in devising poses or setups. Some of the most exciting poses are those that cannot be held for more than a few seconds; the camera offers a workable solution to this problem, provided the model grants permission to be photographed. Later, the slides or photographs can be used to draw from or as references (Figs. 2-5 through 2-8).

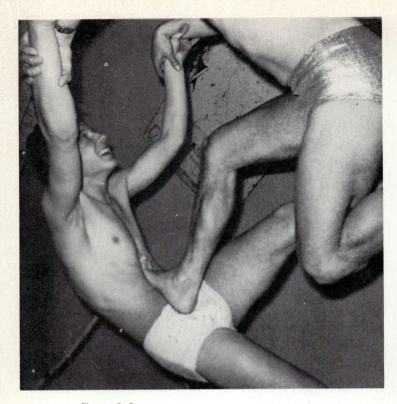

Figure 2–5.
Photograph.
Circus performers as models.

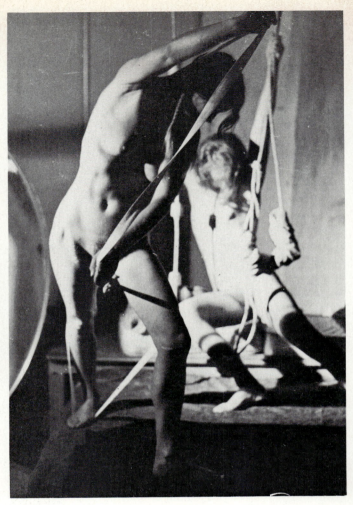

Figure 2–6.
Photograph.
Models.

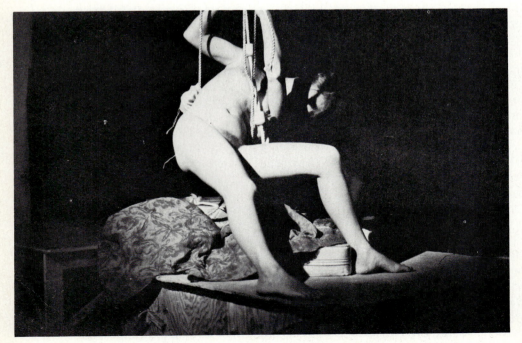

Figure 2–7.
Photograph.
Rope supports.

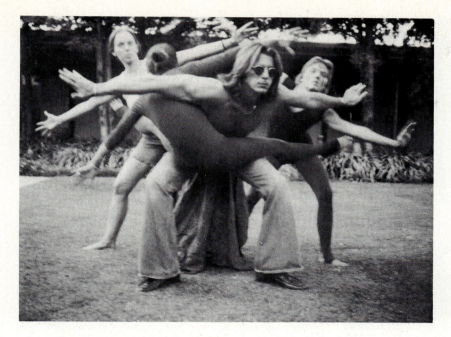

Figure 2–8.
Photograph.
Inspired by modern dance, students take
a group pose while others sketch.

This interaction between imaginative models and artists can intensify the creative mood of the group, provided, of course, that the model and the other participants understand each other.

Then, there are the character models, sometimes worn and weather-beaten, full of wrinkles and folds. After the initial tendency to correct nature and to make the model look younger and more attractive, the serious student will heed the teacher's urgings to emphasize, to exaggerate, to use the folds and the creases to heighten expression, and in the process, may discover the special beauty of these so-called unattractive subjects.

When the model is average and nondescript, the challenge is even greater in that the artist must really seek to express those qualities that depend only on the drawing itself rather than on the model. This is usually attained only when artists have already honed their skills and sensitized themselves to the nonobvious through much experience in seeing and drawing.

STUDENTS AS MODELS

Besides the professional model, the most available source of live subjects in a studio are the art students themselves. Frequently, I like to involve my students in the total activity: setting up the poses, devising setups and costumes, taking turns as models, photographing, and of course drawing. This approach presents many advantages: The personal involvement and physical participation from inception to realization of a project creates heightened energy in the studio. The room buzzes with ideas and expectation (Figs. 2-9 and 2-10). Perhaps the greatest advantage is direct understanding of the transformations brought about by costumes, props, and drapes. Other advantages are understanding the poses the body can or cannot hold and empathy with the physical points of stress in given poses.

The activity is nonthreatening. Unlike acting, which requires mastering and projecting a role as well as memorizing lines, it is required only to hold still as part of a small group or tableau—which makes it quite acceptable to most students. This type of activity can be only a part of the routine of the group since most participants wish to have as much drawing time with the model as possible, even though they do enjoy the personal involvement.

THE MAGIC OF COSTUME

The urge to dress up, to adorn, to disguise, is quasi universal, in one form or another, and many countries have a version of the Mardi Gras. In fact, many an adult relishes a Halloween costume party, seizing the occasion to shed a habitual, perhaps drab, image and fleetingly becoming someone or something else.

The metamorphosis that can be achieved

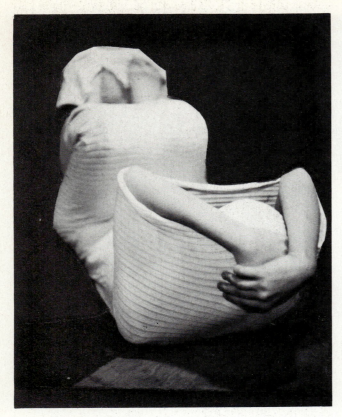

Figures 2–9 and 2–10.

Photographs.

Figures created, posed, and photographed by student artists.

Note how the ribbing in the material helps the observer understand and track the volumes in space.

with an unconventional costume is almost uncanny, and this transformation gives the student another opportunity to view the figure in a new and different frame of reference (Fig. 2-11).

An increasing number of artists prefer to view the figure as a kind of found object, which can be modified and redefined by the addition of costuming and adornment. Thus they explore and invent visually stimulating forms that excite the imagination, and in some cases, the new configurations become philosophical as much as esthetic visual statements.

The danger when working with the costumed model is to fall into a picturesque postcard or exotic mold, which is largely passé and quickly boring.

Gradually, an artist, teacher, or art group can acquire a costume wardrobe: draperies, hats, caps, stoles, scarves, leotards, vests, skirts, masks, and so on. Goodwill, Salvation Army, swap meets, and army surplus stores are good sources; so are discards from friends and family. It is helpful to have an adequate storage area for easy access.

As part of preparing setups, my students are encouraged to improvise costumes. As the costume is conceived, it provides additional practice in rethinking the body and the image it projects. A general theme is chosen for a tableau involving costumed figures. The costumes are usually improvised with a minimum of sewing, except for those

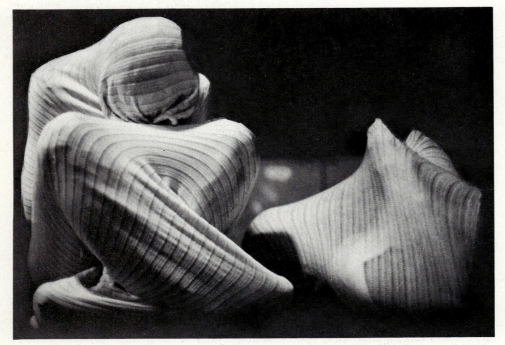

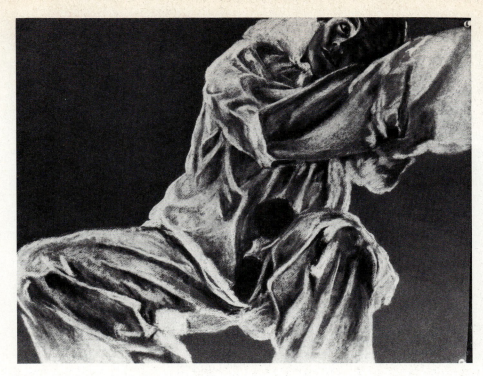

Figure 2–11.
WENDY PECCITO, student.
Charcoal.
The model depicted here is interpreting the character
of Pierrot: his sensitivity, vulnerability, and sadness.
The pose also offers an opportunity to study and draw
the flowing quality of the garment, its folds, and the
play of light and dark on the satiny texture.

who enjoy sewing and perfecting a costume in greater detail (Figs. 2-9 through 2-12). It is amazing what can be done with just leotards, jeans, and T-shirts as a starting point, upon which students build with cardboard, wire, egg cartons, pieces of netting cloth, and plastic. Masks and headdresses can be made from scratch or pieced together from parts of existing costumes or discards. Many participants find it valuable and often inspiring to do some research in ethnic costumes, which they use as ideas for variations or points of departure for their own costumed transformations.

As always, preparatory activities must not obscure or supplant the main goal of drawing. Magnificent work can be and has been done in the most austere or unlikely environment and from models clad in ordinary, nondescript street clothes.

SUGGESTED EXERCISES

The costume-making projects described are obviously inspired by the theater; however, the following improvisations are far from ambitious undertakings and require minimal technical skills. They are most successful when they are entered

Figure 2–12.
Hats and headresses.

19

in a relaxed spirit of play, the way a family improvises costumes for Halloween with remnants, old bedsheets and discards, or any makeshift materials. This frees the participant from ponderous self-consciousness, and the project becomes a liberating activity that combines play and creativity—a potent alloy.

The completed costumes are then worn by the participants, who take turns posing singly or in groups. The rest of the group can draw from the poses or take snapshots for later reference.

Hats, Headdresses, and Masks

Crazy hats and headdresses. As a simple introductory project, construct an interesting or crazy hat. Start with an actual discarded hat, which is transformed with paper, cardboard, cloth and other accessories and notions, or build the hat from scratch. The more bizarre and unusual the result, the more intriguing the project becomes.

The hand-held mask. The mask can be a project in itself, a reworking of the human face and features, or it may be part of a total, imaginative body covering. Although it is possible to modify a commercial mask, it is more exciting to design the mask from scratch.

A good starting point may be the hand-held mask, which is made up of a wide paddlelike cardboard shape on which the stylized features are drawn or of a collage designed with large Xerox photographs. The surface may be kept flat or slightly shaped. Perforations can be designed to reveal parts of the face of the wearer while providing openings for the eyes.

The half mask. The most common is the upper half mask which leaves the lower part of the face uncovered, but it is also possible to design a lower half mask. Use flexible materials such as apple-box dividers or thin cardboard. Arbitrary colors; stylized features; and the addition of feathers, paper, cloth, and so on can enrich the redesigned covering.

Paper bag mask. This may be the simplest of all mask-making projects. Simply paint features in bright colors on a large paper bag. You can paint a second mask on the other side of the bag, to create ambiguity about which way the wearer is facing. You can also devise a double mask by tying the large bag tightly in the center and stuffing the upper part with paper. Saul Steinberg has made a wonderful series of inventive bag masks.

Figure 2–13.
Hand-held mask.

Figure 2–14.
Half mask.

Figure 2–15.
Paper bag mask.

Cardboard masks. A variant of the relatively soft paper bag mask is the rigid square or cylindrical mask, made from a cardboard box, which can be drawn on, cut into, and added to. Their design can suggest kachina dolls or Marisol-like sculptures.

The bag masks and the box masks may be mounted on poles of varying heights to form a disembodied crowd.

Head bands. This project combines the mask and the headdress. Attach a cutout and designed cardboard extension to a headband; the features

can be stylizations of human features, animal features, or combinations of the two. It is possible to superimpose two such heads to the same headband, not only adding height to the wearer but also creating a totem-pole effect.

Found objects. Many found objects are easily turned into masks: wire strainers, egg cartons, nets, helmets, and so on. The possibilities are limitless.

The designs of Norman LaLiberté and Pauline Johnson can serve as inspiration.

The advantages of the cloth poncho are that it is more durable and less prone to tearing than its paper version and is less likely to settle into unwanted creases.

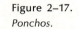

Figure 2–17.
Ponchos.

Figure 2–16.
Cardboard masks.

Body Coverings

Raingear. Occasionally, raingear (hats, plastic capes, boots, umbrellas, scarves) transforms the body into an odd and interesting configuration that lends itself to imaginative groupings and nonliteral interpretative drawings.

Ponchos. It is particularly easy to design a poncho made of plain wrapping paper. Cut the paper into the desired shape, usually a large circle, square, or diamond. Cut out a circle and slit in the center to admit the head of the wearer. Then decorate the poncho, using brightly colored crayons or poster paint, with repetitive patterns or free-form designs. Heavy black outlines help set off the decorative pattern. Again, take turns posing and drawing. The ponchos may be worn with the masks or the hats or with both.

Material for the poncho need not be limited to wrapping paper. Burlap or other loosely woven, inexpensive, heavy material can serve as a base. Decorations are then sewn or glued on: strips of cloth, beads, and so on. Holes can be cut as part of the decorative pattern.

CHAPTER THREE

Introduction
to Basic and Experimental
Tools and Techniques

A DYNAMIC INTERRELATIONSHIP: THE MEDIUM SPEAKS

The Medium Carries the Idea

An idea can only be materialized with the help of a medium of expression, the inherent qualities of which must be surely sensed and understood in order to become the carrier of an idea.

Hans Hoffman

Each of the ingredients in a work of art has the intrinsic power to act on the others: the tools, the paper, the technique, the concept, the subject. Each helps shape the other, but I like to think that the artist remains the ultimate shaper. The *what* can be greatly intensified or weakened by the *how*; and the artist who has selected watercolor as a medium rather than oil, or charcoal rather than pencil or pen for example, has already to some degree chosen a certain way of perceiving, conceiving, and expressing a particular configuration.

A common disturbing occurrence for the novice is to draw, paint, or print a satisfactory composition only to be frustrated by technical flaws: The paint or ink flakes off, the paper buckles or tears, the image gets smeared, and so on. Such accidents can be minimized through familiarity with the properties of one's materials. Beginning artists should therefore acquaint themselves with

the various tools and materials available in order to understand and respect their properties and limitations and to find out which are the most suitable for given techniques and lend themselves best to their given purpose and temperament.

The usual and logical sequence of investigation and practice is to start with a few traditional tools and techniques, and as mastery is gained, to add others. For beginners, frequent preliminary practice sessions with various materials and techniques are helpful to familiarize them with the handling and with the difficulties involved. It is evident that the greater technical range one possesses, the greater confidence and versatility one builds in this part of the process. There comes the time when artists know their tools and techniques so thoroughly that they can almost automatically and unerringly select the most appropriate ones for a given project—having learned along the way that what is created in one medium is rarely translatable in another without undergoing a profound change in expressive impact.

Time for a Change

But when one seems to know a medium almost too well, when the handling becomes too easy or too pat, when the work looks technically faultless and highly predictible, when there are no discoveries

left in the relationship between the artist and materials, it is the signal that it is time to introduce some experimentation, some new combinations and technical risks.

Fighting It Out

Besides experimenting with tools and techniques with which they are unfamiliar, artists may also deliberately select materials that they know are physically incompatible. The confrontation of unlikely materials often leads nowhere, but occasionally it yields exciting and unexpected discoveries. Resist techniques are the result of that kind of experimentation.

A balance needs to be maintained between a craftsperson's knowledge and control of materials and techniques and a spirit of freedom and experimentation.

Eventually, after having experimented with a number of media and techniques, artists usually limit themselves to a few favorite ones, allowing for some occasional explorations. There are no rules in this matter: The artist's own inclination is probably the best guide, provided choices are not limited by esthetic timidity.

The Excitment of Pure Manipulation

For some artists, the playful manipulation of materials, with no particular idea in mind, is quite rewarding. The act of manipulation itself can suggest a concept or be a point of departure, just as random cracks in a wall could suggest shapes to Leonardo da Vinci. Yet for the majority of beginners, there is a danger in relying too much on this procedure: It may result in endless repetitions whereby the means become very limited ends. Materials should indeed be both respected and allowed a certain life of their own. Chance combinations can be pregnant with suggestions, and it is part of the creative process to see and incorporate these suggestions if they fit the purpose of the artist.

But whatever the approach, free and spontaneous or careful and concerted, there is indeed a special excitement in the very manipulation of tools and materials. Just as cabinet makers enjoy the physical quality of the wood that they have carefully selected and the feel of the appropriate tool in their hand, or just as we can see a seamstress almost caress the material that will become a garment, so do artists enjoy the physical properties of their materials and tools—the certain surface finish of a paper, a particular viscosity of ink or paint, a special density of pastel, the specific softness or resistance of a pencil or brush.

Getting Into It

Some artists revel in a total involvement with "messy" materials: They enjoy the tactile experience and do not mind the resulting mess around them and on them. Others manage to use the same materials in a more aseptic way; rarely do they or their work show traces of their contact with runny, drippy, smeary media. Others yet have an insurmountable repugnance to these messy materials and techniques, and they feel more comfortable and successful with "cleaner" and less smeary materials. Generally, and keeping in mind that there are glaring exceptions, artists who fall in the first category are those who are likely to thrive on the accidental and the unpredictible, whereas those in the second group often prefer a high degree of neatness, precision, and technical predictibility. The number of masterful works illustrating the various uses of different tools and techniques is eloquent testimony that neither approach is superior to the other; it is simply a matter of personal preference.

From the Fingertips to the Toes

Many considerations enter in the choice of technique. Certainly the intent of the drawing, the familiarity of the artist with the tool and the medium, the drawing surface, the personality of the artist and his or her style;—all these and more are factors in the choice. Even the size of the drawing plays its part. For example, when the surface is 8½ × 11" or smaller, the relative smallness of the working surface requires a technique that limits the physical involvement to the small muscles of the hand and wrist: something freer than writing but related to it. As the format of the drawing increases, the elbow is called into action, and finally, when the drawing surface reaches or exceeds 18 × 24", the drawing movement involves the shoulder and trunk as well, in a large movement or sweep. When working on larger works it is probably best to stand in order to have greater maneuverability in viewing the model and to enjoy greater freedom of movement.

The size of the tool and the way in which it is held and handled affect the technique and the impression it leaves on the drawing surface. For example, pencil, charcoal stick, or Conté crayon should not be held like a writing tool, especially for a scale larger than the average notebook; doing so may be constricting. Greater freedom of sketching movement is obtained by holding these implements between thumb and forefinger, with the shaft lying loosely across the palm of the hand. This allows a greater swing span from the wrist and elbow. On the other hand, linear details are usually executed with small movements of fingers and wrist, with the drawing instrument held like a writing tool.

Having said this, I must add that when artists are conversant with their tools and techniques in an almost instinctive way, and if they are gifted enough, they can hold their tools in any way that suits them, including between their teeth or toes; they can sit, stand, or lie and come forth with fine results.

Tigers and Does

Along with the psychological emphasis on freedom and self-assertion, art students are often encouraged—almost coerced,—to be bold and to work freely. But freedom without discipline and experience often leads to affected boldness, where the largeness of the scale, the thickness of the line, and the sloppiness of the smudge pass for directness, vigor, and power. If the artist's personality and esthetic needs are best served by bold visual statements, that boldness and directness will soon emerge, even if the initial efforts have been tentative and hesitant; and if delicacy and understatement are the natural artistic expressions of the participant, these qualities will eventually defeat efforts at bold graphic statements. In fact, there is more impact in an honest, delicate, and sensitive drawing, than there can be in contrived, misunderstood boldness. All this to say that the power of a drawing is far greater when it is an authentic artistic statement than when it is forced. Again, the choice of concept, materials, technique, and style form an organic whole, which cannot go against the grain of the artist.

Interestingly enough, we cannot always guess what a person's artistic bent is by outward appearance, and somehow I am always a bit amused when the boldest and most experimental drawings in my classes emerge from a very quiet, seemingly timid person, or when a young strapping athlete comes forth with a delicate and subtle drawing—a reminder to beware of stereotypes and expectations based on them.

CHOOSING THE PAPER: GENERAL CONSIDERATIONS

There are many kinds of traditional drawing surfaces: paper, cardboard, scratch board, gessoed masonite, wood, and so on. The most common and familiar is paper.

When choosing a paper for a specific project and a given technique, the artist needs to consider the essential characteristics of a paper, such as its *weight, absorbency, tooth,* and *tactile properties*. Its relative cost, too, is a consideration, as the artist does not need to invest as much for a surface meant for practice or preparatory quick sketches as for a full-fledged drawing. The *weight* of a paper, which affects its thickness is expressed by the weight of a ream of 500 sheets; its *absorbency* refers to the amount of water it can retain without buckling or tearing. Weight and absorbency are extremely important factors when selecting papers for washes or watercolor. A paper that is not quite heavy enough can be wetted and stretched to avoid buckling. (The procedure will be described in context.) The *tooth* refers to the grain or roughness of the paper; it affects the ability of the paper to accept and retain a given medium. This is particularly important when the artist intends to use a powdery medium such as pastel.

The majority of papers are quite versatile and can be used for a number of media and techniques. Most beginners start working on a moderately priced multipurpose paper. However, as their skill and self-assurance grow, they will also use other papers; it is important therefore, that they acquaint themselves with the basic properties of common working surfaces in order to choose techniques compatible with them.

Other factors may enter into the choice, such as the erasability of both the surface and the drawing medium and whether the surface needs to be prepared before one can draw on it.

Bond, Newsprint, and Advertising Sections

Because of their relative low cost, bond, newsprint, and the advertising sections of newspapers are commonly used for quick warm-up sketches and studies. Bond paper is lightweight and smooth-surfaced and lends itself well to com-

pressed charcoal, pencil, and ink. However, its lack of absorbency renders it unsuitable for ink washes. Newsprint and advertising sections, which are very absorbent, can also be used for compressed charcoal and pencil but are too absorbent for pen and ink, unless a bleeding line quality is desired. Useful as they are, these papers are impermanent, turning yellow and brittle in a relatively short time. This drawback precludes their use for anything more ambitious than warm-up and preliminary sketches.

A serviceable size for bond and newsprint is the 18 × 24" pad, but bond is also available in smaller pads, which are particularly handy for drawing out of doors or out of the studio.

Rag Papers

Rag papers are the "noble" papers. Valued for their toughness, permanence, and versatility, they are available in several categories: *Hot-pressed* are smooth, hard-surfaced, and not very absorbent, which make them best for pen and ink drawings. *Cold-pressed* are absorbent and toothy and can be used for a variety of media. *Rough papers* have the most pronounced tooth, and are therefore most suitable for chalk and pastels.

The high cost of rag papers limits their use by the beginning artist, who would be wise to start working on less expensive papers. However, when the artist has moved from faltering exercises to greater assurance, he or she will enjoy the sheer pleasure of working on a fine paper and will delight in feeling the responsiveness of papers and tools of quality that are compatible with one another and that enhance the drawing.

Rice Papers

The term *rice paper* is a misnomer, since most oriental papers are made from the inner bark of mulberry or other fruit trees. The beauty and variety of their textures are pleasures in themselves.

These papers have a smooth side and a slightly rougher side, but the difference between the two is often difficult to ascertain. Artists using ink or paint usually work on the smoother, less absorbent side. The high absorbency of some oriental papers may be a drawback in using brush and ink, unless the artists are working in a soft-edged style. If they want to work in a hard-edged style, they can overcome the problem by sizing the paper with alum and glue. Some oriental papers have been commercially presized. The presence of sizing can be determined by dropping a very small amount of water on the surface. If the drop retains its shape, does not spread, and leaves a damp mark after being wiped, the paper has been sized. If none of the water is absorbed and the drop does not leave a damp mark, the paper has been waterproofed. Both sized and waterproofed papers can be used for ink drawings. The softness of the line quality on a sized, but not waterproofed, paper can be a desirable effect. It is possible to control the linear ink quality on waterproofed paper from hard to soft edge.

Although the nonsized paper's great absorbency may preclude its use for linear work, its lovely translucency can be an asset for painting; printmaking, especially wood blocks; and collages. The textural richness of oriental papers becomes an integral part of the design of the print or the drawing.

Black, White, and Toned Papers

Usually, the student artist draws on white paper. Occasionally, the process should be modified, so that the artist works with white lines or masses on a dark surface. White ink, crayon, Conté, pastel, or paint can be used on a variety of black papers: charcoal paper, railroad or poster board, construction paper, and so on.

The traditional techniques used on black backgrounds are basically the same as those used on lighter surfaces: line, crosshatch, dots, fine scribble-scratch, and so on. But now, when the artist works in masses, he or she indicates the figure or object through its highlights (when working on a light background, he or she defines it through its shadows). This reversal of graphic definition does not arise when the figure is defined through line only. Working on a black surface can yield dramatic results, but the beginner should bring up the drawing gradually and cautiously since it is more difficult to erase white markings made on a dark background than impressions on white paper.

Toned papers allow the artist to work in three values: dark, middle, and light, the middle tone being provided by the paper itself. The artist then adds the lights and the darks. There are many very beautiful toned papers available, especially among the charcoal papers. Artists can also tone the paper themselves. For example, if they are working with charcoal or graphite, they may want to first coat the surface of the paper evenly with a middle value

of graphite or charcoal. The light areas are then obtained by erasing or by applying white pastel or chalk, and the darks are then added.

The Gesso Ground

A nonpaper surface that is quite useful is the untempered masonite board coated with gesso. It can be bought ready-made, or artists can prepare their own panel. A number of books describe the technique of preparation. Most beginners, however, start with commercially prepared gesso panels.

The gesso board provides an excellent drawing surface for a sustained drawing; almost all drawing media can be used: graphite, pencil, ink, wash, even chalk. If charcoal is used, it should be either compressed or wet charcoal so that it may adhere to the smooth surface. Subtle tones can be obtained by rubbing graphite, chalk, or charcoal into the surface with a stump or eraser or by brushing over and into the areas with brush and water (see Fig. 3-3).

EMPHASIS ON LINE, TONE, OR COLOR

Many media can be used for a variety of techniques. Pencil, for example, which is primarily a linear medium, is also used to create tonal masses; so is pen and ink. Some media, however, lend themselves more naturally to some techniques than to others. For instance, charcoal, litho crayon, and Conté can be particularly suited for dramatic masses of lights and darks, whereas pencil and silverpoint are especially effective for linear definition and delicate tonal areas; watercolors, pastels, wax crayons or felt markers are more likely to be used when the drawing is conceived and expressed through color.

It is convenient to describe media as belonging to two basic categories: the dry and the wet. I shall describe them in relation to the techniques with which they are most commonly associated, namely, in terms of their use for linear, tonal, or color emphasis. A few nontraditional media and techniques will also be introduced. My main purpose remains to point out the relationship of the physical factors of medium, tool, drawing surface, and technique.

A practical note: The price of art supplies is often very high, and the expense can limit artists in their choice of materials; it can even inhibit their free use of them, especially in nontraditional, experimental techniques, where the risks of technical failure are higher. To circumvent such a concrete deterrent, the determined beginner may resort to some simple practical strategies. For example, when buying in large quantities reduces the price of the individual item, a few people can buy together and divide the cost. It is also advisable to collect materials on a regular basis so that when artists need a given paper or material, they are not faced with an immediate concern with cost. Besides reduced cost, there are many esthetic advantages to the preparation of one's own materials; this is not possible for all materials, but gesso boards and scratchboards are cases in point. Some artists are now making their own paper with spectacular esthetic results.

Tools and Techniques for the Linear Approach

The most basic tools associated with line and the draftsmanship approach are the pointed tools such as pencil and pen. However, exciting linear definition can be obtained with many other tools, including makeshift ones such as twigs, dowel sticks, pipe cleaners, eye droppers, glue squeeze bottles, mucilage brushes, string, and so on. Lines can be drawn, trailed, incised, scratched, brushed, printed, or bleached, and each means produces a different quality.

Graphite pencil. Inexpensive, easy to carry, easy to erase, easy to use alone or in combination with other tools and media, extremely versatile and available universally, the graphite pencil—commonly misnamed *lead pencil*—is the most familiar and practical companion of the sketching artist.

A mixture of carbon and clay, graphite is available in pencils and in rectangular sticks; it can also be reduced to powder by grinding the stick over sandpaper. The degree of darkness—the softness or hardness of the impression it leaves on paper—depends on the relative proportion of carbon to clay in the compound: The more carbon there is in the amalgam, the softer and darker the impression, whereas a proportionally larger amount of clay produces a harder and greyer mark. Pencils are coded by letter and number. The soft and medium soft pencils are coded with the letter B and a number; the higher the number, the softer and darker the pencil mark. The medium hard to hard pencils are coded with the letter H, which is also accompanied by a number; the

higher the number, the harder and greyer the impression. Thus, 9H is the hardest of the H series and 1H the least hard of the same series, whereas 8B is the softest and darkest of the B series and 1B the hardest—1B softer than 1H. HB is a degree of hardness that bridges the H and B series. Although 2B is the almost universal all-purpose medium-soft pencil, the artist should have a comprehensive range of pencils, from dark to light and from soft to hard: 2B, 6B, HB, 3H, and 6H might be a good range for a beginner.

Graphite pencils can be used on almost any moderately grained drawing surface, but hard pencils leave better impressions on Bristol board; with its fine tooth, the kid-finished Bristol board is especially well suited for delicate pencil marks produced with medium-hard pencils, whereas the smooth-finished Bristol board provides a fine drawing surface for very hard pencils. Soft and medium-soft pencils work best on a soft-surfaced, cold-pressed paper or on multipurpose paper.

As a general rule, pencil impressions are easy to erase, especially those produced by middle-range pencils; but the heavier and thicker markings left on the softest papers, as well as the impressions left by the hardest pencils, are more difficult to erase. The difficulty in erasing is also affected by the quality of the surface and the degree of pressure that was applied. The art gum and pearl erasers are familiar, but the white plastic eraser seems to be the most efficient for pencil.

As was stated earlier, the graphite pencil is a linear tool par excellence, although it is versatile enough to create shading and tonal areas. The variety in the line quality is determined not only by the style of the artists, the way they hold their tools, the amount of pressure they apply, how they choose to create their graphic boundaries— the single smooth trail or the multiple broken line—but also by all the other factors already mentioned concerning the physical properties of tools, materials, and drawing surfaces (Figs. 3-1, 3-2, and 3-3).

Silverpoint. A beautiful, elegant, thin, and even but firm line can be obtained with silverpoint, but this is not a tool and a technique for the rank beginner for it leaves an impression that cannot be erased. The impression is produced with a stout silver wire about 1″ long inserted into a stylus or drafting pencil holder. The point is sharpened by rubbing it at an angle on sandpaper. Usually, the artist works on heavy, smooth paper coated with gesso; student work is usually done on heavy

paper coated with white poster paint. Over a period of time, the silvery impression left by the silver point oxydizes to a grey-brown line, which is also quite attractive.

Pens. Until the nineteenth century, the quill and the reed were the major drawing implements, and they still have their devotees today. The quill pen is cut and shaped from the pinion feathers of a large bird; the reed pen, from a still-green reed. A reed pen gives a blunt and thick line, whereas the quill produces a finer and more nuanced linear quality; however, in order to preserve this quality of line, the tip of the quill has to be frequently recut. Reed pens are often used in concert with quill pens in order to obtain a variety of line

Figure 3–1.
PABLO PICASSO (1881–1973).
Igor Stravinsky. Drawing (1920).
Picasso Museum, Paris. © S.P.A.D.E.M.,
Paris/ V.A.G.A., New York.

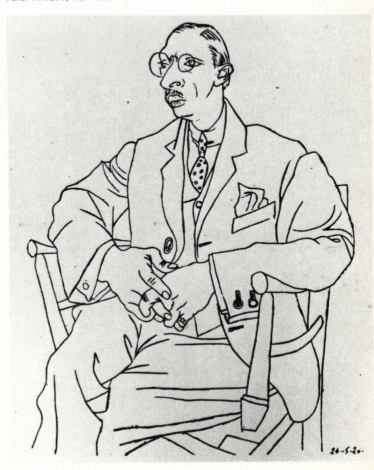

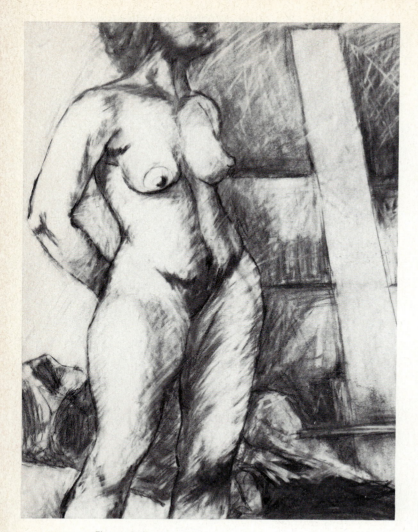

Figure 3–2.
EDWARD BELLUSO, student.

Soft graphite pencil on hard-surfaced paper.
First, the pencil strokes were applied vigorously and then softened with an eraser. The eraser was also used in slashing strokes across tonal areas to create additional textural interest.

Figure 3–3.
M. DEHRING, student.

Graphite drawing on paper previously prepared with gesso.
The main outlines were first lightly penciled in. The tonal modeling was then added by rubbing with a wad of cotton dipped in powdered graphite. The proportions of the figure were purposefully slightly exaggerated in order to emphasize the sense of space.

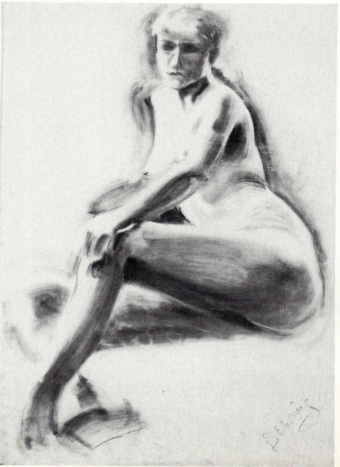

qualities. By the nineteenth century, steel pens largely replaced the quill and the reed. They present a number of advantages: The tip does not have to be recut, they are availabe in a great variety of widths and flexibility, and they are durable. They should be washed after each use, especially when they have been dipped in india ink, in order to keep the point from being caked with dried ink.

The fountain pen is a variation of the steel pen. Its built-in reservoir makes it a practical tool for drawing in ink away from a studio, when one wishes to reduce the gear one carries and eliminate the risk of spills. The felt-tip pen and its many variations serve the same purpose as the fountain pen. A script pen, in steel or nylon, commonly used for fine lettering, is also a serviceable, flexible, drawing implement. The linear quality it produces can be varied further by using the point frontally as well as by using its side for a thinner line.

Because the quill and steel pens have sharp points that may catch and tear the surface of a soft-finished paper, it is advisable to use them on a smooth, hard-finished surface. Other pens can also be used on hard-finished papers, but if they are used in combination with ink wash tones, it is preferable to use a moderately textured paper—as long as the paper is not too absorbent, for an overly absorbent paper diffuses the ink lines as would a blotter.

Brushes. Loaded with ink, a brush produces a heavier, more sinuous and modulated line than charcoal, pencil, or pen. A great variety of brushes are available for a great variety of purposes and techniques. In all cases, the linear quality of the line obtained with brush and ink or paint is determined by the flexibility, width, and shape of the bristle; the amount and viscosity of the ink or paint; the pressure exerted on the brush; and the properties of the receiving surface.

The best among the soft-haired brushes is the red sable. The round red sable is probably the most popular brush for drawing and watercolor; No. 7 and No. 12 are serviceable, all-purpose sizes. Because of the high cost of red sable brushes, beginners usually start with sablene or with ox-hair brushes. The pentel brush, with its own ink reservoir, produces thick and thin lines as well as dry brush effects. It is practical for out-of-studio work because it eliminates the need for a separate ink container. The striping brush, found in auto-mobile supply stores, also produces a variety of line qualities, but one needs to get used to its extremely short handle.

Hard-bristled brushes are more likely to be used for tonal areas (and will therefore be described in the discussion of tonal emphasis).

Drawing inks. Inks have been a drawing medium for centuries, both in the Western and in the Oriental traditions. An almost unending variety of effects can be achieved with inks by varying the strength of the solution, from full strength to highly diluted, and by varying the tool and the method of application: pen, reed, or brush.

India ink, a traditional favorite of many artists, is made of carbon or lamp black pigment to which a shellac binder has been added. At full strength, it leaves a rich, velvety black trail and lends itself particularly well to hard-edged linear drawing. Waterproof India ink is a very durable medium. Permanent ink can be diluted before use, but once it has dried after application it can no longer be lightened by the addition of water.

THE TONAL APPROACH

Because the nonlinear or painterly approach to drawing places greater emphasis on masses than on contour, it often requires the modeling of forms through light and dark. This can be achieved in three basic ways: By modulating and blending tones of Conté or charcoal with the help of a stump, by graduating tones of ink wash or watercolor, or by graduating the density of cross-hatch areas executed in pencil or ink. Through skillful handling, these techniques can yield a full tonal range, from the darkest and boldest to the lightest and most delicate.

A number of traditional tools and materials can be chosen to achieve these ends: charcoal, Conté, pen and ink wash, and lithographic crayon, among others. For particularly delicate tonal effects, ground graphite and silverpoint may be preferred.

The tools just mentioned as being especially well suited for tonal emphasis are not restricted to that use and are often used for linear techniques. In fact, a single tool or medium can be used for different techniques within the same drawing. Certainly, pen and graphite pencil can be used to produce line and contour as well as crosshatch tonal definition, for example.

Charcoal

Charcoal is one of the oldest and still most popular drawing tool. Stick charcoal is a carbonized twig of willow, vine, or beechwood. Because there is no binder, it is extremely friable. Its powdery texture requires it to be used on a special paper, abrasive and toothy enough to retain the charcoal's dusty trail in its grooves and on its grainy surface. Charcoal paper is the best surface and is available in white as well as in an array of subtle, muted colors.

Charcoal is easily removed or erased with a kneaded eraser, which can also be used as a drawing tool. It is necessary to keep the eraser constantly kneaded so that it remains soft. Chamois cloth, a piece of very soft, pliable animal skin that has been especially treated, is also used to wipe out or to lighten areas of charcoal; the stump or tortillon, a rolled piece of blotter in the shape of a pencil, can be used to spread and blend areas of charcoal and create tonal transitions.

Compressed charcoal. Compressed charcoal, which is also marketed in stick form, is a compound of ground charcoal and a binding agent. This combination gives it greater adhesive power and produces a deeper black than does vine charcoal. It is available in various degrees of hardness, from the softest and blackest (00) to the hardest and greyest (05). One of the advantages of compressed charcoal is that it can be used on smooth paper; a minor disadvantage is that it is not as easily erased as vine charcoal.

The charcoal pencil, a variation of the compressed stick, is encased in a wooden shaft. Although thicker and darker than most graphite pencils, it permits a thinner and more delicate line than either vine or compressed charcoal, and it is therefore more appropriate for smaller or more detailed drawings. It is available in several degrees of hardness and blackness, ranging from HB (hard) to 2B (medium) to 4B (soft). A distinct advantage of the charcoal pencil is that unlike the other charcoal media, it is a clean tool, producing a minimal amount of chalkdust.

Charcoal techniques. There are many ways of sketching with charcoal, but these can be grouped into two main approaches: massing-in and modulating the form with the broad or side edge of the charcoal, or hatching with the thinner charcoal pencil. The two approaches are often combined, and many variations are possible:

Grind the charcoal to powder or charcoal dust and spread it over an area with a wad of cotton. Darker areas and accents can be added with stick or pencil charcoal.

Dip the compressed charcoal stick in water to obtain a rich, bold black.

Soak willow charcoal sticks in olive oil overnight in order to produce dark impressions that do not dust off.

Use the charcoal pencil point in a scribble-scratch technique, which is freer than the crosshatch, to create dark tonal areas.

(Crosshatching is described later with other tonal graphite techniques.)

Fixative

Being a powdery, dusty substance, charcoal, once applied, needs to be stabilized and fixed to the drawing surface to avoid smearing the completed sketch or drawing and to facilitate handling. A fixative is therefore sprayed evenly over the whole drawing after it is completed. Sometimes the artist wishes to modify the study or drawing after it has been sprayed with fixative. This is possible only if the fixative used is a *workable fixative* rather than regular fixative. However, the artist must allow the protective layer of fixative to dry fully before doing any further work on the drawing.

When applying fixative, it is essential to disperse the spray evenly and thinly over the whole surface of the drawing. This is best done by moving the spray can evenly from a distance of approximately 2 feet from the drawing. This prevents flooding any given area of the surface. Spraying should be done outside or in a well-ventilated area so that the artist is not forced to inhale the fumes.

Conté and Lithographic Crayon

Conté crayon is something between chalk and a wax crayon. It is a widely used medium, appropriate for quick sketches as well as for fully developed drawings. Because of its greasy content, it does not rub off the paper evenly, and thus can be used for linear work or for smooth tonal gradations. Subtle variations and gradations are possible through controlled pressure and the use of both the point and the side of the crayon. Conté is available in stick or in pencil form in black, white, sepia, and sanguine, and it comes in three degrees of hardness: hard (No. 1), medium (No. 2), and soft (No. 3). It works best on a smooth paper surface and

can be erased with the kneaded eraser. If Conté crayon is used lightly on heavily textured paper, it only leaves an impression on the top ridges of the grainy surface, creating a pointillist texture.

Like charcoal and Conté, the lithographic crayon can be used effectively to suggest tonal masses. It contains a large amount of grease binder, which makes it more durable than crayons. If drawings executed with lithographic crayon are worked over with turpentine—applied with a brush, cotton, or soft tissue—they take on a rich painterly appearance.

Graphite Techniques for Tonal Emphasis

The shape of the tool and the consistency of the medium suggest that pencils are more apt to be used for linear techniques, and sticks and powders lend themselves best to the formulation of masses and tonal areas. Yet as we know, tones and masses can also be produced with pencil through hatching or crosshatching. Tones produced by graphite are generally lighter than those produced by charcoal, and they often exhibit a silvery sheen, not unlike silverpoint.

The *graphite stick,* which is about 3" long and ¼" wide, can be angled on any of its sides to create dramatic edges or planes. Graphite slabs are also available. Both the sticks and the slabs can be broken into smaller pieces for easier handling.

Graphite powder is obtained by grinding a graphite stick or slab against medium or rough sandpaper. The powder is then stored in a small jar. It is applied with a cotton wad, a Q-tip, a stump, or a small soft rag to create soft, delicate tonal areas. Accents can be added with pencil. This medium is particularly effective when subtle tonal effects are desired. Further gradations and nuances can be introduced by brushing turpentine over portions of the tonal areas. Dark accents can be made darker by dipping the brush in both turpentine and graphite powder and applying the mixture to the desired area.

Another variation is the *graphite wash,* which is executed by mixing the ground graphite powder directly with turpentine into a thin paste. A brush loaded with turpentine is then dipped into this mix and applied to a sheet of smooth-finished paper that has already been soaked with turpentine just before the application of the mix. The turpentine evaporates quickly, which necessitates frequent re-soakings of the paper as the application of the graphite mix proceeds. The tonal quality obtained

varies with the degree of hardness of the graphite and the kind of brush that is used: a bristle brush for the strong tonal areas and a soft-haired brush for more delicate tones. The graphite wash resembles a grey watercolor wash, but its surface is more granular.

Hatching. This is a method of modeling the form through a series of closely spaced parallel lines. The relative closeness between the lines determines the degree of light and dark produced: The closer the parallel lines, the darker the tonal area. Hatching can be used to describe the volumetric quality of the form through the modulated degrees of lights and darks as well as through the indication of plane directions. The parallel lines can be straight or curvilinear, following the direction of the plane described (Fig. 3-4).

Figure 3–4.
JACOB DE GHEIN II (1565–1629).
Boy Seated at a Table with a Pen and Writing Tools.
Pen and iron gall ink on brownish paper (1610–1612).
The Yale University Art Gallery, New Haven.
The hatching lines clearly define the directions of the planes and the volumetric quality of the form.

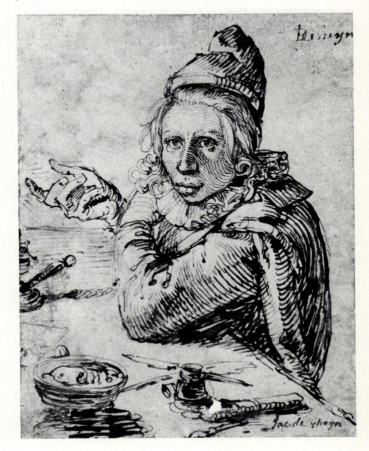

Crosshatching. Closely related to hatching, crosshatching is also used to create graduated tonal differentiations, transitions, and volumetric formulation. Crosshatching systematically superimposes a second and sometimes a third layer of hatching at a direction opposite to the preceding one, thus creating denser and darker tonal areas. The successive layers of hatching and crosshatching produce different degrees of darkness: lightest where there is only one layer; increasingly dark with the addition of the second and third layers (Fig. 3-5).

Hatching and crosshatching, which in fact are linear means to create tonal areas, are effectively done with hard pencils (H to 6H) because these produce sharp separations between the close parallel lines and impart an overall silvery sheen. Because of its slight tooth and hard-finished surface, kid-finished Bristol board is recommended as a drawing surface for clear delineation.

Tonal Pen-and-Ink Techniques

The hatching and crosshatching just described for pencil drawing is also used with pen and ink. The technique is quite traditional and is used in printmaking as well as in drawing. The novice must guard against a common failing: the ten-

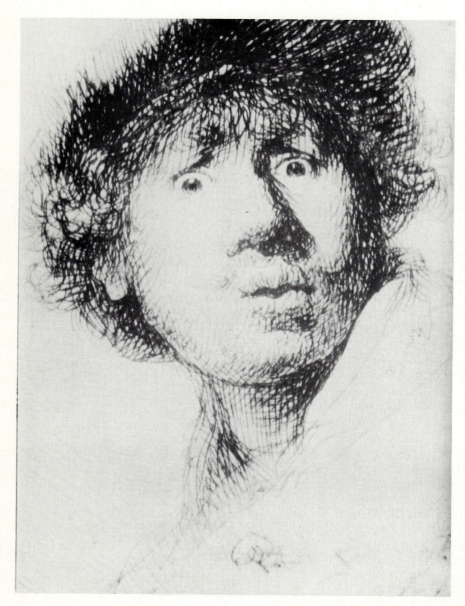

Figure 3–5.
REMBRANDT VAN RIJN (1606–1669).
Self-Portrait (1630).
Etching.
Courtesy of the Trustees of the British Museum.
The original etching is quite small (2 × 1 ¾"). This enlargement shows clearly the masterful use of the crosshatching technique, with subtle gradations of density to define the volumes.

dency to produce three sharply defined bands of crosshatch—light, middle tone, and dark. It takes practice to produce subtle tonal blendings and to avoid the band effect—unless that effect is the choice of the artist. It is a good idea to allow the background paper to show through the crosshatch lines, no matter how close they are to each other; this adds sparkle to the drawing. The beginner is also cautioned to avoid ink puddling, which destroys the quality of the clear linear web. It is therefore important to allow each crosshatch layer to dry before starting the next one. For a different, freer effect, a scribble-scratch or a scribble technique can be used instead of the crosshatch.

A light or medium ink wash may be incorporated with the hatching; if the artist intends to add areas of ink wash, the initial crosshatch must be executed in permanent ink so that it does not become diluted or smeared by the addition of a water medium.

A smooth surface or hard-finished paper provides an excellent surface for a clearly defined crosshatch web, but if wash ink is incorporated, a soft-finished paper is needed.

Ink wash. The use of pen or brush and ink for linear emphasis has been discussed. Ink wash is a tonal technique that remains popular with contemporary artists who find a special fascination in playing cool blacks against warm blacks, with variations in between, and who take pride in the skill required to work in hard-edged washes or in smoothly blending imperceptible tonal gradations.

Basically, the wash technique is a process of wet into wet: A wash of water is first applied with a soft brush over a lightly penciled drawing; this is followed by the application of a light mixture of water and ink (much more water than ink) to the appropriate areas with the same brush. While it is still wet, a slightly darker wash is applied to modulate the tone where a darker area is desired. The process continues until the darkest tonal areas have been formulated, the dark tones emerging smoothly from the lighter ones. The tonal range can be kept basically light or basically dark as desired (Fig. 3-6). If the artist intends to produce very smooth and subtle blendings, the main technical problem is to not allow a layer of ink wash to dry before adding a darker one; if the underneath layer is allowed to dry, there will be a hard-edged demarcation between the tonal areas. This is quite acceptable if that is the effect wanted by the artist; but if the concept requires quasi imperceptible gradations and blendings, the tech-

nique of working wet into wet, progressing from light to dark, should be followed. A tissue, a clean rag, or a soft brush may be used to blot gently excess ink or to lighten an area.

A wash drawing may be completed without the addition of reinforcing lines in pen or brush and ink, but many artists do use linear reinforcement, creating a rich interplay of linear definition with mass suggestions (Figs. 3-7, 3-8, and 3-9).

India ink is commonly used in wash drawings. There are two kinds: permanent and washable. After it has dried, permanent ink cannot be readily lightened or further dissolved with the subsequent addition of water; soluble or washable ink can be diluted by adding water after it has been applied and has dried. The artist needs to become

Figure 3–6.
HELEN WHITMAN, student.
Ink.
Special attention was given to the negative space contiguous to the figure.

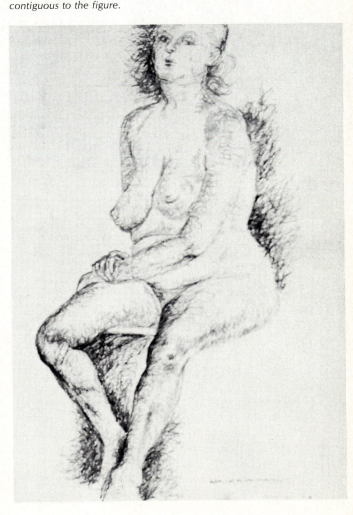

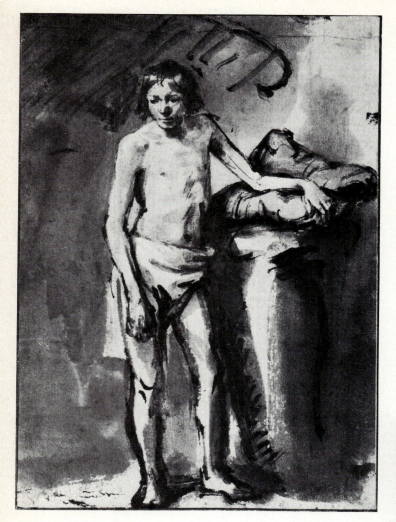

Figure 3–7.
REMBRANDT VAN RIJN (1606–1669).
Male Youth Standing.
Wash drawing.
Albertina Museum, Vienna.

soluble inks for the flexibility they afford. However, if the artist works entirely with soluble inks, he or she will prefer to add the linear indications or accents after the wash has been applied so as not to dilute or blur the line.

Some artists make their own black, water-soluble ink by dipping a sumi stick in water and grinding the softened stick on a grinding stone. The result is a rich black paste or thick liquid, which can be thinned down to the desired consistency by the addition of water. Erasable inks can also be produced by makeshift means. For example, Hyman Bloom devised an ink with Conté crayon and water; it can also be done by dipping the Conté stick in turpentine. In both cases, the wet Conté produces a soft inky line, which has the

Figure 3–8.
ROSE DILLBERGER, student.
The feeling of volume and weight is convincingly conveyed in this seated figure. The drawing was executed in ink on heavyweight paper and was strengthened with a few linear notations and dry brush accents.

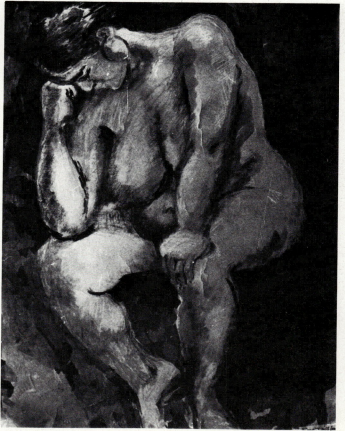

acquainted with the possibilities and limitations of both types of ink in order to obtain the flexibility and the range of effects that is wanted. For example, washes can be applied over dry lines that have been drawn with waterproof ink without blurring them. This can be an advantage or a disadvantage: The beginning artist may be intimidated by a medium that leaves little room for erasing or correcting. Fortunately, artists can work with soluble erasable inks. Not quite as dark or durable as waterproof India ink, these can still be manipulated after they have dried; that is, the tonal area or the linear impression can be lightened or even washed away by adding water and by blotting. The seasoned artist often values the

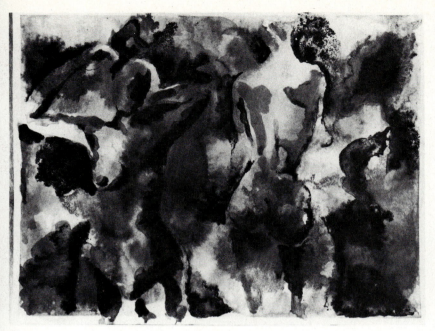

Figure 3–9.
CYNTHIA ROGERS, student.

Ink washes were allowed to flow one into the other, forming a rich, evocative ground; figurative imagery was then pulled from the vague configurations and reinforced with additional washes and a minimal use of line.

advantage of being erasable. Bloom has also successfully used a ready-made water-soluble white ink called White-White: By dampening a tonal area that has been produced with a wash of white ink and sponging up this wet area, a faint, ghostly image is left (see Fig. 11-10).

In addition to black, drawing inks come in a variety of very attractive earth colors, ranging from reddish-brown sepia and modified olive green to yellowish bistre. These can be mixed with each other to produce an even greater range of colors although bistre has a tendency to fade. However, if artists choose only high-quality inks such as Pelican, they are less likely to be frustrated by this problem.

The wide, flat, and soft Japanese wash brush is especially serviceable for applying large areas of wash tone. Other Japanese brushes come to a point, and depending on the pressure applied, can be used for fine linear drawing or for flat wash application. The best of these is a long-haired brush. There is a less expensive model called a bamboo brush, which is also quite versatile. The brushes used for linear techniques, sable, sablene, and ox hair, can also be used for tonal purposes.

After use, brushes should be carefully cleaned with the appropriate cleaner and then washed with soap and water and fully rinsed. They should be kept upright in a container to avoid putting pressure on the bristles and thus deforming the brush.

Because the wash technique involves water and ink, two very "runny" ingredients, it is wise to use a grainy, heavy-weight, absorbent paper such as watercolor paper. The technique is usually practiced—and there should be a lot of practice before a major project is attempted—on all-purpose watercolor paper. To avoid buckling, this paper should be wetted first and taped around all edges to the drawing board. A sustained project should be executed on a better grade of heavy rag watercolor paper such as Arches 140 lb. or its equivalent. It is not necessary to tape down a heavy paper since its weight prevents buckling. When one is working in washes or watercolor, the board must not be sharply slanted, as slanting causes the ink to run and leave unwanted trails.

Dry brush. A quite effective process for nonlinear painterly drawings is the dry-brush technique. This involves the application of oil or acrylic paint with a stiff bristle brush on a relatively nongrainy hard-surfaced paper. Ink can also be used, but in that case, the brush should be loaded sparingly and a grainy paper used . No water is added to acrylics since the effects are more exciting when the brush is almost dry, leaving an uneven, striated patch where the paper shows through the strokes. In order to ensure the proper consistency of the medium, it is practical to remove the excess by brushing the paint on absorbent paper before

applying the brush to the work itself. The paint is applied with short scrubbing strokes, the strokes going in different directions so that the paint is deposited unevenly. The result is a rough texture and diffused edges. Some artists combine dry brush with a wash applied before or after the drawing. Interesting results are obtained by carefully controlling the amount of paint applied: Where the paint is applied very lightly in one layer, much of the paper shows through and the effect is that of a light tone; where the paint is applied in more than one layer, each layer going in a different stroke direction, less paper appears through and the area appears darker.

Scratchboard. The scratchboard technique can produce linear or nonlinear results. The line or tone is derived by incising or scratching the upper layer of a specially prepared black surface with a pointed instrument, such as a stylus, dowel stick, or pencil knife. This can be done on a commercially prepared board, or artists can prepare their own by applying two coats of gesso on a board of medium thickness. After each application, when the gesso has dried fully, the board is sanded to a very smooth finish. When the second coat has been sanded, two coats of permanent India ink are added, making sure again that the first coat is quite dry before the next one is applied. In drawing on this surface, beginners need to accustom themselves to a process whereby the configuration is developed from dark to light, unlike the usual procedures. Middle-tone areas can be produced with a modified hatch or crosshatch obtained by incising. To produce light tones, whole areas can be scraped out with a single-edged razor blade or a stencil knife. Depending on the tools used and the handling of them, the artist can define the shapes through clean or jagged edges.

COLOR EMPHASIS

A drawing is not necessarily limited to black and white or to a monochromatic chalk or Conté crayon study. Colored pencils, colored inks and dyes, wax crayons, felt pens, pastels, oil pastels, watercolor, and oil and acrylic paints can be used in the drawing process. Sometimes the demarcation between drawing and painting is tenuous. For our purpose, if the color is an adjunct to a pen, pencil, charcoal, or Conté crayon study, it remains a drawing; but if the study is done in watercolor, pastel, or paint with a few linear accents for definition and reinforcement, it is dominantly a painting.

Pastel

An intriguing and versatile medium, pastel is a compound of chalk and gum arabic; it is available in a great array of intense and muted colors and in various degrees of hardness. The soft pastels are cylindrical sticks, and the harder ones are compressed into rectangular sticks.

Pastel is not a transparent medium, but it has great matte brilliancy, and pastel drawings made with materials of good quality and protected properly retain this brilliance with minimal fading. As with charcoal, pastel is deposited through pressure as a trail of ground powder in the grooves and on the crests of a toothy paper surface that retains the powdery material.

There are papers especially manufactured for pastel. Excellent for extended studies and compositions, these papers may be too expensive for exploratory or practice drawings. Many artists substitute charcoal paper. Very fine sandpaper is also a working alternative, but it is not available in sizes larger than 8 × 11", which limits its use to that relatively small format. For that reason, charcoal paper is more commonly used as an alternative.

As with vine charcoal, and for the same reason, a fixative must be used to stabilize the pastel particles on the paper. After completing the drawing, and even between successive stages of a given study, the artist sprays on the fixative. Application of a workable fixative allows the artist to work over or add to a given area without disturbing or muddying it. Three or four layers of fixative are usually applied over the surface, allowing each layer to dry before the next one is sprayed. A thin, evenly distributed spray is advised because too much fixative may alter the color. It is applied in the same manner as was described for charcoal. Once the drawing or painting is considered completed, it can be further protected by framing it in a cardboard mat and placing it under glass. The raised surface of the cardboard mat around the edges of the drawing prevents direct contact with the glass and therefore prevents smearing.

It takes practice to develop technical assurance with pastel since it cannot be erased, and the artist must develop a sense of when and how to fix

the different layers or areas in order to rework them. Once the artist has gained a measure of control over the medium, the results can be most gratifying.

Pastel techniques. During the eighteenth century, artists used pastel in a delicate, blended manner, emulating the smoothness of traditional oil painting. The nineteenth-century French artist Edgar Degas developed a distinctive, bold technique, which imparted a shimmering quality to an opaque medium; he revitalized the pastel technique, choosing it as a favored medium for the depiction of many of his ballet dancer series.

Degas first outlined the drawing in charcoal on a toned cardboard. He then applied the main color areas in flat tones; upon these, he superimposed bold, separate strokes, which brought added vigor and excitment to the surface. By using opposition of tones and colors, and by breaking the surface with small strokes, he made the medium sing. He even used the process of fixing the pigment to add a further vibrating quality. He accomplished this by applying frequent layers of fixative at different stages of the drawing, and when each layer was dry, he played a new color layer against the preceding one, leaving some of the ground to show here and there. The total effect is one of rich, shimmering, vibrating colors defining the form. He "pushed" the medium to new bold effects by occasionally spraying the pastel with hot water and immediately using a brush to work into the wet surface. He also was able to obtain a thick impasto painterly quality by working with pastel sticks that had first been soaked in steam (see Fig. 6-20).

Pastel, like graphite and charcoal, can be ground into a powder to be rubbed with a wad of cotton on the surface of a moderately grained paper.

The pastel techniques of today are quite varied, combining a number of techniques and mixed media too numerous to mention (Figs. 3-10 and 3-11).

Oil and Crayon Pastel

The oil and crayon pastels, which are available in various forms and in a large assortment of colors, are hybrid products, combining smooth, waxy properties with the brilliance of chalky pastel. Thus the pigment is more adhesive and can be

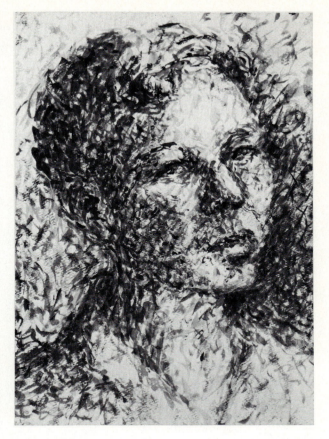

Figure 3–10.
BERNARDINE RIDER, student.
The portrait was executed in an impressionist water-color technique, using dabs over dabs of transparent watercolor, creating a vibrant effect.

applied on relatively smooth or hard-finished paper. A homemade oil pastel can be obtained simply by soaking regular pastel sticks overnight in a jar of olive oil. Although it is more difficult to blend and fuse different colors as smoothly as one can with regular pastel, blending of a few colors is feasible. For a beginner, oil or wax pastels share a common disadvantage with chalky pastel in that they cannot be erased easily. However, being less friable than chalk pastel, and therefore adhering more smoothly to a hard-finished paper surface, they are better suited to a hard-edged stylistic concept, where the artists wants shapes defined by sharp demarcations.

Several technical variations are possible, which extend the range of the material. For example, it is possible to dilute oil pastel with

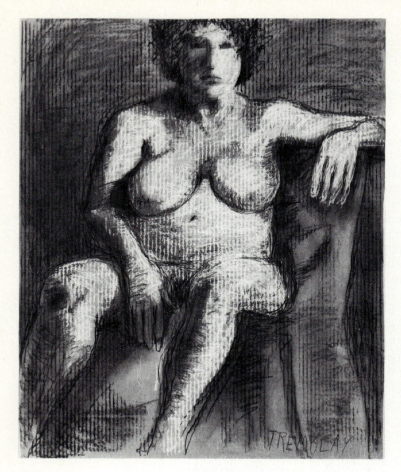

Figure 3–11.
PATRICIA TREMBLAY, student.
Pastel on corrugated paper.
The strong texture of the drawing surface, which
retains the pastel along its vertical ridges, imparts an
overall unifying pattern to the drawing.

turpentine to make it more translucent; turpentine brushed over an oil pastel drawing gives it the quality of an oil painting.

Watercolor

A thin, transparent medium, watercolor is composed mostly of dry pigment, gum arabic, and glycerin and is available in tube, cake, or liquid form. As its name implies, watercolor requires the additon of varying amounts of water.

The brushes mentioned in the description of ink wash are also watercolor brushes. Sable is best, and is the most costly; sablene and ox hair are quite good, as are a number of Japanese brushes. Brushes should be kept clean and stored upright in a container, brush side up.

Weight and absorbency are important factors in choosing a paper for watercolor. Preliminary and practice projects can be executed on all-purpose watercolor paper that has first been wetted and smoothly taped on all sides to the drawing board (or it can be moistened with a sponge after having been taped to the board) to avoid buckling. The artist who is ready to undertake a more ambitious watercolor project would probably enjoy working on a heavy rag paper such as Arches 140 lb. In this case the weight of the paper eliminates the necessity to wet it and tape it to the board. Again, it is advisable to work on a relatively flat surface to avoid runs.

There are numerous watercolor techniques, including the wet-in-wet approach which is similar to the wash technique, and the wet-on-dry glazing

favored by the nineteenth-century French painter Paul Cézanne. The wet-in-wet technique requires practice, since rapidity and control are essential. The medium should be applied quickly and smoothly, with the proper balance of pigment and water constantly maintained. When one wishes to keep the color gradations and transitions fluid and subtle, this technique is usually used. If one wishes to obtain a free, spontaneous quality, the wet-on-dry glazing method may be preferred. In that case, the watercolor is applied in light patches, with the paper surface showing between the patches, and the watercolor is allowed to dry. As it dries, it forms a faint edge around the transparent patch. Other patches of thin watercolor are added, some partially overlapping preceding ones, and a lot of paper is still allowed to show through. Often, artists use both techniques in the same composition, to contrast subtle blendings with delicate hard edge. The translucent quality of watercolor is enhanced by the whiteness of the paper that has been left untouched or allowed to show through.

Interesting effects are also obtained by scraping areas of color, while they are still wet, with a single-edged razor blade. Another possibility is to protect parts of the composition with rubber cement or paraffin before the application of watercolor; when the watercolor has fully dried, the rubber cement is rubbed off, leaving textured white paper in the area that had been protected. Watercolor that has dried may be erased in small areas or lightened by running water over it and gently blotting.

A host of nonorthodox techniques has been added to the more traditional ones, yielding rich and intriguing results. Some of these techniques involve the addition of starch, salt, soap, and so on, thus changing the consistency, texture, and working quality, as well as the resulting image, of the watercolor. The beginning artist who wishes to work with watercolor is urged to gather more technical information, available in many excellent specialized books.

EXPERIMENTAL EMPHASIS

The element of chance, which is always present in most creative projects, is even more evident in those that are achieved with nontraditional, unorthodox tools and techniques. In such cases, the artist may even have elected to dramatize the element of technical risk.

Having gained relative skill with the traditional linear means—pencil, pen, Conté crayon or brush—artists may add others, less predictable tools and techniques to their range: the blurred line traced by the pen on a damp surface; the scratchy, nervous trail made with an ink bottle stopper; the variety of thick and thin lines produced with balsa twigs; the sinuous linear impressions left by string, thread, or cord; and the multiple combinations and varations possible. I should add that the term *nontraditional techniques* is a loose one, encompassing techniques that have been used for a few decades as well as newer ones.

In reviewing some experimental drawing tools and techniques, I will concentrate on three areas: drawing with other than traditional tools, transfer techniques, and building by destroying. There are certainly other avenues of investigation, but I will focus on these, which can, in turn, lead to other variations. As the participants try new variations, they should keep in mind—in addition to esthetic considerations—such practical concerns as safety, toxicity, and perhaps durability of results.

Why Nontraditional Techniques Arose

There is an interesting parallel between the gradual desacralization and democratization of subject matter in Western art and the progressive acceptance of experimental, nontraditional tools and techniques. The discovery of the inherent beauty, dignity, and worth of hitherto neglected subjects—the shift from "noble" subjects and themes to the anonymous, the commonplace, the grotesque, and the discarded—is reflected in the inclusion of materials and techniques that would have been considered unthinkable by the skilled artist of a former age: twigs, fingerpaints, rags, and torn or burnt materials, for example.

Such tools and techniques have proliferated to the point that only a few can be mentioned here. Some are simply relatively new products: acrylics, felt markers, acetate papers, air brushes, for example. Others, discovered by the cubists, the Dadaists, and the surrealists, have been freely adapted to new purposes and new imagery. In some cases, the techniques require modification of the drawing surface by scratching, crumpling, and so on. Others involve the addition of unorthodox materials to traditional ones, changing the properties of the original medium, as we have seen with the addition of starch or soap to watercolor, for example. Often, destroying is part and parcel of the creative process itself, adding a graphic

reminder of the vulnerability of all things to the image produced. A whole range of drawing techniques fall in this category: erasing, bleaching, tearing, peeling, scorching, and so on. These techniques are best suited for the artist whose pictorial language requires a certain roughness of edge and who needs to exteriorize the constant tug between destruction and construction. What we broadly call nontraditional or experimental techniques have expanded the parameters of drawing so that the dividing line between related pictorial disciplines, such as drawing, design, painting, or printmaking, has become increasingly blurred. Photographs, slides, film, and video tape, can also be part of the drawing process in a number of possible variations.

I should emphasize that I regard the experimental approach as a healthy addition to the expressive range of the artist, but I think that the artist needs to know traditional techniques as well to be able to experiment with greater insight and sensitivity.

Collage

Collage comes from the French verb *coller*, which means "to glue." A collage, therefore, is a configuration made up of pasted-down shapes or fragments of paper, cloth, or other materials. The entire composition may consist of such a patchwork, or the collage may be combined with a drawing to form an integrated whole (Figs. 3-12 and 3-13).

One advantage of the collage is that as long as the component parts have not yet been pasted down, they can be moved freely on the page until the artist is satisfied with the composition. If the collage is combined with drawing, either one can be started first and the second added or inserted.

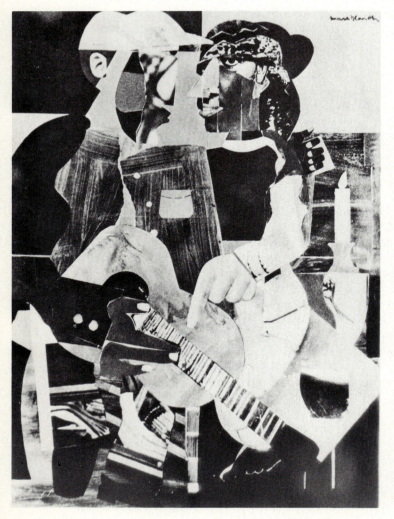

Figure 3–12.
ROMARE BEARDEN.
Serenade (1968).
Collage.
Collection Jacques Kaplan, New York City. Courtesy of the Artist.

A large, flat decorative mosaic of broken heads and figures, based on the Black experience. The fragmented, chopped pieces of magazine images are reassembled into an incongruent configuration of masks and guitars that do not comfortably fit together and yet exert a strong pictorial and emotional impact.

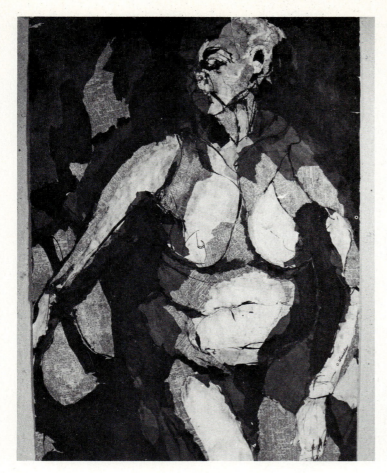

Figure 3–13.
Student work.

Combination of drawing and collage.
Areas of newspaper sections were pasted on the preliminary drawing to produce a subtly textured middle tone. Grey ink washes of varying degrees of darkness were added, as well as white opaque areas, to formulate the volumes and create the value pattern. Linear definition was added last.

The materials for the collage may be used as found or modified by crumpling, tearing, printing, burning, and so on. The oriental papers, with their rich and uneven textures and tones, are especially exciting to work with. Tissue and crepe papers may also be used, but their colors are likely to fade quickly.

When combined with a drawing, collage, like texture, should be used discretely so that it does not destroy the unity of the composition by calling attention to itself to the detriment of the drawing.

Resists

Rich and unpredictable effects can be created with resist techniques, which involve the use of two media that are normally incompatible, such as wax and watercolor or ink. When watercolor or ink is applied to a waxy surface, it curls up, leaving a path of uneven droplets. A small amount of liquid soap added to the watercolor or ink facilitates application over the waxy surface. White crayon, paraffin, or rubber cement are usually used for the resist surface. After the watercolor or ink mixture has been applied over the waxy surface and has dried, some artists leave the white crayon, paraffin, or rubber cement, whereas others prefer to scrape them or rub them off so that the original paper surface can be revealed in those areas where the ink or watercolor has not been allowed to take.

Felt Markers

Felt markers are so common, that it seems belabored to introduce them as an experimental tool. Yet, in addition to the bright effects that can be expected when they are used in the conventional manner, unusual and exciting results can be obtained when they are used with turpentine on clear or frosted acetate or on glossy, nonabsorbent paper. (Clear or frosted acetate enhances the brilliance of the color by allowing light to pass through it, as in stained glass windows.)

One method is to spray or drop turpentine over areas that have been drawn with the markers. The turpentine partly and unevenly dissolves the impression left by the markers, leaving a rich, textured area. After this area has dried, the artist may continue to draw on the modified area, combining clear, clean lines with the swirling textures. With some practice, the artist may use this technique with control, although the element of surprise, the unexpected manner in which the turpentine affects the original flat area of color, is part of the reason for choosing it (Figs. 3-14 and 3-15).

Drawings on acetate are meant to be seen against a source of light. When the drawings are executed on nonporous, highly glossy papers instead, almost any color applied appears sharp, brilliant, and dramatic. Felt marker ink may also be applied directly with a brush from the can in various degreees of transparency—in fact, from transparency to opacity—offering a great variety of intensity and color mergings. Once again, I cau-tion the artist to have plenty of ventilation or work outdoors when using felt marker inks.

Building by Destroying

Erasing. Most novices regard the eraser as a reassuring corrective instrument, but it can also be a sketching tool. For example, if the drawing surface has been toned with charcoal or graphite powder, the image can be defined through eras-ing. The eraser can also be used to smear and redirect slashing lines across the drawing. A simple but effective way to produce soft and modulated dramatic tonal definition is to use an ink eraser to remove the highlights and the middle tones when a sheet of all-purpose watercolor paper has been prepared with two coats of India ink: the first coat brown or any other dark color, and the second one black. For still richer effects, a slightly grainy paper may be substituted. Gener-ally speaking, when the eraser is used as a

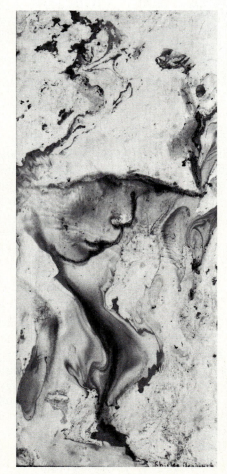

Figure 3–14.
SHIRLEE BENJAMIN, student.
Marblizing.
After having prepared a marblized ground, Benjamin discovered the image in the accidental rhythmic lines and textures, and with the addition of a few lines in brush and paint, brought out the image she had discovered while respecting its soft and fluid quality.

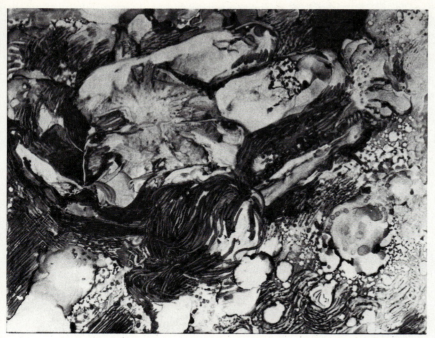

Figure 3–15.
JIM CRANDALL, JR., student.
Felt markers on clear plastic.
Rich textures were produced by dropping and spraying turpentine, which partially dissolved the ink.

sketching tool, better results are obtained on a lightly or moderately grained paper than on a smooth, hard surface (Fig. 3-16).

Scraping: Fingerpaint. Immediately after black or any dark fingerpaint has been applied to a glazed, nonabsorbent paper or illustration board, and while it is still wet, the drawing is executed by scraping out the highlights and middle tones with a stencil knife, razor blade, wedge, or pointed instrument. It is necessary to work rapidly, before the paint dries.

Bleaching Exciting linear and tonal effects can be achieved with black cover-stock paper or railroad board, using plain laundry bleach as the drawing medium.

A very fluid line with rich variations of thickness and thinness, of clarity and diffusion, is obtained by applying full-strength or lightly diluted bleach on dark railroad board. The bleach can be applied with a number of tools: pens, Q-tips, or small sponges, each of which produces a different linear or tonal quality. One can even use a pen for hatch or crosshatch or pointillist techniques.

The bleach reaction is not immediately visible, and it takes a few seconds after application for the resulting impression to emerge, a little like watching a Polaroid photograph develop. It is wise to experiment with the technique before attempting it on an actual drawing since the results are so

Figure 3–16.
WENDY PECCITO, student.
Erasing.

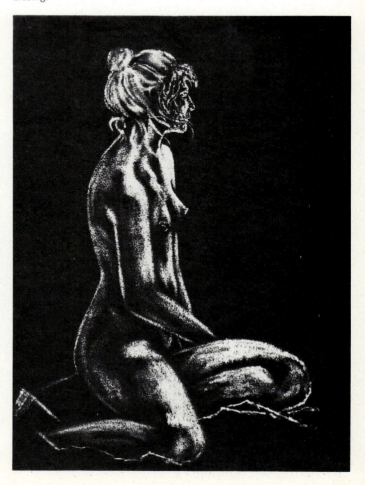

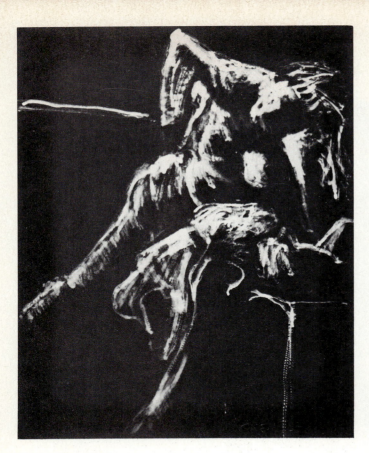

dependent on the reaction that different strengths of dilution have on different cardboard stocks. Some cardboards are not suitable at all, and therefore a number of stocks should be tested with the solution before embarking on a given project. The artist will notice that the color varies with the solution and the particular stock used: Hard-cover stock usually turns greyish green, and black railroad board turns from pink to tan (Fig. 3-17). I would also advise the participant to work in a well-ventilated area to avoid inhaling the bleach fumes.

Dépouillage, Déchirage, Grattage. These techniques create shapes through peeling, cutting, tearing, or scraping.

Some artists overlay a number of textured, colored papers and cut, dig, tear, or strip away areas, revealing the colors and values of the various layers and thereby working out the tonal scheme. Charcoal, pencil, pen, or brush drawing can be used in conjunction with the technique (Figs. 3-18, 3-19, and 3-20).

Transfers

As with some forms of collage, transfers incorporate parts of an existing image or texture into a new visual configuration; the technique allows for the integration of parts that may be totally dissimilar: a consciously childlike drawing with a photographic image, for example. Unlike collage, which involves adding to the original surface, transfers are made through chemical or mechanical means.

Figure 3–17.
PATRICIA TREMBLAY, student.
Bleach solution and railroad board.
The drawing was executed on black railroad board with Q-tips dipped in laundry bleach solutions of various strengths. Drawing in this manner presents an exciting element of surprise and chance since it takes a few seconds for the bleach solution to produce a visible trail. The image emerges in variations of tans and ochres, depending on the brand and strength of the bleach and its interaction with different railroad boards. The drawing has the appearance of a print.

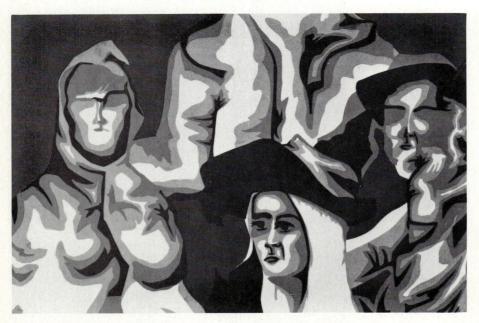

Figure 3–18.
Student work.
This composition was achieved by cutting through four layers of colored papers. It has the crisp quality of a poster.

44

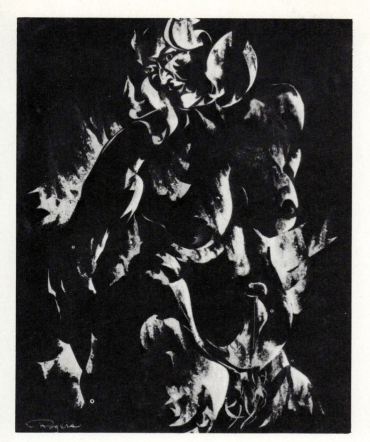

Figure 3–19.
CYNTHIA ROGERS, student.
Building by destroying.
The drawing was executed on black railroad board. The lights were obtained by cutting into the board and peeling and tearing the paper away. The image obtained is quite ambiguous until it can be deciphered.

Figure 3–20.
Student work.
Exercise on the theme of erotic fantasies.
Three or more layers of photographic images were used for tear-through.

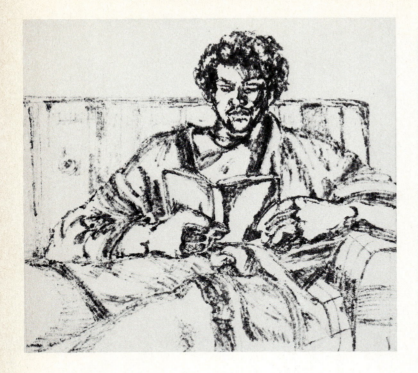

Figure 3–21.
MICHELLE BREZAE, student.

The technique of transferring photographs in whole or in parts from magazines and combining them with drawing can yield very exciting images. A number of methods are possible.

A photograph can be cut from a magazine, then covered with lighter fluid and burnished vigorously face down onto a sheet of nongrainy paper. The impression appears faint but legible. It can be elaborated on and combined with a pencil or ink drawing.

An alternate method is to cover the photograph or illustration with several coats of gel medium, allowing each coat to dry overnight. After the last application has dried, warm water is run onto the paper side of the film, and the gel film, which now bears a clear, transferred image, can be gently separated from the original illustration. The film is then affixed to a sheet of paper with Will-Hold Glue or a similar product, and it can be utilized as part of a collage or as the basis for a further elaboration with pen and ink.

Only a few nontraditional techniques have been mentioned. The area of investigation is wide open, but as with props and paraphernalia, the means must not take precedence over the goal of drawing expressively (Figs. 3-21 and 3-22).

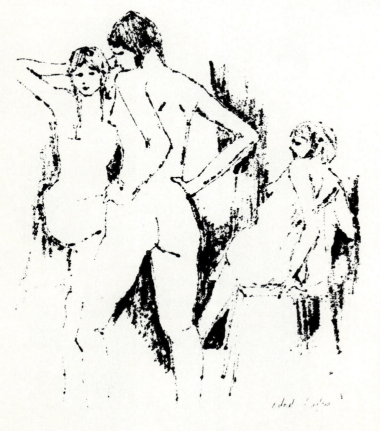

Figure 3–22.
DEBORAH FIRESTONE, student.
Quite fortuitously, some participants discovered that the drawing they had done with a felt marker looked even more interesting on the second page, onto which it had "bled." Seizing on this accidental discovery, they developed it further by drawing with felt ink on tissue paper that had been placed on a sheet of watercolor paper. The final version was the transferred impression on the watercolor paper.

CHAPTER FOUR

Perceptual Awareness

COMING TO OUR SENSES

By the time some students have gone through art school or college, they are like a loaf of bread that has been burned on the outside but remains raw on the interior. They have suffered from overexposure, having heard it all, seen it all, done it all. For them, all too often, there is hardly anything new or exciting left. Yet in spite of this extended exposure, vital insights have sometimes been overlooked or bypassed. The experiences are too often superficial and reduced to the instructor's pet gimmicks, which may produce impressive results, but more often than not, the fundamentals of art and the excitement of personal discovery and creation are missing. Having said this, it must be acknowledged, however, that fortunately there is exciting ferment going on in many art schools and art departments and that a number of creative artists keep emerging from these institutions, eager to play their role in the search for new modes of artistic perception and expression.

Fresh and authentic perception lies at the very heart of creativity; there can be no creative experience without it. Therefore, it seems to me that a brief introduction to perception and its relationship to the art experience would be of value to the student who wishes to draw from life. The purpose of this overview, simplified though it may be, is to foster a greater awareness of analytical and intuitive cognition and of the subjectivity and conditioning involved.

I hope that this introduction may encourage a partial reorientation, a kind of reawakening of the senses, and with it a keener, fresher, more personal and authentic vision.

The Senses: Gateway to Perception

Perception Is a Guess-timate

Perception is a guess or estimate of what is "out there" depending upon how we read the clues; therefore it can never be absolute and often is unrealiable.

Earl Kelley

We See Less and Less

We do a lot of looking: we look through lenses, telescopes, television tubes. . . . Our looking is perfected everyday, but we see less and less.

Frederick Franck

So much of our life is involved with perception, yet few of us know much about it. On the simplest level, it is a cognitive process whereby our mind recognizes, sorts, assesses, and interprets the information that our senses receive from the outer world. The senses, then, are the gateway to perception: sight, sound, touch, taste, and smell. Our senses provide the raw data that must be instantly deciphered and interpreted by the brain. The outer world is full of stimuli and messages,

and although our senses are equipped to handle some of these, they are not sensitive enough to receive others. Moreover, because we are subjected to a constant bombardment of stimuli, we have learned to be quite selective in our awareness. We also unconsciously choose to respond only to those signals that have meaning for us at a particular moment, depending on our needs, interests, wishes, and frame of mind.

By and large, the average person has gradually learned to limit the range of perception to those stimuli that are closely related to survival and daily practical life, and between childhood and adulthood, there is a gradual blunting of the senses. The artistically inclined person, on the other hand, has kept the perceptual apparatus delicately alive to those stimuli that mesh with his or her artistic concerns.

Multisensory Vision

Visual perception is not only visual, just as olfactory perception often involves more than just the sense of smell. The full experience of a given situation is made richer by the involvement of more than one sense acting synergistically. For example, in a predominantly visual experience, the tactile sense, actual or implied, is often a powerful enhancement.

We may be more aware of the combination of sensations in mundane life experiences, such as the relationship of sight, smell, and taste in food, but such multisensory combinations affect many areas of perception in varying degrees. When viewing a graphic work of art, we rely mostly on our sight, but our appreciation and enjoyment are often enhanced by the tactile quality of the work: the paper or canvas surface; the smooth, delicate application of the drawing or painting medium; or the grainy, coarse, obvious texture of the surface.

The Senses Can Be Fooled: Believing is Seeing

Seeing Is Polysensory

Seeing is polysensory, combining the visual, tactile, and kinesthetic senses.

Robert Mckim

In our everyday world, most of us feel that we can depend on the messages transmitted through our senses. "Seeing is believing," we say. Yet time and again, experience and experiments have shown that *all* the senses can be fooled. The eye is easily fooled by optical illusions and sleight of hand, just

as the ear can be misled by auditory confusion, or the touch by contrasts of temperature. Most of us go on believing even after our senses have been proven wrong. As a matter of fact, the corollary of "seeing is believing" is probably "believing is seeing."

The artist who deals with visual representation should be aware of the optical illusions and effects that the juxtaposition of certain lines, shapes, colors, and values induce. Linear perspective, based on the spatial effect caused by converging lines, has been one of the standbys of realistic graphic representation. There are other optical illusions with which the artist needs to be acquainted; for example, perfectly vertical lines are perceived as slanted when crossed by a series of small diagonals; or a geometric figure appears to advance or recede depending on the way the onlooker focuses on it; or again, hues may seem duller or brighter, advancing or receding, depending on the surrounding colors or values; or the same line or shape is perceived as large or small through its relation to the shape or line next to it or surrounding it (Fig. 4-1). These, among others, are some of the visual effects that artists eventually learn as part of their practical understanding of visual perception.

Relativity and Subjectivity of Perception

We See Nothing

. . . we see nothing truly until we understand it. . . .

John Constable

Perception is a tricky phenomenon. Only the simplest type of perception can be recognized by everyone. The moment the situation becomes more complex and involves more subtle elements, each person perceives the data somewhat differently, as anyone who has listened to eyewitness reports knows. Indeed, our perceptions come not only from the objects around us but from our past experiences as well; and since no two people bring the same experience to the raw data, they cannot see it in exactly the same way. Often, the objective relation between the stimulus and the individual's perception of it is tenuous. The chief reason for this is that every act of perception involves a filtering process. As the raw data of the senses pass through the brain, they are filtered by a number of factors: one's educational, cultural, and social environment; philosophical and religious associations; preconceptions and biases; and emotional and physical stress. The Rorschach test was

A.

B. C.

Figure 4–1.

These optical illusions clearly illustrate the dynamic interrelationships of optical units.

a. The same circle of medium value appears darker against a light background than it does against a dark background.

b. The same circle appears larger when it is surrounded by circles greatly smaller than it is, and it seems smaller when it is surrounded by circles larger than it is.

c. Although parallel, the vertical lines crossed by a series of small diagonals appear slightly slanted.

The artist should be aware of the visual forces that such optical illusions represent in order to use them effectively.

based on the fact that faced with the same undefined visual stimulus, each individual projects a subjective interpretation and "sees" different things in the same inkblots.

Paradox

Each one sees what he carries in his heart.
Goethe

Sooner or later, we need to face the fact that in perception, as in many facets of life, we function within a paradox. On the one hand, to a large degree, certain forms of perception are taught by the culture of which we are a part; we are molded by education, accepted values, a shared and familiar environment, and a common language, all of which make us functioning and related members of a society. On the other hand, we do not have a common world; each of us perceives the world from a personal, subjective vantage point, and that perception cannot be exactly duplicated or shared.

For the artist, the dilemma consists in reconciling a keen sense of objective perception with a highly individual, subjective one, which is essential to personal vision and creative expression. The solution to this equation varies with each artist, but in the end, it resides in the degree to which artists are able to create their own esthetic world—which is part of the culture they share and yet the product also of their own unique perception, sensitivity, and expression.

Perception and the Split Brain: Apollo and Dyonisus

Not only is perception a tricky phenomenon, but it is made even more complex by the fact that the human brain is so constituted that there is a physical dichotomy in perception and thinking. The left side of the brain, which controls the right side of the body, is connected with logic, objectivity, abstraction, order, and science. The right side of the brain, which controls the left side of the body, is associated with imagination, dreams, intuition, and the arts.

It might be helpful to list the two complementary modes of consciousness related to the functional divisions of the brain. This list is based on Robert Ornstein's *The Psychology of Consciousness.*

Left Brain	Right Brain
Physical control of the right side of the body	Physical control of the left side of the body
Intellectual cognition	Intuitive understanding
Analytical, objective	Holistic, subjective
Lineal	Nonlineal
Abstract	Concrete

Left Brain	Right Brain
Active	Receptive
Logical	Irrational
Verbal	Sensory
Time awareness	Space awareness
Focal thinking	Diffused thinking
Apollonian	Dionysian
Masculine (Yang)	Feminine (Yin)
Light	Darkness

Symbolically and poetically, the mode of consciousness controlled by the left hemisphere of the brain has been associated with the sun, light, masculinity, language, and science: those concerns and symbols that the ancient Greeks attributed to Apollo, the god of reason. The right hemisphere of the brain, which controls the left side of the body, is identified with the moon, darkness, femininity, the arts, the unconscious: those qualities that were connected with Dionysus, god of the irrational. It is interesting to note that the Western world, as a whole, has particularly valued the qualities attributed to the left brain—reason, logic, and science—and has looked askance at those less measurable qualities associated with the right hemisphere of the brain, which are essentially mysterious, intangible, and nonquantitative.

Most people tend to favor one mode of thinking and perceiving over the other, and this applies to artists as well. It is likely that the linear, controlled, classically oriented artist relies more heavily on left hemisphere perceptions than do the expressionists or romantics. But it is also probable that the most gifted artists are able to combine both modes in varying degrees. The controlled linear definition of Jean-Auguste Dominique Ingres, for

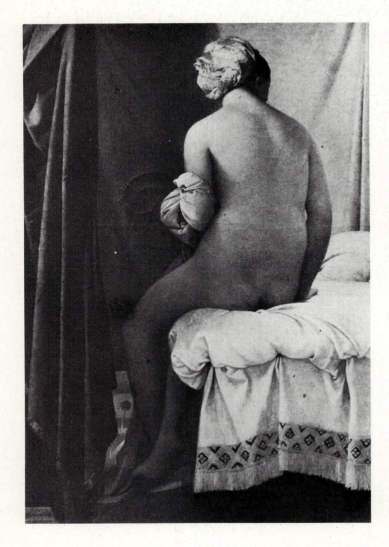

Figure 4–2.
JEAN-AUGUSTE DOMINIQUE INGRES (1780–1867).
Bather of Valpincon (1808).
Oil
The Louvre, Paris.
Upon careful examination, what registers at first glance as a clear, limpid, realistic image reveals subtle distortions and a pervading lyrical mood. The awkward position of the foot and the odd multiple view it reveals must have delighted Picasso.

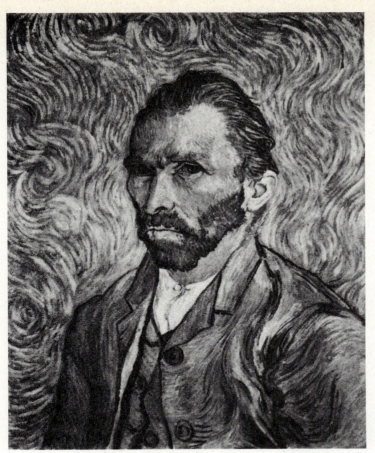

Figure 4–3.
VINCENT VAN GOGH (1853–1890).
Self-Portrait (1890).
Oil.
Musee d'Orsay, Galerie du Jeu de Paume, Paris.
The turbulence and emotion projected by this self-portrait do not preclude a solid concern for composition. It is interesting to note that although he was the epitome of the expressionist painter, so strong was Van Gogh's need to stay in touch with reality that he insisted on working from the subject rather than from memory or imagination.

example, is imbued with a pervading subtle poetry (Fig. 4-2), just as the emotional swirls of Vincent Van Gogh are endowed with a solid techtonic understanding (Fig. 4-3).

It would certainly be enriching if we could train ourselves, through perceptual exercises, to develop and make use of a fuller and richer range of perceptual modes of expression while remaining basically true to our natural inclination toward one or the other mode. It is good to recall that the ancient Greeks recognized the duality and the complementary value of this dichotomy by worshipping Apollo and Dionysus at the same altar—but at different times.

A False Sense of Permanence

The complex network of concepts, categories, rules, and regulations within which we function tends to give us the illusion that things are or should be permanent, unchanging—that the world is orderly and linear. Although movement, flux, and change are primary factors of life, much of art concerns itself with arrested moments in time, with a freezing of the configuration. There are at least two logical explanations for this preference. One, of course, is that the medium itself, the act of drawing on a surface, congeals a

given image into a finished and unchanging visual configuration. The other is that there is psychological security in the control of the mercurial, unpredictable changes that keep us constantly off-balance in our daily lives. This is probably why, as a whole, we are more object-oriented than process-oriented, avoiding the confrontation with constant change and instability. This is also one of the reasons why camera vision is so satisfying. This concern for the object, for the defined and static view, for a sense of permanence, runs deep, and forms of art that challenge this concept are often unsettling.

Yet tremendous benefits can be gained by confronting the notion of flux, change, and metamorphoses in art. For one thing, such concerns have far-reaching philosophical ramifications in our acceptance and appreciation of the notion of constant change. This can expand our view of life as well as open us to new perceptions, concepts, and techniques in the art experience.

Human Vision and Camera Vision

One of the popular misconceptions has been to equate the photographic image with the way we see. But the eyes do not see like the camera. The

camera records the image mechanically with a monocular fixed focus, and generally each portion of the picture is given the same emphasis. Human vision is binocular, but it cannot take in a comprehensive scene in nature as a whole with equal attention to all the parts. The eyes apprehend the image through a series of short, moving glances, relating and integrating the parts to the whole in the process of looking and perceiving. Rarely is it fixed on one view; rather, it is a combination of views, which become fused into one composite.

In his search for authenticity, Paul Cézanne, the nineteenth-century French artist, incorporated slightly shifting points of view within one composition, consciously allowing the nonmechanical, nonmonocular aspects of human vision to impart to his work a living, encompassing quality, which registers to the onlooker as subtle distortions (Fig. 4-4).

Seeing in Stereotypes

Experiencing Objects Directly and Fully

The trouble is, we've been taught what to see and how to render what we see. If only we could be in the position of the men who did those wonderful drawings in Lascaux and Altamira!

Pablo Picasso

The Artist Is a Receptacle.

The artist is a receptacle for emotions that come from all over the place: from the sky, from the earth, from a scrap of paper, from a passing shape, from a spider's web . . ."

Pablo Picasso

Very few people experience the world with the freshness and intensity evident in young children and gifted artists. Most of us are no longer really aware of our surroundings. Stale percepts have

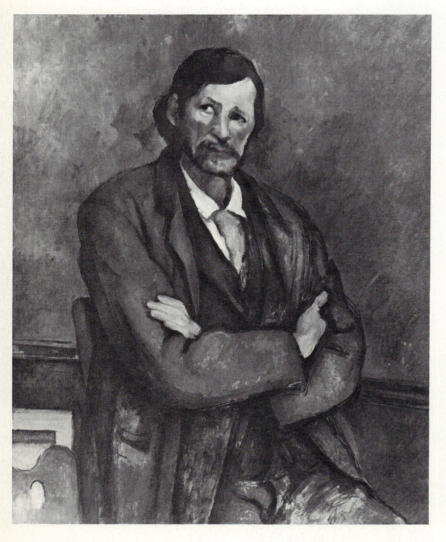

Figure 4–4.
PAUL CÉZANNE (1839–1906).
Man with Crossed Arms (c. 1899).
Oil.
Solomon R. Guggenheim Museum, New York City.

In his mature work, Cézanne was acutely concerned with the phenomenon of human vision and the way the observer's eye moves from one focus to another in order to form a composite image. His desire to reflect the configuration as it registers through the combinations of visual clusters led him to draw and paint images that may appear slightly distorted when they are compared to monocular camera vision.

long ago been substituted for individual vision. As a whole we seem anesthetized to the richness and significance that surround us, and we are unable to respond in a meaningful and personal way.

This indirect way of perceiving has led to the limiting tendency of seeing and thinking in stereotypes. We see the world in accordance with the way we have been conditioned to see it, and vision has become crystallized in frozen patterns. For example, if a person has been conditioned to an acceptance of realistic academic art, it is extremely difficult, as a rule, for that person to accept art that stems from another perceptual mode. Thus, the average student comes to the art experience encapsulated in a heavy defensive armor made up of various concepts and percepts that were slowly built up over the years.

In summary, what seems only too evident is that much of Western conditioning and imprinting has been dominated by left hemisphere thinking, with its concomitant mistrust of the nonverbal and nonmeasurable. A strong sense of order, clarity, reason, logic, and permanence permeates our thinking and influences the imagery with which we feel most comfortable. To these philosophical preferences, our puritanical ethic has added the elements of seriousness, emphasis on a practical product, and tradition. These qualities should certainly not be wantonly downgraded; so much of our culture and civilization reflects their positive application. However, they are not the only qualities that foster discovery, creativity, and thought. In fact, strangely enough, their opposites—or as I prefer to think of them, their complementaries—those attitudes that are associated with right brain thinking, may be conducive to a very productive creative perception. James L. Adams lists the following factors in this category: relaxed attentiveness, the willingness to fantasize, playfulness and sense of humor, tolerance for the chaotic, and a willingness to take risks.

Of course, a reliance on this set of attitudes does not ensure creative perception, any more than a dependency on the first set precludes it. There really are no formulas for creative perception. I would like to suggest only that a person who wishes to rekindle one's sense of creative perception should be open to those ways and techniques that may, by their novelty, help one to perceive a familiar object in a fresh, new context. This necessitates a temporary suspension of practical considerations; an open mind; a readiness to enjoy the imaginative, the intuitive, and even the irrational; a kind of personal courage; and above all, a basic trust in one's own responses.

Learning to Unlearn: Reorientation of Perception

Unlearning to Learn

Our capacity to see, hear, touch, taste, and smell, are so shrouded . . . that an intensive discipline of unlearning is necessary for anyone before one can begin to experience the world afresh, with innocence, truth, and love.

R. D. Laing

To see things as if for the first time is actually impossible, since we cannot shed our previous experiences, memories, and transmitted knowledge. The most that we can strive to do is to try to recapture something of the sharpness and intensity of our childhood impressions; and to do that, we need to embark on a reorientation of percepts and concepts. We need to unlearn some of our old ways of perceiving, to let go of our frozen concepts, and be open to a world of constant change, where previously accepted ideas are frequently reviewed.

Mobilized Awareness: Relaxed Attentiveness

Too often, by the time we reach adulthood, our sense of perception is efficient enough for the mechanics of daily routine but too blunt for the appreciation and enjoyment of perceptual data beyond our daily primary survival needs. Most of us function with an atrophied sensory panoply, often missing the qualitative dimension of life, even in something as simple as the perception and appreciation of our physical surroundings.

Therefore, the artist needs to cultivate or reactivate a sharp and constantly mobilized awareness of the changing visual configurations to which most individuals have become somewhat inured or insensitive. A mobilized awareness is not necessarily an aggressive awareness. In fact, artists whose perception is naturally acute may subconsciously and seemingly passively register images, shapes, and impressions, which are stored as memories and reactivated when needed.

Personal Vision

Breakthroughs

One of life's most fulfilling moments occurs in that split second when the familiar is suddenly transformed into the profoundly new. . . .

Edward B. Lindaman

Over and beyond fresh perception, yet related to it, some artists and art students possess an intangible, mysterious quality, which we call personal vision. It is something truly undefinable. The artist can look at the same thing that we do yet see it differently, and it isn't just the technique that makes it so. It has to do with the uniqueness, originality, sensitivity, and power of the artist's concept and interpretation. It transmutes our shared experiences and images into an artistic statement that is profoundly personal and alive and yet contains enough shared qualities to make it accessible and illuminating to others.

A vast range of artistic experiences and options should be made available to the beginning artist, in the hope that the various suggested ways of perceiving and expressing may facilitate the discovery and development of that rare, precious, elusive, yet essential quality that spells the difference between a fine, competent craftsperson and a truly gifted artist.

Formula-Oriented Approach

The novice often falls into a set way of perceiving and drawing, usually picked up from the formula-oriented "how to" books. In this standardized approach, the model is observed in constant light and drawn in outline, starting with the head and gradually working down the figure, perceiving and drawing one part at a time. Glances are alternated between the model and the paper that the student is working on. All this is done without a specific time limit. There is nothing basically wrong with this approach for the advanced student or artist, but for the beginner, it is fraught with pitfalls. It can induce faulty proportions and a general lack of unity; it also reflects the false notion that there is only one correct way to draw.

Breaking Old Patterns

Old habits are extremely tenacious and resistant to change. Even after a change of concept or technique has been accomplished, there is a tendency to revert to old patterns.

One method to combat this tendency is through a series of art exercises that run counter to the usual ways of perceiving. These exercises are somewhat disorienting and perhaps even a little uncomfortable at first, but eventually, the participants enjoy them. Some of the exercises may seem bizarre, but most of them have been used successfully to help beginners to loosen up and to extend their knowledge of perception. These suggestions are contrasted with their traditional counterparts and are meant to help the student break away from old, unwanted patterns. The unconventional means are not intended to replace the traditional ones but only to jolt the fledgling artist into a fresher perceptual frame of reference. Eventually, the artist should be able to perceive freshly without necessarily resorting to these slightly disorienting approaches.

EXERCISES IN PERCEPTUAL BLOCKBUSTING

Note: Participants who are beginners and are following the book in sequence may find these exercises difficult and confusing. In that case, they may prefer to skip them for the present and come back to this section. A number of these exercises and concepts reappear later in the book in other contexts. This multiple exposure to given problems should clarify the exercises and remove the baffling element, which can be disconcerting at first. I have found from personal experience that when a new concept is presented, a repetition of the same assignment some time later often clarifies it enormously.

Simultaneous Vision/ One Part-at-a-Time Vision

When we learn to perceive life and art in their "all-at-onceness" rather than as a "one-thing-at-a-time" phenomenon, we begin to break away from the linear approach and to see things and movements in their interrelationships, which leads to a greater awareness of unity.

Draw from the posed model. Instead of completing one part at a time, work simultaneously over the whole figure, starting in the middle and working in all directions; or else start at the bottom and work your way up to the head.

Instantaneous Vision/ Constant Vision

The purpose of the next exercise is to respond as directly as possible without preconceptions, to train your memory and to learn to see the whole image at once. This type of experience can help you recognize objects instantaneously.

Sketch in total darkness what you saw in a momentary flash of light. These images should be

comparatively simple at first and progressively more complex as you go on. You can work from slides or actual setups.

Seeing by Its Middle/
Seeing by Its Edge

Seeing the figure by its mass implies a visual grasp of its totality, but often the edges are not clearly defined, giving the student an uneasy feeling. Most people tend to see the object by its edge, where the form is clearly defined in reference to its surroundings; therefore people feel more secure with it. They know where the object ends and space begins.

Using the side of the charcoal or Conté crayon, mass in the form of the figure, letting the edges be somewhat indefinite. Now compare this to one of your outline drawings that show the edges clearly.

With the Eyes Squinting/
With the Eyes Wide Open

Normally we draw with our eyes wide open, but squinting our eyes when looking at the model simplifies the patterns of light and dark, thus imparting a greater sense of unity. Another way to see this phenomenon is to take a slide out of focus.

Make a drawing from the posed model in which you draw only the flat masses of light and dark. This can be achieved by squinting the eyes.

With the Eyes Closed/
With the Eyes Open

An excellent way to train the memory is to observe the model and then close the eyes and try to fix the image in the mind's eye.

Make a drawing from the posed model by observing the pose and then trying to retain the image in your mind's eye. Now try to draw the figure with your eyes closed.

Looking at Model Only/
Looking at Model and Paper

Looking only at the model while drawing helps one to keep a continuous eye flow instead of a series of broken glances.

Look at the outlines of the model and slowly trace them on the paper without looking down at the paper.

Drawing from Unusual Angles/
Drawing from Fixed Viewpoint

Our tendency is to perceive the figure from one fixed point of view. By looking at the figure from unusual angles—frog's eye view, bird's eye view, and so on—one can begin to break the habit of static viewing.

Look and then draw a person from the frog's eye view (from below, looking up), from the bird's eye view (from above, looking down), and so on. Use a charcoal pencil.

From Combined Viewpoints/
From a Fixed Viewpoint

By combining several views in the same picture, rather than drawing one fixed view, one begins to think more sequentially. It is as if the artist walked around the model to do the drawing.

Make a number of drawings of the same model, slightly superimposing one over the other. This tends to give a fuller indication of the activity, and at the same time, the figures seem to be more abstract. Use charcoal pencil.

Upside-Down Vision/
Right-Side-Up Vision

When drawing from a picture that has been turned upside down, the artist disassociates from the subject matter and concentrates on the form itself. Paradoxically, in most cases, the result is closer to the subject than if the student had drawn it in the usual way.

Take a picture or a photograph, turn it upside down, and then carefully draw it in pencil.

Negative Space Orientation/
Object Orientation

The beginner is usually object-oriented and the negative space that surrounds the object is generally neglected. By perceiving the space between and around the object first, the artist begins to perceive the figure.

Take a photo from an old magazine and cut the figure out, leaving only the background space; now paste this background on a piece of paper. You will immediately see the white silhouette of the figure. You can do the same in drawing. Be sure that the outline you draw is that of the space next to the figure rather than the outline of the solid figure.

Incompletion (Closure)/
Completion

In the early stages, the novice often insists on surrounding every shape with an outline. It is a good practice to see how much of the outline can be eliminated and still convey the image of the figure. When one makes an incomplete drawing, the eye of the viewer resorts to a phenomenon referred to as *closure,* which is the natural tendency to see and organize the divergent parts into a totality. *Continuance* is the tendency to continue the eye movement along the path of a line even after the line has been terminated. This effect occurs from the momentum built up by that line.

Make a drawing from a person in outline; then erase away all the nonessential parts. This exercise is more difficult to do well than one imagines.

Model in Movement/
Model Constant

Usually the model is drawn in a stationary position, but sometimes the model is asked to be in constant motion while the students attempt to draw—which many find disconcerting. It is not the figure that should be drawn but the figure in movement; therefore, the emphasis should be on rhythm in line.

The model is asked to take a series of continuous poses in slow motion, moving from one pose into the next without stopping while you draw. Use charcoal pencil.

Exterior/
Interior

Reality exists on more than one level. By trying to represent more than one level at a time on a given surface, an intriguing image can emerge.

Take a photograph of a nude figure from an old magazine and cut out certain sections of the body in order to replace them with the depiction of layers of different depths. For example, anatomical details can be pasted on top of these sections, thus showing partial uncovering of the sublayers.

Opposite Hand/
Customary Hand/
Both Hands

Drawing with the opposite hand is disorienting for many people. Occasionally choosing to do so may help to bring about a new awareness in your drawing. Try to draw with the hand that you normally do not use for this purpose. Now try using both hands simultaneously.

Long Stick and Glue Brush/
Traditional Tools

Purposely using tools that make drawing more difficult to control sometimes helps students to work more freely and thus produces expressive results.

Tie a charcoal pencil to the end of a long stick, about 30" in length, then sketch with it.

Use a glue brush dipped in ink and sketch from the model.

Fingerpaint and Paint Rag/
Traditional Techniques

Fingerpaint is generally used by children, but the adult student will probably find other ways of using it. An effective way is to use scrapers made of wood or cardboard; a single-edged razor blade or a palette knife is also a good tool as is the paint rag.

Using black or brown fingerpaint, cover a 9 × 12" piece of smooth nonabsorbent board. Then scrape out areas that would be equivalent to the light shapes.

Drawing with Pencil in One's Mouth/
Drawing in the Usual Way

This next concept is going to sound quite ridiculous, but sketching with the pencil in your mouth or between your toes can bring forth unusual yet amazingly controlled results.

Prepare a drawing pad so that it will be in a convenient position once you have your pencil in the ready position. Then slowly draw a head, preferably your own, in outline. It may surprise you to find that you have more control than you could have imagined. It also makes us aware of the so-called "handicapped" artists, who are far less handicapped than those people who are sure they cannot draw even if they have full use of their arms and hands (Figs. 4-5 and 4-6).

Temporary Sense Deprivation

By temporarily depriving yourself of one of your senses, you can heighten the others. By covering your eyes, you can heighten the senses of touch

Figure 4–5.
DORIS THIESSEN, student.

Figure 4–6.
Student work.
Figure 4–5 was drawn with the pencil held between the teeth, and Figure 4–6 was executed with the pencil held between the toes. In both cases, there is an amazing degree of control.

and hearing. However, if deprivation is too complete or too prolonged, it can dull the senses or even cause temporary breakdowns (Figs. 4-7 and 4-8).

Touch Drawing of the Head

Team up with another person. Face partly away from each other. One person becomes the model and the other the artist. Using just the fingertips of one hand, gently explore your partner's face without looking at the person. Draw as you touch. Do not look at your paper until you have completed the exercise.

Touch Self-Portrait

Place a wad of clay in front of you. Touch and explore your head, first the basic shape and then the features. As you do this, begin to shape the clay correspondingly. The clay head should be facing in the same direction as your own, making it easier to transfer the tactile sensation to the shaping of the clay. Do not look at the clay head until you consider it complete.

OBSERVATION

The Importance of Observation

Observation, directed outwardly or inwardly, constitutes a most important part in the drawing process; it cannot be overemphasized. It is a skill

Figure 4–7.
REGGIE BELL, student.
Drawn with eyes closed.

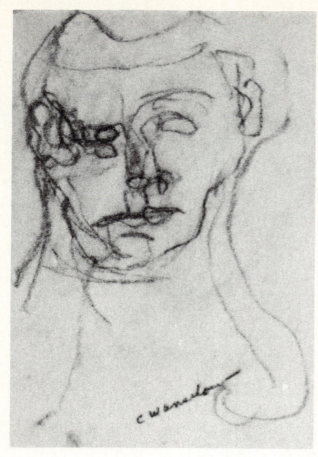

Figure 4–8.

C. WANSELOW, student.

Both Figures 4–7 and 4–8 were drawn with the eyes closed, the artists relying on the sense of touch. The purpose of this exercise is to sharpen the awareness of the sense of touch by temporarily depriving the artist of the sense of sight and to translate the data received into a pictorial representation.

that operates in tandem with, if not as a prerequisite to, that of drawing. It is said that many artists of ancient China often spent hours, days, and even weeks contemplating their subjects before attempting to portray them. Many artists and would-be artists are too much in a hurry today and get flashy results, but their facility at drawing often lulls them into a false sense of mastery. The relationship of observation to the drawing of the figure, therefore, should not be overlooked; and there is no real conflict between observation and imagination. In fact, in the visual arts, imagination can be more fertile and creative when it rests on a rich memory bank of painstakingly observed material, which can then be rearranged and reinterpreted.

Two Types of Observation: Objective and Subjective

A Special Kind of Seeing

The kind of seeing that cuts through isolated objects to search out the elusive relation between them, that penetrates the surface of appearances to discern an internal structure beneath, is our concern.

Edward Hill

When observing objectively, the artist tries to be almost clinically detached, recording and describing what the eye sees, filtering out feelings and personal reactions as much as possible. It is an attempt to look, see, and record in a nonjudgemental, nonintrusive manner. Such a description of drawing could apply to skillful scientific rendering; however, the esthetic sensitivity of the artist—the sense of composition, the choice of subject and placement, the personal iconography—all contribute to that extra dimension and quality that we call art. An example of objective depiction of the figure is the illustration by Ingres (Fig. 4-2). It is the result of careful, probing observation, translated visually with consummate skill and a profound understanding of the delicate interrelationship of vision, skill, and technique. In this case, the result is a form of classical drawing. Of course, even when objectivity is the goal, a personal element will always enter into the work of art. In fact, its absence is usually felt as a missing ingredient.

On the other hand, when observing subjectively, the artist willingly allows personal emotions to enter and sometimes dominate the process. This experience allies acute observation with visceral response. Often, this kind of observation leads to exaggeration of proportions and features for the sake of greater impact. The drawings of Van Gogh are almost archetypes of this process, where the artist observes and interprets the outer world with both care and passion. The drawings of Egon Schiele are further examples of this "charged" observation and expression (Fig. 4-9).

Although seemingly contradictory, both types of observation can be utilized by the same person at different times and for different purposes; however, it is likely that a given artist will, over a period of time, favor one over the other, according to personality and esthetic preference. Both kinds of observation require training, sensitivity, and patience. Objective observation develops the ability to observe freshly and keenly, whereas subjective observation requires the willingness to involve the self, to take the risk of

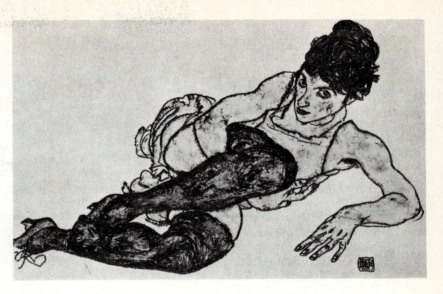

Figure 4–9.
EGON SCHIELE (1890–1918).
Reclining Woman.
Tempera and black chalk.
Galerie St Etienne, New York City.

Schiele's incisive contour drawing endows the model with a quality of seductive depravity.

feeling and expressing emotion. Neither of these two forms of observation are passive; each require a galvanization of the senses. When the probing turns inward, the observer becomes the observed, with all the risks and possible discoveries such investigation implies.

Whether it is objective or subjective, the disciplined observation with which we are concerned goes beyond mere looking and recording to a probing of both the surface and inner structure. The complex process of looking, observing, perceiving, seeing, drawing, interpreting, and expressing is, in the long run, as significant a means of heightening our perception and comprehension in our daily lives as it is essential in the visual and artistic experience (Figs. 4-10 through 4-13).

Observation and the Sketchbook

Looking Is Not Seeing

To look at a thing is very different than seeing it.
Oscar Wilde

Seeing and Drawing

Drawing is the discipline by which I constantly rediscover the world. I have learned that what I have not drawn, I have never really seen, and that when I start drawing an ordinary thing I realize how extraordinary it is, sheer miracle.

Frederick Franck

Perceptual awareness is a necessary precondition to observation and drawing; but we tend to be somewhat lax and casual in our habits of observation unless we have a tangible means of recording visual impressions and reactions on the spot.

The very act of figurative drawing, which requires attentive observation, sharpens one's perceptual awareness to an acuity it would rarely have otherwise. One might say that drawing is a

means to better seeing. The sketchbook is an excellent vehicle for this activity. Generally small and unobtrusive enough to be easily carried almost everywhere, yet large enough to sketch most subjects, it is particularly well suited for quick sketches in public as well as in private places. An intermediate size, such as 11 × 14″ is quite convenient. It provides the artist with an ever-ready means for recording and responding to the surroundings.

On location. The following is a partial list of places where one can find a profusion of subjects to observe and sketch. The suitability and safety of the locale must be taken into account before the artist begins to sketch in public.

Beaches	Open markets
Piers and docks	Train and bus depots
Playgrounds	Airports
Amusement parks	Courthouse
Carnivals, circuses	Hospitals
Fairgrounds	Waiting rooms
Swap meets	Unemployment office
School grounds	Racetrack
Neighborhood parks	Sports arenas, gyms
Old-age homes	Ballet and folk dance studios
Libraries	Dance halls and discos
Food markets	Musicians' hangouts

Materials for the sketchbook. Actually all that are needed for outdoor sketching are a pen and a sketchbook. However, for those who wish to use a greater range of tools and techniques, the following can be added:

Colored pencils	Watercolors; brush, medium

59

Colored wax crayons	Compressed charcoal
Compressed pastels	Balsa stick and twigs
Pencils: 2B and 6B	India ink

As the range of tools and techniques widens, the sketchbook can include not only gesture drawing, but also contour, light and dark masses, and sustained drawings—approaches that will be described in subsequent chapters.

A variety of approaches. When working in the sketchbook the artist often emphasizes objective recording of the subject, but this certainly does not need to be the only approach. The studies can be subjective and emotional as well. They can be varied in concept, technique, and style, ranging from brief sketches to more completed ones. The object is not to come forth with a masterpiece every

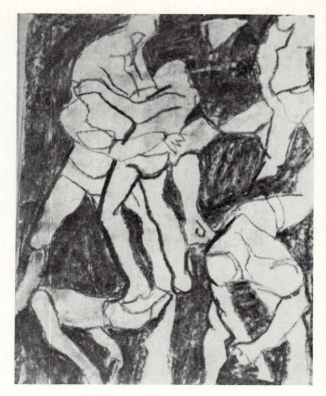

Figure 4–11.
CHRIS PYRENE, student.
Rapid gestural contour of wrestlers.

Figure 4–10.
HOKUSAI (1760–1849).

Vigorous, animated, keenly observed and recorded, this series of drawings of wrestlers shows a profound understanding of the quick gestural contour.

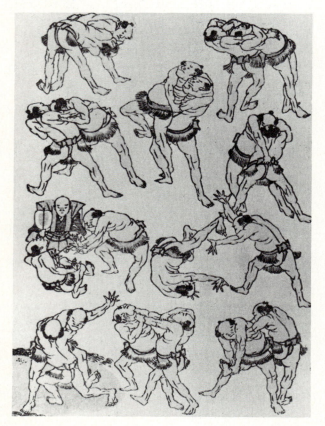

time one draws but to gain as much experience as possible in observation, sketching, and expression, independently from studio problems.

Toning the grounds. As was previously mentioned, the blank, white page is somewhat inhibiting. Toning every other page with one of the earth-colored pastels not only provides a beautiful and unifying ground to draw on but also has the added advantage of giving a sense of greater freedom to the artist. This color is rubbed into the paper and the excess is removed. The remaining tone can be sprayed with fixative.

A variety of distances and angles. A variety of views, angles, and distances provides a whole range of possibilities: the closeup, half, and three-quarters view of the figure; the full single figure or multifigure grouping; looking up at the figure or down to it or from any other unusual angles—all add a challenge to the problem and increase the variety of drawing experience.

A range of techniques. A whole grouping of techniques is available to practice skills and to obtain different effects: wash, crosshatch, point, resist,

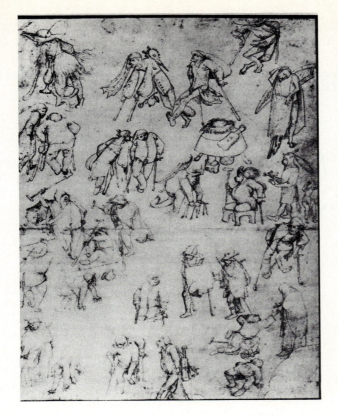

Figure 4–12.
Attributed to HIERONYMUS BOSCH (fifteenth century).
Cabinet des Estampes, Bibliothèque Royale, Brussels.

Despite a slight gothic stiffness, these sketches are permeated with an animated quality, which endows them with excitement and immediacy.

and so on. *Note:* These techniques are described in the chapter dealing with tools and techniques, but it is advisable for the beginner first to work with techniques that are simple and familiar and then gradually experiment with others.

Observation and the camera. Like the sketchbook, the camera can be an indispensable part of the artist's equipment. It provides a further means to sharpen one's perception, particularly of the detailed fragment that goes unnoticed unless one seeks it and focuses on it. Another advantage of the camera is the rapidity with which a subject can be recorded, often completely candidly, especially body positions that would be difficult or impossible to keep for more than a few seconds.

The camera can be used in its own right or as a means to an end. If one has a darkroom available, experiments can be pursued in the developing process. By combining parts of several photographs, new points of departure can be created for further sketching. Many of the recommendations made for sketching apply to the camera as well.

Because the goal here is not the use of photography as an art per se but as an adjunct to drawing, the camera need not be an expensive and complex model. Students don't have to become involved with mechanics and gadgetry, unless they choose to do so.

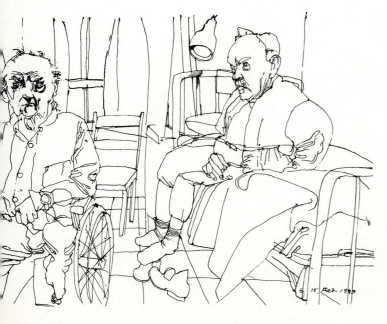

Figure 4–13.
ALAN E. COBER. Drawing, ink (February 15, 1973).
In The Forgotten Society, Dover, 1975.
©*Alan E. Cober.*

With an unflinching, yet compassionate, eye, the artist has searingly drawn the images of those we might prefer to consign to oblivion—the old, the sick, the handicapped, the insane, the jailed—in a series of powerful and moving drawings.

CHAPTER FIVE

Gesture, Memory, and Movement

Perhaps one of the most effective ways to start "learning to unlearn" is by working with gesture. Its seeming simplicity is quite beguiling because it is not quite as easy as it looks. The difficulty lies in the fact that the very concept of gesture drawing runs counter to the usual tendency of the beginner to want to complete one part of the figure at a time and to outline the shapes in a realistic manner.

DEFINITION OF GESTURE DRAWING

Gesture drawing does not concern itself with distinct outlines; its validity rests on a quick perception of the main thrust of the figure, its direction and basic movement. For those who have not done gesture drawing before, the experience and comprehension of the exercise may be baffling at first, but before long it becomes meaningful and enjoyable. It sharpens the perception, and an invaluable by-product is an increased awareness of what is hidden below the surface of the form, giving it impetus and life.

MATERIALS

The materials used for gesture drawing are the most common and most available; gesture drawing can be done with virtually any type of drawing tool on any paper. However, if one wishes to emphasize the freedom, boldness, and expressiveness inherent in this type of drawing, such tools as twigs, balsa sticks, ink bottle stoppers, and moistened charcoal may be used quite effectively. A small rag or tissue dipped in paint or ink may promote a very free approach, but the freest and boldest technique involves the direct use of the fingers dipped in ink or paint.

GESTURE DRAWING AS A WARM-UP

Over and Over Again

I endeavor to complete a drawing in one single, continuous gesture. However, far from trying to be selective and impeccable, I write down forms over and over again, in a sort of animated framework, never tentatively but as fully as possible. The rehearsal is conducted with full phrases and not single sounds.
Rico Lebrun

It is important to do a great many gesture drawings without concern for the immediate results. It is only after a warm-up period that students begin to hit their stride. Although gesture drawings are most often done as warm-up exercises before starting a more sustained pose, they can also be used as preparatory sketches or stand as valid drawings in themselves (Figs. 5-1, 5-2, and 5-3).

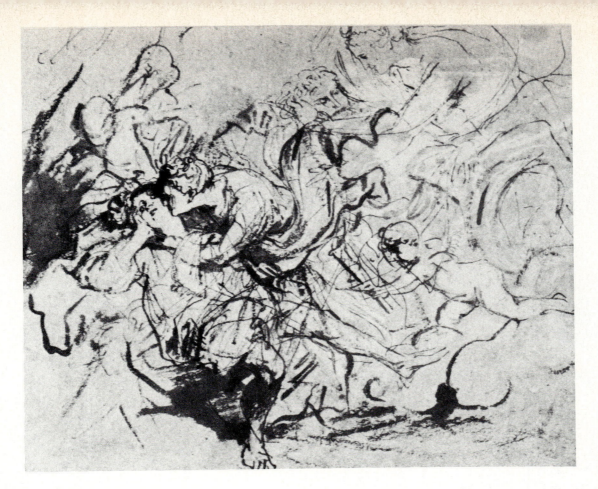

Figure 5–1.
ANTHONY VAN DYCK (1599–1641).
Diana and Endymion.
Pen and ink heightened with white on blue-grey paper.
Pierpont Morgan Library, New York City.

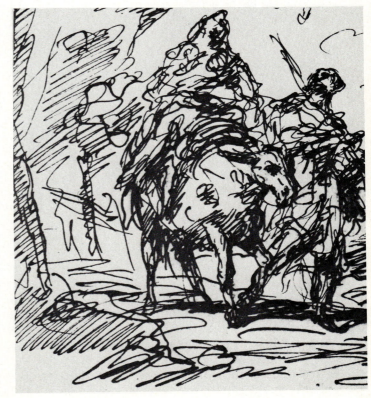

Figure 5–2.
GASPARI DIZIANI (1689–1767).
Flight into Egypt.
Detail.
Pencil, pen, and sepia on yellowish paper.
This is a very free, very loose drawing—almost a scribble—yet it is highly legible and endowed with great energy and vitality.

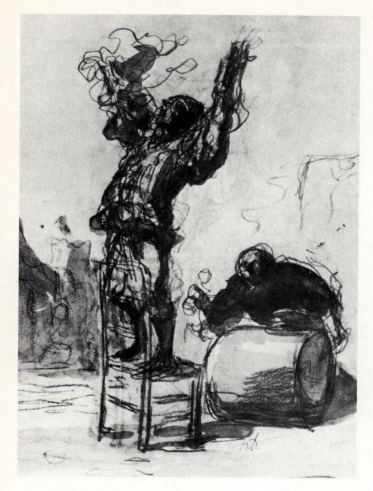

Figure 5–3.
HONORÉ DAUMIER (1808–1878).
Clown.

Pencil and watercolor.
Metropolitan Museum of Art, New York City.

Daumier's Clown *is an extremely dynamic watercolor drawing. The drummer is portrayed in an almost stroboscopic manner, and the gesticulation of the clown is conveyed through a skein of crisscrossing, nervous, multiple lines that neither enclose the figure nor freeze the image.*

BASIC CHARACTERISTICS OF GESTURE DRAWING

Working Rapidly

Gesture drawings should take from about ten seconds to a minute. Limiting the time for the exercise forces the participant to respond to the figure without intellectual analysis of the form. It elicits an instantaneous visceral response often more "true" to the pose than a studied, thought-out one would be.

Capturing the Essence of the Action

To capture the twisting, pushing, pulling, stretching, bending, and so on, it is necessary consciously to overstate the action at first in order to counter the beginner's tendency to understate or work timidly. This exaggeration of the main thrust of the figure in action adds animation to the drawing and "feels" closer to the actual pose.

Seeing and Responding to the Image in Its Totality

This is most effectively done by working simultaneously over the whole page, without regard for detail and without lifting the sketching tool from the paper.

Seeing from the Hidden Core

It is difficult to free oneself from seeing the boundaries only, the outer edge of the form. It seems easier to follow a clear line of demarcation between the figure and its surrounding space and to outline the volume seen against that space. This is why hard-edged drawing comes more naturally to the beginner than gesture drawing. However, seeing from the core is essential to the perception of the force lines and direction of the form.

Identifying and Empathizing with the Pose

What It Is Doing

You should draw not what the thing looks like, not even what it is, but what it is doing. . . . Gesture has no precise edges, no forms. The forms are in the act of changing. Gesture is movement in space.

Kimon Nicholaides

In this type of drawing, one of the goals is to reduce the psychological distance between the pose of the model and the act of drawing, until the artist becomes one with the pose. This is a very difficult feat; in fact, it is never entirely possible. One way to try to approximate this goal is for the artist to actually do what the model does: twist, bend, and reach to personally feel the points of muscular stress in each pose. Such an activity requires a willingness on the part of the artist to identify with the pose. It is akin to the actor who momentarily becomes the character being portrayed or the dancer who "dances" an animal through his or her own body.

Figure 5–4.
A partial repertoire of body gestures reflecting basic emotions can be helpful in reconstructuring the figure from memory. Practice in fleshing out these skeletal notations is necessary.

TYPES OF GESTURE DRAWINGS

Even within the limits and restrictions of gesture drawing, numerous conceptual differences are possible.

Gestural Core

The emphasis is on the hidden center of the form, denoting its axial direction. This kind of drawing is often used as a structural base for other types of drawings (Fig. 5-4).

Skeletal Core

A quick indication of the main lines and directions of the spinal column, rib cage, and pelvis is often used, like the gesture core, as a substructure for other types of gesture drawings (Fig. 5-5).

Figure 5–5.
LORRAINE CAULEY, student.
Compressed pastel.
A multifigure gesture study, using the skeleton as a reference to the core of the figure. The line is rapid and scribbly, imparting a sketchy and dynamic quality to the drawing.

Scribble-Scratch

This is a type of gesture drawing where the scribble-scratch technique itself suggests a quality of indefiniteness and flux. The scribble technique is a web of circular continuous lines that crisscross over each other, whereas the scratch technique is a series of uneven straight lines crossed over one another in any direction. The broken, uneven, crisscrossing web precludes a clear definition of the figure. The scribble and the scratch can be used separately or in combination (Fig. 5-6).

Spiral Gesture

The figure is depicted as a spiral around its core. The figure is built in a continuous spiral from head to foot, with a wider spiral in the chest and pelvic area and a narrower one in the waist and limbs. The spiral gesture is related to the cross-contour drawing, but it is done much more freely and rapidly (Fig. 5-7).

Gestural Ellipse

Here the figure is translated into a series of loose, connecting elliptical forms that overlap one another.

Mass Gesture

The bulk of the form is suggested by massing it in with the side of the charcoal or the Conté crayon; no lines are used. This type of gesture drawing is related to the concept of mass as weight (Fig. 5-8).

Caricatural Gesture

A type of very quick sketch that exaggerates the characteristics of the figure to give it greater pictorial expressiveness, it can be achieved with a number of techniques: mass, ellipse, spiral, scribble-scratch, and so on.

Extended Gesture

This is an extension of any gestural approach as a five- or ten-minute sketch.

Note: The preceding descriptions include the most common varieties of gesture drawings. Artists and students often invent additional variations, which may grow from the particular properties of the drawing medium used; as long as the

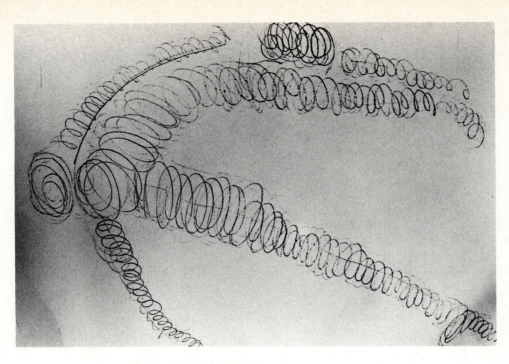

Figures 5–6, 5–7, and 5–8.
Three examples of gesture drawings: spiral, mass, scribble-scratch.

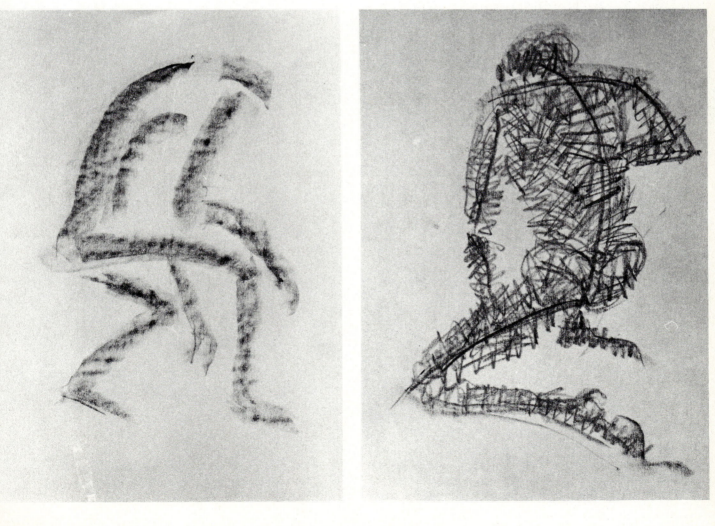

emphasis remains on the perception and depiction of the main thrust of the figure, the sketch falls within the scope of gesture drawing.

SUGGESTED EXERCISES

Prelude to Drawing

For those who lack experience in working from a model, it may be beneficial to go through a number of preliminary exercises in "predrawing," as it were, by sketching directly on photographs, illustrations, or Xeroxed copies gathered from old magazines. This activity appears to be a nonthreatening and effective way to understand the various concepts operative in figure drawing without burdening the beginner with a host of problems at the same time, such as proportions, foreshortening, and other concerns.

Work directly in black or white ink on some good action illustrations; use a different type of gesture approach for each drawing: core, sketetal, scribble, massing-in, and so on.

If you are reluctant to work directly on the reproduction, you may place transparent tracing paper on top of the photograph and then execute the sketch on the tracing paper. A second alternative is to work on a number of Xeroxed copies of the same action photograph or illustration. An advantage of using either of these solutions is that the same pose can be used to practice different gesture drawing concepts and techniques. In all cases, the original reproduction should be large enough to provide a clear and meaningful image of the figure.

Sketching from Slides

Another possible transition before working from the live model is to sketch from projected slides of the figure. Make a series of very rapid gesture drawings in each techniques described, allowing no more than thirty to sixty seconds per exercise.

Fluorescent Stripes

A helpful device to visualize and understand the core line concept is to clad the model in black leotards and tights with fluorescent colored stripes sewn down the middle of the front, back, and sides of the body, arms, and legs. Work in the dark—a black light is projected—sketching the core line of the figure only, using chalk and black

paper. Affix a small goose-neck flashlight to the easel to see the working surface while sketching in the darkened studio.

The Pipe-Cleaner Skeleton and the Hidden Core

Because gesture drawing is inherently very free, the beginner sometimes flounders, not knowing what to emphasize or to omit. Since the core or center of the figure is so crucial to an understanding of gesture drawing, and since this core line is hidden from view, I often encourage my students to construct a simplified flexible skeleton with pipe cleaner. They do so by using an actual skeleton or reference books that show clearly the human skeleton from different views. When necessary, splice one pipe cleaner to another to add to its length. Pay special attention to the basic proportions of the rib cage, pelvis, and spinal column. It is not necessary to put in all the ribs as long as the rib cage is clearly indicated. For greater ease of handling, attach the finished skeleton to a thin pole inserted in a small base. If the skeleton is not mounted, it can simply be held in the hand.

The use of the skeleton makes it quite possible to approximate the pose of the model very rapidly; the core line is easily seen, and the awareness of the basic supporting structure is transposed to the gesture drawing (see Fig. 5-6).

Of course, the device can only be used for poses lasting at least a few minutes; when the exercise requires a faster apprehension of the gesture, the time factor precludes its use. With frequent practice, the artist becomes aware of the usefulness of starting a gestural drawing with its structural core, and eventually, when the relative position of the pelvis and rib cage are well understood and can be seen without help, the pipe cleaner skeleton has fulfilled its use and may be laid aside.

Gestural Exercises in Constant Light

Using compressed charcoal on bond paper or newsprint, make a series of gesture drawings from the model:

Core line figure in black tempera (one minute each)
Scribble-scratch head in ink (one minute)
Massing-in the figure in charcoal or Conté (one minute)

Skeletal gesture in pen and ink and thin brush
Caricatural gesture in pen and ink (one minute)
Extended gesture in pen and ink (five to ten minutes)

Note: See descriptions of these approaches and techniques on page 66.

Variations:
Improvisational Compositions

As one gains more practice, it is interesting to put a number of sketches on the same page, allowing them to overlap one another slightly. The addition of a tonal area behind parts of the figure adds a suggestion of depth and provides a means to establish a pathway for the eye to follow. At times, turn the page upside down or from one side to the other while the composite sketch is in process. This procedure imparts an unexpected and slightly disconcerting quality to the informal composition.

Expressing Emotions
through Body Gesture

To better understand identification or empathy with the pose, pair off and take turns at being artists and models. Act out such basic emotions as joy, sorrow, fear, anger, and so on, through total body gestures rather than just facial expressions (see Fig. 5-4). If you find posing physically or emotionally uncomfortable, simply sketch as the third member of an existing paired group. You are encouraged to search for body gestures going beyond the superficial or stereotypic ones. Those who are particularly free and creative in the interpretative activity can be grouped in clusters to express one single emotion through a multiple-figure configuration, which is then sketched as a gesture drawing or photographed by the rest of the group. Models are encouraged to wear leotards rather than street clothes for this activity.

VISUAL MEMORY

For the artist, observation and memory are intertwined: Each strengthens the other. Without memory and knowledge as references, perception and comprehension are very limited, if not impossible. Yet our goal must remain fresh vision, unencumbered by frozen visual memories. The key, of course, is to transcend the static quality of memory and, instead, to use memory as a dynamic force that enhances the visual experience of the mo-

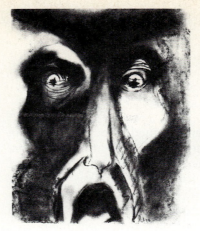
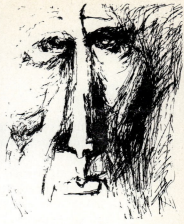
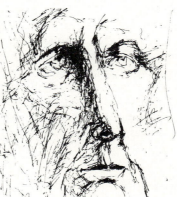
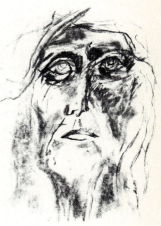
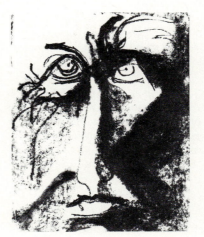
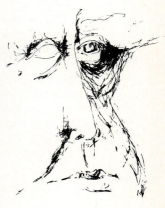

Figure 5–9.
LILY SHENKMAN, student.
A series of self-portraits drawn from memory. These drawings, with the strong emotions they convey through exaggeration and distortion, may come closer to reality than an objective drawing would.

ment. Drawing from memory trains one to apprehend the image quickly and sharply; to perceive the configuration as well as the more salient features; and to dismiss superficial, unimportant details (Fig. 5-9).

Memory, Imagination, and the Stored Image

Another benefit to be gained from drawing from memory immediately after exposure to a visual stimulus is the increased ability to observe and retain an image for later use. This particular approach necessitates an intense degree of observation and contemplation of the model, who should be seen from all sides, from many distances, and under varying light. Through careful observation, the students make several drawings which will become part of their mental image bank. When these are recalled at some future time, they seldom emerge exactly in the same form: They have been filtered, sifted, and recombined, not only from memory but from imagination as well, and they have been modified by the artists' feelings and understanding of the problem at hand.

Interpretation and Imitation

The living model never answers well the idea or impressions that the painter wishes to express; one must, therefore, learn to do without one, and for that, one must acquire facility, furnish one's memory to the point of infinitude, and make numerous drawings after the old masters.

Eugene Delacroix

It is very well to copy what one sees; it's much better to draw what one has retained in one's memory. It is a transformation in which imagination collaborates with memory. One reproduces only that which is striking; that is to say, the necessary. Thus, one's recollections and inventions are liberated from the tyranny which nature exerts.

Edgar Degas

There is a point at which artists must clarify the concept of interpretation versus imitation in their own mind. One of the methods used by some old masters when they were working on a group composition was to work first from direct observation, then to dispense with the models after the initial phase of preparation to allow free rein to imagination and interpretative modifications. Later, if they felt the need for further observation, they would use the same model again. Such an approach frees the artist from literal imitation while reinforcing immediate observation and visual memory.

According to Laurence Binyon, the artists of ancient China worked from memory far more than their Western counterparts. Even the preliminary sketches from direct observation were often dispensed with.

When we think of gestural memory drawing, the Western artist who comes to mind immediately is Honoré Daumier, the nineteenth-century French artist. If we did not know from statements by his contemporaries that his work was done almost exclusively from memory, it would be impossible to make that assumption from looking at the work. So keen an observer was Daumier, so sharp his visual memory, that he was able to extract the very essence of his subjects and infuse them with life and power (see Fig. 5-3). Daumier was not the only Western artist to have worked from memory: Delacroix, Rodin, Degas, Gauguin, and Bonnard are known to have worked from memory as well as from the model.

The Picture File

A particularly helpful tool for the artist is a personal picture file consisting of examples of various physical types and age groups; another file based on human emotions as expressed through body gestures and a third file of body gestures related to occupations can also be useful as references. Such photographs are available in old magazines, which can be bought in secondhand book stores or in thrift shops. Additional material can be provided by snapshots taken by the artist.

The picture file is compiled over a period of time as a constantly ongoing project. The material can be used for further practice with gesture drawing or extended studies when no model is available; it can also serve as reference when the artist is working on a figure composition from imagination. The picture file serves as a memory prod, and it is best used as reference material for creative work rather than as a source for servile copying.

Stretching Memory

There are some seeming contradictions in the relation of visual perception to memory and drawing. On the one hand, it is vital to see in a unified, "total" way to establish immediately the relationship of the parts to the whole. On the other hand, the artist needs also to see analytically, to see subtle differences, and to be aware

of the visual uniqueness of each organic shape. This analytical kind of seeing will be addressed subsequently.

A Flash in the Dark

One approach in hastening the ability to see in a cohesive, integrative way is to use the method pioneered by Hoyt Sherman at Ohio State University in the early 1940s: A slide representing simple shapes is beamed for a fraction of a second on the sceen; the projector is then turned off, and the viewers, in total darkness, draw what they have just seen. This exercise is continued, and eventually actual objects replace the slides; finally, a model is used under the same conditions. A bright light momentarily illuminates the subject or model so vividly that the configuration thus perceived impresses itself in sharp relief as an afterimage on the memory of the artist. By sketching immediately and in darkness after this short and dramatic exposure, the artist does not have time to allow the intrusion of frozen visual memories to interfere with the instantaneous response. Thus, this method offers the advantage of creating a situation in which the instantaneous, cohesive visual perception is made more natural, and it discourages the interference of old imagery.

Flashing

The method of seeing described by Aldous Huxley as "flashing" is particularly well suited for the kind of analytical seeing that we can practice in the art studio or even in our daily lives. In this case, the artists glance at the subject or model for a brief moment only, close their eyes to recall the image just seen as an immediate flashback and then look again to check the accuracy of the flashback. Each glance is part of a three part-operation—the short glance, the recall with closed eyes, and the verification followed by drawing. The observers, then, continue to observe the same pose, using the same process, closing their eyes briefly after each new shift. Thus, the whole image is analytically viewed, the mind integrating the parts into a whole.

Contradictions

It is obvious that there is a contradiction in methods and aims between these two ways of viewing, of memorizing, and of drawing. But perhaps all our consciousness and our very lives are dominated by a basic dichotomy between the whole and the parts, between the immediate "total" perception and analytical comprehension. It may be that this dichotomy stems from our brain division into right and left hemispheres and the concomitant divisions between analytical and emotional; on the other hand, it may simply point out the necessity and validity for the artist to see both the whole and the parts, to see objectively and subjectively, to apprehend an image quickly and to view it slowly and reflectively. This is a bagful of contradictions, and it is one of the many miracles of human endeavor that they can coexist and be resolved in the creative act.

SUGGESTED EXERCISES IN GESTURE DRAWING AND MEMORY STRETCHING

Sketching After the Pose

The model takes an active pose for about a half minute while you observe without drawing. When the model ends the pose, draw it from memory in one of the gestural techniques. The model then repeats the pose so that you may correct the drawing while looking, using another color in order to better compare the corrected version with the original one.

To challenge the visual memory even more, the model can be asked to take two poses consecutively, holding each for a half minute. Then try to reconstruct these poses from memory after the model has stopped posing. The poses are then repeated and the drawings corrected, as in the preceding exercise. If slides of models are available, these may be substituted for the live model. The slides are particularly helpful for the rerun during the correction phase, since there is no question then that what is seen the second time is exactly what was seen the first time; an added advantage is that to the beginner, slides are less intimidating than the live model. In time, the exercise can be stretched to three consecutive poses, but only after much practice with the simpler version.

With One's Back to the Model

Instead of facing the model in the usual manner, turn the easel or drawing table partially away so

that you have to make a special effort to look at the model in order to retain the image before sketching. After executing a number of drawings in this manner, turn the easel completely around so that you have your back to the model. You may observe the model as often as necessary, but each time you must carry the image in your mind the full time that it takes to turn back to the easel.

A Memory Bank

Physical types. Using the core line and superimposing it with elliptical gesture, make a series of rapid sketches of various physical types: heavy, thin, old, young, middle-aged, tall, short, and so on. Make these sketches relatively small so that you can fit several on a single page. These could be used later as reference for drawings.

Gestural manifestations of emotions. Make a series of rapid sketches emphasizing the emotions as expressed with the whole body: joy, anger, arrogance, sadness, and so on. Use the skeletal gesture, emphasizing the spinal column, the rib cage, and the pelvis. Work from life and your photofile (see Fig. 5-4).

Occupations: Related Gestures. Using your picture file or any additional research material that can be found as reference, make a series of rapid gestural sketches that reflect people's occupations. Start with a gestural core and then superimpose one of the gestural techniques. As in the other exercises, make a whole page of small figures in ink.

Flash in the Dark with Slides: Hoyt-Sherman Approach

After you are seated at your drawing board, the lights are turned off. It takes a few minutes to get used to the darkness. A slide representing a very simple flat shape is projected on the screen and remains on view for a few seconds only. Respond almost instantaneously by drawing in charcoal, in total darkness, what you have just seen. The process is continued with other slides representing a gradually increased number of flat shapes, emphasizing variations in position, shape, size, and value.

Flash in the Dark with Objects

This series of exercises is similar to the preceding one, but this time simple real objects are suspended or placed on a table, with a spotlight beaming on them for a few seconds. As in the previous exercises, this becomes gradually more complex as more objects are added. The sketching takes place in total darkness, immediately after viewing. The major difference between the two sets of exercises is that the three dimensional element has been added with the objects.

Flash in the Dark with Models

It is time to progress to the more complex configuration of the human figure. The method remains the same. As before, time is allowed to let you get accustomed to the total darkness; then a slide of the human figure is projected for about twenty seconds. Sketch your response in charcoal for the next thirty seconds, also in total darkness. The same slide is projected a few times so you can see evidence of greater visual retention in your consecutive drawings. After practice with slides, live models are introduced in the same manner, using a spotlight for momentary illumination.

These last three exercises were adapted from Hoyt Sherman's *Drawing by Seeing*.

Tachistoscope

With a tachistoscope or slide projector, a series of simple shapes or objects are projected in a continuum as rapidly as possible. Although probably overwhelmed by the rapidity with which the images appear and disappear, try quickly to record in charcoal what you have just seen. The point is to train your eye and brain for rapid-fire visual perception of a very transitory image. The same series of slides is repeated a few times at the same speed, the viewer seeing and recording more each time. From slides representing objects, you can progress to slides of figures, single first, then simple groupings.

Rheostatic Dimmer

A dimmer is attached to a spotlight, which is beamed on a model, and the light is progressively lowered until the studio is in total darkness. Record in charcoal the afterimage, which lasts for a fraction of a second.

Strobe

A strobe, placed behind and slightly above the students, is beamed at the model, who remains in

a stationary pose in front of the group. After the lights are turned off, the flash mechanism is activated to flicker rather slowly three or four times, after which total darkness prevails. Respond in a gesture drawing to the image just seen. The process is repeated three times with three different poses. The alternating flash of light and total obscurity may disorient you at first, but the process reveals and dramatizes the subject far more than constant light would, and therefore intensifies the memory of the subject seen under these conditions. The total duration of the exercises should be short so that your eyes are not strained by the intensity of the light and dark contrasts. Neither you nor the model should gaze directly into the light, and individuals prone to epilepsy should *not* participate in this exercise.

Visual Essays
from Memory and Imagination

Selecting one single theme, such as old age for example, do a whole series of gesture drawings, some of which can be extended gesture studies. These can be done from life and the picture file. For other themes refer to the section on observation.

THE FIGURE IN MOVEMENT: MOVEMENT AND CHANGE

Seeing and drawing the figure in motion takes a special kind of awareness and understanding because the figure loses its solidity as an object and its outlines begin to disappear. Despite the fact that ours is a world of constant motion and instability, and perhaps *because* of that fact, we seem to cling to the notion of the archetypal subject at rest: motionless and stable—a dependable configuration. A frequent argument used by the reluctant beginner is that drawing the figure at rest is challenging enough; why compound the difficulty by introducing the unsettling element of movement, and where does one begin with a configuration whose outlines keep changing?

In an attempt to reflect the dynamic quality of our technological, fast-paced world, an Italian art movement of the early twentieth-century, Futurism, put special emphasis on finding visual means to express implied motion. One seminal twentieth-century painting is the French painter Marcel Duchamp's *Nude Descending the Stairs*. It is a brilliant example of overlapping forms conveying movement in sequence (Fig. 5-10).

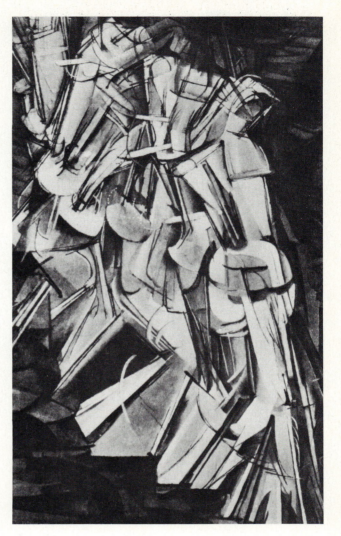

Figure 5–10.
MARCEL DUCHAMP (1887–1968).
Nude Descending a Staircase N. 2 (1912)
Philadelphia Museum of Art, Louise and Walter Arensberg Collection.
This is one of the clearest examples of the figure in movement.

The apprehensive beginner should be encouraged to accept the challenge of drawing the model in movement, for this represents one more way of perceiving and interpreting the subject. Many of the techniques used in drawing the figure in movement are related to gesture drawing in their vigorous, unpolished, fluid characteristics.

The students' fear of not being able to keep pace with the rapidity of the movement may soon be allayed by the realization that the more experience they have in perceiving the whole figure in

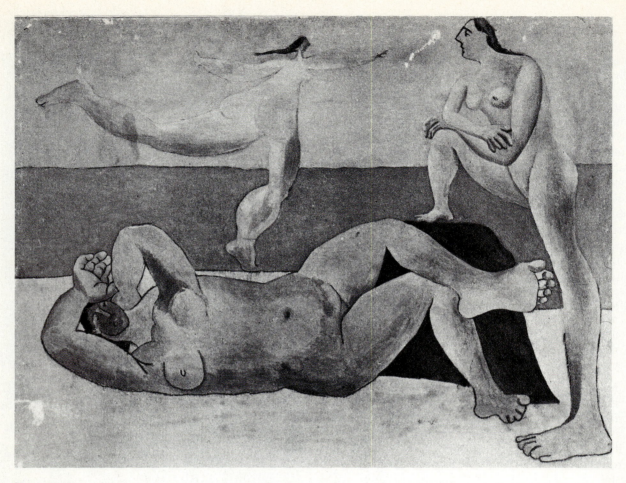

Figure 5–11.
PABLO PICASSO (1881–1976).
Three Bathers (1920).

Oil on wood.
Private collection, New York. © S.P.A.D.E.M., Paris/ V.A.G.A.,
New York.

Through exaggerated foreshortening, the image con-
veys an immediate sense of time and motion: The
running figure especially dramatizes the fusion of time
and space. As it stretches into space, it is both on the
beach and beyond the shore line.

motion and the more they draw it, the more effective their visual memory becomes. Soon their immediate visual memory will allow them to complete the drawing despite the changing configuration. In time, these exercises will greatly increase their ability to construct the figure from memory when they need to do so.

Depicting the Figure in Motion: Devices

Gesture drawing is certainly the primary technique that comes to mind when one wishes to draw the figure in motion: The rapidity of execution; the vibrating, unfinished quality of its multiple line; its blurred edges—these are qualities that lend themselves quite naturally to the depiction of the subject in motion. But many other techniques can graphically convey the factor of movement.

Repetitive transparent overlapping. One of the most effective means of depicting the figure in motion is to draw the different steps involved in the process of changing position, from the beginning of the movement to its end. These drawings overlap one another slightly, as a strobe photograph would.

Exaggerated perspective. The sense of movement is created by extremely exaggerated perspective, stretching in depth the figure and limbs toward the

viewer, making the forward limbs appear relatively gigantic and the ones in space much smaller than normal scale. The exaggerated perspective and contrast in scale introduce a sense of motion in space and even evoke a time dimension (Fig. 5-11).

Sequential advance or retreat in separate frames. Movement can be suggested in separate frames of the same size by drawing the figure progressively larger in each succeeding one if the figure is depicted as advancing, or progressively smaller if the figure is retreating.

Vertical strips. By drawing the figure or object in movement on vertical strips and leaving some space in between, an effect of movement can be achieved.

Displaced squares. Yet another way to suggest figures in motion is to fragment the figures into squares and then reassemble them so that they are slightly off, although still maintaining their verticality and horizontality.

Motion with figure mergings. This method of representing movement is the merging of two spatial versions of the same figure—one further back in space and the other in a more forward position. It projects a feeling of movement through a stretching, blurring, elastic quality. This method was taken from Hiram William's *Notes for a Young Painter* (Fig. 5-12).

Movement as a blurred line. A photograph of a subject in movement appears blurred if the shutter of the camera or the film were too slow for an action photograph. A simple way to impart a similar quality of movement to the drawing is to blur the edge of the form and create an area of transition, which is both figure and space. This effect can be obtained by smudging the charcoal or ink where the blurring is desired. The smudging should be light and somewhat transparent.

Suggested Exercises

Sports, dance, and amusement park file. Collect photographs from old magazines of various sports, dance, and amusement park images in action. These can then be used as references to a variety of gestural techniques.

Repetitive transparent overlapping figures. Using a series of sequential photographs showing the development of a movement from start to finish, draw each major phase on a separate acetate sheet. When a series of three or four of these drawings

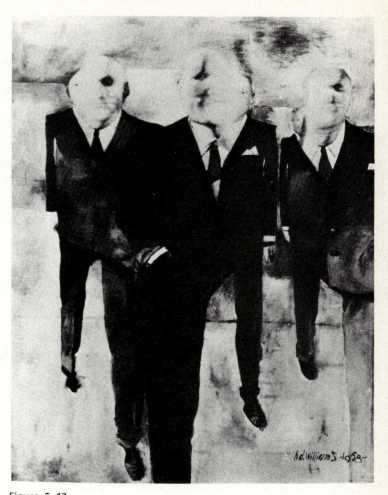

Figure 5–12.
HIRAM WILLIAMS.
Guilty Men (1958).
Collection Dalton Trumbo, Los Angeles.

This is a disturbing image, which paradoxically combines hard edge and concrete treatment with blurring and indeterminacy. The problem of the figure in motion is uniquely solved by combining the foreground figure with the same figure seen in the background, along with a blurred image of the head.

has been completed, place the transparent sheets on top of one another so that the emerging image is a composite representation of the figure in the different phases of a given movement. For this exercise to be valid, consistency in the placement and the scale of each drawing is essential (Figs. 5-13 and 5-14).

Another sequential series. Make a series of drawings of a figure in the act of dancing or involved in a sport or athletic activity. Each drawing is in a

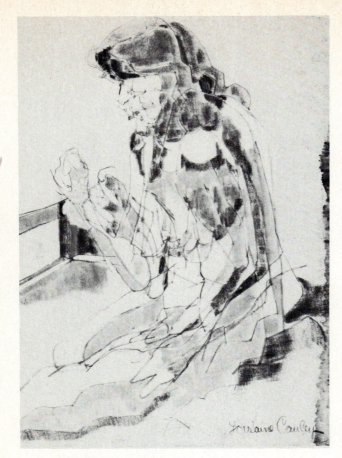

Figure 5–13.
LORRAINE CAULEY, student.
Chalk.
This is an attempt to capture the feeling of movement with the use of graphic repetition in transparent overlapping planes.

separate frame but is part of a related sequence. Again, consistency of scale should be observed. Cut the drawings out and use them as silhouette stencil shields. Place one of these on a sheet of paper and spray around it with acrylic spray, except in the area where the next figure will overlap. Remove the stencil, place the next one in position, and spray. Treat the other related silhouettes in a similar manner, each slightly overlapping the preceding one. When the exercise is completed, the configuration is one of a series of interlocking line silhouettes of a figure in movement.

Repeated form in multiple line. The model assumes a stationary pose, which is based on potential action. Make a free extended gestural drawing, using multiple broken and light lines. The model changes the pose very slightly. Continue sketching, superimposing the new configuration slightly over the first one, but in darker line. The effect is one of implied movement.

Continuous slow motion. While the model is in continuous slow motion, moving very slowly from standing to sitting to kneeling to lying and slowly back, draw in charcoal, attempting to capture the rhythmic quality of the figure in movement. The objective is to convey visually the main linear rhythms crisscrossing over one another, rather than describing the figure itself.

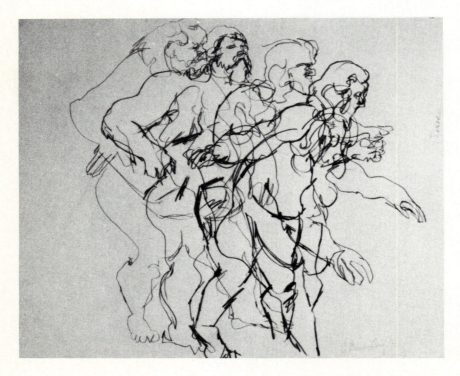

Figure 5–14.
JESSE ARMENDARG, student.
Rapid gestural contour of the model is shown in sequential movement, using transparent overlappings.

76

Rodin's Method

Rodin's method—and an excellent one it is—was to alow the model to move freely about the room. When some pose that took the sculptor's fancy presented itself he either called to the model not to move, or he made a rapid note from the momentary mobile impression that he had received.

Vernon Blake

Repeated slow motion: fixed pivotal point. In this exercise, the model executes a full action gesture in very slow motion—such as bending to pick up an object, straightening up, then setting it down in another spot—keeping one foot on the same spot so that the body pivots on one leg. The motion is then repeated slowly a number of times. The movement is divided into its main points of action—beginning, middle, and end—and the pose at first is held for a fraction of a second at each moment. Draw these strategic poses of the total movement first, and afterward fill in the connecting poses from memory. Do this exercise as a gesture drawing in charcoal or Conté; it is based on Nicholaides' *The Natural Way to Draw.*

Motion by means of exaggerated foreshortening. The model takes an active foreshortened view for those who are in the central portion of the studio. That group of students sketches with extreme exaggeration to suggest not only depth but motion as well. That part of the figure that is closest to the student is drawn in relatively gigantic proportions compared to those parts that are farthest away. The identical pose is then repeated for the students on the periphery of the studio. The drawing is done in extended gesture in charcoal or ink.

In separate frames: one in all. The model starts a walking pose at one end of the studio or work space while the students are at the other end. The pose is held for about three minutes while the students draw the pose within a set frame. All the subsequent drawings are to be done in the same sized frame except for the width, which usually increases as the model comes closer. The model moves forward a few feet after each pose, and the process is repeated about four times. The drawing

increases in scale in relation to the frame so that the last frame includes only the head and shoulders. This series of drawings makes up a sequence of the figure advancing toward the onlooker.

The same problem can be treated in reverse, with the model starting the pose close to the students, and retreating progressively in space; the first and widest frame will contain only the upper part of the body, and the last and narrowest panel will include the whole figure in its smallest scale.

All in one. A variation is to eliminate the frames and to sketch each view on the same sheet of paper, each view slightly larger and overlapping the preceding one. To avoid confusion, do each drawing in another color and move the figures from upper left to lower right on the page.

Vertical strips: corrugated cardboard. Using open corrugated cardboard showing the vertical ridges, lightly pencil in a figure in movement. Repeat and slightly displace parts of the figure to create a double-image effect, which enhances the sense of implied movement. Then ink the vertical ridges in varied line thicknesses in those areas that need to be defined to clarify the image. However, be careful not to merge the ink in the hollows, so that the eye has to jump from ridge to ridge to connect the image.

Drawing from television and videos. Make a series of rapid gestural sketches from television shows or videos, following these preliminary exercises with drawing from more active subject matter: film, theater, and dance performances, for example. The videos present an additional advantage: The viewer may freeze the frame for a few moments.

Stroboscopic photos and gesture drawing. For those who possess the necessary technical knowledge and equipment, taking strobe photographs of the model in movement can be an invaluable aid in seeing the movement in its different phases; gestural drawings can be made from these photographs.

CHAPTER SIX

Basics
of Figure Construction

Compared to gesture drawing, figure construction presents an entirely different approach to the observation and drawing of the human figure. Gesture drawing represents essentially an immediate empathic graphic response to the action of the figure; figure construction is a more deliberate approach, concentrating on building the figure through the observation of its component parts: their size, basic features, and broad visible structural relations and connections to each other.

For many artists, this process entails a systematic study of the basic skeletal and muscular substructure of the body to understand better how it determines the visible shape of the body and its range of possible positions and movements. Although anatomy is not included in this book, I would encourage the participants to avail themselves of the many excellent texts on human anatomy that are available. Some artists and teachers occasionally express their concern that such a study may be the hallmark of the academic approach, with its danger of preparing the student for no more than the skillful but uninspired representation of the figure. But if artistic priorities are kept in focus, I see no conflict between offering some guidelines for naturalistic depiction and the ultimate goal of meaningful pictorial interpretation. In fact, increasing the ease and accuracy with which artists can quickly block in the figure in proportion, and helping them under-

stand the changes in proportions and appearance that occur when the figure is seen in certain poses from certain angles, can foster an invaluable understanding of the human figure and, ultimately, greater freedom in subjective and imaginative interpretations.

But the skill that artists gain by learning the basics of figure construction, which enable them to draw a credible pictorial rendition of the figure from life or to reconstruct it from memory or imagination, should not replace direct observation. The acquisition of the skill of figure construction is a double-edged sword in that artists may be tempted to draw what they *know* of the figure rather than what they *see* at the moment. Vigilance in retaining balance and authenticity of observation and vision is therefore necessary; then the artists can take full advantage of their skill at reconstructing the figure from memory and imagination when they need to do so, and their work is not a mechanical and predictable image but is endowed with sensitivity and a sense of life.

The question is: What comes first, figure construction and anatomy or the subjective response? I personally like the first exposure to emphasize the empathic and subjective approach, following it very soon with objective study and analysis. But that is a matter of preference. The important thing is that neither aspect be neglected and that the students be exposed to a variety of drawing experi-

ences, which sharpen their representational skills and equip them to express and interpret the figure in esthetically sensitive compositions.

A MATTER OF VISUAL COMPARISON: GENERAL PROPORTIONS

If the process of observing and depicting the figure objectively could be reduced to one dictum, it would be to study the relationships of the parts to each other—their comparative sizes, directions, shapes, and so on—and to relate these to the whole. This process requires an integrated and simultaneous vision of the parts and the whole.

Many books on figure drawing state that the erect adult human figure is seven and a half heads high; that is, using the size of the head as a unit of measure, the total figure includes seven and a half units or divisions. Some writers further subdivide the unit into halves, which facilitates the location of some of the parts of the body more precisely (Fig. 6-1).

If the head is the first division and the unit of measure, the second unit ends just under the pectorals (or under the shoulder blades if the figure is viewed from the back); the third one cuts across the upper part of the pelvis and the navel; the fourth division, coinciding with the groin and the base of the buttocks (slightly above the buttocks line for females), is located just a little below the midpoint of the erect figure; the fifth unit falls somewhat above the knee, the sixth at midcalf, and the seventh a bit above the ankle.

The shoulder width equals two heads, the upper arm measures one head and a half, and the forearm and the hand measure approximately two units. The head is about two-thirds the size of the rib cage; the pelvis is the length of a head; and the hand, in vertical position, covers three-quarters of the face, the distance from the chin to the middle of the forehead.

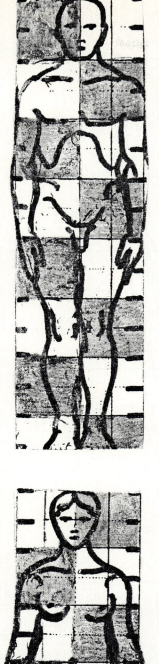

Figure 6–1.
Human proportions
The standing figure is divided into head units.

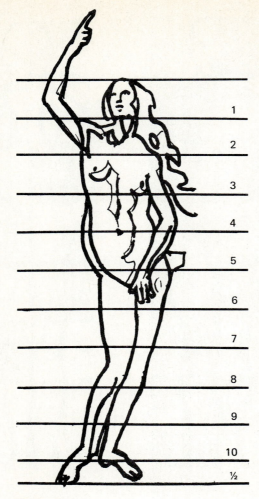

Figure 6–2.
Diagram (after Katharine Kuh).
The figure is taken from Botticelli.
Proportionally, it is much taller than the
traditional classical seven-heads measure.

These generalizations on human proportions should be no more than they purport to be: broad averages that do not take into account the wide variations that exist among individuals. Moreover, as soon as the figure appears in any other position than upright, foreshortening enters into play, and these references no longer apply. In short, an awareness of the basic average proportions of the figure is useful mostly in preventing the beginner from making unplanned gross mistakes in proportions, but it is certainly no substitute for rigorous personal observation.

It is also well to remember that many of the finest works of art depicting or dealing with the human figure do not conform to the conventional classical ratio; some, like the figures of Botticelli or El Greco, may be 9 to 12 feet high, and others, like the figures of Cuevas, have often dwarflike proportions (Figs. 6-2 and 6-3). Artists frequently take liberties with classical or realistic proportions for the sake of composition or expression or both (Fig. 6-4).

MALE AND FEMALE

Since the 1920s, the Western world has witnessed recurring periods during which it has been fashionable to equate ideal human proportions with those of young males—the *ephebe* look—applying this criterion to both males and females: the slender look with small breasts and narrow hips; a kind of young unisex. This is a relatively recent phenomenon. Traditionally, and especially in art,

Figure 6–3.
JOSÉ LUIS CUEVAS.
Romeo and Juliet (1964).
Courtesy of the artist and Tasende Gallery.

Squat and gnomic, the figures recall
pre-Columbian imagery rather than classical
proportions.

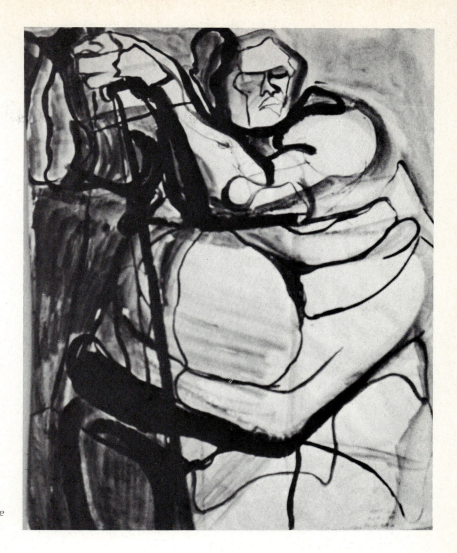

Figure 6–4.
GERALDINE GETZ, student.

The exaggerated proportions—small head and large body—and the use of various line qualities help give this drawing its expressionist signature.

the structural differences between the male and female body have been appreciated and often accentuated. The Venus of Milo, which represents a canon of female beauty of ancient Greece, or the full-figured Rubens or Renoir females are a far cry from the contemporary female ideal.

Yet even if the differences between the sexes are downplayed, they cannot be ignored since they are based on biological function. For example, to differing degrees, the average female torso is smaller and fleshier than that of the male, her hips wider, and her shoulders narrower; the female torso can be schematized to a triangle, with the hips as the base, whereas the male torso can fit into a longer inverted triangle, with its base at the shoulder line (Fig. 6-5). The female pelvis is not only shorter, wider, and larger than the male's but also set at a greater angle in relation to the vertical axis of the body (Fig. 6-6). Other obvious structural differences include the higher and narrower waist of the female; the male chest is relatively flat, even when the body is muscular, whereas female breasts form two hemispheral forms of varying sizes, projecting slightly toward the sides (Fig. 6-7); and usually, the male flank is shorter than the female.

A FEW SIMPLE AIDS

Very early, artists have used some simple visual aids to help them see and draw the model in relationship, that is, in proportion. One of the simplest means is to divide the drawing surface vertically and horizontally with two intersecting lines. These provide an arbitrary and stable visual reference for establishing size differences and relative distances between the parts of the body.

A pencil held at arm's length in the vertical and horizontal positions is also occasionally used by a beginner to line up and compare the forms along these two basic directions; but as soon as artists have had some experience in careful observation and trust their own ability to observe and compare, they usually abandon this use of the pencil.

81

Figure 6–5.
Diagram comparing the proportions of the male and female torso.
The female torso can be inscribed in an isosceles triangle, whereas the male torso can be inscribed in an inverted triangle.

Figure 6–6.
Diagram.
The female pelvis is more tilted than that of the male.

Figure 6–7.
Diagram.
The male rib cage is broader than that of the female.

The viewfinder is an easily available device that some art students find useful. It consists of a small cardboard frame with a 2½ × 2″ opening, which is covered with a piece of clear acetate; this transparent window has been divided into small, even squares with thin ink lines. The viewfinder is held at arm's length. Looking at the model through the little window, which frames their view of the model, artists can choose the total or the partial image of the figure that they wish to include in their composition. The small squares help them see the proportions and directional changes in the figure until they are better prepared to assess these with the unaided eye. Novices may even wish to draw on paper that has been divided into squares so that they can coordinate what they see through the viewfinder grid with the paper grid. If realism is the intent, they must hold the viewfinder in the same position throughout the drawing to keep the angle of vision constant and the relation of the parts consistent with it. Again,

as the student develops the ability to observe and assess proportions, relationships, and directions, they usually discard this aid.

BLOCKING IN THE FIGURE

At first, the piecemeal approach to drawing the figure—observing and drawing one part at a time—often yields disappointing results: By the time the drawing is completed, the figure is frequently out of proportion—the head may be too large for the body, the hands and feet generally too small. Although an artist may use disproportion by choice to heighten expression, unwanted distortion simply denotes a lack of effective observation and depiction skills.

Just as beginners must learn to see and depict the different parts of the body in proportion, so must they develop a sense of the relative proportion of the total form to the format of the drawing surface. There seems to be a generalized tendency for the beginner to draw a configuration that fits the average notebook size (8½ × 11"), even when the drawing is made on a larger surface, 18 × 24", for example. One possible strategy to counter this tendency is to start by establishing the parameters of the basic shape of the total configuration and relating it to the format of the drawing surface.

The Cocoon and the Ghost

This general configuration can be established as a faint, ghostlike shape, using a soft, erasable pencil, charcoal, or Conté crayon. It appears as a large, soft-edged, blurry silhouette that indicates the outer limits of the total shape, including, but not defining, the secondary negative spaces between limbs and torso. This is then followed by greater definition within the soft silhouette.

In his book on figure drawing, Philip Wigg advises the student to imagine the figure totally encased in a cocoon; the student draws the cocoon first, and then indicates the body parts and subdivisions of the shapes within the imaginary cocoon.

My own version is to use an actual translucent stretch tube as the casing: The model steps into it, and the figure is seen as encased in a translucent cocoon, which sets the outer limits of the total configuration while revealing the figure within it clearly enough for the artist to see the smaller forms and components within the larger shape (Fig. 6-8).

Another way to guard against the tendency for disproportion is to block in the figure before the actual drawing. This procedure allows the artist to make tentative decisions on the relationship of the parts to each other, to the whole, and to the format, and therefore, ensures a greater probability of success. The ghostly silhouette or the cocoon can be used in conjunction with these guidelines. The procedure again moves from the general to the specific by establishing tentative lines of reference before the more permanent detailed configuration is established. The rough layout of the figure is useful for whichever format the artist is working

Figure 6–8.
Photograph.
The model is encased in a translucent stretch sack. The transparent covering helps the viewer to see the total configuration, including the immediate space contiguous to the volumes. This is seen as a cocoon from which the form can be "carved" and defined, moving from the general to the specific.

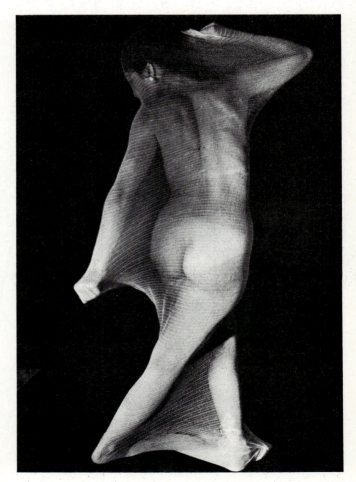

with: from a small notebook sketch to a large drawing, and from the conventional rectangular format to any other.

The Bottom Line: The Constants

The key to the blocking-in process is the establishment of basic reference points and lines. The initial blocking-in defines the parameters of the figure and reflects a series of temporary decisions, subject to corrections before the actual drawing. However, there are two constants: The top and bottom lines remain stable references, whereas the other guidelines may be changed and shifted until the artist is satisfied with their placement as reference points. Thus, the width of the figure is established in relation to its height.

Once the top and bottom limits of the figure have been set, it is a good idea to indicate tentatively the knee, shoulder, and pelvic lines and the base of the rib cage. You will notice that these indications are not listed in top-to-bottom order, proceeding from the shoulder line to the knee line, but imply an attempt to see the figure as a whole rather than in piecemeal progression from head to foot. The line notations indicate both the relative vertical distances between the body sections and their horizontal or diagonal directions or tilt (Fig. 6-9). The basic horizontal sightings are followed by the indication of the gestural core of the body; then the vertical limits are determined, and tangential sightings are made to connect two or more outer edges of the form, thus verifying the relative directions and slants of the parts as well as the outer edges of the form. An additional bonus of the tangents is that they help define the immediate negative space between parts of the body.

During sightings, it is important that the drawing surface and the body of the artist be aligned and not at a great angle to each other; for if the page is at an angle, it obviously becomes more difficult to determine the diagonal, vertical, and even the horizontal directions.

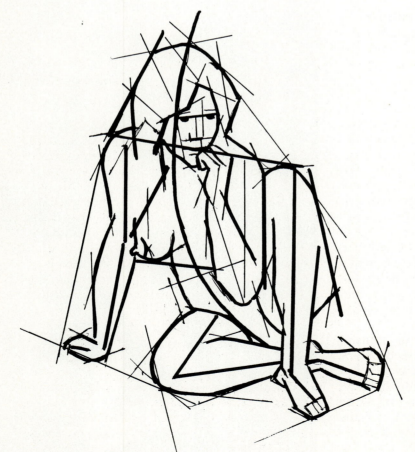

Figure 6–9.
Diagram.
Blocking in the figure.

Figure 6–10.
Diagram (after Bridgman).
The figure can be analyzed in terms of alternating round and square units.

BUILDING THE FIGURE

Interlocking

The human body being such a complex piece of machinery, the uninitiated observer is rarely aware of the intricate and various ways in which the parts connect, and I am referring only to those parts that are visible and therefore important to the artist: bone connections and muscle connections at the main articulation points. The parts interlock in many different ways: some, like the ball and socket of a simple piece of machinery; others, in complex and subtle articulations and meshings of bones and muscles with turns, twists, and wraparounds, each designed to give maximum strength and balance to the body in its various possible positions.

George B. Bridgman, whose book on the construction of the figure is a traditional standard reference work, advises the student to study the transitions between the body parts and draw them in an exaggerated manner to gain an understanding of the mechanics involved. The study of these transitions and connections is made even clearer when the forms are somewhat geometricized so that they are seen as interlocking geometric elements. Bridgman also recommends that the student think of the *total* human configuration as being made up of basic geometric units, mostly cubes and cylindrical shapes. For example, the cube-shaped head rests on a cylindrical neck, which merges into square shoulders, which in turn blend into the rounded rib cage; the rib cage attaches to the square hips and buttocks, followed by the rounded upper thigh, which connects with the small square of the knee, which sits on the triangular calf, which merges into the square ankle. These alternating round and square shapes are excellent memory aids for the beginner who wishes to develop a basic reference system to reconstruct the figure from memory and imagination (Fig. 6-10).

It is also important for the artist to understand how the different parts of the body realign when the body changes position. By making a series of simplified studies based on the relative positions of the geometricized segments and their connections and articulations at different angles and directions, depending on the position of the body, the students clarify their understanding of figure construction. Later, they become more able to see and depict the thrusts and counterthrusts of the parts of the body through direct observation of the more subtle and complex surface indications.

Bending, Twisting, and Turning

As part of their apprenticeship in observing and drawing the human form, artists should view the model in as many positions as possible to see how they affect the relationship of the parts. Bridgman offers another effective schematizing device: He suggests that the figure be seen as two main cubes, the rib cage and the pelvis, connected by a flexible line that goes through both cubes and represents the spinal column. Then, as the body bends and twists, the student observes and records graphically what occurs in the relationship of the three components: the two blocks and the connecting rod. Some positions cause the two blocks virtually to touch on one side while stretching out like a fan or an accordion on the other. In all positions, the inclination and twist of the spinal column are the determining factors, since the rib cage and the pelvis are both attached to the column and move with it in relation to it and to each other. The extreme flexibility of the spinal column is what makes all these positions possible and allows configurations of great visual dynamism (Fig. 6-11).

Foreshortening

When a hand, arm, foot, leg, or torso projects directly toward the viewer, it appears considerably shorter than it is; and it presents a strange, awkward-looking image, one that does not conform to the relative proportions of the standing figure at rest. But as the limb or torso is moved so that it no longer points directly at the observer, the foreshortening is reduced, and therefore, the limb or torso appears more consistent in size and shape with our expectation of what it should look like.

For beginners, the foreshortened view is often an intimidating challenge to their skill at depiction—a challenge they like to avoid. Yet the

Figure 6–11.

Diagram (after Bridgman).

One can understand the twists and bends of the torso by representing the rib cage and the pelvis by two blocks united by a flexible rod passing through their centers.

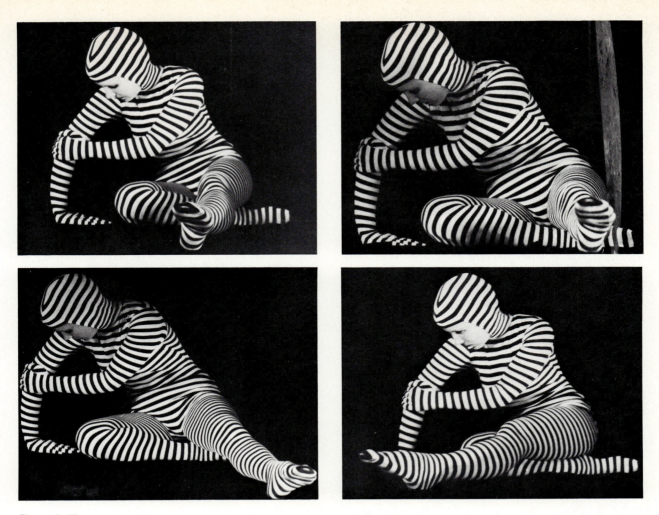

Figure 6–12.

Photographs.

Wearing striped leotards and tights, the model is shown in one pose from different vantage points to illustrate different degrees of foreshortening. The changing cross contour of the leg on the right is clearly seen with the help of the striped leotard. Studying these cross contours can be of great help to the student who is intimidated by foreshortening. It is necessary to draw the cross-contour lines as one sees them, even if the configuration seems strange.

foreshortened view is one of the most dynamic ways of seeing the figure: It contracts and compresses parts of the body in very abstract configurations, adding dramatic impact to the image while intensifying the awareness of space. The drawing of a highly foreshortened human configuration is sometimes almost undecipherable at first because the resulting image does not conform to the archetypal static body image that we carry in our mind's eye. As students gain confidence in their skills, they no longer avoid the foreshortened view of the figure and often even prefer it to the more conventional one for the visual possibilities it offers.

Students can increase their skill in depicting foreshortening by drawing the figure in close cross contour, so that they combine rigorous visual observation with a mental tactile tracing of the surfaces and edges that they are defining (description in Chapter Twelve). A sustained study of masters' works showing foreshortening, and the building of a photographic file of examples of foreshortened views are a helpful adjunct to the study.

Foreshortening can also be made clearer to beginners by having the model slowly shift the projecting arm or leg so that they may watch the progressive changes in shapes, proportions, and relations of parts that occur. In the process of analyzing the phenomenon and developing the skill to portray it, it is helpful to see and draw a given sequence from the foreshortened view to the nonforeshortened view and back several times. As an introduction to foreshortening, I have used models wearing horizontally striped leotards and tights to help with the tracking of the form (Fig. 6-12).

Eye Level and Foreshortening

The position of the model in reference to the eye level of the artist is yet another factor influencing the foreshortened view: When the model is placed below eye level, the head and shoulders appear proportionally more prominent and larger than the rest of the body. The inverse happens when the model is viewed from below: The legs seem more important in size than the torso and the head, which appear to recede in space. In either case, if the model is placed directly above or below the viewer, the degree of foreshortening is the greatest possible, and the body configuration may then appear unfamiliar to the point of quasi illegibility (Figs. 6-13 through 6-19).

A SERIES OF CHOICES

Before starting to draw a given figure, the artist has to make a series of choices regarding the point

Figure 6–13.
Bird's Eye View.
Photograph.

The figure is seen from above, showing more of the top of the head and shoulders and less of the lower limbs.

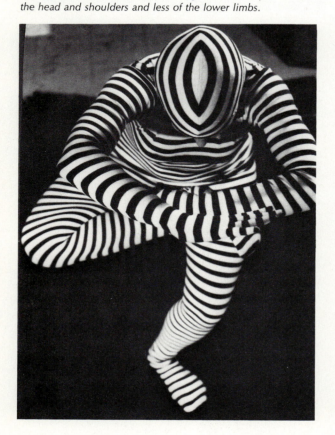

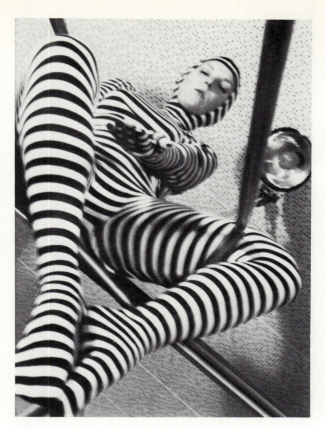

Figure 6–14.
Frog's Eye View.

The figure is seen from below, showing spatial exaggeration. The parts closer to the viewer appear larger than those that are farther up. The frog's eye view also presents foreshortening, and therefore, the horizontally striped leotard and tights are used to clarify the form as well as the space.

of observation and how this will affect the perception of the model: What will the distance be between the artist and the model? Which angle of vision is preferable? Which eye level?

The distance from which the model is observed influences the format and dynamism of the drawing: The closer the artist stands to the model, the larger the configuration and the more immediate and dynamic the perceived image. Often, when working from a close distance to the model, the artist emphasizes the sense of visual immediacy and dramatic presence by cutting off the image with the edge of the picture frame, thus dramatizing the partial figure (Fig. 6-19).

The direct front view and the profile views, although often creatively interpreted, usually present less pictorial excitement than the three-quarter view, which combines the front and side views.

88

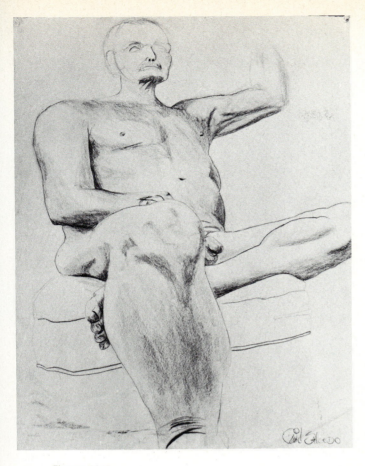

Figure 6–15.
DAVID SALCEDO, student.

Figure 6–16.
Student work.

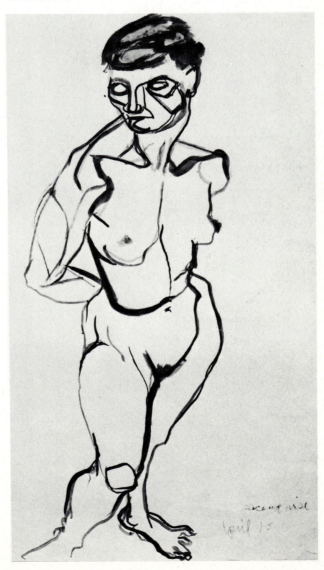

Figure 6–17.
LAURA CHRISTENSEN, student.

Figure 6–18.
Student drawing.

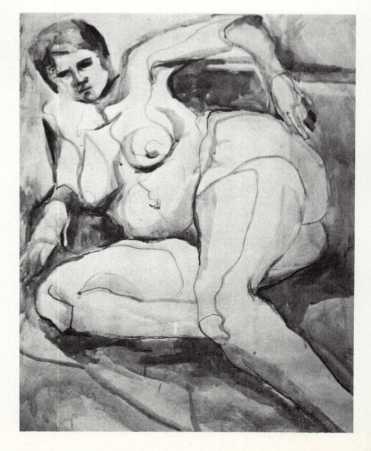

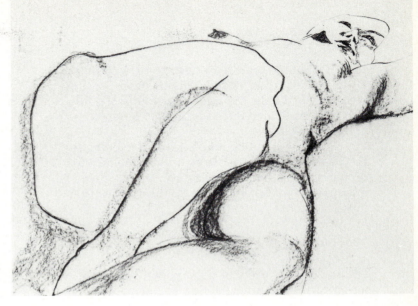

Figure 6–19.
JOAN LANO DE SIO, student.
Drawings 6–15 through 6–19 illustrate foreshortening. Notice how the placement and cropping of Figure 6–19 add energy and intensity to the composition.

Some beginners are such creatures of habit that they routinely take an accustomed place in the studio, a little like taking their customary seat at the family dinner table. It is useful for the participant to venture to different parts of the studio and choose the angle of vision most exciting for a given composition. In fact, it is best to move completely around the posed model at different distances until one finds the observation post that seems to offer the most suitable pictorial possibilities.

The circuit around the model helps the artist better understand the figure and the pose. I think that a particularly valuable exercise in figure construction is to make quick sketches or studies of a single pose from a number of vantage points: full face, profile, three-quarters, rear. Ideally, the vantage points should vary in distance from the model, in angle vision, and in eye level. If the model stand is powered, it can be rotated slightly at given intervals while the model keeps a single pose. Later, if the artist wishes, he or she can incorporate a number of the views in a single composition as different figures, or as a single composite figure (Fig. 6-20).

Figure 6–20.
EDGAR DEGAS (1834–1917).
Dancer Tying Her Sandal.
Cleveland Art Museum. Gift of Hanna Fund.

The same pose seen from different vantage points reads as a flowing, loose composition rather than as individual studies. A few strategic linear accents help contain and define the figures, which are basically constructed through mass.

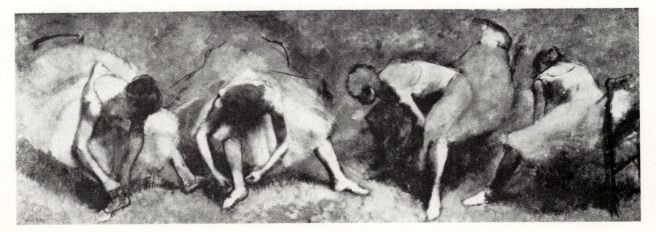

SUGGESTED EXERCISES

Proportions (for the Beginner)

Find a photographic reproduction of a standing figure; measure its head vertically, and use this measure to divide the figure vertically; see how close the result is to the classical ratio of seven and one-half heads.

Sketch a standing model without reference to the classical ratio; then see how close the finished drawing comes to the classical ratio of head measures to total height. Repeat the exercise from imagination.

Blocking-In Guidelines

On an 18 × 24″ sheet of bond paper, block in the figure of the standing model, using the top and bottom lines as constants. Carefully indicate the other guidelines, such as the knee, shoulder, pelvis, and base of the rib cage, paying attention to their tilt in relation to each other. Follow by placing the core line and indication of width. Now, mass in a soft, light grey silhouette shape to fit on top of this guiding grid.

The basic blocking-in can be even more meaningful when background props, such as a drape, table, or box, are part of the blocking-in of the total composition and serve as spatial references.

Cocoons and Tangents

The purpose of these exercises is to see and record the simplified configuration of the figure. This can be done by first establishing the outermost parameters of the configuration, and then carving the figure from this flat, generalized shape.

Lightly indicate the faint ghostlike silhouette directly from the model, or use the translucent stretch tube to help you see the undefined shape. For the latter approach, the model assumes a pose in the transparent stretch tube so that the stretched material clarifies the concept of the tangent lines connecting one projecting edge to another. Indicate the basic vertical and horizontal sightings as well as the tangents, and complete the broad enclosure within which the figure will be defined. Then sketch the negative space, that is, the space between the figure and the tautly stretched material.

In the second phase of the exercise, the model resumes the same pose without the stretch tube. Define the image within the reference points, sightings, and cocoon. Once the figure has graphically emerged, you can treat it in any way you choose: as a relatively flat silhouette, as a contour drawing, or as a volumetric study.

Interlocking

Observe the nude model carefully, paying particular attention to the ways in which the body masses and segments interlock. Using the Bridgman method of simplifying and geometricizing the segments and their connections, draw from the model, emphasizing the interlocking aspect of the whole. The drawings are quick, schematic studies.

Pelvis and Rib Cage: Relationship

Using a cube for the rib cage and another for the pelvis, connected to each other by a rod that allows some space between the cubes, do a series of quick sketches in charcoal from a model that takes quick poses—bending, twisting, and turning. Your sketches will show succinctly how the position of the spine affects the relative position of the rib cage and pelvis.

Foreshortening

Dressed in horizontally striped, long-sleeved leotards and tights, the model takes a pose in which an arm or leg is fully extended. Make a few analytical cross-contour studies from various vantage points, one of which should offer the greatest foreshortening (the most acute foreshortening occurs when the observer directly faces the extended limb). The striped leotard and tights facilitate the perception and depiction of the foreshortening by providing tangible tracking lines for the artist to follow. After executing some studies featuring foreshortened views in this manner, practice drawing from the same or similar poses without the leotard.

The Circuit

The model assumes a comfortable pose on the stand. If the stand is powered or can be manually rotated, it is partially rotated every ten to fifteen minutes to allow you to draw from a single pose viewed from different angles. The process is

repeated until there have been six stops along the full circuit. If the stand is not powered, take six stations around the stand.

The exercise can be expanded to include eye-level, above eye-level, and below eye-level views. The drawings are gestural contours.

THE HAND

Everything about the human figure is endowed with feelings and expression, but mostly we seem to concentrate on facial features and the hands as a focus of expression.

The very shape of the hands, their position, and their movement can convey many emotions: tranquility, anxiety, supplication, tenderness, and so on. The hand is also a reliable indicator of age, as we can easily see by comparing the small, pudgy hand of a young child with the gnarled hand of an older person. Because of their intrinsic expressive qualities, hands have been a favorite subject for studies by many masters.

Although enormously complex in its unseen engineering (after all, the hand is the most mobile part of the body, capable of both heavy and intricately delicate tasks), its outward shape is comparatively simple. As with any shape, the artist must view the hand in relation to the rest of

the body and especially in relation to the wrist and the arm.

The most common mistake made by beginners is to draw the hands too small in relation to the rest of the body. In general, the hand covers about three-quarters of the face, as you can see by placing the heel of the palm of your own hand against your chin; your middle finger will reach about the middle of your forehead. If you place your hand sideways alongside your chin, with the heel of the palm against the middle of your mouth, your middle finger will reach a point approximately just past the lower lobe of your ear (Fig. 6-21).

Moving from the general to the specific, we can view the hand at rest in its large mass as a kind of mitten from which the fingers can be carved out. Again, the shapes of the palm, the back of the hand, and the articulated fingers can be analyzed and simplified as oblong or squared-off units. The beginning artist should not automatically reduce the shape of the hand to that of a glove outline, unless the simplification and stylization are desired and are in keeping with the rest of the figure. The proportions and understanding of the structure should result from penetrating observation, and the character of the drawing should be consistent in style and concept with the rest of the figure.

Figure 6–21.

Diagram.

This shows the proportion of the hand in relation to the face. The hand is larger than we realize.

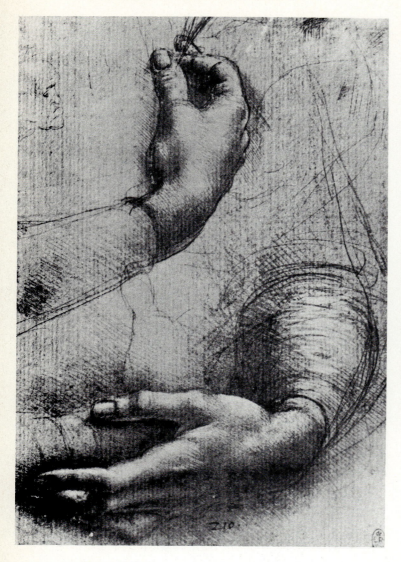

Figure 6–22.
LEONARDO DA VINCI (1452–1519).
Study of a Woman's Hands.
Silverpoint and white.
Royal Library, Windsor Castle.

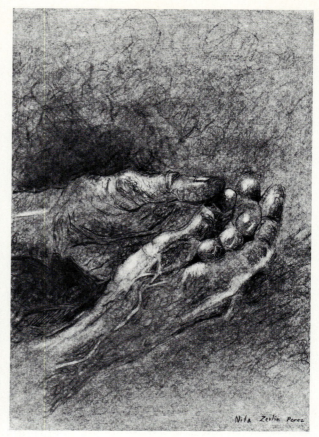

Figure 6–23.
NITA ZERLIN PEREZ, student.
Hands.
Pastel and charcoal.

In order to practice skills in observation and graphic depiction, there is probably no better exercise than to do an extended series of hands in a variety of positions and from a variety of angles of vision: extended, beckoning, working, at rest, grasping, pointing, in a fist, supplicating, intertwined, relaxed, clenched, and so on.

I would suggest that the participant not only look and draw from life but also study the magnificent work done by the Renaissance masters as well as the hands in classical Japanese drawings (Figs. 6-22 and 6-23).

PROPORTIONS OF THE HEAD

Artists and viewers are naturally intrigued with the depiction of the face, since it reveals the most unique and immediately recognizable features and expression of the subject and is a focus of attention and reaction.

My natural inclination is to avoid the diagram or "how-to" approach to life drawing, but experience has shown me that if they are used cautiously and for a very short time, some of the diagrammatic devices can be of value to the novice as points of reference in relating observation to drawing. The basic guidelines may help rank beginners to translate what they see into a credible drawing; with practice and observation and increased technical skills, the student will attain the ability to depict likenesses. To some, this is the ultimate achievement, but it is no more than a skill-serving

observation—a worthy but limited achievement; not enough for the artist whose goals include sensitive and insightful interpretation within a larger esthetic context. Curiously enough, the beginner is more apt to obtain a likeness faster by slightly exaggerating the characteristic features of the sitter.

A short overview of the basic proportions of the head and the placement of its features is usually a sufficient introduction to the beginner, who knows from experience that the individual proportions and features of a sitter rarely follow the statistical average and that nothing can supplant patient, honest, and insightful observation. As they draw from life, beginning artists immediately must leap to a mode of depiction where they rely on their own acute observation of all the elements that contribute to the uniqueness of shape, features, and character of the head of the model: its position, angle, and inclination in relation to the neck and shoulder line, as well as the angle and eye level from which they view it. The shape is further modified by such variables as the bony structure of the skull; the shape and size of major facial features such as cheek bones, brow bridge, side arch, bridge of the nose, lips, expression lines; such seemingly external factors as the shape of the mass of hair also influence the total head configuration.

BUILDING THE HEAD

The egg serves as the basic shape of the average head, with the rounded portion at the top (Fig. 6-24). It can be diagrammatically segmented into crown, hair, eyes, nose, mouth, and chin lines. The basic egg shape itself is subject to many individual variations: wide, elongated, rounded, squarish, and so on.

The diagrams in Figure 6-25 are divided into three bands, each series presenting one frontal view, one three-quarter view, and one profile view; the first row represents the three views seen at eye level; the second row, the same views above eye level; and the third row, below eye level. The changes in eye levels show the foreshortening that occurs in these cases.

Eye-level Frontal View

In the eye-level frontal view (Figs. 6-25a and 6-26a), the head can be schematized by first dividing the egg shape vertically through its center, running from the top of the skull to the center of the chin. All the facial features align themselves symmetrically along or on both sides of this axis: the eyes, the wings of the nose, the declivity between the tip of the nose and the upper lip, and the mouth.

The hypothetical average head seen in this view can be further divided by horizontal guidelines that help determine the relative placement of the features. A bisecting line midway between the crown and the bottom of the chin represents the eye line; another horizontal division bisecting the bottom half equally again indicates the base of the nose. The remaining space between the nose line and the bottom of the chin can be divided into three equal parts: The first segmenting line below the base of the nose coincides approximately with the separation between upper and lower lips, and

Figure 6–24.
Diagram.
The head is reduced to its basic structural planes.

AT EYE LEVEL

A. *Eye level, full-front view: The head is divided into three sections.*

B. *Eye level, three-quarter view: The eyes and mouth appear contracted; the ear touches the egg shape inscribed within the head.*

C. *Eye level, profile view: The head is divided vertically into four equal parts and horizontally into three.*

ABOVE EYE LEVEL

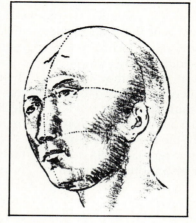

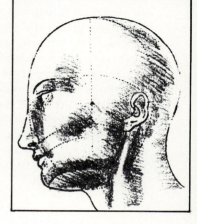

D. *Above eye level, full-front view: The guidelines curve upward in an arc; eye, mouth, and chin line slant downward.*

E. *Above eye level, three-quarter view: The guidelines curve upward in an arc; the mouth slants diagonally.*

F. *Above eye level, profile view: The guidelines curve upward in an arc; the nose, mouth, and chin project outside the egg shape inscribed in the head.*

BELOW EYE LEVEL

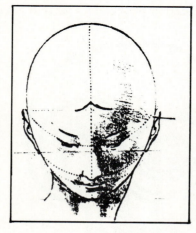

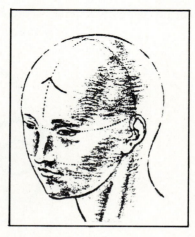

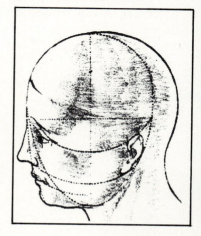

G. *Below eye level, full-front view: The guidelines curve downward in an arc; the top of the head is showing, the nose, mouth, and chin are compressed.*

H. *Below eye level, three-quarter view: The guidelines curve downward in an arc; eye, nose, and mouth slant diagonally.*

I. *Below eye level, profile view: The guidelines curve downward in an arc; nose, mouth, and chin project outside the egg shape inscribed in the head.*

Figure 6–25.
Diagrams of head at eye level, above eye level, and below eye level; in front view, three-quarter view, and profile view.

FULL FRONT VIEW

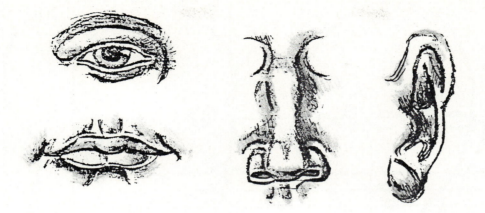

THREE QUARTER VIEW

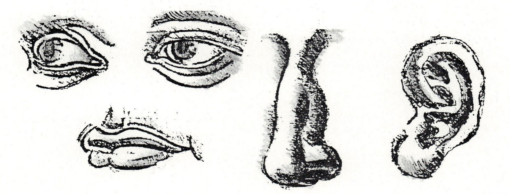

PROFILE VIEW

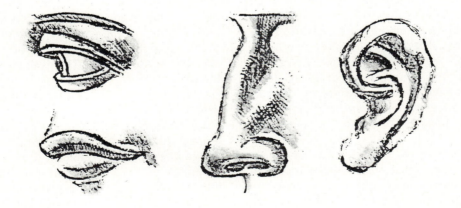

Figure 6–26.
Details of features (eyes, nose, lips, ears) seen at eye level in front, three-quarter, and profile views.

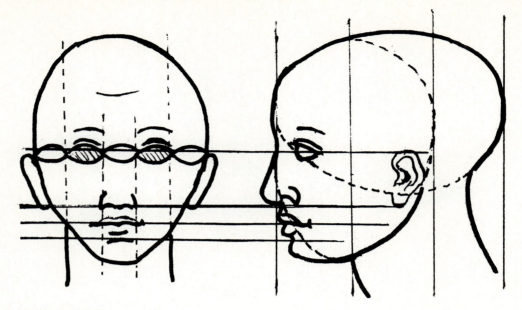

Figure 6–27 (left).

Diagram.

The eye line is divided into five sections, each one representing the width of an eye; the two external divisions represent the space between the external corner of the eye and the boundary line that defines the head; the "third" eye represents the average space between the eyes.

Figure 6–28 (right).

Diagram.

In the profile view, the head can be schematized by fitting one egg shape, representing the cranium, laterally into the basic egg shape, representing the head.

the second segmenting line represents the upper part of the chin; the remaining space corresponds to the bottom part of the chin. You may notice that in the frontal view, the head is fullest and roundest at the eye-line division (Fig. 6-27).

The eye line can also be divided into fifths, each division equal to the width of an eye. Thus, the divisions on the lateral edges of the face mark the space from the external corner of the eye to the contour edge of the head, two divisions approximate the space for the eyes, and the center one measures the distance between the eyes (Fig. 6-27).

The ears attach at a slight forward angle (the lower part angling somewhat toward the face), and they fit between the eye line and the nose line. In the frontal position, the ears are greatly foreshortened and appear flattened against the contour line of the head (Fig. 6-25d). Figure 6-25 shows the eye, mouth, nose, and ear seen in full front, three-quarter view, and profile.

In the frontal view, the eyes, often almond shaped, present a small, short, and narrow extension toward the tear duct on the inner corner. The eyelid covers part of the upper eye; the amount of eyelid visible when the eye is open varies with the individual. As one ages, the fleshy part between the lids and the eyebrows frequently sags over the outer corner of the eye. The eyebrows are just over the eyelids.

Starting with a small indentation, the nose rises to form a bridge that slopes downward and outward and terminates in the ball of the nose and the nostril wings. The outer edges of the nostril wings line up approximately with the width that separates the two inner corners of the eyes, and the neck fits in the width produced by extending imaginary vertical lines from the outer corners of the eyes (see Fig. 6-26a).

The lips are constructed along the middle line that separates upper from lower. The lower line of the upper lip is shaped somewhat like a bow. The

upper line of the upper lip is similar in shape and tapers as it terminates. The lower lip is often fuller but not quite as wide as the upper lip (see Fig. 6-26a).

Above Eye Level

When the head is seen frontally above eye level, the original horizontal guidelines appear as a series of arcs curving upward as they circle the basic egg shape, and the features—eyebrows, eyes, nostrils, and mouth—now align along these semicircular divisions. Compared to their placement in the frontal eye-level view, the features are higher within the egg shape; for example the apex of the eye line corresponds to what was the hairline. The other facial features show the same upward displacement, and part of the under surface of the chin is visible (see Fig. 6-25d).

Below Eye Level

In the below eye-level frontal view, the guidelines curve in the opposite directions; that is, they swing downward, and again, this represents the original horizontal axes of the facial features. In this foreshortened view, the base of the nose appears at about the same level of the lips in the eye-level view, part of the crown of the head is visible, and less of the chin is seen (see Fig. 6-25g).

Three-Quarter View

This view combines the profile and the full-face views. Now the central vertical division moves to one side, bisecting the egg shape unequally along a curved surface. The part closest to the artist is larger, and the part farthest away is more contracted as it recedes in space. The features align themselves vertically along this division and also appear horizontally contracted on the section farthest from the artist. The nose is seen in profile view.

In the three-quarter views from above and below eye level, the features align horizontally along upward or downward curving guidelines as they do in the frontal views seen from these vantage points (see Figs. 6-25b, e, and h).

Figure 6–29.
PATRICIA TREMBLAY, student.

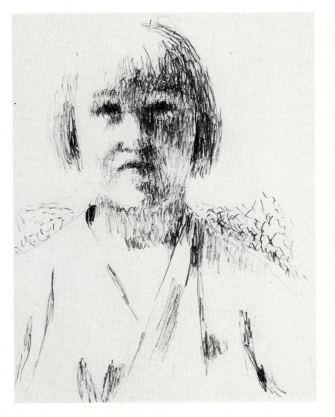

Figure 6–30.
NITA ZERLIN PEREZ, student.

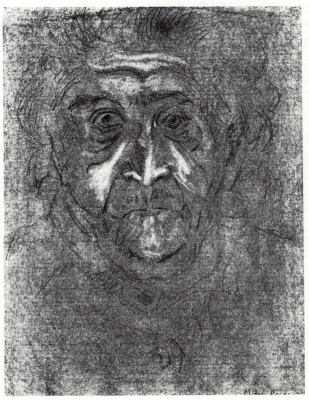

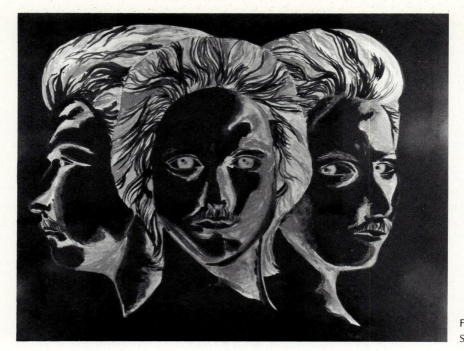

Figure 6–31.
Student drawing.

Profile View

At eye level, the profile view of the head can be schematized by inserting an egg shape on its side into the original upright egg shape. This helps approximate the cranial mass as it relates to the jaw. The neck occupies the space between the two egg shapes, and the salient facial features (nose, lips, chin) protrude beyond the outline of the head (Fig. 6-28).

Again, when seen above or below eye level, the profile view undergoes corresponding foreshortening (see Figs. 6-25c, f, and i).

Caveat

The preliminary remarks about diagrams must be repeated. Many beginners seize these devices with enthusiasm because they help avoid gross errors of proportions; but as soon as the student has been made aware of the average proportions of the average head and face, the diagrams must be discarded, and life drawing should be what it purports to be—drawing from life, from honest and careful observation, with insight and sensitivity in regard to the subject and to the drawing process itself. When the artist blocks in some guidelines before placing the features of the sitter, they rarely fall in the exact relationships that prevail in the diagram of a stereotypic head;

however, the variations exist within the basic frame of reference offered by the diagrams. Soon, as their skills, knowledge, and assurance grow, artists become increasingly more able to endow their drawings with vitality and expressiveness, and they find the means to reveal both the uniqueness of their subject and of their pictorial interpretation (Figs. 6-29 through 6-34).

Figure 6–32.
Student drawing.

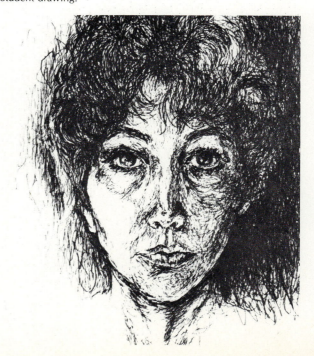

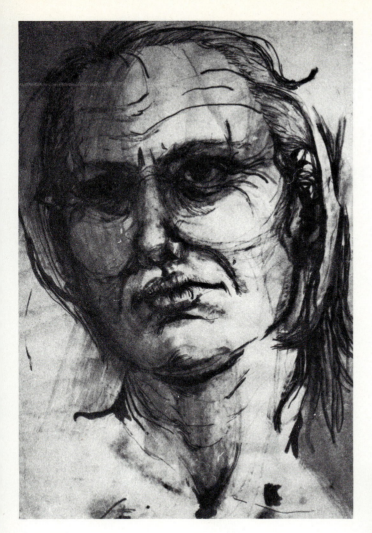

Figure 6–33.
Student drawing.

Figure 6–34.
Student drawing.

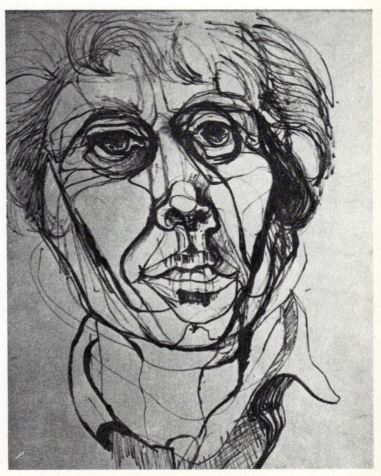

CHAPTER SEVEN

The Building Elements

A LIFE OF ITS OWN: PENT-UP ENERGY

Life of Its Own

For me a work must first have a vitality of its own. I do not mean reflection of the vitality of life, of movement, physical action, frisking, dancing figures and so on, but that a work can have in it a pent-up energy, an intense life of its own, independent of the subject it may represent.

Henry Moore

We often hear that a work of art must have a life of its own. What is meant is that the composition is not inert but that its components are visual forces, which when put in a special relation to each other, possess the potential power to create bodily tensions in the viewers and to move them emotionally, regardless of the subject matter.

If artists place the building elements of their composition into particular relationships to each other, it is because they know instinctively and through study and experience that these relationships are essential to the esthetic impact of the work; what we call the elements—*point, line, value, form, texture,* and *color*—possess a pent-up force or energy that is activated and rendered effective by the sensitive handling of the artist and the esthetic responsiveness of the viewer. This energy is esthetically meaningful only when it is the result of a skillful orchestration of opposing or complementary visual forces.

PUSH AND PULL

Push and Pull

When a force is created somewhere in the picture that is intended to be a stimulus in the sense of a push, the picture plane answers automatically with a force in the sense of pull, and vice versa.

Hans Hoffman

For every thrust, there is a counterthrust. Depending on its relation to the background and neighboring shapes, each line, form, or color has a specific push-pull potential; that is, it sets up a tension that attracts the eye of the onlooker and redirects it to another area. The act of viewing is thus guided along a certain path by the intrinsic properties of the elements and their arrangements. The energy potential of a given element is intensified or weakened by the placement of the other elements, which together form the total graphic configuration.

BODILY FELT TENSION: EMPATHY

Most of us have had the kind of enthusiasm and empathy that involve our whole body when we watch an exciting sports event: Our own muscles tense up, and our body unconsciously participates in our identification with the action or the athlete

of our choice. Something similar, though far more complicated and subtler, occurs with sensitive and sensitized art viewers: They, too, become emotionally and physically engaged in the interaction of visual forces set up by the elements in art. They do not just react to the subject matter but also respond to the tensions generated by the formal arrangements of the elements. But each viewer responds to a particular graphic arrangement differently because each brings a different sensitivity and a different body of past experiences; and just as a chance sound may evoke a pleasant or unpleasant memory, so can form or shape trigger dim memories that unconsciously influence the response to the visual stimulus.

Although we commonly refer to certain configurations as being delicate or bold, strong or weak, warm or cold, restricted or free, the shapes do not possess such attributes, of course; rather, the viewer assigns these qualities to them, based on personal or shared associations and experiences.

AN ACT OF JUGGLING

Learning to draw and compose a picture is like learning to juggle a large number of diverse objects simultaneously and seemingly effortlessly. Perhaps the most effective way to gain mastery of the process is to juggle no more than a few elements at first, thus reducing the complexity of the act. Eventually, more elements are added, until the artist is able to keep them all going at one time in one flowing and controlled rhythm.

As each element is skillfully added to the others, the energy level within the picture field is intensified—and so is the possibility of error and loss of equilibrium. At all times, the artist must be aware that each new element introduced has to become an integral part of the whole rather than a tacked-on addition. Like juggling, this takes practice, patience, and the ability to tolerate a few failures, until one develops the "feel," the sense of timing, of relative weight, which allow all the parts to work together in the fragile equilibrium of all living things.

FORM OR SHAPE

Form, or shape, is a most complex and elusive element to define because it is made up of the other elements and yet is distinct from the total composition. Form may result from purely linear combinations, or it may incorporate any or all the other elements, such as point, value, and color. However, whatever the number of elements involved, the shape is what "reads" as a visual unit within the drawing or painting; the term *form* is a more general term, which usually refers to the total structure or composition of the finished work.

The shapes may be divided into two basic types: geometric and free flowing; either type may be relatively flat—that is, form a plane along a depth that nearly coincides with the drawing or painting surface—or it may create the illusion of surface directions in space, which in turn can combine to form volumes (Figs. 7-1 through 7-4).

Figure 7–1.
Student work.
The shapes are made up of planes, which in turn create volumes. The edges of these planes often extend into the negative space, effecting a merging of the two. It also gives a spiky, jagged look to the image.

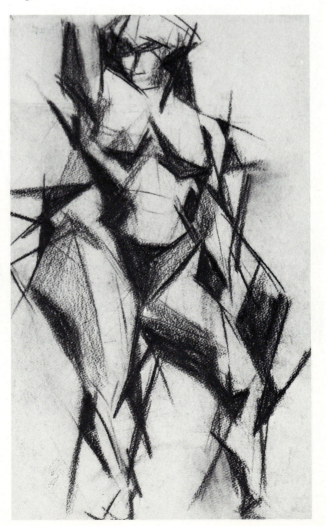

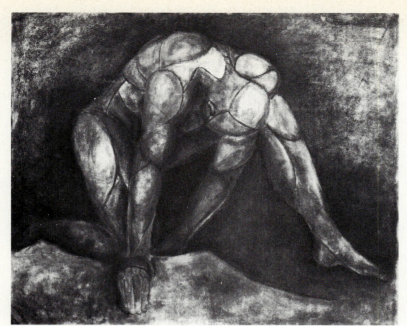

Figure 7–2.
Student work.
The shapes in this drawing appear heavy, bulky, and rocklike.

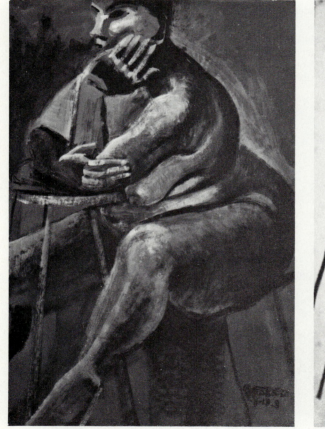

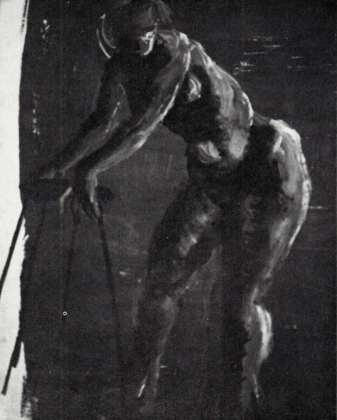

Figure 7–3. LAURA CHRISTENSEN, student. Figure 7–4. TONY GALT, student.

These two studies, executed in black, white, and opaque grey watercolor, emphasize the feeling of mass and weight. Compositionally, they both fill the format, touching the edges on at least three sides. Figure 7–3 was executed in dry brush technique, whereas Figure 7–4 was executed in scumbling technique.

104

Geometric or free flowing, shapes can have additional characteristics:

Mechanical or free-hand	Curvilinear or rectilinear
Bold or delicate	Open or closed
Heavy or light	Symmetrical or asymetrical
Solid or perforated	Recessed or projecting
Opaque or transparent	Elongated or
Precise or indeterminate	squat

Again, the physical qualities of the shapes often have an emotional impact on the viewer, an impact that can be enhanced by the general thrust of the total scheme or composition.

Form and Space

Spaces Have Form

Intervals of space are as much a part of visual design as the silences between sounds are part of the design of music.

Museum of Modern Art

Regardless of the specific properties and configuration of any shape, it must exist in a spatial container, which we call the *picture field*. We may think of that container as a box, shallow or conveying the illusion of depth, within which the graphic drama is enacted (Fig. 7-5).

Each shape is defined by the space contiguous to it, and the two are inseparable. Beginners have a tendency to depict the subject without conscious regard for the space that helps define it, and that is an integral part of the total configuration. As a shape emerges, so does its pictorial "space"; the two are shaped simultaneously. When students become sensitive to the essential connection between space and shape, their way of viewing the subject matter is usually transformed, and they become aware of the difference between primary space—that is, the space that surrounds the object or figure—and the secondary space, which exists between overlapping shapes (Figs. 7-6 and 7-7).

Sometimes the artist introduces tangible spatial indicators within the composition—a table, boxes, screens, drapery, floor plan, and so on—or clothing accessories that project beyond the boundaries of the figure—a brimmed hat, parasol or

Figure 7–5.
Diagram of picture plane and picture field.

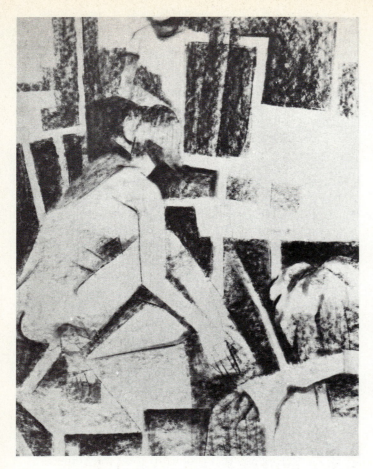

Figure 7–6.
CARL BURKHOUT, student.

umbrella, or stole. These are then interpreted as overlapping planes, or in classical perspective—depending on the degree of verisimilitude the artist wishes to establish in relation to spatial definition—illusionistic or compressed (Fig. 7-8).

Open and Closed Forms: Mergings

In their relation to space, the shapes may be open or closed. If there is a line or an edge surrounding the shape and clearly separating it from the background, the shape is referred to as a *closed form;* but if parts of the shape are left undefined, allowing the merging of lights with lights and darks with darks between figure and ground, the configuration is referred to as an *open form.*

Closed form tends to isolate the figure or subject from the ground, whereas open form creates the means for partial mergings of mass and space. (This concept is developed further in Chapter Thirteen.)

Suggested Exercises

Shape. Draw from the model, emphasizing flat geometric forms; reduce each part of the figure to its closest geometric equivalent: egg-shaped head, cylindrical neck, barrel-shaped torso, cylindrical tapering limbs.

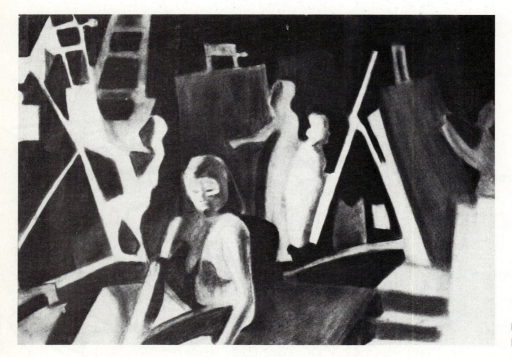

Figure 7–7.
DAN YORK, student.

These drawings illustrate an awareness of negative space. The easels and figures, reduced to simplified planes, act as spatial references as well as guides to a given compositional path of movement.

The preceding problem may be modified by adding shading to impart a three-dimensional quality to the drawing. In this case, the intent of the exercise is to depict the figure as a wooden mannequin rather than as a flat cutout.

Referring to the paired contrasting physical qualities of shape (page 105), select four such qualities and draw from the model in pen and ink, emphasizing the chosen attribute: delicate or bold, elongated or squat, precise or indeterminate, and so on. The drawings should be on one page.

Make a contour drawing of the model, enclosing the figure fully with a boundary line. Use pen and ink or pencil.

Draw the same model in the same pose as in the preceding exercise, but leave the form open in some parts, so that the figure merges with the ground in these areas.

Space. With charcoal, concentrate on drawing the negative space around the model. In order to emphasize awareness of it, avoid outlining. Place your charcoal on its side at approximately 1" or 1/2" of what would be the outer edge of the body, and mass in the charcoal up to that approximate edge. Repeat the process until you have fully described the immediate space next to the boundaries of the figure. It is advisable to work up to the edges, starting from various areas, to avoid outlining. When the drawing is completed, the figure will emerge as a light silhouette revealed by the definition of the space around it (Figs. 7-6 and 7-7).

Economy of means. Using charcoal or pentel brush on all-purpose watercolor paper, sketch rapidly from the model, indicating only the negative spaces around the head, waist, and lower part of the legs. Placed economically and strategically, these negative space notations alone suffice to suggest the total configuration.

Letting the paper breathe. After studying a wash drawing of Tiepolo (Fig. 7-9), draw the figure in ink, using a broken-line quality, and add middletone shadow areas in ink wash. Accent the shadows with darker grey ink where necessary, and add a few black accents if needed. The figure will be partly drawn and partly suggested and will be depicted mostly in light and middle tones.

LINE

Line is undoubtedly the primal element of drawing. From the earliest times, it was used to depict recognizable subject matter through incision or

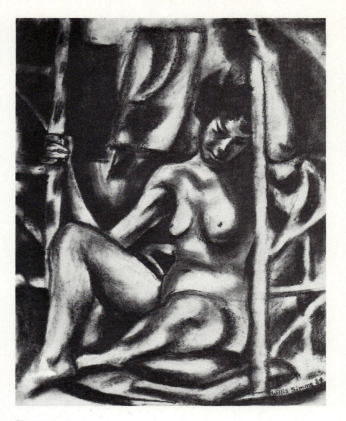

Figure 7–8.
WILLIS SIMMS, student.
The props were carefully placed in order to clarify the space surrounding the model.

drawing, and it remains the primary way to produce a drawing.

The line is not always fully and clearly stated; sometimes it is inferred, as in the edge created by the juxtaposition of two values or two colors or as in the discontinuous or broken line, which the mind continues and completes past its terminal point.

Line fulfills a number of functions: As a contour line, it describes the form through its edges and through its depth. As a gestural line, it indicates the direction or movement of the subject; it can also be used as the axis or central core of the mass. As a calligraphic line, it is used to describe, adorn, or decorate the basic shape. However, essentially, the line defines and describes a shape by establishing its boundaries while serving as a path of action for the eye to follow. We will investigate further the concept of linear definition as an esthetic choice when we address the classical approach to drawing.

Figure 7–9.
GIOVANNI BATTISTA TIEPOLO (eighteenth century).
Virtue Crowning Wisdom.

Pen and ink with traces of black crayon on white paper.
Metropolitan Museum of Art, New York City. Rogers Fund, 1937.

*The freedom of the sketch and the mergings of
positive and negative space create a composition so
open that it is difficult at first to decipher the central
figure of the bearded man. It is a masterful study of
fragmented elements forming a unified whole. The
choppy, dark accents; the fingerlike interweaving of
light, dark, and middle tones; the cursive, broken, and
sinuous linear suggestions all combine into a vibrant,
unified composition.*

Physical Qualities and Empathic Response

Lines present great variety in their physical qualities:

Thick or thin	Regular or uneven
Dark or light	Single or multiple
Quiet or active	Precise or blurred
Flowing or broken	Free or mechanical

Lines of various types are often used within a composition for greater visual excitement and expressiveness.

In describing the linear quality of a drawing, we frequently use many highly charged adjectives: bold, nervous, sinuous, elegant, erratic, indecisive, vibrating, angry, serene, dynamic, assertive, dancing, playful, jarring, and so on. Of course, the line is not any of these things. As with shape, the attributes reflect the viewer's associations and response to the particular physical quality of a line.

108

A thick, choppy dark line, for example, evokes a different response in the viewer than a thin, flowing one. The former may be interpreted as powerful and angry or bold and assertive, whereas the latter may be associated with delicacy or elegance. As in music, each type of line may have a particular individual resonance, but when it is orchestrated with other lines and other elements of the drawing, the total composition evokes more complex emotions and responses. Sensitive viewers empathize with the means and graphic configuration, as well as with the overt or suggested subject matter (Figs. 5-1 and 7-10 through 7-14).

Suggested Exercises

Without drawing from actual subject matter, practice different linear qualities with different tools and different handling of the tools:

Physical Quality	Suggested Tool
Bold and thick	Charcoal, brush and ink, or pentel brush
Dynamic, dark	Black ink and brush or pentel brush
Mechanical	Pencil or pen and ruler and compass
Delicate	Pencil, pen, or ink with crow quill pen
Light and ephemeral	Diluted ink and pen
Broken, evocative	Dry brush
Multiple	Pen or mucilage brush

Of course, the relationship between the tool and the physical quality of the line is not an absolute, and delicate effects can be produced with tools usually used to elicit bold qualities—and vice versa.

(In Chapter Three, other less traditional tools and techniques were mentioned.) After having practiced the different linear qualities produced by different tools and different handlings, draw from the model, with conscious awareness of the linear quality desired and of the means used to obtain it.

VALUE

Value is the element that establishes light and dark relationships within the composition. It creates contrasts, which define the form and contribute to its readability while enhancing the total design.

It is true that we live in a world of colors, not a world of greys; yet one of the properties of color

Figure 7–10.
GEORGES ROUAULT (1871–1958).
Head of Christ (1905).
Collection of Walter P. Chrysler, Jr.
This sketch painting is made with a variety of lines: thick, thin, connected, broken, light and dark. Together they powerfully express a feeling of pain and suffering.

is its degree of light and dark, and this range is what we seek to recognize and use effectively when we consider the tonal scheme of a drawing or painting.

Limiting the Value Range

Just as there is a tonal scale in music, so is there a scale of tonal values in the graphic arts: a series of nine evenly graduated steps of lights and darks, starting with white and ending with black (Fig. 7-15).

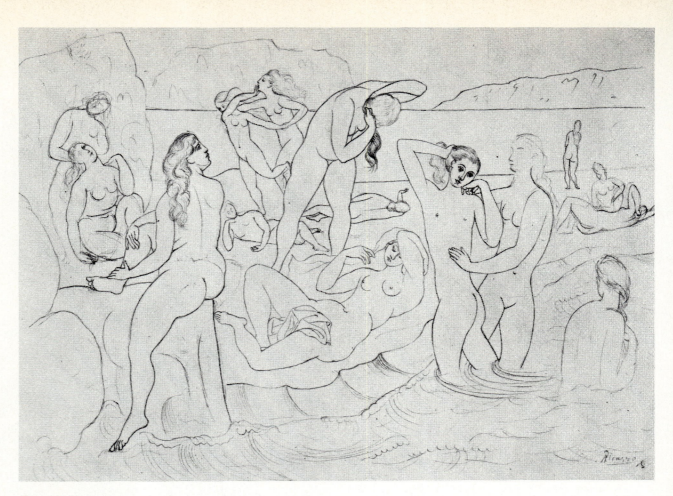

Figure 7–11.
PABLO PICASSO (1881–1973).
Bathers.
Graphite.
Fogg Art Museum, Harvard University, Cambridge, Massachusetts. Bequest of Paul J. Sachs: "A Testimonial to my friend W. J. Russell Allen." © S.P.A.D.E.M., Paris/ V.A.G.A., New York.

Figure 7–12.
DIEGO RIVERA (1886–1957).
Mother and Child (1936).

Ink drawing on paper.
San Francisco Museum of Modern Art. Albert M. Bender Collection.

Figure 7–13.
LOIS COHEN, student.

Figure 7–14.
Student drawing.

These drawings illustrate different qualities of line. In Figure 7–13, the line is fluid and expressive, varying from thick to thin, smooth to broken, single to multiple. In Figure 7–14, the configuration is interpreted through a sketchy, multiple, and broken line, supported by some hatching to suggest volume and space.

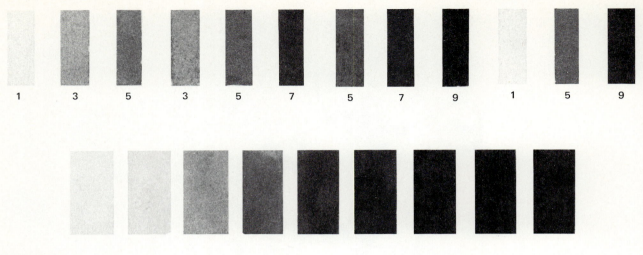

Figure 7–15.
Value chart.

Artists can emphasize a given mood by selecting their value range from a limited portion of the value scale, or they may opt for strong value contrasts by using values from both ends of the scale.

Artists usually simplify the immense range of darks and lights found in nature. They limit their value range and attempt to modulate their light and dark definitions and patterns as legibly and expressively as possible within the arbitrary range chosen.

The Value Key

There are four major value groupings, or value keys, derived from the original nine-tone value scale, and each value key tends to imbue the composition with a particular associative mood:

> *The high key* represents the upper lightest third of the value scale (range 1 through 5) and generally conveys a mood associated with pleasantness or delicacy.
>
> *The middle key,* or middle range of the scale (3 through 6), usually reflects quiet, calm, and restraint.
>
> *The low key,* or lower and darker part of the scale (5 through 9), seems to infuse the composition with a sense of mystery or melancholy.
>
> *The full scale* expands the full range of the value scale (1 through 9), from the lightest to the darkest, and often generates a feeling of excitement and dramatic contrasts. But even when using the full scale, the artist usually selects values from the upper, middle, and lower range rather than all nine gradations.

It is important to recognize that the associations between value scale and emotional impact are not absolute or mechanically triggered. The mood and emotional impact of a drawing or painting depend on many complex factors—above all, on the relationship of all the contributing elements. It is quite conceivable, therefore, that under certain circumstances, each of the generalizations just made could be successfully contradicted. Nevertheless, the generalizations do have a basis, as you can empirically determine for yourself by contrasting your reaction to a high-key composition and a low-key composition, without regard to the subject matter.

It should be added that some artists do not restrict themselves to the traditional nine-step scale, and therefore, not all graphic works fall neatly into one of the four major keys described.

Chiaroscuro

Chiaroscuro, an Italian term meaning "light and dark," is the technique of modeling the form and giving it a three-dimensional effect by the skillful blending of graduated tones from highlights to deep shadows. The technique was used in ancient Roman wall paintings and was later refined to consummate skillful illusionistic rendition in the Italian Renaissance (Fig. 7-16).

You will notice that the play of lights and darks that gives volumetric definition to the observed figure varies according to the source of light. Thus, the same figure seen from the same observation point presents different light and dark patterns when seen under different lighting: single light, frontal, overhead, side, back lighting, fringe lighting, and so on.

Figure 7–16.
LEONARDO DA VINCI (1452–1519).
Cartoon for the Virgin and Saint Anne.
Charcoal heightened with white.
National Gallery, London.

The grouping of the four figures follows a basically triangular compositional scheme. Bathed in soft tones and executed with exquisitely soft, delicate, and subtle modeling, the composition evokes a quiet, mysterious, and poetic mood.

Figure 7–17.
Portrait of the Lady Lien (thirteenth century).
Courtesy of the Trustees of the British Museum.

The tonal composition is basically restricted to contrasting flat areas in the middle value range. The impression is one of restraint and stateliness. There are no highlights or shadows, and the suggestion of three-dimensionality is indicated through the linear contours only.

Most of the time, we think of chiaroscuro in its most dramatic impact, involving the full range of values, from the lightest to the darkest. However, it may be used in any of the value keys, depending on the tonal mood the artist wants to convey.

The most common materials and techniques used in drawing to model the form in lights and darks are charcoal and Conté crayon. Other frequently used materials and techniques are the crosshatch, ink wash, and wash drawing with resist. (These techniques have been described in Chapter Three.)

Flat Value Contrasts

Flat value contrast is a direct and effective way to accent forms and to separate them from each other and from the background. It does not allow subtle shadings nor the illusion of realistic three-dimensionality that chiaroscuro does, but it conveys an impression of simplified clarity, and its tradition goes back to the art of ancient Greece, Egypt, and China (Fig. 7-17).

Value as a Structural Force

Like all the other elements, value is used both descriptively and structurally. Its structural role is to give greater importance and density to certain areas, thereby increasing the visual tension in that area and encouraging the eye to linger there. The distribution of value areas is a way to direct the viewer's eye, to call attention to one shape, and to redirect the eye to another one (Fig. 7-18).

Suggested Exercises

Flat contrasting tones. Using 8 × 10″ all-purpose watercolor paper and an assortment of pastels graduated from white to black, make four drawings of the model. Each composition is to be conceived in flat value contrasts, the first one in high key (basically light, ranging from white to middle grey), the second in middle key (3 to 6 on the value scale), the third in low key (5 to 9 on the scale), and the fourth in full scale, ranging from white to black with low and middle tones. Make sure that in each drawing the background is included in the total value key of the composition. Use minimal modeling. Instead, simplify and reduce the light and shade definitions to flat contrasting shapes (Figs. 7-19 and 7-20).

The modeled drawing. When viewing and depicting the picture through mass, the artist's chief concern is with a feeling of weight and three-dimensional bulk. The edge remains somewhat indeterminate at first while the artist concentrates on the three-dimensionality of the figure, rendered through gradations and blendings of light and dark values. After having established the masses and the volumetric quality of the sub-

Figure 7–18.
HONORÉ DAUMIER (1808–1879).
The Song.

Pencil, pen, and watercolor.
Sterling and Francine Clark Art Institute, Williamstown,
Massachusetts.

*The four figures emerge as modeled masses of lights
and darks, further defined by a nervous, nonconfining,
multiple line. The dark background sets off the figures,
whereas the dark values of the modeling partly fuse
background and figures together.*

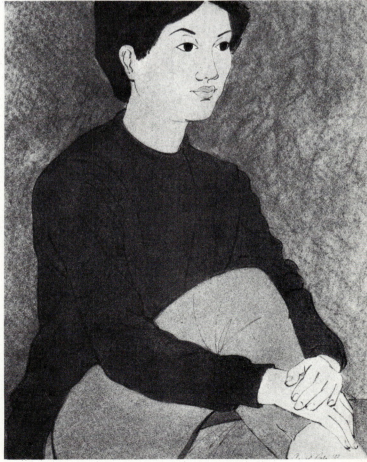

Figure 7–19.
CAROL PATE, student.
Pastel.
*Done with flat value contrasts, this work completely
eliminates highlights and shadows. The relative
three-dimensionality of the figure is depicted through
the contour line.*

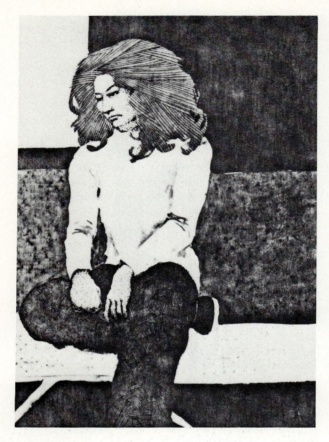

Figure 7–20.
KAREN MUNSELL, student.
The composition is built on the arrangement of simplified, basically flat contrasting value areas, some of which are textured.

ject, if the artist wishes to work realistically, he or she may define the edges and the linear details more precisely.

As an introduction to the problem, draw a large head from life, using 8 × 10″ all-purpose watercolor paper and a stick of compressed charcoal. Holding the charcoal on its side, spread it over the whole surface, producing a middle-tone background. Rub this into the paper with tissues. Then draw the head by erasing the highlights with a charcoal eraser and massing in the shade areas with the side of the compressed charcoal stick. The tonal gradations should be subtle and suggest roundness and three-dimensionality. The same problem can be adapted to the figure. In either case, the method of modeling starts with the middle tone; the highlights are produced through erasing, and the shadows are added by carefully graduating and blending tonal areas.

Modeled drawing: wash and resist. Place the model in such a way that a strong light delineates the form through highlights and deep shadows. After sketching in the figure lightly in pencil, formulate the highlights with a white crayon, using the side of the crayon rather than the point. Prepare a light wash (black ink diluted with plenty of water), and brush in the light and middle tones. While the light wash is still wet, brush in the deeper shadows with a dark wash. Finally, add ink lines for greater definition but do not enclose the form.

A variation is to draw in ink, indicating the gradations of value with hatch and crosshatch of various densities. A wash of grey ink may be added to the shadow areas.

White on white. A challenging study in delicate tone transitions is provided by white-on-white setup: The model, clad in white leotards, tights, gloves, and white mask, poses in front of a white backdrop. Light is beamed from a front off-center source so that delicate shadows are cast. The starkness of the white configuration can be quite striking and somewhat surrealistic. The tonal gradations are subtle and high on the value scale. By slightly moving the light's source and varying its intensity, numerous variations of value transitions may be achieved and depicted.

Black on black. By connecting the spotlight to a rheostatic dimmer, the light can be progressively lowered, so that while the model is still discernible as a rounded form, the highlights are barely visible. The figure emerges in subtle transitions in the darkest end of the value scale. Occasionally, the setup can be modified to emphasize the darkness and subtlety of the tonal gradations even further by clothing the models in black coverings— tights, gloves, hood, perhaps even a black mask— and by adding a dark backdrop. Even with the spotlight fully on, the figure and the background are seen in a close value range.

TEXTURE

Everything that surrounds us has a specific texture: rough, smooth, hard, soft, furry, silky, obvious, subtle. And even though texture is not a primary element of the visual experience, it plays a discrete but important role in our apprehension of a graphic work. Some textures irritate, others please; some excite, others soothe. In some cases, a repeated small pattern can convey a textural

effect; open-weave materials such as lace, netting, and cheesecloth are not only textured but patterned as well. The same may be said of wood grain, textured papers, and plastic wall coverings, which may all be used in collages. Our reaction to textures completes our reaction to a visual stimulus.

Although, by definition, texture is primarily apprehended through the sense of touch, we often receive a tactile message through the visual depiction of a textured surface. We have had enough empirical experiences to associate certain visual clues with a tactile sensation and reaction.

In a drawing or painting, texture can be implied by skillful representation of the quality of the surface, or it can be actual, as in a collage. In all cases, it enriches the surface of the drawing or painting and contributes to the variety of the visual and emotional experiences offered. It may be used to attract attention to a given part of the composition, or it may simply create a vibrant, pulsating surface. Contrasts in textures create interest and excitement and induce eye movement from one part of the configuration to another. Often, an overall texture serves as a unifying factor in the composition (Figs. 7-21 through 7-24).

Unless strong textures are an integral part of the concept of a given work, the beginning artist would be wise not to give undue prominence to texture. Its excessive use may retain the eye on a given spot rather than guide the flow of vision, as it should in a well-integrated total design. Texture is most efficacious when we are not made unduly aware of it and when it is subordinated to the total configuration.

Suggested Exercises

Frottage. Draw the figure in contour with pencil on 12 × 18" bond paper. Place various patches of natural textures underneath the paper, and pick up these textures as areas by rubbing over the paper with a soft pencil (B-6), in the technique known as *frottage*. Rub lightly where you want light or middle tones, and rub more heavily where you want darker tones.

Take a sheet of thin drawing paper and, using an assortment of grey pastels ranging from light grey to dark grey, draw the figure in contour and fill in areas in flat value contrasts. As in the preceding exercise, place various textures under parts of the sketch: burlap, open-weave material, textured papers, sandpaper, sand-blasted wood, and so on. Rub lightly or strongly on the surface with pastels of contrasting value—light over dark, dark over light—picking up the textures through frottage. Make a conscious effort to work with an effective value pattern as you are adding textural interest.

Spatter. Draw the model in light pencil on a watercolor paper that you have first toned in light to middle tones with charcoal or Conté crayon.

Figure 7–21.
VINCENT VAN GOGH (1853–1890).
The Zouave (1888).
Ink.
Guggenheim Foundation, Tannhauser Collection, New York.
This is a vigorous contour drawing executed in a series of basically flat areas of contrasting graphic texture, each area enclosed by a strong outline. The textures are obtained through very simple, almost elementary means: crude hatch and crosshatch and variety in the direction and intensity of the pen stroke. The variation in density of the dots in the face and neck creates a suggestion of modeling so that these areas are the only ones to suggest volume in an otherwise flat composition.

Figure 7–22.
GUSTAV KLIMT (1862–1918).
The Kiss.
Osterreichische Galerie, Vienna.

This is a texturally rich composition consisting of flat, decorative, contrasting floral and geometric patterns against a relatively subdued background. The quiet, plain surface of the flesh areas and background balance the textural adornment and keep it from being overly profuse.

With the help of a hard toothbrush, spatter black ink in those areas that you wish to be dark. Later, you may define the highlights with white tempera.

Zipatone patterns. Draw the figure in ink on bond paper, contour fashion. Cut out shapes of various Zipatone patterns and use them as collage to enrich the pattern and texture of the drawing in given areas. Zipatone-like patterns can be prepared by the artist, using pens of various sizes and a ruler.

Textured collage. Again, draw a large contour drawing of the model in pencil, ink, or brush and ink on Bristol paper. Incorporate textured areas by gluing in patches of real textures, such as cardboard, mesh, burlap, sandpaper, and wool. Remember that even though the real textures are added for visual impact and for direct involvement of tactile associations, they still should serve the total composition and not dominate it.

POINT

The point, or dot, is the simplest of all the graphic elements, and it can be used with great effectiveness. The basic dot is the impression left by the tip of a sketching or painting tool; depending on the tool and material, dots can vary in size, tone, and shape, and they can be spattered, stamped, finger printed, and so on.

A Way to Indicate Mass

Even though a line can be formed or implied by the juxtaposition of closely related points or dots, the point lends itself more readily to graphic notations of light and dark masses. This is especially true in establishing gradations of value. It is the factor of proximity—the density or sparseness of the dots—which determines the degree of light and dark of the mass or shape; by juxtaposing and superimposing dots, a darker tone can be produced. The artist needs to practice the application and control of the density of the dots in order to obtain smooth, gradual transitions of tones to create the effect of three-dimensionality.

Unlikely as it may seem, very realistic drawings can be achieved with dots only. In fact, the reproduction of photographs in printed material is achieved by reducing the original photograph into patterns of dots. We, as viewers, generally possess the innate ability and tendency to coalesce even the slightest visual clues into coherent imagery, especially when it can be reconstituted as familiar imagery.

Pointilism

One cannot address the role and versatility of the point as a pictorial element without reference to Georges Seurat, the nineteenth-century French artist, who constructed his compositions with the

painstaking and skillful application of dots. He used this technique both in his drawings and in his paintings. In the paintings, the dots were not just the agents or carriers of pure colors, to be blended by the eye of the onlooker, but also served to create an overall unifying pattern and texture. In the drawings, the varying density of the dots determined the value pattern of the shapes and masses (Fig. 7-25).

Structural and Psychological Implications

A shape made up of graduated densities of points often conveys a misty, open quality, which facilitates the merging of figure and ground. The soft quality of large dot clusters can impart a mysterious, evocative mood, while producing an overall vibrating surface that unifies the composition (Fig. 7-26).

Suggested Exercises

Finger-printed head. Select from a magazine a large head with a strong light and dark value pattern. Draw this head life size in pencil on bond paper. Dipping your finger in black poster paint, print a series of large dots in the dark areas. In the middle-toned areas, apply the dots more sparsely, and leave the light areas untouched.

The same exercise may be done directly from life; the model should be lit in such a fashion that a strong pattern of lights and darks is produced. The same exercise can be carried out with the full figure.

On rough paper. Draw the model in charcoal on a large sheet of highly textured paper. Because the surface presents high and low ridges, the lines and tonal areas will appear pointillistic; that is, they will not be connected as solid areas or lines.

COLOR

As Pieces in a Puzzle

Colors must fit together as pieces in a puzzle or cogs in a wheel.

Hans Hoffman

Although it is a major element in painting, eliciting the greatest emotional impact, color plays a secondary role in drawing. Yet one can draw with colored

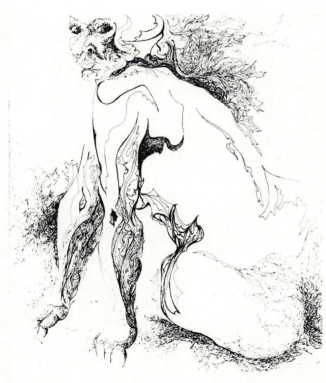

Figure 7–23.
CYNTHIA ROGERS, student.

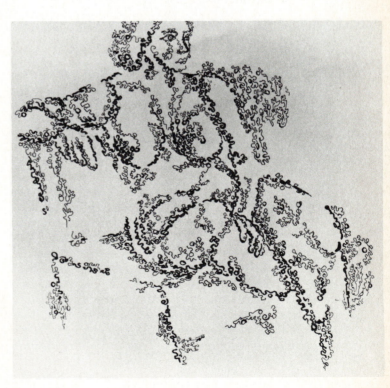

Figure 7–24.
ELIZABETH TOKAR, student.

The choice of calligraphy suggests a textural motif inspired by nature: flames, termite-eaten wood, leaves, and so on.

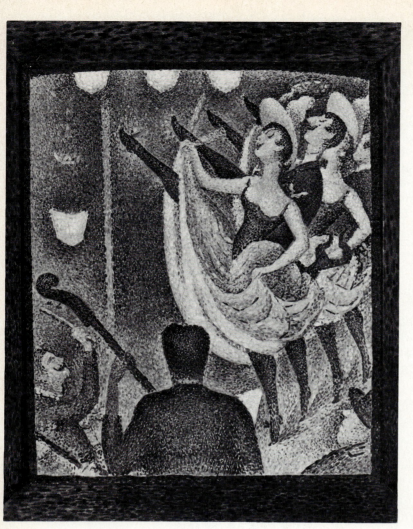

Figure 7–25.
GEORGES SEURAT (1859–1891).
Study for the Chahut.
Oil on canvas.
Albright-Knox Art Gallery, Buffalo, New York.

A shimmering screen of vibrating textures, like a dance of atomic particles, animates the painting with a sense of perpetual motion.

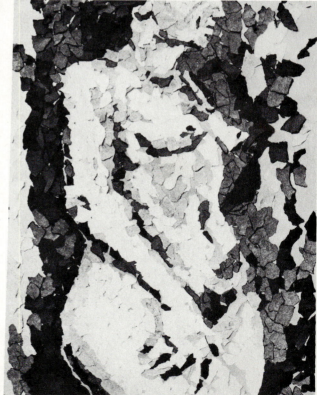

Figure 7–26.
SHARON ROSEN, student.
This mosaic, made of small chips of paper of different tones of grey, is a variation of pointilism.

inks and with colored pencils or crayons; therefore, color has a distinct place as one possible element in a drawing.

Color plays an important role in our lives: In our choice of clothes, furnishings, even foods, we are aware of the influence of colors on the emotions. The reds and yellows, or "warm" colors, are associated with the sun, with strength and light, whereas the "cool" colors, such as the blues and greens, seem to induce a peaceful mood. Although these effects can be modified by other factors, such as placement, size, intensity, and value, artists must know the optical and psychological impact of given colors in order to orchestrate them for harmonious or jarring effects.

An element of drawing, color serves as a structural force as well: The warm colors seem to advance, whereas the cool colors appear to recede. These optical properties create a push-pull tension on the picture plane and in the picture field. Areas of tension are created by color contrasts, and the resulting flow of energy initiates movement within the composition; that is, it attracts the eye along a certain path.

Color Groupings

The beginning artist tends to use too many colors in one composition. It is usually wise to limit oneself to a basic color group or combination. The student soon recognizes that colors that are opposite on the color wheel can create an exciting or even jarring effect, whereas neighboring colors or variations on one color tend to produce a tranquilizing mood. In the former, there are color contrasts; in the latter, gradual changes. Other groupings are traditionally harmonious: the triads (three colors that form an equilateral triangle on the twelve-color wheel) and the tetrads (four colors that form a square or a rectangle on the color wheel).

After investigating and experimenting with the basic color combinations, eventually the artist develops an intuitive approach. Some artists limit themselves to intense, pure colors, that is, colors taken from the color wheel without any modifica-

tion or greying. Others prefer to depart from the spectral purity of the color wheel and to modify the hue by adding black or white. The colors can also be greyed down with the addition of their complementary, that is, the color opposite on the color wheel. The materials and methods used in the color application also affect the result since for example, a color appears different when it is applied with dry brush than with a crayon or a brush.

Suggested Exercises

Monochromatic and limited color collage. Make a contour drawing of the model on an 18 × 24″ gessoed chipboard surface; strengthen the pencil line with brush and black ink. Apply overlapping pieces of tissue paper of one of the earth colors in the negative and shadow areas, leaving the light areas white. Elmer's white glue can be used to paste down the pieces of tissue paper. Other earth-colored pieces of tissue paper may be added for further enrichment.

Tinted drawings. Make an 11 × 17″ series of linear pencil drawings from the model. Use colored pencils for different parts of the drawings, including filled-in areas.

Limited color with one-color saturation. After looking at some of the works of Picasso's blue and pink periods, develop a contour drawing of the model with light areas of grey and blue or rose pastel gently rubbed into some of the surfaces. Delicately add two or three other hues, letting the initial color dominate. Keep the whole application of color very light and subtle.

Pastel: full range. With a greyish-blue pastel stick, draw the figure on pastel paper, approximately 18 × 24″. Gradually add other colors. The flesh tones should be made up of multiple colors, the cool colors dominating in the shadow areas and in the negative space. The use of background accessories, such as drapes, vase of flowers, or bowl of fruit, can be helpful in providing more colored areas as well as spatial references for the total composition.

CHAPTER EIGHT

Principles

THE RULES OF THE GAME: A VISUAL LANGUAGE

Art is often compared to a language, a visual universal language. If we go along with this notion, certain assumptions must be made. In order to use a language most effectively, it is necessary to know something of its syntax and vocabulary. Some practitioners distrust this conceptual approach and prefer a more direct and intuitive one. Indeed, many artists do have a natural inclination for the visual language and are quite eloquent with it without formal study, and there is something to be said for the totally direct approach and its faith in innate originality. A number of so-called primitives or naive artists such as Rousseau and Bombois have produced works of great charm and freshness of vision, displaying an uncanny and innate sense of composition; but too often, the outcome of such an approach is a repetitive and limited kind of visual expression. Conversely, emphasis on rules can be deadly since it may limit freedom of experimentation, which can lead to new directions in pictorial expression.

It is salutary to realize that the guidelines for visual organization have not been handed down to the artist from Mount Olympus but have been formulated, after the fact, from the analysis of the common factors that seem to contribute to the formal harmony of works considered to be our artistic patrimony. In this particular language, beginners can express themselves even as they learn.

Although almost all beliefs are undergoing revolutionary and disconcerting changes, which demand a serious reevaluation of formerly held principles, I think that we should be careful not to throw away the baby with the bath water. Rather, through personal study, experimentation, and discovery, each artist can try to cull what still seems alive and pertinent from the past and merge it with the present in an ongoing process of growth and transformation.

The inherent danger in rules, at least in artistic rules, is that they can become fossilized and that the mediocre artist and teacher will rely on them as guarantors of successful composition. The vitality of the creative spirit cannot be unconditionally shackled to rules, even to those based on the study of past masterpieces, or derived from the underlying structural principles of the physical world. Yet to study these principles and to experience them through personally felt responses is certainly quite beneficial to the art student. The concepts of relationship, movement, unity, and balance become a series of personal discoveries rather than a set of academic precepts. Some artists may find that some of the traditional principles do not serve their personal needs; in that case, they can either modify them or even replace them with solutions that better suit their esthetic expression.

In contrast to the elements, which can be easily identified and analyzed in a composition, the principles cannot really be analyzed separately: *Relationship* bears on *movement*, which bears on *balance*, which bears on unity. It is a round robin. But an arbitrary separation of terms is made in order to explain, at least in part, why certain compositions seem to "work" and why others may cause a quasi physical sensation of imbalance or chaos. Artists rarely "reason" their composition in verbal terms. Usually, they go through an apprenticeship, where through a process of trial and error, they slowly accumulate and internalize a nonverbal knowledge of the graphic combinations that are satisfying to them. They know instinctively that every part must be essential to the whole, and they develop a physical and emotional esthetic sense, which tells them when a combination of elements contributes to the most effective total form or when a single factor detracts from it. Thus, the principles mentioned here—relationship, movement, balance, and unity—are actual experiences for the artist, lived as compelling esthetic sensations; and if the artist is successful, these experiences will be relived by aware viewers, who will add their own set of reactions and interpretations, which make the esthetic experience so intensely personal.

It should be noted that the concept of composition used here does not apply to the warm-up exercises, studies of details and fragments, and graphic notations that fill the pages of an artist's notebook. These studies are invaluable to the artist and often display exquisite skill or exciting directness and vigor. It is also true that any markings on a drawing surface generate a dynamic visual interplay, but what emerges is a limited kind of composition. My use of the term entails the relating of all the forms to each other and to the whole to form a cohesive, meaningful, and pictorially satisfying configuration. This can be achieved through a totally instinctive process, and chance can play its part in a felicitous composition; but my use of *composition* implies a process that combines an understanding and channeling of the visual forces at work as well as artistic instinct.

THREE PHILOSOPHICAL ATTITUDES

The way in which we interpret the language of vision depends on the philosophical attitude we hold and the esthetic current we identify with.

According to Lester D. Longman, when considering any body of rules, three fundamental attitudes are possible. We can be *absolutists,* assuming that every artistic search must measure itself against a sacred body of esthetic rules. For the absolutist, the adherence to the rules fosters a body of work that continues the best of the past and concerns itself with essence, permanence, and stability. Although such a rigid position may carry within it the seeds of petrification, some artists have chosen to function within the confines of accepted rules, and they have had the strength to bring forth authentically original works despite the constraints—a little like the poet who chooses the challenge of one of the most difficult and restrictive traditional poetic patterns, the sonnet, to create a poem of soaring beauty.

The opposite of the absolutist is the *iconoclast,* who claims that all the traditional rules have lost their significance and that any set of artistic rules is inimical to the development of a new esthetic expression. The iconoclast rejects all canons in the belief that total artistic freedom is an essential condition for creativity and originality. In fact, although there are many art works that represent a conscious break with the classical Western tradition, examination often reveals that they have retained a few nonobvious factors of traditional composition or a connection with an art tradition outside the mainstream of classical Western art.

The *relativist* accepts the new and the experimental and welcomes its coexistence with the classical. In fact, relativists believe that the new can revitalize the traditional values; and they are willing to examine, modify, reinterpret, and incorporate those principles of visual organization that seem valid, while occasionally eliminating those that they cannot use in their chosen mode of expression. In the main, they work selectively within the broad principles that run through the art legacy they have inherited; but the tradition to which they claim kinship transcends Western art, including arts and traditions of other cultures as well. It is probably obvious that the relativist position is the one with which I feel most comfortable.

INTERRELATIONSHIP

One of the key principles of composition is interrelationship, that is, the influence of the optical units on each other and with the total composition. I cannot stress enough that the artist cannot count on a given line, value, color, texture,

or shape as having an absolute and independent characteristic, for the moment an element is put down, it interacts with the other elements. In fact, the dynamic interrelatedness is such that when one is modified, all the others are affected to some degree, and a series of subtle changes take place: A line appears longer, shorter, lighter, or bolder than it did before; a shape seems more defined or more amorphous; a tone appears darker; and so on. These interactions and transformations go on with each addition to or modification of the composition, until the artist deems the work finished—that is, when all the parts are orchestrated to his or her emotional and esthetic satisfaction.

Since artists cannot foretell the end result when they start a composition, anything put down is on a tentative, trial-and-error basis. With time, many artists develop a sense of what is needed to fulfill their particular esthetic requirement of the moment, and they can achieve it instinctively or with a minimum of intellectual analysis.

WORKING SIMULTANEOUSLY

If we accept the premise that a pictorial composition is the end result of the dynamic interrelationship of all its components, we accept as a corollary that an effective way to compose a picture is to work on the whole simultaneously, so that adjustments may be readily made and so that the configuration emerges more organically. This is not to say that the one-at-a-time approach is categorically incompatible with a harmonious whole per se. The choice of approaches is always a matter of timing and artistic need. The artist who has had varied drawing experiences and who has attained great skill in coordinating eye and hand may find the one-at-a-time approach preferable and quite rewarding. But many beginners will avoid the pitfall of disproportionate compositions by working simultaneously on different areas, coordinating and integrating the parts in relation to a greater ensemble.

MAN IS THE MEASURE

As Gyorgy Kepes states, it is logical that human beings begin with themselves as the basis of measure in their surroundings, judging verticality and horizontality, right and left, up and down, and advance and recession in relation to their own body. When artists draw, the image they depict is

predicated on their own sense of gravity, and therefore the base of the image is deemed heavier than the top and is perceived as being closer to the observer than the other parts of the configuration (Fig. 8-1).

Figure 8–1.

Diagram: Man is the measure.

When observing our surroundings or looking at a work of art, we begin with ourselves as primary references: up and down, horizontal and vertical, advance and recede—all these assessments are based on our own upright position and our almost inescapable relationship to gravity.

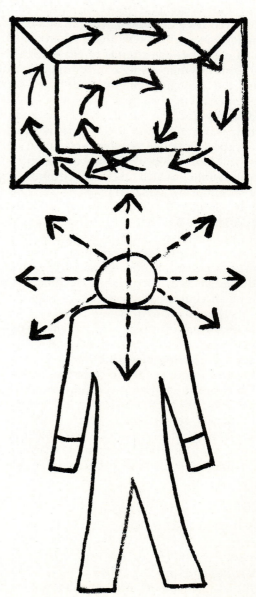

The picture surface or *picture plane*, with its customary horizontal and vertical borders as the limits of the graphic depiction, constitutes the primary frame of reference for the artist. As soon as a point, line, or shape is drawn on that surface, it imparts a sense of space within the picture plane, creating a shallow, boxlike spatial effect behind the picture plane, which we call the *picture field*. All the elements placed in that field will seem to advance or recede in relationship to each other, in the illusion of space that exists behind the surface.

THE FORMAT

The Format

Composition, the aim of which is expression, alters itself according to the surface to be covered. If I take a sheet of paper of given dimensions, I will jot down a drawing which will have a necessary relation to its format. I would not repeat this drawing on another sheet of different dimensions, for instance on a rectangular sheet, if the first one happened to be square.

Henri Matisse

The format of the picture plane may vary in size, proportions, or even shape; it can be long and narrow like a scroll, or it may be a square, an oval, a circle, a triangle, or even a free form (Figs. 8-2 and 8-3). The most common shape, however, is the rectangle. In every case, and whatever the format, the artist needs to be sensitive to its shape and the relation of the composition to it. Besides the outer edges of the picture plane, there is also

Figure 8–2.
Three diagrams based on the works of Raphael, Ingres, and Orozco illustrate different formats and how each artist solved compositional problems inherent to these formats.

Figure 8–3.
PAUL FUSARO, student.
Several views of one model, seen from a number of vantage points and distances, are executed in simple contour against a plain black background; they are grouped as a composition within a long, horizontal format.

the hidden optical center, which lies just above the geometric center that marks the intersection of the hidden vertical and horizontal axes.

One of the ways to create balance between the figure and the space around it is to anchor the figure to at least three sides of the picture plane: bottom, top, and side. By having the major shape touch the edges, the artist induces a sense of visual immediacy and balance within the format, while creating tension areas throughout the picture plane, energizing most of the positive space (Fig. 8-4).

Figure 8–4.
Diagrams.

Three compositional analyses, based on paintings by Kuhn, Corot, and Matisse, show how in these paintings the artists anchored the figure to three sides of the frame, thus filling the format fully. This device is particularly helpful to beginning artists, whose works tend to be too small in relation to the format.

Of course, the three-sided contact is not the only way to create balance between figure and field, but it may be one of the most easily understood for the beginner; and it counters the novice's tendency to draw a figure too small for the format. Again, nothing being absolute, a small figure seen in a large empty space may be a very effective way to express a mood of loneliness or isolation; however, it should be a desired effect, and that is not the same thing as drawing too small and without understanding the relation of the configuration to the format.

Self-Contained or Open Format

Emphasizing the Essential

In a picture every part will be visible and will play the role conferred upon it, be it principal or secondary. All that is not useful in a picture is detrimental. A work of art must be harmonious in its entirety; for superfluous details would, in the mind of the beholder, encroach upon the essential elements.

Henri Matisse

Many artists adhere strictly to the self-contained format, wherein every part is so related and dependent on the other parts that to add or subtract anything after completion destroys the whole, as in an exquisitely balanced construction of playing cards. Such a composition is based on a strong closed-movement path, where every part plays a supportive role in leading the eye back or close to its original starting point.

But there are other artists who have purposefully chosen to work within a looser, more open format: The graphic statement seems to spill beyond the edges, merging with the space and life around it, without a beginning or an end (Fig. 8-5).

Cropping: Fitting the Format to the Configuration

Usually the artist works within the format, fitting the configuration to it; however, some artists prefer to work like the photographer, cropping the picture to the chosen format. When working in this manner, artists often make a number of drawings or studies on the same page, one overlapping the other. Then, with a viewfinder, they may choose what they feel to be an interesting portion of the overlapped drawings and crop that portion. In this case, the artists fit the format to the configuration they have chosen, instead of fitting the configuration to the format. In either case, the format is an intrinsic consideration in the composition.

Figure 8–5.
HENRI DE TOULOUSE-LAUTREC (1864–1901).
Moulin Rouge (1892).
Oil on canvas, 48⅜×55".
Art Institute of Chicago. Helen Birch Bartlett Memorial Collection.

The composition follows an open format. It is built on a strong diagonal thrust starting at the right of the center point of the lower edge and turning inward, leading to the central grouping. The standing female figure on the right brings the observer's eye down to the large, frontal, partially cut figure at the right, which, by its dramatic cropping leads the eye outward, implying the movement and life that continue beyond the borders of the painting. You may notice that the artist has included himself and his tall cousin in the background.

Suggested Exercises

One part at a time. Draw from the model in pen or pencil in the contour technique, starting at the top and working down, carefully completing one section at a time—the head, torso, one arm, and so on—finishing with the legs. This is the way most beginners approach figure drawing at first. Unless the beginner has an innate sense of proportions, the danger of error in size relationships is soon evident.

Simultaneity. In contrast to the preceding exercise, draw from the model, still using the linear approach, but work simultaneously over the whole composition: Start in the middle and work up, down, left, right, without completing any given section before moving on to another, continuing until the configuration is complete. This method tends to make the participant more aware of the relationships of size and shape.

Formats. Select three quadrilateral formats: a long, narrow rectangle emphasizing verticality; a shorter horizontal one; and a square. Draw the figure from the model within these parameters in such a manner that it fits the format: The very pose

of the model may be set so that it lends itself to the selected format. If possible, see that the configuration touches at least three edges of the picture plane.

Draw several figures from the model in ink or pencil on 12 × 18″ bond paper. The drawings should be close to each other, with some overlapping. Using a temporary adjustable frame made with four strips of thin cardboard, select a part of your drawing page that appears to have the most satisfying relationship of figures to ground. Crop this area and paste it onto another paper, leaving small borders around it as a frame.

MOVEMENT

Design and Life

It is in rhythm that design and life meet.
Philip Rawson

A Prepared Path

The beholder's eye, which moves like an animal grazing, follows paths prepared for it in the picture.
Paul Klee

Movement is life. All matter consists of energy in movement. Our lives are bound by cycles of various rhythms, major and minor: the seasons, the ebb and flow of the tides, the growth of each living organism. Athletes and dancers are particularly aware of the importance of finding the right stride or rhythm; and even everyday, mundane physical work is done more efficiently when it is coordinated with a given rhythm. Tunes for aerobic exercises and marching music are examples of rhythms found to coordinate group or individual physical tasks or body movements.

Rhythmic Movement

In art, too, movement is an essential component. In fact, ancient Chinese artists considered rhythmic vitality the main principle of a composition, rather than imitation of nature.

The visual forces that constitute a composition pulsate along major visual pathways, which have been created by the placement of the elements and their relationships to one another. The pathways guide the eye of the viewers, retaining them here, redirecting them there, from one tension cluster to another. This directed eye path is referred to as *implied movement*, and its specific rhythm is the pace set by the repeated pattern of accents and pauses. The rhythm can be simple or quite complex, smoothly flowing or frenetic, but it always consists of a series of visual accents, variations, and pauses (Fig. 8-6).

Fig. 8–6a

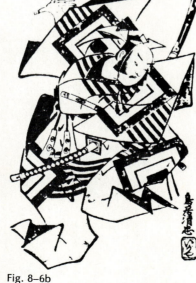

Fig. 8–6b

Figure 8–6a.
TORI KIYONOBU (1764–1729).
Woman Dancer.
Metropolitan Museum of Art, New York. Harris Brisbane Fund.

Figure 8–6b.
TORII KIYOTADA.
Actor Dancing (1949).
Metropolitan Museum of Art, New York. Harris Brisbane Fund.

These two woodcuts illustrate the role that rhythm or directional movement plays in conveying contrasting moods: In depicting the actor dancing, the artist used opposing diagonals, suggesting a dynamic and fierce set of movements verging on violence, whereas the drawing of the female dancer, with its gently flowing, curved lines, suggests harmony, restraint, and delicacy.

The Traditional Visual Circuit

The traditional visual circuit is usually initiated somewhere along the base of the picture, and it moves upward and inward either along the left or right side of the composition. When the point of deepest penetration is reached, the path begins to move across the picture until the other side is reached, at which point the eye is directed downward toward the focal area, where it comes momentarily to rest, and then continues in the direction of the starting point, the whole movement forming a kind of spatial spiral (Fig. 8-7).

Figure 8–7.
Diagram of the traditional visual circuit.

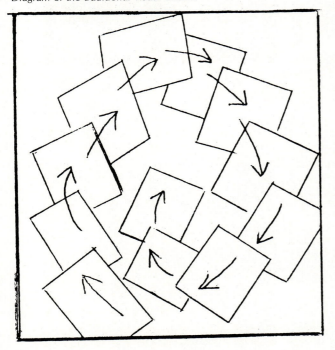

This simplified explanation of the eye path is based on Sheldon Cheney's generalizations and is not at all meant to suggest that most compositions follow categorically this specific movement. Rather it is meant to suggest that many compositions, especially in the past, developed dominant and subordinate movements that held the composition in an enclosed configuration.

Although many works exhibit this kind of spiraling movement around a focal point, other compositions are quite effective without it. They follow a structural logic that fits the particular concept of the artist; for instance, some arrange on one surface what appears to be separately enclosed compositions of various formats. The esthetic and psychological relation of the individual frames, the relatedness of tone, mood, style, and concept, makes it work. Yet another variation is the vertical or horizontal serpentine movement across the otherwise blank page.

Movement Schemes

There are special series of movement schemes that are determined by the direction of the lines in a picture. These lines interweave, forming a pattern of movement that is characterized by its relative flatness, compression, and fragmentation, which readily lends itself to the abstraction of the human form. (See Chapter Twenty.) These movement schemes follow a number of basic patterns (Figs. 8-8, 8-9, and 8-10).

Opposing diagonals. These are lines crossing through each other at different angles. This type of configuration tends to generate a feeling of excitement.

Intersecting curvilinears. These are curving lines that interpenetrate, creating curving shapes of varying sizes. When the curves are large, they generally elicit a tranquil feeling, but when they are made up of small curves, the feeling is more likely to be nervous or exciting.

Vertical and horizontal interweaving. The interweaving of vertical and horizontal lines forms rectangular shapes of varying sizes. This configuration tends to create a feeling of strength and security.

Dominant verticals and minor horizontals. The deployment of a series of vertical lines with short horizontal breaks irregularly spaced is sometimes associated with uplift.

Since we all respond somewhat differently, we should view these schemes as a guide only.

Suggested Exercises

Overlapping shapes. One of the most common means of suggesting implied movement is through the use of partially overlapping shapes. In the Renaissance, diminishing size through linear perspective was used to suggest movement through space, that is, into the picture field; but contemporary artists are less likely to use this device, except

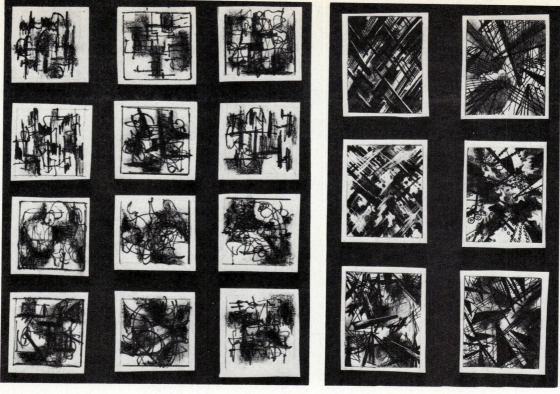

Figure 8–8.
ELIZABETH TOKAR, student.

Figure 8–9.
ELIZABETH TOKAR, student.

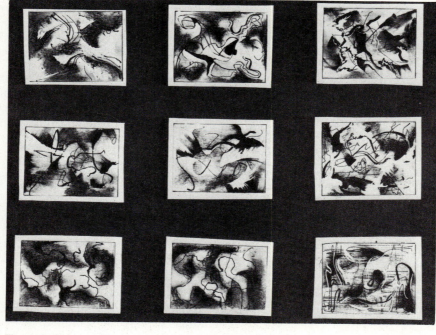

Figure 8–10.
CYNTHIA ROGERS, student.

Nonobjective improvizations based on movement schemes are occasionally used as a basis for figure compositions: The figures are "discovered" in the composition and are "assisted" without losing the basic movement pattern; sometimes figures drawn from life are incorporated into a preexisting movement pattern and meshed with it.

130

in an exaggerated manner, as in some surrealistic works (Fig. 19-1). Many artists prefer to work within a shallow space, in a desire to respect the integrity of the picture plane.

Movement with planes. Using pen and ink on a sheet of 8 × 10″ watercolor paper, draw a multifigure composition in pencil, reducing the shapes to flattened overlapping planes. Go over the pencil drawing in ink and dramatize the edges by partially toning them with dots or crosshatch. Be conscious of the eye path you are creating by the placement of the shapes in relation to one another, and try to establish the most effective enclosure.

Movement with volumes. On an 8 × 10″ sheet of charcoal paper, draw a multifigure composition in charcoal. Reduce the figures to volumes that overlap. The overlapping of three-dimensional shapes should suggest movement around a focal point in the picture field and back to the picture plane. Model the forms with charcoal tones. Use volumetric overlapping shapes as background props for consistency.

TENSION AND EQUILIBRIUM

The equilibrium we refer to is the dynamic state of equalizing the relative weight or mutual attraction of the various opposing visual forces in the composition.

Here again, we start with the picture plane: its optical center of gravity (which lies somewhat above the geometric center), the four edges of the drawing surface, and the implied picture field. It is within these parameters that the sense of equilibrium is determined.

Tension

Each element radiates a certain amount of energy and creates a field of force; the degree of energy released depends on many factors, such as size, shape, texture, and color. When there is a conjunction of these fields of force, such as a cluster of crisscrossing lines or colors, the energy field is expanded and intensified. Thrust is met with counterthrust, force with force, push with pull, and so on, so that the last element set down resolves the tension in an ultimate delicate equilibrium. A strong tension may also be created by tipping the axis of the main part of the configuration (Figs. 8-11 and 8-12).

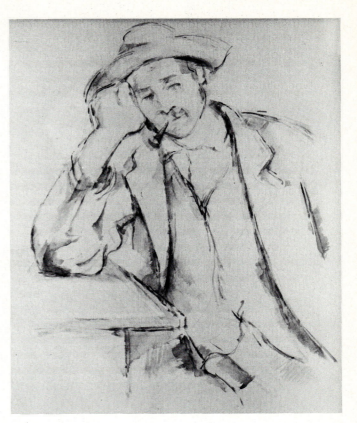

Figure 8–11.
PAUL CÉZANNE (1839–1906).
The Smoker.
Barnes Foundation, Merion, Pennsylvania. © *The Barnes Foundation.*

Figure 8–12.
Diagrams showing tension.
Fields of force are established between shapes depending on their relative sizes, location, color, and texture.

The areas or clusters of concentrated energy are experienced by sensitive viewers as body tensions, to which they react organically and psychologically, empathizing with the energy released by the visual relationships.

Although viewers may be less aware of their empathy with the sheer movement and equilibrium of the composition than with overt pictorial communication, their response is subliminally influenced by involvement in the architectonics of the composition.

Sensitive Areas: Hot Spots

A Play of Energies

Each energy calls for its complementary energy to achieve self-contained stability based on the play of energies.

Paul Klee

The inexperienced artist views the drawing or painting surface as a neutral ground, where one area equals another area until a marking is made on it. But all points on the surface are not equivalent, and the sensitive draftsman knows that the potential for visual energy is greater in some areas than in others: The surface hides potential hot spots, as it were. For example, the areas surrounding the optical center, the base, the right-hand side, and the corners attract the eye, so that a marking in these areas delivers extra impact. We usually build and "read" a picture in a manner coherent with our consciousness of being weighed by gravity; that is why, perhaps, we seem to favor anchoring the configuration, explicitly or implicitly, to the base. Such built-in habits are the reason why a shape that is cut off at the edge of the picture plane attracts more attention than if it were placed in another part of the picture. Some artists avoid filling the corners with shapes in the belief that corners act as arrows, leading the eye out of the picture plane. Through experience, artists develop a sense of these hot spots and use their potential for intensification as needed for their graphic composition.

Types of Balance

Symmetrical balance can be achieved almost mechanically by repeating the same shape or a very similar one on both sides of an imaginary axial line, which divides the picture plane horizontally, vertically, or diagonally into halves, or by radiating the same shapes from a central point (Fig. 8-13).

Figure 8–13.
ROBERT HANSEN.
Man-Men Galaxy 1966.
Courtesy Long Beach Museum of Art, California.
Radial balance through the placement of silhouettes in a circle.

Asymmetrical balance implies a subtler kind of balance, wherein the equilibrium is achieved through the equalization of dissimilar visual forces in various parts of the picture plane or picture field. The principle behind this balance is a sense of relative weight of the visual elements; for example, a small but intense color spot can balance a large neutral area, or a thick, short, dark line can offset a longer, thinner one, depending on their relative placement. This applies to all the elements and their combinations.

A particularly effective but undefinable asymmetrical balance is that found in many ancient Chinese and Japanese paintings, where far greater emphasis is given to the empty spaces than to the figures, which may occupy a very small part of the total configuration. It seems that what is called negative space in the Western tradition, is the main field of energy, reversing the occidental pattern. Yet these asymmetrical and seemingly unbalanced compositions, by traditional Western standards, convey a fully satisfying sense of completeness and exquisite equilibrium.

Value balance. Among the various ways of creating equilibrium, the utilization of basic divisions of lights and darks offers interesting possibilities. This is accomplished by the division of the picture plane into unequal areas of lights and darks—

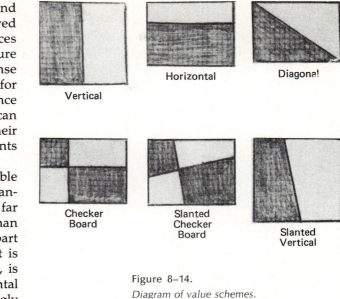

Vertical　　Horizontal　　Diagonal

Checker Board　　Slanted Checker Board　　Slanted Vertical

Figure 8–14.
Diagram of value schemes.

either horizontally, vertically, or diagonally—with some lights entering the dark area and some darks entering the light area (Fig. 8-14).

A variation of the value balance scheme is the division of the picture plane into four areas, forming two light areas and two dark areas

Figure 8–15.
Follower of Caravaggio.
Study.

Pen and brown ink.
The Fine Arts Museums of San Francisco; The Achenbach Foundation for the Graphic Arts.

The value pattern of this study is particularly intriguing; it divides the composition into two main areas: a light side and a dark side. Strategically placed white areas were left in the dark side and suggest the illuminated side of the figures, whereas the dark areas within the light side indicate the shadows on the figures. There are no middle tones. The forms are boldly suggested with a broad brush and a few nervous, cursory lines. The interlocking pattern of lights and darks is exquisitely balanced yet exudes a quality of vitality and spontaneity.

touching corners, in a loose version of a simplified checkerboard pattern. The tonal areas should be of varying sizes, and the divisions provide a more interesting breakup of the surface if they do not follow neat horizontal and vertical lines. The divisions can even be slightly tipped, and they are particularly effective when they are subtly achieved with minimal hard-edged definition and with mergings of shapes and space in the value scheme. A number of Rembrandt's studies illustrate the masterful use of value balance (Figs. 8-15 to 8-20).

Figure 8–16.
REMBRANDT VAN RIJN (1606–1669).
St Paul.
Red chalk, India ink wash.
Louvre, Paris.

Rembrandt's composition is built on a loose diagonal, which divides it into a light and a dark side, with a few darks entering the light area. The drawing is executed very freely, with multiple, fluid lines, which give life to the figure and do not freeze it in time.

Figure 8–17.
ARSHILE GORKY (1905–1948).
Self-Portrait (c. 1937).
Estate of Arshile Gorky.

The composition, carried out in large, simplified planes over a checkerboard value scheme of two light areas and two dark areas, is particularly effective, and its very simplicity is beguiling, as it serves an intensely probing portrait.

Figure 8–18.
MAURICIO LASANSKY.
Firebird.
Intaglio.
Courtesy of the artist.

*A subtly architectonic composition
broadly based on the contrast
between two light areas and two dark
areas forming a loose checkerboard,
with some darks flowing into the
light areas and some lights flowing
into the dark areas, without impairing
the carefully constructed tonal
framework. The subject matter,
which emerges and disappears in
dreamlike imagery, blends
particularly well with the alternate
lights and darks.*

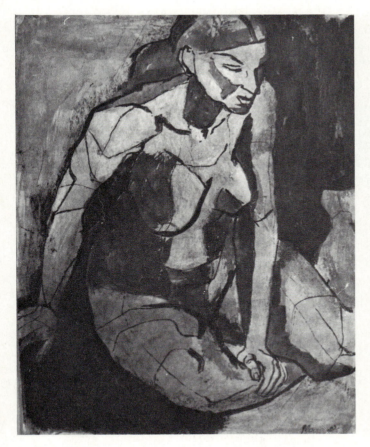

Figure 8–19.
Student drawing.

Figure 8–20.
Student drawing.

The distribution of tonal values follows the checkerboard pattern of two light and two dark areas in opposite corners; within the figures, there is an interweave of darks and lights, with a predominance of darks on the left side of the composition, to avoid an overall and boring sameness.

Imbalance. Imbalance is probably the most frequent compositional pitfall for the beginner. For example, it can occur when the composition is top-heavy and runs counter to the pull of gravity, which is a physical and psychological tenet of our lives; it may be caused by the projection of forms that seems to violate the picture plane; it can also occur when the beginner creates too deep an illusion of space in a single area of the picture, making a kind of "hole" in the picture plane.

Making New Rules

Yet a number of artists, especially contemporary artists, have deliberately and successfully discarded the principle of balance in composition; to these artists, the unbalanced or precariously balanced configuration carries a special kind of exquisite tension, a kind of physical and emotional disruptive factor that has greater esthetic and affective impact than the relative equilibrium of a more classical composition. They may build a composition purposefully top-heavy, bottom-heavy, or lop-sided; they may create "holes" of deep space that do not respect the picture plane; they may defy the so-called laws of gravity and color harmony. In fact, it may be safely said that every principle of composition has been successfully bypassed or contradicted by many original and creative artists. As always, it is a matter of skill and intuition: In the hands of some artists, the lack of visual balance may invalidate the total configuration, whereas the skillful and experienced artist may create a new kind of balance that runs counter to all traditional tenets (Fig. 8-21).

By and large, the need for balance in a composition is something felt by both the artist and the viewer, and the artist usually devises the structural scheme that will enhance his or her esthetic purpose best. True, there is such a thing as mechanically insured optical balance, but it is rarely used, most artists opting for a kind of occult equilibrium that is derived from a sensitivity to the relationship of the elements to one another. The factors favoring such an equilibrium may be analyzed after the fact, but most often the balance is achieved intuitively, through a process of juggling and making modifications until the artist has reached the point after which nothing should be added or subtracted.

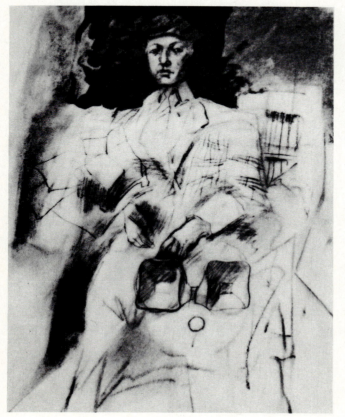

Figure 8–21.
WILLIAM BRICE.
Man with Cap IV (1956).
Charcoal and ink.
Collection of Mr. and Mrs. James E. Pollak.

This drawing demonstrates how successfully a skillful and sensitive artist can contradict the theories and canons of traditional composition and create an expressive drawing. Here, the visual emphasis is placed on the upper part of the picture plane, and the lower part is left light and very sketchy. Traditionalists might call it top-heavy and lacking in stylistic unity. Yet the composition works, and the size of the light bottom area, along with the spots of middle tones, counterbalance the small, dark shape of the upper part of the composition.

Suggested Exercises

Symmetrical composition. Draw a figure or grouping from life in line or in mass, using symmetry as the balance factor; the shape and spaces will be evenly weighed against each other and in relation to a central axial line. Use pen and ink on 9 × 12″ bond paper.

Radial balance. Look at a photograph of the figure through a kaleidoscope that reflects at least three repeats of the image from a central point. Draw from this configuration first in pencil and then in ink.

Value balance. Using 9 × 12″ bond paper, divide the page vertically into two unequal parts. The large side will be predominantly dark, and the smaller side will be predominantly light, or vice versa. In charcoal, superimpose a drawing of a single figure or figure grouping, straddling the light and dark sides. In the dark areas, create some lights by erasing, and in the light areas, introduce some darks. The figure or figures should be basically realistic, seen partly in light and partly in shadow, with mergings of figure and ground.

Adapt the preceding exercise, using a diagonal or a horizontal division. In either case, the edge of the division should be kept blurry, and the transitions from light to dark along its implied edge should be kept soft.

Using a modified simple checkerboard value scheme of two light and two dark areas touching at corners, draw a multifigure composition in charcoal on top of the value division. Again, keep the value transitions fluid while adhering to the basic, predetermined tonal scheme.

UNITY AND SYNTHESIS

Unity is the resolution of the paradox of opposing visual forces. It implies a sense of wholeness and oneness within the composition, with each part essential and acting in unison with the other parts. There are a number of unifying factors with which the student should become acquainted: consistency of concept, style and technique, proximity, continuance, closure, dominance, subordination, and similarity and contrast. A knowledge of these factors can be of some help in achieving a sense of unity but does not necessarily guarantee it, of course. It should be realized that unity, along with relationship, movement, and equilibrium, must be a part of the total fabric of the composition from the start. Once one learns these fundamental concepts, the approach to unity is best applied intuitively.

Simplification

By isolating unrelated floating forms on the picture plane, or by overloading the composition with too many shapes of diverse qualities, the beginner may fragment the composition instead of unifying it. Sometimes these isolated and fragmented shapes can be balanced by the use of a close value key throughout the composition or by depicting the shapes in soft focus with undefined edges, thus reducing the details and blurring the boundaries between the shapes.

Proximity

The Law of Proximity

Optical units close to each other on a picture plane tend to be seen together and, consequently, one can stabilize them in coherent figures.

Gyorgy Kepes

The factor of proximity makes use of the fact that shapes, even dissimilar ones, exert a pull on one another and tend to be seen as a larger visual unit. Shapes are perceived as being related and part of a larger unit when they touch at an edge or meet at a corner. They can also overlap or interpenetrate, thus forming larger integrated configurations.

Visual Momentum: Continuance

Even after a line is terminated, its visual momentum sets up a directional continuity or force in the mind's eye of the viewer, which prolongs the line beyond its physical terminal point. For this reason, we tend to continue the rhythm of a visual repeat motif after it has stopped. This is evident in Orozco's *Zapatistas,* where the diagonal repetitive directional movement of the figures suggests an extension into space and time (Fig. 8-22).

The Hidden Connection: Closure

Closure is the mental completion of an implied or suggested configuration made up of scattered visual fragments. It is possible because of the factor of continuance. The tendency of making a configuration from fragments can be handily utilized in binding the disparate parts of a picture into a cohesive whole (Figs. 8-23 and 8-24).

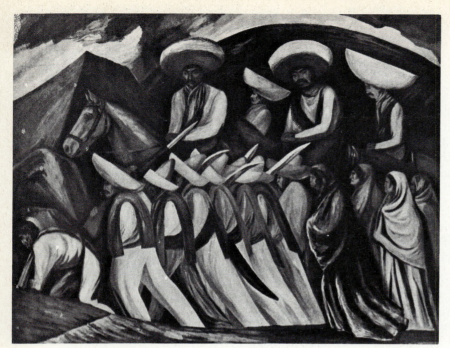

Figure 8–22.
JOSÉ CLEMENTE OROZCO (1883–1949).
Zapatistas (1931).
Oil.
Museum of Modern Art, New York City.

The rhythmical repetition of the diagonal motif for the figures in the foreground imparts a sense of energy and movement to the composition and seems to carry this sense of movement beyond the edge of the canvas.

Figure 8–23.
LEONARD BASKIN.
Boyhood of Guercino (1967).
Courtesy of the artist.

The viewer's eye completes the configuration, which emerges through a few delicate linear notations—enough to impose an intense poetic presence to the image.

Figure 8–24.
YUKO ITO, student.

The figure is stated through the dynamic interplay of strategically placed visual clues and blank spaces. The viewer completes the image through the visual and mental process of closure.

138

Dominance and Subordination

When we state that in a unified composition each part must be essential and act in concert with the other parts, it does not mean that every element is given equal importance; equal care, yes, but not equal weight.

As in a play, there are major roles and supporting roles, and as in a well-constructed play, every part, even the minor ones, should be indispensable to the esthetic and expressive significance of the whole. The shapes that assume the major roles are often placed strategically off-center or near an edge; these focal areas can be given further emphasis through size, value, texture, or color, whereas the supporting shapes or spaces help guide the viewer's eye to the focal clusters and contribute to the intelligibility and harmony of the total configuration.

Similarity and Contrast

Visual forces may be similar or contrasting. Shapes that are similar or alike in configuration, size, value, color, texture, or direction are more easily unified than dissimilar shapes. However, they may result in a dull and uninteresting composition.

Although contrasting visual forces are more exciting, they are also more complex and more difficult to unify. Some means must be found to bind them together into a composition: the repetition of a given motif in various parts of the picture, the use of transparent interpenetration, the simplification of the tonal value scheme, or the saturation of the color scheme with one dominant or pervasive color. These are some of the ways, but certainly not all, the artist may unify contrasting elements.

Concern for unity should not lead to blandness and monotony. To be alive and memorable, the composition needs contrasts; these contrasts may be strong or discrete, as the artist chooses. Variety in itself can foster interest and excitement, whereas the principle of similarity tends to unify. However, contrast and variety without a gathering of the visual forces into a unified whole lead to a dispersal and weakening of visual energy; on the other hand, overreliance on similarity may result in visual monotony and lack of dramatic impact. Visual unity, then, emerges from a delicate balance between the freshness and surprise brought about by contrast, combined with the subtle or even subliminal visual recall brought about by similarity and repetition.

Unity: Strict or Loose

Some of the factors considered in format and movement resurface when we address the principle of unity. There are two basic types of unity: strict and loose. Strict unity is predicated on the subordination of all the elements of the composition to the main movement and their convergence to a major focal area. This is often achieved through a merging of shapes into one major form, which may include the fusion of figures and field. Definition and detail are less important than the total organic and cohesive form. With its grand sweeping movement to which all shapes are subordinated, strict unity is usually associated with nonclassical, baroque composition.

Loose unity, however, relies more on strategically placed islands of shapes that are connected to each other through the harmonious relationships of elements rather than through a flowing unifying movement. Defined edges usually characterize the shapes in a composition based on loose unity. Leonard Baskin's *Frightened Boy and His Dog* (Fig. 8-25) is an example. Because its pictorial significance is not the product of a single cohesive movement, the borders of the picture plane are not as critical as they are when strict unity is the main compositional factor. Loose unity also allows a composition to be conceived as a triptych, for example, where each panel is readable and significant in itself yet relates to the other two for the total composition and impact (Fig. 8-26). These three examples should point out that the notion of unity does not follow a single canon but offers enough latitude to be a factor in both the classical and the nonclassical concepts of composition.

Suggested Exercises

Similarity. Draw a figure from the posed model, consciously organizing the composition on the principle of similarity: use of recurring basic shapes and spaces, quality of the line, recurring values and areas of texture, and directional devices. Use pen and ink on all-purpose watercolor paper.

Contrast. Draw the figure, using a number of contrasting elements: strong contrasts in shapes, values, textures, and directions. In order to keep cohesiveness within the variety, allow some of the contrasting shapes to touch or interpenetrate, so that they may be perceived as forming larger

Figure 8–25.
LEONARD BASKIN.
Frightened Boy and His Dog.
Woodcut.
Courtesy of the artist.

A loosely held composition consisting of three isolated images on a common blank ground, it is held together by a common technique and by the fact that the three shapes are so placed that they form an implied rectangle within the slightly larger picture frame. The posterlike simplicity of the image captures the viewer's attention and conveys a pervading mood of fear and isolation in a most direct manner.

Figure 8–26.
MAX BECKMAN (1884–1950).
Departure.
Triptych.
Museum of Modern Art, New York.

In a triptych, each panel is an esthetic entity while forming a larger, loosely unified whole with the other two. In this case, all three panels are obviously closely related in style. The middle panel, however, is different in composition and mood from the other two in that its compositional scheme is less turbulent and allows for quiet open areas and a suggestion of air and space. The side panels, built on a tight, compact compositional scheme that brings the figures close to the picture plane—and therefore to the viewer—project a mood of concentrated violence and impotent victimization.

140

encompassing visual units. A careful, nonsymmetrical distribution of some recurring visual *leitmotivs*—or variations of shapes—throughout the composition also helps to unify the contrasting elements.

Focal point. Draw from the model, selecting a focal point on the figure and keeping your eyes trained on that given point as you relate the rest of the figure to it. Use pencil on bond paper.

Strict unity. Draw a figure composition from life, preferably from more than one model, in which you are consciously subordinating all the directional forces and all the elements to one main movement scheme centered on a strong focus. Use pencil or ink on bond paper.

Loose unity. Using the same or a similar pose as in the previous exercise, draw a figure composition based on loose unity. Part of a figure may be cut off by the frame, but the primary movement within the composition should be compelling enough to hold the visual forces in check and avoid dispersal of visual energy.

CHAPTER NINE

Multifigure Composition:
From One to Many

Although some exercises presented in the preceding chapters have dealt with more than one figure in a given composition, the emphasis has been on drawing the single figure. All the considerations the artist faces in the single figure drawing are present in the multiple-figure composition—only more so. The addition of one figure or more heightens the artist's awareness of the essential compositional concerns: the relation of figure to figure and figure to ground, the spatial definition, and the overall visual rhythm and movement path. The creation of an effective movement path, so important for any visual composition, is particularly critical to the multifigure configuration, and for beginners, it is probably wise to avoid drawing isolated figures; rather, they should allow the figures to slightly overlap, thus binding them automatically to one another and creating a continuous path flowing from one form to the next while providing a way to define spatial relationships. As their sense of composition becomes increasingly internalized and quasi visceral, the beginners may attempt less "safe" compositional schemes. As in the single-figure drawing, a harmonious composition results from the total integration of perception, concept, expression, original realization, and technical skill.

Under the ordinary conditions prevailing in the average studio, the participants draw from one model only per session. Even so, this does not limit them to single-figure compositions, and a number of strategies are possible to make multifigure compositions from a single model.

THE DIRECT APPROACH

With their quick or extended studies from different poses or views from the model, artists may improvise groupings of their drawings on the page. If they intend to use this strategy for a multifigure composition, it may be helpful to ask the model to give a preview of the three to five poses that will be assumed during the session. Thus the artists have a preliminary idea of the relation of the poses to each other; this advance knowledge will help them make a quick decision on the placement of the individual figures on the page (Figs. 9-1 through 9-4).

When artists work alone on a one-to-one basis with the model, they may have previously prepared a few tentative groupings from imagination (Fig. 9-5). They then choose the grouping that seems compositionally most promising; and after blocking in the figures sketchily on the working surface, they ask the model to assume the corresponding poses, which they then draw in turn

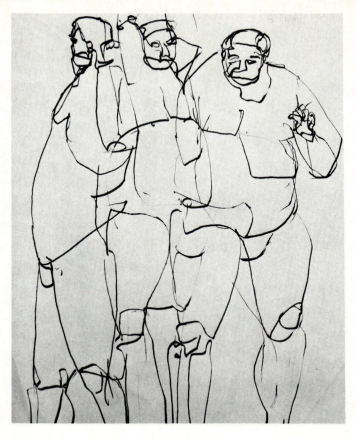

Figure 9–1.
NAOMI ERNST, student.
Ten-minute contour study.
These three enmeshed figures were drawn from one
model while the model stand was rotated every few
minutes; the drawing was executed without looking at
the paper and without pausing to separate one figure
from the other.

Figure 9–2.
PATRICIA TREMBLAY, student.
Pastel.
In this soft-toned, soft-focused drawing, the two figures
are depicted in such a manner that they can also be read
as one wider, flattened, and stretched-out single figure
or as the combined views of a figure in movement.

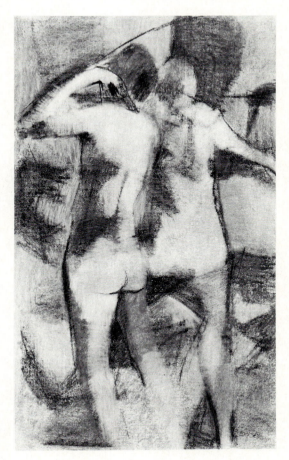

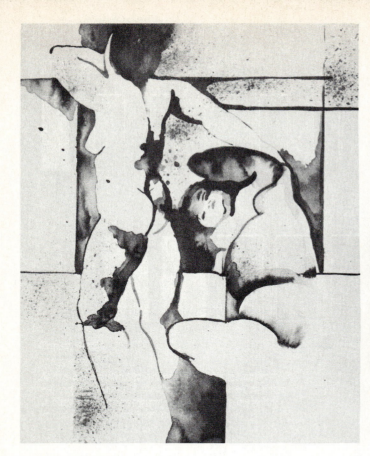

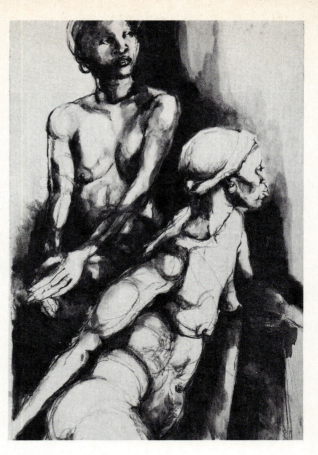

Figure 9–3.
ELIZABETH TOKAR, student.
Pen and ink wash.
This composition incorporates negative space, turning and twisting, incompletion, and spatial containment.

Figure 9–4.
YUKO ITO, student.
The composition is made up of two views of the model drawn as compartmentalized contour.

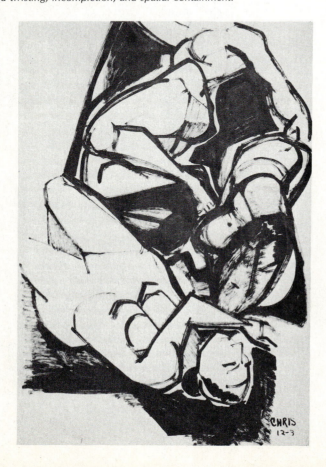

Figure 9–5.
LAURA CHRISTENSEN, student.
The bold and decisive lines, the simple tonal pattern, the placement of the figures in relation to one another, the strong movement path established by all the visual factors—all contribute to the effectiveness of the composition. Its vigorous simplicity makes it a particularly good preliminary study for a linoleum or woodcut print.

until the composition is completed. Of course, they may find it necessary to modify their original thumbnail grouping as the realization of their drawing in process requires it. Depending on the conception, the drawing may be basically gestural, contour, or a volumetric crosshatch. If the artists then wish to develop the multifigure composition further as a more ambitious extended work, the large study can serve as a basis for such a work; the model takes the same poses but holds them for longer periods of time.

The thumbnail approach can also be used by a group. In that case, each artist asks the model to take the three to five poses needed and hold them for a few minutes each. The drawings are executed in quick contour, and each participant can decide to develop these multifigure compositions later.

FROM PREVIOUS DRAWINGS

In this approach, artists draw separate contour or volumetric studies from a model seen in different poses or from different views, keeping the drawings related in scale in order to facilitate later groupings. They then choose those studies that they wish to incorporate into a multifigure composition. It is helpful to make a few rough layouts first to determine the relative placement of the figures to each other and to the page. Then the artists proceed with the new configuration, giving great care to the integration of the single drawings to the more ambitious and complex composition. Even though the preliminary drawings may have been executed as contour studies, the multifigure composition may be developed in any stylistic concept (Fig. 9-6).

Figure 9–6.
ELIZABETH TOKAR, student.
This is a series of four drawings, each based on the same multifigure composition and each interpreted in a different stylistic concept.

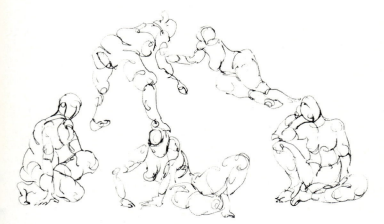

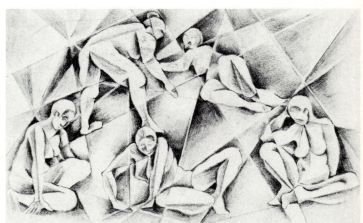

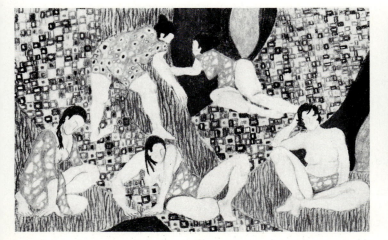

DRAWING AS COLLAGE

Collage is an alternate method of composition that is particularly useful to the beginner because of its great flexibility. Figure drawings are cut out and placed on a sheet of paper, each one carefully positioned in relation to the others and to the surrounding space, with some overlappings. The artists move and shift the cutout shapes until they find the most satisfying arrangement, at which point they paste down the shapes. This method has the obvious advantage of allowing for adjustments and rearrangements before the shapes are pasted down.

MORE THAN ONE MODEL

Occasionally, it is possible to hire two professional models to pose for one session. In this case, the drawing proceeds directly from the pose. When more than two models are needed for a grouping, those members of the sketch group clad in jeans and leotards can take turns at being models. The advantage of this method is that it provides an available pool of models if the group wishes to do multiple-figure compositions directly; the disadvantage is that the artist cannot draw while posing. This disadvantage can be offset by taking a number of photographs of each grouping to be used later by the participants who posed.

When no models are available, slides of models may be projected; the artists draw from these, combining them into multiple-figure compositions as they would from a live model.

FROM IMAGINATION

Observation and Imagination

A distinction is made between artists who work directly from nature and those who work purely from imagination. I think neither of these methods should be preferred to the exclusion of the other. Often both are used in turn by the same man; sometimes he needs contact with reality before he can organize them into a picture.

Henri Matisse

After the artists have gained a reasonable knowledge of the human figure through observation, study, and drawing, one may assume that they can now rely on their memory to draw the figure from imagination when this suits their purpose. For example, they can mesh a multifigure composition with a basically nonobjective movement scheme. On first exposure to this approach, I would advise the artist to work in a medium that can easily be corrected, such as pencil or charcoal. Later, ink may be added to firm up the drawing. When the essentials of the multifigure composition have been established, a model may be asked to take poses of the figures that have been drawn from imagination for verification and clarification.

When choosing to work with a multifigure composition, the artist may want to work around an overt or implied theme. However, because a theme is intimidating, and because the beginner tends to subordinate primary pictorial concerns to illustrational ones, I think it is prudent to delay the introduction of themes until the artist has had experience in stressing the purely compositional factors. But I do believe that themes have a place in the pictorial experience and do not invalidate it, as long as the content is not a pretentious, trite, or maudlin pretext for mediocre and weak pictorial solutions.

COMPOSITIONAL OPTIONS

Although all the factors of composition that the artist confronts in a single-figure drawing are present in a multiple composition, the esthetic problems posed by the additional figures require a highly developed sense of the dynamics of pictorial relationships and of the esthetic and affective impact of a more complex composition (Fig. 9-7).

In terms of the figure arrangement and the relation of the figures to the format, to the space, to each other, and to the overall movement scheme, the artist can choose from a great number of basic compositional options and variations. If we consider two major approaches to multiple-figure composition—each approach open to many variations—one of these is an organic pictorial arrangement that grows from the effective grouping and depiction of observed figures. More often than not, the major movement scheme emerging from this type of grouping will be a variation of the spatial spiral. This approach blends the perceptual and the concerted, with the perceptual as a starting point (Fig. 9-8). The other major approach stresses the movement scheme itself, starting with a preset structural and underpinning onto which the figurative elements are imposed; it is obviously more conceptual than the preceding one.

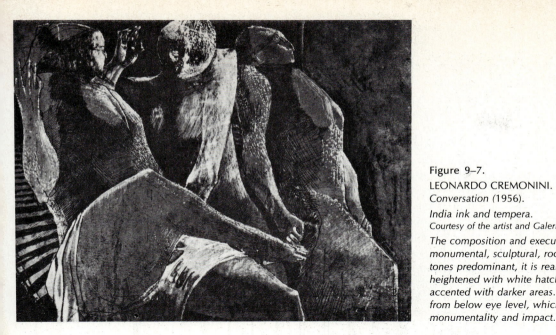

Figure 9–7.
LEONARDO CREMONINI.
Conversation (1956).

India ink and tempera.
Courtesy of the artist and Galerie Claude Bernard, Paris.

The composition and execution emphasize a monumental, sculptural, rocklike quality. With middle tones predominant, it is realized in dark ink crosshatch heightened with white hatching and white dots and accented with darker areas. The grouping is viewed from below eye level, which intensifies its monumentality and impact.

Figure 9–8.
LAURA CHRISTENSEN, student.

The figures are drawn with bold, vigorous lines; there is a clear and strong movement leading the eye from one unit to the other; and the definition of the negative space concurs in establishing this visual path.

The Spatial Spiral

In the first option, which is the more intuitive and yet the more traditional one, the artist uses background shapes mostly to clarify and further tighten the movement path leading from one figure to another and to establish the depth of the spatial container created in the picture field. When this approach is chosen, the artist frequently depends on the traditional spatial spiral eye path, with an interweaving of lights and darks if the movement is strengthened by a tonal pattern. The figures can be treated as closed or open; if the latter, they often straddle the light and dark pattern. As a structural element, the compositional option may bear on the style of the work, but by and large, the style and the technique are almost independent of the compositional approach. Therefore, the same basic figure composition can be developed in almost any style, depending on the needs, personal preference, and iconography of the artist: open, closed, linear, volumetric, realistic, abstract, and so on (see Fig. 9-6).

Preset Movement Scheme

In the second option, the movement scheme is derived from a preset nonobjective pattern, which remains the visible structural underpinning onto which the multifigure composition is imposed. This pattern may be based on vertical or horizontal emphasis, curvilinear design, opposing diagonals, dominant verticals, or various combinations of these. Dark and light areas can contribute to the movement path within the pattern; and the figures that mesh with the structural pattern may straddle the lights and darks, creating an ambiguous sense

of negative and positive space with mergings and fusions of figures and ground in a relatively shallow picture field. On the other hand, if the artist prefers, the figures and the light and dark pattern can be designed to coincide with some edges of the preexisting structural pattern, in order to combine into a hard-edged, linear composition. In either case, this approach lends itself more naturally to the invented or abstract composition than the more traditional figure composition based on a modified spatial spiral (Fig. 9-9).

I encourage students to try this option as an exercise in clarifying certain aspects of abstraction because it points out the commonality of formal problems involved in both the figurative and the

Figure 9–9.

JULIE LAUGHLIN, student.

Ink and wash.

This is a highly energetic and expressive drawing on the theme of the bullfight. Diagonal thrusts and counterthrusts serve as a compositional axis within which the figures are incorporated.

nonobjective compositions: how, in both cases, the artist needs to establish an effective and compelling movement path, utilizing all the pictorial elements involved. There is also, I think, something quite valuable in moving from the nonobjective to the figurative and back again in the same composition.

Suggested Exercises

From one to two. If only one model is available, he or she takes two related poses, which are held for a few minutes only. Indicate lightly the main thrust of the pose in charcoal as a gesture study, paying attention to the placement of one figure in relation to the other and to the general format of the drawing surface. If necessary, alter this format later by cropping. Once the relation of the two figures has been satisfactorily established, the model goes back to the first pose and holds it for a period of twenty to twenty-five minutes. Make a more detailed study, using the gesture notation as a preliminary structure; repeat the process with the second pose.

After a few successful experiences with two-figure compositions, you may want to confront more ambitious multifigure compositions.

Thumbnail improvisations. Thumbnail improvisations of multifigure groupings are a valuable warm-up exercise, preceding and preparing the more sustained studies. The advantage of these quick thumbnail notations is that you can try out a number of possible compositional variations rapidly and spontaneously, without self-conscious concern for the immediate results. It is a kind of loosening-up process. The smallness and tentative quality of each sketch precludes overworking the drawing. It is a disciplined approach to freedom. The thumbnail studies can be drawn from groupings of students taking turns at posing for a few minutes. Sometimes, informal snapshots can serve as a basis for the quick studies. The more advanced students can first invent the grouping and develop it later as a sustained drawing from observation or from imagination (Figs. 9-10 and 9-11).

Spatial spiral composition. As a preparation for multifigure compositions based on the spatial spiral, the beginner might benefit from the study and analysis of a few choice compositions by the masters. An actual simplified graphic analysis of the basic composition may be attempted. The compositional pattern is best apprehended by squinting the eyes while looking at the reproduc-

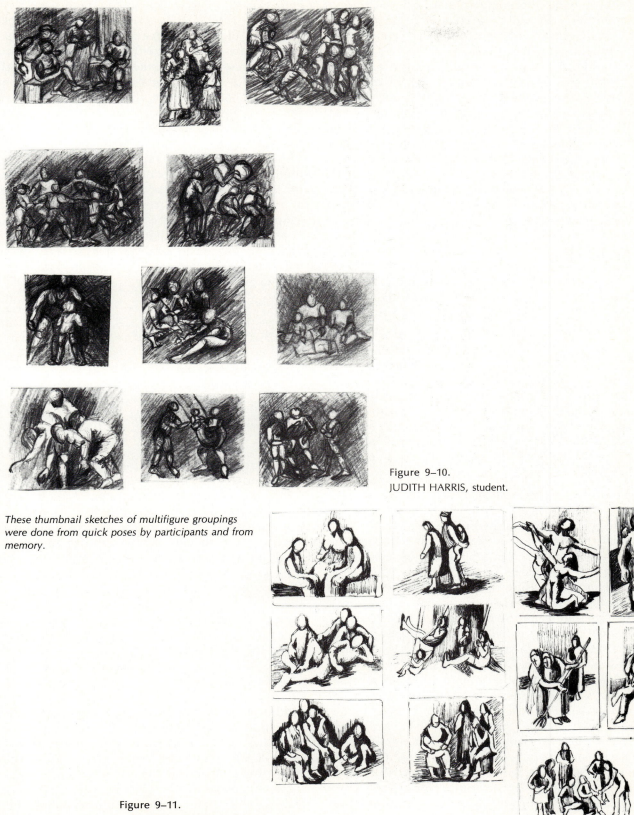

Figure 9–10.
JUDITH HARRIS, student.

These thumbnail sketches of multifigure groupings were done from quick poses by participants and from memory.

Figure 9–11.
ELIZABETH TOKAR, student.

tion, so that the configuration appears out of focus and is reduced to its main compositional structure. The analysis can be done very sketchily and its size kept relatively small.

Make a few thumbnail layouts based on previously drawn single figures that are related in poses. After selecting the thumbnail composition to be attempted, block in lightly the figures on an 18 × 24″ sheet of paper, taking special care to relate the figures to each other and to the picture plane. Add a few planes or volumes as background props to clarify the sense of space that you want to create. After the initial blocking-in, concentrate on the negative space; as the composition takes shape, you can develop the shaded areas in tonal graduations, progressing from the general to the specific. Pay special attention to the light and dark areas as carriers of the movement path.

Using the same basic composition, you may want to try at least two stylistic variations: silhouette, linear, semiabstract, or volumetric with compartmentalized contour.

Collage composition. Draw a series of poses from the model, working in the same scale and style. Cut out the figures and place them on a new working surface, shifting them until a satisfying composition is attained. Then tape the cutout figures temporarily into place. When you are sure that you have grouped the figures to your satisfaction, complete with a few additional shapes and values.

Preset movement scheme. Make a few nonobjective, linear overall movement schemes with the directional emphasis of your choice. You may use some patterns made as previous exercises. The patterns should be indicated rather loosely so that they may lend themselves more easily to figurative development. Using the nonobjective movement scheme as the anchoring structure, make a series of multifigure improvisations in which the suggested figures are inventively incorporated into the scheme. These improvisations can be executed in wash with pen, ink, and brush.

Select a few of the more successful improvisations and develop them into larger projects in charcoal and pastels.

Black-and-white composition. Whether it is conceived and executed as a spatial spiral movement or grafted onto a nonobjective, preexisting movement scheme, the multifigure composition can be developed into any style desired. One conceptual approach can be particularly helpful to the understanding of composition: Occasionally limiting the composition to strict black and white—or any two-tone combination—clarifies the symbiotic character of the positive and negative spatial relationships. As a vehicle for dynamic and often stark expressive possibilities, the simplified tonal pattern adds to the pictorial range of the artist. An additional bonus is that such carefully worked-out figure compositions based on dark and light contrasts are particularly well suited to translation into prints.

Note: There is no set pattern or formula for multiple-figure composition any more than there is for the single-figure composition. These two basic approaches are only starting points. Serious fledgeling artists soon discover their own predilections, find their own solutions, and invent all the variations needed to create expressive and effective multifigure compositions—within and without the guidelines.

THEMES AND ANATHEMA

A Legend, a Story

My painter's language is founded on the belief of a traditional function of art, that is, to communicate, through dramatic presentation, a legend, a story.
 Rico Lebrun

The figure as a metaphor is introduced in Chapter 19. Pictorial themes and metaphors are related. Although a thematic interpretation may treat a single figure, such as Job or Prometheus, they often involve a multiple-figure composition. Like the metaphor, themes offer a very rich source of poetic imagery, and if not too literal or narrow, can be valid in the visual arts as well as in literature. They can be highly suggestive, dreamlike, imaginative, loaded with meaning, and yet open to many interpretations. They offer a ready handle for grasping an idea and its concomitant emotions. When the delicate balance of form and content is successfully managed, the human figure as a metaphor or in a thematic context becomes a very effective, evocative way for esthetic, emotional, and intellectual communication, ranging from the light and airy to the brooding and enigmatic.

The controversy regarding themes in drawing and painting must be addressed. Many an artist strongly feels that the use of themes in art is anathema, debasing the essential concern of art, which is a search for form. The more experimental artists, those who concentrate on the process and the manipulation of media to the quasi exclusion of

other factors, often deem their search to be the condition of discovery and originality. For these artists, an obvious or even nonobvious theme is no more than illustration, which falls easily into pretentiousness. At best they look on these concerns as extraneous to the real art problem. My personal feeling is that a theme is what the artist makes it—shallow illustration or evocative poetic visual statement. My students do use themes occasionally, as a means of investigating this evocative dimension within the art experience; and when the use of themes is well understood, I do not think that it interferes with the formal concerns of the artist or with process.

One needs only to recall the many painters and graphic artists, past and contemporary, who have used themes in their work to feel reassured about the fact that content need not be the enemy of form, although content at the expense of form is not art. A study of a single theme interpreted by a number of artists is a salutary experience, showing how a given subject can be expressed and felt through different perceptions, styles, sensitivities, media, and techniques. Dante's *Divine Comedy*, illustrated in the nineteenth century by William Blake and Gustave Doré, and in the twentieth century by Rico LeBrun and Leonard Baskin, is a case in point (Figs. 9-12 through 9-15). It is a reminder that there are as many interpretations and styles as there are individual creative artists and that a work of art can be valid as such within its intellectual frame of reference or purely as a visual statement, requiring no knowledge of the theme (Figs. 9-16, 9-17, and 9-18).

Figures 9–12 through 9–15 illustrate many pictorial interpretations of one theme. Dante's Divine Comedy *has been a source of thematic inspiration to artists of many periods and many styles. The following four illustrations are all based on the same passage from* Inferno *(XXXIX, lines 79–81).*

Figure 9–12.
WILLIAM BLAKE (1757–1827).
Tate Gallery.

Blake's interpretation is characterized by a frozen hieratic gesture. Imaginative and highly subjective, it reflects a kind of artistic naivety in the slight disproportion between the heads and the bodies (the heads are generally too large), the short-waisted figures, the stiff and sometimes awkward twist of the bodies, and the stylized expressions. Yet the relative awkwardness of the figures do not preclude strength and a direct emotional appeal.

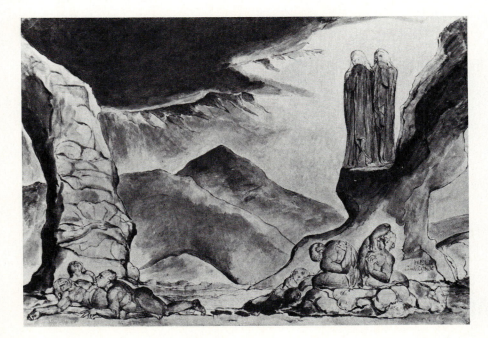

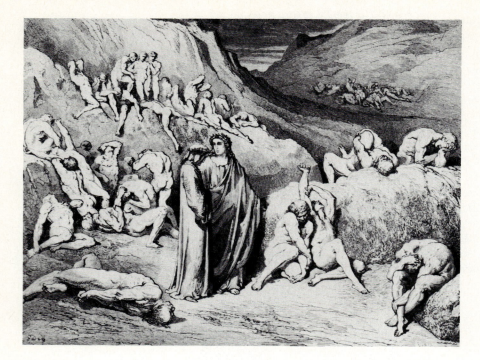

Figure 9–13.
GUSTAVE DORÉ (1832?–1883).
From the Doré illustrations for Dante's Divine Comedy, Dover Publications, Inc. N.Y., 1976.

In contrast to Blake's earlier work, Dore's romantic illustration appears superficially more skilled in its depiction. The figures, clustered in pictorially cohesive groupings and placed in a kind of theater set, are anatomically correct, and the gestures are more varied and more fluid. Yet although the composition is elegant and esthetically satisfying, it lacks the personal intensity and involvement apparent in Blake's rendition.

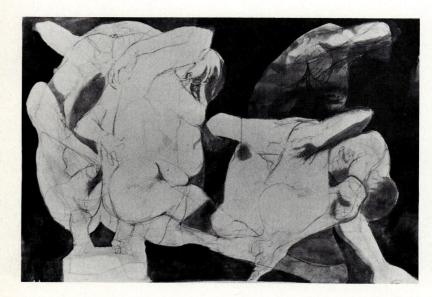

Figure 9–14.
RICO LEBRUN.
Courtesy of Constance Lebrun-Crown.

In Rico Lebrun's 1961 treatment of the theme, the figures are brought closer to the picture frame—and therefore to the viewer—in a dramatic grouping of tortured bodies seen as a merged mass against a stark, dark background. The absence of a setting puts the total visual emphasis on the figures, who are tearing at their own flesh.

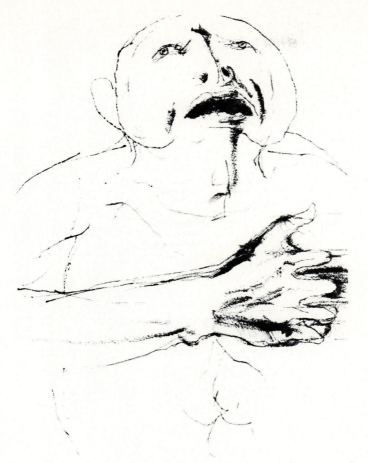

Figure 9–15.
LEONARD BASKIN.
Courtesy of the artist.

Here, through the most economical line, the artist personalizes and condenses the theme even further by filling the frame with one single suffering figure, reduced to its essential gesture and expression of torment.

Figure 9–16.
HOWARD WARSHAW.
Ulysses and the Pit (1962).

Collage and acrylic on paper.
Courtesy of Marc Ferrer.

This study can be considered from a number of viewpoints: theme, abstraction, concept, or technique. I am choosing to look at it from the point of view of concept, that is, the problem of the visual expression of the metamorphosis of man into animal, which was the stated objective of the artist. Note the dramatic interplay of darks and lights and how the overlapping of tranparent overlays (achieved with Zipatone) adds extraordinary vibrancy and exciting optical shifts to the composition.

Figure 9–17.
MAURICIO LASANSKY.
Nazi Drawing N. 13 (1966).
Pencil.
Courtesy of the artist.
This is a grisly allegorical drama, in which victim, executioner, and symbols of death, are rendered with a delicate, soft-hatching technique. The transparency and delicacy of the technique overlay the violence that permeates the drawing with the quality of a dream, half remembered, half repressed.

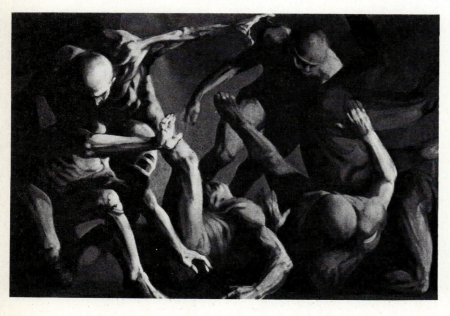

Figure 9–18.
MURRAY STERN
Untitled (1975).
Oil.
Courtesy of Mrs. Murray Stern.
The composition of football players stripped of uniforms and clothing (except for two helmets) can be read as an allegory of brutal energy, violence, and hostility. The strong anatomical emphasis— foreshortening; ribs, joints, and muscles—adds to the sense of a mortal combat in which the participants are both the victims and the agents of death.

Thematic Interpretations

I invite students to improvise on themes of their own choice, taken from the Bible, Greek mythology, folklore, legends, Shakespeare, and so on. As in the dance or the theater, the mask or costume wearer becomes, for the moment, what he or she portrays. I like to encourage students to use universal themes because it is an activity that stimulates the creative imagination, and it involves the students more deeply in the relationship of form and content.

The very nature of universal themes carries with it the potential for constant renewal. A sensitive and skillful artist can certainly reinterpret them in his own terms and style, endowing them with a contemporary and personal validity.

Often, the theme is not chosen beforehand but emerges from a composition in progress; it is clarified or left vague, stimulating the imagination through its suggested formulation. When, on the other hand, a group or class has agreed to work on themes, one possible way of handling the mechanics of it is to form groups of four to six members, each group choosing a theme and creating the total setup: costumes, props, and group pose. The configuration can be dramatically lighted by one-sided spotlighting, and the mood can be further intensified with music or sound effects.

Subject matter for themes and tableaux is almost limitless. Here are a few topics that can serve as examples or springboards:

> Greek and ancient Egyptian myths
> Myths from various other cultures
> Biblical episodes and stories
> Fairytales
> Life as a circus
> The circus
> Nightmares
> A Fellini gallery: Personal mythology
> Prisons
> Cabarets
> Rituals

Once the initial trepidation has been overcome, the involvement of the participants creates an electrical atmosphere, taking on the excitement of total theater; the visual imagery that may emerge can be powerfully evocative.

Suggested Exercises

Life as a circus. Do a series of drawings based on the theme of "Life as a Circus." Use costumed models, sketches done at the circus, imagination, and/or a combination of these.

Danse macabre. The *danse macabre*, which deals with the human condition and the fraility of life, has been a popular theme throughout the sixteenth and seventeenth centuries.

A whole group of costumes of the Middle Ages—such as the jester, knight, prince, princess, king, queen, witch, Merlin, monk—can be used for a series of very exciting themes based on fairytales and the *danse macabre*.

Select a popular fairytale, improvise costumes, draw and paint the setup.

Dante's Inferno. Make a series of brush and ink drawings from posed models and mannequins based on Dante's *Inferno*. It can be updated and reinterpreted, as many contemporary artists have done.

CHAPTER TEN

Originality and Influence

Any consideration of the principles of composition is based on a study of masterpieces through the ages, which, though completely dissimilar in concepts and styles, appear to possess common underlying structural factors. Many contemporary artists no longer adhere to the classical principles of composition and have adopted variations, mutations, or radical violations of these principles, which in many cases are quite effective for the artists' concepts and esthetic purposes. However, these successful reassessments and transformations do not invalidate the works and esthetic principles of the past. In fact, I believe that thoughtful reevaluation and even eventual rejection of a principle requires esthetic sensitivity and understanding enhanced by the study of past and contemporary arts.

Working from the Masters

Occasionally, I like to select a mentor, a master, and let him guide me through a revision of one of his paintings. . . . I try to move into his terrain, bringing my own ammunition. . . . I do not believe by even the most pious stretch of conscience, that this belittles my own personality.

Rico Lebrun

There are artists, art teachers, and art students who feel quite ambivalent about studying the masters and being influenced by them, fearing that a close study might impede their progress toward originality and the development of a personal style. But no one lives in a vacuum, and we are all subject to influences. It has rightly been said that art comes from art; that is, each great artist starts the esthetic journey with a study of the works of another artist whom he or she admires. Thus, when critics or art historians trace the development of a major artist, they usually find the artist first working "in the manner of"; eventually, creative and original artists work their way through a number of such influences until they find their own signature. This is a kind of apprenticeship with the arts of the past and the present.

Since most artists are influenced at first, and often benefit from such influences, they should select their spiritual parents carefully, for these chosen masters inflect a stylistic direction and leave an imprint. In the course of their esthetic development, artists may choose more than one spiritual master at a time, and the amalgamation and transformation of three or four "manners" can lead to a new and original vision and pictorial expression.

It is not uncommon to outgrow a set of spiritual parents and replace them with another set, and even the mature and consummate artist usually keeps a special esthetic chapel of those artists of the past and present with whom he or she feels a privileged affinity and kinship. Virtually all the great masters, past and contemporary,

have been influenced by other masters, to the point that they did not hesitate to make copies of the works they admired most—to understand these works better through the experience—and many artists have acknowledged their esthetic debt to a favorite master. The greatness of the truly creative artist lies in the ability to transform and transcend these influences through his or her own alchemy into a new personal vision and style (Figs. 10-1, 10-2A, and 10-2B).

Figure 10–1.
MARY CASSATT (1845–1926).
The Coiffure (1890).
The Art Institute of Chicago, Mr. and Mrs. Martin A. Ryerson Collection.

Its elegant line quality; soft, flat value contrasts; and discrete decorative patterns make this work highly reminiscent of the Japanese prints that the post-impressionist artists so admired.

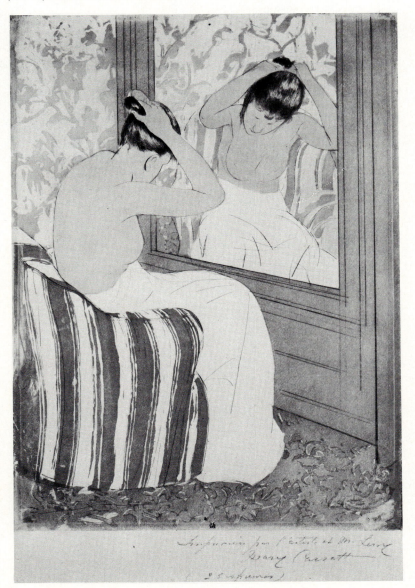

Figure 10–2a.
DIEGO VELASQUEZ (1599–1660).
Innocent X (1650).
The Doria Pamphilj Gallery, Rome.

Figure 10–2b.
FRANCIS BACON (1909–).
After Velasquez: Portrait of Innocent X.
*Courtesy of Des Moines Art Center, Des Moines, Iowa. Coffin
Fine Arts Trust Fund, 1980.*

*The connection between the original Velasquez painting and Bacon's is both basic and tenuous. The composition and
apparent subject are closely related, but the intent and impact are totally different. The haunting image of the silent scream
permeates Bacon's version with a powerful emotional charge that totally divorces it from the relative objectivity of the original
Velasquez and relates it to the anguished existential cry of Edvard Munch (Chapter Seventeen).*

My own conviction is that a study of masters
can be of great value to the fledgling artist, as long
as it is used to illuminate the creative experience
and thus contributes to the esthetic growth of the
artist.

There are numerous ways of studying chosen
masters. Copying is one of them. The aspiring
artist may choose to copy very accurately, faith-
fully retracing the technical aspect of the experi-
ence while gaining a deeper understanding of
every compositional aspect save the mysterious
and intangible components that lie at the source of
creativity. The artist may prefer to copy in a freer
and more interpretative manner, combining the
basic composition of the work with his or her own
style. Picasso, among others, did this kind of
interpretative copying when he was himself the
most copied artist of his time (Figs. 10-3A and
10-3B). Before him, Van Gogh had also often felt
the need for copying, thus reaffirming that his
quest for pictorial authenticity was not predicated
on rejection of the past but was nourished by his
appreciation and understanding of artists who
preceded him as well as by the imperatives of his
creative genius (Figs. 10-4A & 10-4B).

Unless studying from the masters is philo-
sophically abhorrent to beginning artists, I like to
encourage them to choose a master drawing or
painting—from the past and from the present—
and analyze it probingly and carefully. At first,

Figure 10–3a.
NICOLAS POUSSIN (1594–1655).
Bacchanale: The Triumph of Pan (1638–1639).
The Louvre, Paris.

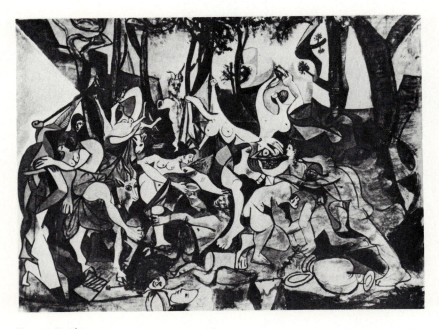

Figure 10–3b.
PABLO PICASSO (1880–1973).
After Poussin: Bacchanale (Augustust 24 to 29, 1944).
Watercolor and gouache.

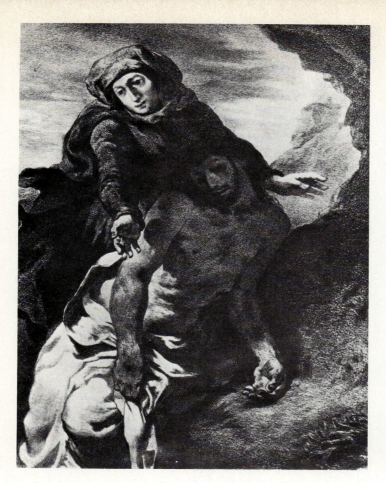

Figure 10–4a.
EUGENE DELACROIX (1798–1863).
Pietà (1850).
Lithographic reproduction by C. Nanteuil.

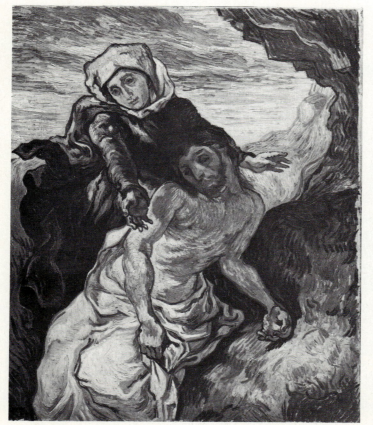

Figure 10–4b.
VINCENT VAN GOGH (1853–1890).
Copy of Delacroix' Pietà.
Collection National Museum Van Gogh, Amsterdam.

In this faithful study and copy of a Delacroix composition, Van Gogh extracted the essence of his chosen model, but the paint application retains his unmistakable technical and stylistic imprint.

they do it verbally as objectively as possible, writing a detailed description of what they see in terms of the architectonics of the composition. As part of this verbal analysis, they try to answer this question: Does every aspect of the composition enhance the total impact—esthetic and emotional—of the work? Following the verbal description, it is quite valuable to make a pictorial analysis—of the linear scheme and the distribution of the shapes, values, and textures—and a diagram of the basic movement scheme, each aspect as a separate analysis. Then the participants may find it important to compare their responses to the work before and after the analysis. Such sustained study of a given work generally helps students really to look at a work of art that they admire and to learn from it (Fig. 10-5).

This process of study and analysis may seem to run counter to the creative process, which is predicated on an intuitive synthesis of all the elements. Yet I believe that taking a drawing or painting apart and reliving, as much as possible, its graphic formulation, can be of immense benefit to students—as long as they are aware of the limits and pitfalls of this exercise, and as long as they are committed to a program that emphasizes direct creative perception and expression. The study and analysis of a masterwork may contribute to an intellectual and esthetic understanding and appreciation of the particular work and of the art process, but the elusive quality that makes a work of art great remains the secret of the original alchemist—and each artist must find his or her own secret.

Figure 10–5.
Student work.
Analysis of a painting by Jan Vermeer.

TONE

ANALYSIS

OF

"THE ARTIST IN HIS STUDIO"

BY JAN VERMEER

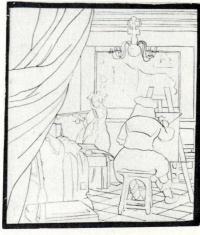

LINE

OVERLAPPING PLANES

EYE PATH

A FEW CONSIDERATIONS FOR PICTORIAL ANALYSIS

Stylistic Concept

Is the work considered a sketch, a sustained drawing, or a study for a painting?

Is the figure seen and drawn in gesture? Contour? Mass? Is the graphic idiom realistic, abstract, cubist, surrealist, or expressionistic?

If there is departure from naturalism, which graphic means are used? Simplification? Alteration? Distortion? Dislocation? Geometrization? Fragmentation?

Is the abstraction perceptual or conceptual? Is it a combination of these approaches?

Are the shapes basically geometric or amorphous? Open or closed? Monumental or small and diminutive? Suggested or fully developed?

Materials and Technique

Which materials and drawing tools have been used? Which technique? Is the technique consistent with the concept, theme, style, and mood? Was the drawing surface toned beforehand, or was it left unmodified? Is the work realized in a single medium or in mixed media? If a single medium was used, is there a single technique or a number of techniques, such as line, crosshatch, wash, and so on?

Format and Placement

What is the format of the work, and how is the composition anchored to it? Or how does it conform to it?

Is the placement of the configuration in relation to the format static or dynamic?

Line

Is line the dominant or the supportive element in the composition? What are the physical characteristics of the lines: thick, thin, continuous, broken, multiple? Is there sameness of stroke or diversity? What are the emotional characteristics of the overall linear quality: bold, nervous, delicate, elegant?

Value

What part does value play in the overall composition? Is it a dominant element? Which value key is used: high, low, medium, or contrasting? Is value treated as flat value contrasts or as graduated highlights and shadows? What is the general emotional effect conveyed by the tonal treatment: moody, mysterious, tranquil, neutral, delicate, dramatic? How do the movement and mood relate to the tonal key and the distribution of values?

Texture

Does texture play an important or a minor part in the composition? Is it graphically depicted through various techniques or actual, as in a collage? Is the texture naturalistic, invented, decorative, pervasive, localized, rich, or discrete? Is the emotional effect irritating, soothing, abrasive?

Movement Scheme

Is the composition basically vertical, horizontal, diagonal, or circular? Is the movement scheme self-contained, or does it spill beyond an edge or a corner? Does the inferred movement elicit a sense of stability, quiet, serenity, calm? Or does it evoke dynamism, force, frenzy, disquietude, violence?

Spatial Representation

Which means has the artist used to depict spatial relationships: flattening of the forms to deemphasize deep space, classical perspective, exaggerated perspective, overlapping, transparency, foreshortening, accent on negative space, mergings of figure and ground?

From which eye level or eye levels was the figure seen: at eye level, below, or above? From which angle of vision?

Suggested Exercises

Thumbnail studies. Study carefully a black and white reproduction of a master of your choice. On bond paper, draw a frame format in proportion to the original but much smaller: approximately 4 inches on its longest side. With pencil, approximate the main movement and rhythmic pattern in curving and straight lines. Indicate the negative areas where positive and negative forms meet. You may find it enlightening to set the original upside down so that your analysis of the composition is dissociated from the subject matter. Make a number of such studies.

Rapid analysis in paint. Again, work from a black and white reproduction. Use black, white, and grey tempera paint mixed to creamy consis-

tency to analyze the basic forms and value patterns, leaving out all the details. As with the thumbnail studies, I think that the problem is even more beneficial when you work from the reproduction placed upside down so that the whole emphasis is on the relationship of forms and values (Fig. 10-5).

As an old master: self-portrait. Select a drawing or an etching of a portrait by an old master. Copy it in pen and ink, but insert your own likeness executed in the same technique.

In the manner of Study a figure composition drawn by an old master: Rembrandt, perhaps, or Michelangelo. Ask the model to take a similar pose in a setting somewhat reminiscent of the original. Execute your drawing in the manner or spirit of the master you have chosen.

After this preliminary exercise, choose a model and create your own setting. Interpret the subject in the style and manner of the artist whom you have in mind and whom you have already studied and analyzed. The interpretation should include compositional concept as well as technical means. For example, if the master you have in mind is Rembrandt, you would conceive your interpretation in strong and dramatic lights and darks, and you would develop the study in crosshatch and wash. If you choose Michelangelo for your model, the emphasis would be on a volumetric approach, with obvious delineation of the muscular structure; the technique would be either charcoal or crosshatch for the modeling (Figs. 10-6A and 10-6B). Should you select Van Gogh as the master, the figure would appear more flat and simplified and would emerge in strong outlines, with flat value contrasts and arbitrary textural emphasis. The technique might be a simplified heavy-ink outline, with flat value contrasts and obvious decorative textured areas. Later, the interpretation can be much looser (Fig. 10-7).

These exercises may be considered pastiches. They do not stress personal vision and originality, and they are not meant to be vehicles for a personal visual statement. Rather, they serve as experiences in artistic empathy, and their purpose is to further conceptual, esthetic, and technical understanding (Figs. 10-8 through 10-11).

After studying the figure taken from a detail of Michelangelo's Last Judgment, *Willis Simms drew from a model who had assumed a pose similar to that in the Michelangelo detail. The assignment was to use the original as inspiration for a very free interpretation.*

Figure 10–6a.
MICHELANGELO (1475–1564).
Detail from the Last Judgment, *Sistine Chapel.*

Figure 10–6b.
WILLIE SIMMS. student.

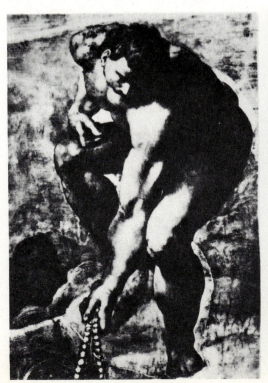
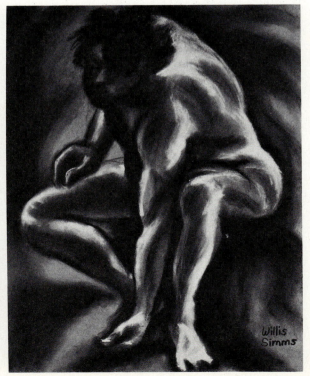

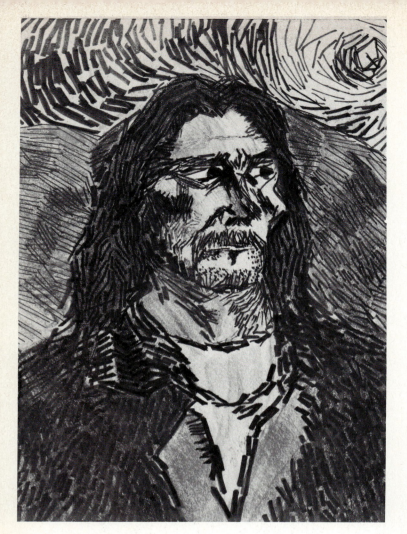

Figure 10–7.
VICTOR ESTRADA, student.

*The assignment was to draw a portrait in the style of a
favorite painter. Here, obviously, the inspiration was
Van Gogh, but although the style is clearly borrowed,
the individuality of the artist comes through
nevertheless.*

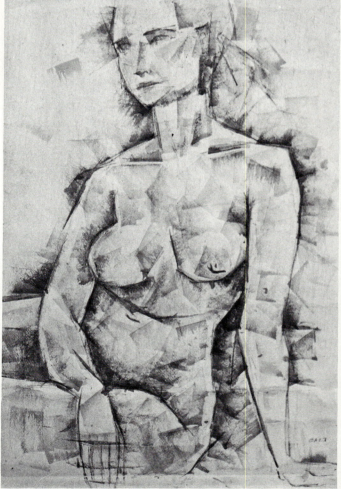

Figure 10–8.
TONY GALT, student.
Watercolor.

*A wedge that had been dipped in watercolor was
dragged over the surface of the paper in order to state
the figure through a series of overlapping, subtle
geometric patches. It was built from a greyish-blue
monochromatic base superimposed with patches of
delicate hues. The linear definitions were strengthened
later. The approach and technique were inspired by
the work of Cézanne.*

164

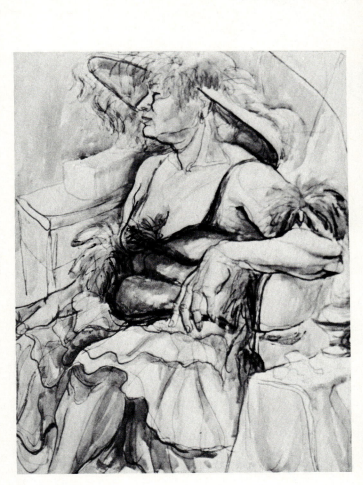

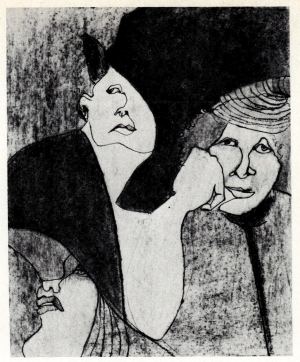

Figure 10–10.

JOAN LANO DE SIO, student.

Figure 10–11.

JOAN LANO DE SIO, student.

There are elements of Toulouse-Lautrec and Fellini characters in these incisively expressive drawings, yet they are far from being copies, and the personal style of the artist is evident.

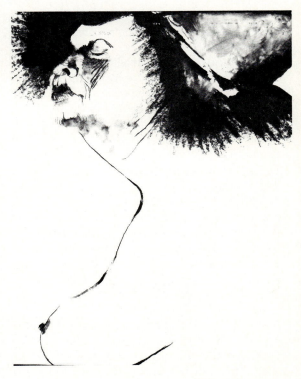

Figure 10–9.

Student work.

Ink and watercolor.

The costumed model looked like an apparition from the Moulin Rouge and inspired the artist to draw with Toulouse-Lautrec in mind. Not a pastiche, not a study "in the manner of," it simply shows how a work can be inspired by another without being a stylistic copy.

CHAPTER ELEVEN

Two Major Currents

Artists tend to see and respond to forms through the filter of their own world view. Just as there are artists who have a need for clarity and definition, there are others who have an equal need for the underdefined and the indeterminate. The first approach reflects a sense of distinctness and permanence, the subject matter being clearly described by its linear boundaries, whereas the second suggests unpredictability, ambiguity, openness, and flux.

In the Western tradition, these two basic ways of perceiving and expressing the world and the images within it have crystallized into what may be called the *classical* and the *nonclassical* traditions. Obviously, not every artist or art movement fits neatly into this or that category: Although many do, others span both; others still, the Dadaists and surrealists, for example, fit neither. Yet if one were to make a sweeping statement about the major works of artists who occasionally straddle both currents, it is usually possible to discern a greater inclination toward one or the other: linear, enclosed form or nonlinear, indeterminate image.

LINEAR AND NONLINEAR: A PERSPECTIVE

The art historian Heinrich Woefflin contends that these two opposing concepts have sometimes coexisted and sometimes alternated in Western art since the classical Greek period. However, this basic esthetic duality came to a dramatic confrontation in sixteenth-century Italy, when the Venetian artists of the high Renaissance challenged the classical Renaissance's insistence on the supremacy of the enclosing line.

Thus, sixteenth-century Italy presents us with two virtually contemporary movements, both heirs to a common cultural heritage and yet expressing two quasi-contrary esthetic philosophies and world views. The first, examplified by the works of Raphael (Fig. 11-1), projects clearly defined, stately, and timeless visual configurations, where the figures are made legible through their linear boundaries; the second, examplified by Titian (Fig. 11-2), attaches greater importance to mass as a means of depiction, integrating volume and space in compositions that reflect movement, flux, and infinity.

It is certainly informative to pair off major representative artists of the Western world from the sixteenth century to the present to see how they are heirs to one or the other main traditions, transcending differences and metamorphoses of styles. As was already cautioned, no artist or art movement should be pigeonholed into a set category; few artists fulfill all the characteristics set by Woefflin. The basic criterion used is whether they give emphasis to line or to mass.

Starting with the archetypal sixteenth-century contrasting pair of Raphael and Titian, we can continue with Dürer (Fig. 11-3) and Rem-

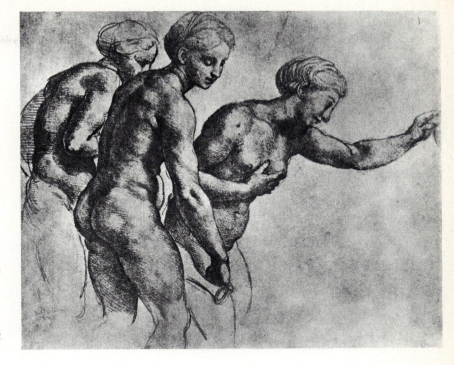

Figure 11–1.
RAPHAEL SANTI (1483–1520).
The Three Graces.
Chalk.
Windsor Castle, Royal Library, Berkshire, England. By gracious permission of Her Majesty the Queen.

A typical example of classical Renaissance drawing, characterized by the stateliness and restraint of the composition; clear linear boundaries enclose the figures, which are further defined by the light and dark modeling.

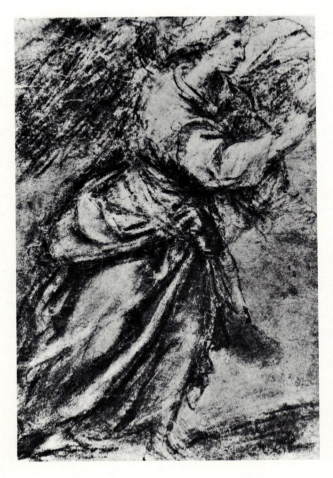

Figure 11–2.
TITIAN (1472 or 1482–1576).
The Angel of the Annunciation (c. 1565).
Uffizi Gallery, Florence.

In Titian's Annunciation, the sharp, hard-edged linear enclosure of Raphael has been replaced with soft, shifting contours created by tonal areas, which also function as shape and mass notations and as transitions between figure and background. The few lines that exist are faint, feathery, nonenclosing; they suggest rather than define. The lack of clear demarcation between figure and background, the relative indeterminacy of the configuration, the soft-focused tonal pattern impart a feeling of gentle, vaporous movement.

Figure 11–3.
ALBRECHT DÜRER (1471–1528).
Adam and Eve (1504).

Pen and brown ink with wash on white paper.
Pierpont Morgan Library, New York City.

Dürer has chosen to depict a crucial biblical episode as an arrested moment in time, dramatized and universalized by a totally stark, dark, neutral background. Dürer follows the classical tradition of separating the figures from the ground through a clear definition of the figure by its edges. The volumetric quality of the form is described with crosshatching of various density.

brandt (Fig. 11-4) straddling the sixteenth and seventeenth centuries, Flaxman (Fig. 11-5) and Goya (Fig. 11-6) straddling the seventeenth and eighteenth, Ingres (Fig. 11-7) and Delacroix (Fig. 11-8) in the nineteenth, and Leonardo Cremonini (Fig. 11-9) and Hyman Bloom (Fig. 11-10) in the twentieth. Other names could have easily been chosen to represent these same contrasting emphases.

What, then, are the common factors that relate such radically different artists as Raphael, Dürer, Flaxman, Ingres, and Cremonini? Obviously, they favor the linear approach, and their works are conceived as closed-form visual configurations; that is, each part is clearly defined through actual or implied linear boundaries, the shapes are highly legible, and the forms may be further clarified by careful modeling. The sense of movement is usually minimized: If there is a suggestion of movement in the figure, it is stately, or at least, arrested in a kind of pose that eliminates the threatening implication incipient in spontaneous movement. A further salient characteristic is the clear demarcation that exists between figure and

space and a feeling of stability that imbues many of these compositions.

If, on the other hand, we track the common traits that run through such varied artistic expressions as the works of Titian, Rembrandt, late Goya, Delacroix, and Bloom, a totally different esthetic concept and world view emerge. Now the dominance of line gives way to the dominance of mass; instead of clear definition and isolation of figure and ground, we see partial mergings of figure and space. Lights and darks are used in dramatic contrasts, with the dark areas sometimes encompassing both the solid form and its adjacent space in an indeterminate and mysterious fusion of matter and space. No longer do we have a sense of measure, finitude, and timelessness; instead the figures and the composition convey turbulence and flux, one form merging into another and all flowing into one grand rhythm.

I hope that it is evident that neither way of seeing and interpreting the figure is superior to the other. Each of us responds more to one than to the other perhaps, according to our natural inclination, but it is a good idea for the beginner to

Figure 11–4.
REMBRANDT VAN RIJN (1606–1669).
The Reading (c. 1631).
Pen and ink wash.
Musee Bonnat, Bayonne, France.

Although depicting a meditative moment, the whole composition breathes vitality and flux, suggesting the constant play of lights and darks of a flickering source of light, which moves shadows over figures and space, partially engulfing both. The vigorous and exciting calligraphy of Rembrandt's brush boldly espouses and enhances the fine balance between the restful activity and the sense of movement and flux.

Figure 11–5.
JOHN FLAXMAN (1755–1826).
Gods and Titans (Work Days and Theogony of Hesiod). Line engraving by William Blake from design by John Flaxman.
Royal Academy of Arts, London.

The epitomy of neo-classical style, the forms are carefully enclosed, with very precise edge definition. The composition is based on a radial balance scheme of upraised arms. (Although John Flaxman's works are no longer well-known, his style and ideas have exerted considerable influence on major artists such as David, Ingres, and even Goya, and, through them, on 20th Century artists.)

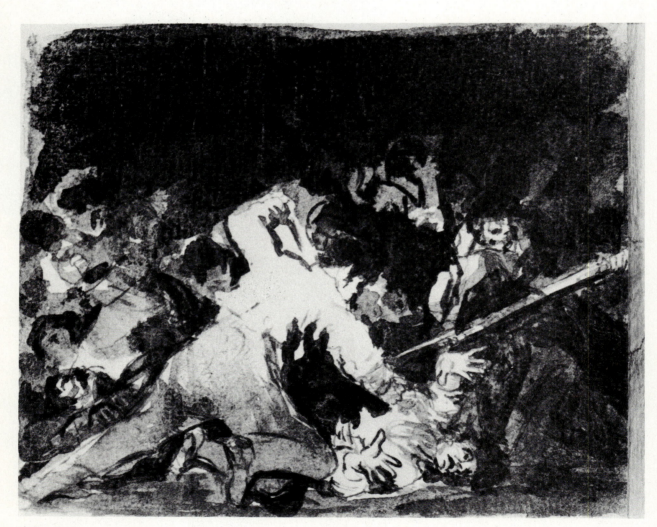

Figure 11–6.
FRANCISCO GOYA (1746–1828).
War Scene (1810–1815).

Sepia washes.
Prado Museum, Madrid.

This is a highly dramatic scene executed in strong tonal contrasts, with dark areas enclosing and invading the light ones. The main figures are revealed through a harsh light, whereas the figures in the background are barely suggested and hardly legible. The indeterminancy and confusion of the shapes, along with the strong tonal contrasts, add to the graphic interpretation of a violent melee. Based on a series of thrusts and counterthrusts, the whole composition is a seething, explosive tangle of bodies, and it conveys a state of violent flux.

Figure 11–7 (left).

DOMINIQUE INGRES (1780–1867).

Portrait of Paganini.

The Louvre, Paris.

Ingres' probing but restrained contour line and the delicate modeling of the head, capture the sensitivity of the violinist who is depicted in a stationary, arrested pose. The figure is vertically centered and separated from the background by a clear and precise delineation.

Figure 11–8 (right).

EUGENE DELACROIX (1798–1863).

Portrait of Paganini (1835).

Phillips Collection, Washington, D.C.

Delacroix' interpretation, although a painting rather than a drawing, illustrates the concept of mass over line as an esthetic preference. The figure, caught in action, does not stand out against the background, but rather its contours merge with it. Only the face, shirtfront, and hands are light. The rest is mysteriously dark, and the strong tension of the body of the violinist is barely distinguishable from the dark background that encompasses it. The indeterminate treatment of the figure and ground is part of a romantic interpretation of a musician lost in his own intense concentration.

These two interpretations (Figs. 11–7 and 11–8) of the same subject are especially noteworthy because they were executed by the recognized leaders of two opposite esthetic schools: Dominique Ingres, who personified neoclassicism, and Eugene Delacroix, the best-known romantic painter.

Figure 11–9.
LEONARDO CREMONINI.
Articulations and Disarticulations (1958–1960).
Courtesy of the artist.

The figures are stated through delicate but precise contour lines and are reinforced with crosshatch. The poses are stiff and hieratic. The composition, which follows a basic vertical and horizontal scheme, thinly masks the incipient intimation of death.

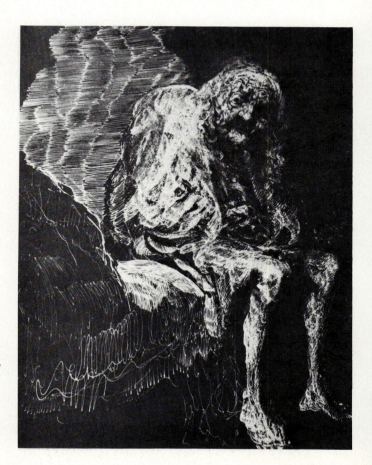

Figure 11–10.
HYMAN BLOOM.
Old Woman (1956).
White ink on blue paper.
Anonymous.

Bloom's powerful portrayal is executed in a series of hatching white lines on a dark surface. As it nears the edge of the figure, the hatching does not end cleanly to form a precise linear edge but keeps a jagged quality, which lends a sense of slight indeterminancy to the contour. The seated figure of the old woman seems to be in the process of being swallowed by the inevitable shadows.

experiment with both concepts and stylistic realizations in order to discover which is most satisfying as a means of personal pictorial expression.

Mindful of the fact that drawing is, among other things, a visual language, the terminology should be understood. Following is a list of clarifying terms that deal with the two main currents: the defined and the indeterminate.

CLARIFYING TERMS

Closed Form: The form is enclosed by means of a continuous outline or by an implied edge made up of distinct value contrasts.

Open Form: The lines that surround the form are broken or eliminated in places, allowing a merging of the lights on the figure with the light areas in the background, and the merging of shadows on the figure with the dark areas of the background.

Core: The hidden center or heart of the form, it is roughly equivalent to the skeleton or the visceral mass in the human figure.

Modeling in Light and Dark Masses: The drawing is developed in three-dimensional masses in graduated tones. This can be achieved with a variety of materials: pencil, charcoal, pastel, ink, or a combination of these.

Draftsmanlike: The emphasis is on the linear quality of the drawing.

Painterly: The emphasis in the drawing is given to the relationship of masses of light and dark, imparting to the composition a sensuous quality akin to painting.

Simultaneity: The artist conceives and executes the drawing or painting by working over the whole surface at the same time, thus working in an organic and related manner, as Cézanne did.

Part at a Time: The artist views, draws, and completes one part of the composition at a time, in contrast to the concept and technique of simultaneity.

Incompleteness: The artist deliberately leaves portions of the picture incomplete, in order to integrate the subject with the space around it and to involve the viewer in the deciphering of the image.

Classical (Neoclassical)	Anticlassical (Baroque and Romantic)
Clarity of Form Concentration on the thing itself, its description, solidity	*Indeterminancy of Form* Concentration on relationships of forms to each other and to the whole movement
Seeing by Edge (outer/inner) Form defined by fixed linear boundaries; modelled by tone or hatching/crosshatching, isolating and separating form from ground; line is primary	*Seeing by Mass and Core* Form partially obscured by open-formed mergings (passages) of dark shadows with dark grounds and highlights with light grounds, forming new, independent combinations; suggestion and evocation, mass primary
Stability and Restraint Sense of orderliness, dependability, permanence, timelessness; measurable, absolute, intellectual, static, stately pose	*Unpredictable and Visceral* Emotional and dramatic, erratic and unstable; change and sense of process, flux; limitless, elusive, emotional, visceral, dynamic, twisting, turning forms
Draftsmanly Drawing and painting separate processes; one part at a time	*Painterly* Drawing and painting fused into one process; emphasis on totality
Appeals to tactile sense—"stroking form with the eye"; a sense of completion	Appeals to visual sense; awareness of textural differences; a sense of incompletion—"letting the paper breathe"
Detailed idealized realism; concealed brush stroke; to be seen from up close; local color	Impressionistic; rich, broken color; to be seen from a distance; composite color
Closed form Self-contained within the picture frame; pointing everywhere back to itself	*Open form* Suggesting movement beyond the picture frame
Vertical and horizontal oppositions	Opposing diagonals, curvilinear swirling masses
Central axis and symmetrical balance	One-sided emphasis
Made up of a series of harmoniously strung-together independent parts	Overriding tonal rhythm with all forms subordinate to it, melding into a unified whole
A finite spatial field	An improvisational-appearing limitless void

CHAPTER TWELVE

Clarity and Definition:
Seeing by the Edge

From the earliest times the human species created images that were easily identifiable. The precise outlines that enclosed the forms and isolated them from each other, as well as from the background, gave the necessary clarity and definition. In the beginning, this need for clarity was probably related to survival. But today people are still largely object-oriented, and the first conceptual impulse of a beginner is to separate clearly a subject from the background.

The prehistoric figurative drawings found in South Africa are witness to the urge to re-create schematized but recognizable symbols of the human form. The silhouette, or hard-edged image, is the common denominator of the figurative graphic representation of most ancient cultures as well as children's art. This seems to hold true regardless of the style or local iconography (Fig. 12-1).

In most cases, value differences were used chiefly to separate one form from another for easier recognition, and highlights and shadows were virtually nonexistent. The imagery was symbolic rather than perceptual.

It can safely be stated that whenever artists want or need to make a clear visual statement today, they most often devise a style that is basically linear or hard-edged. This is evident in illustration and in advertising. Trademarks, international symbols, road signs—all graphic, nonverbal messages are executed in clear and simplified silhouette for immediate visual recognition.

THREE MAJOR DIVISIONS

For the sake of clarity, hard-edged figure drawing has been divided into three categories: silhouette, analytical contour, and expressive contour. It may be helpful to define and describe these major divisions and their most common subdivisions.

Silhouette Drawing

The word *silhouette* is derived from the name of an eighteenth-century French minister and writer who popularized a form of outline drawing filled in with black ink, resembling the clear-cut shadow of a profile against a white or very light background. What we call a silhouette drawing now is a very simplified outline, which depends mainly on its edge for legibility and meaning. In pure silhouette, the interior space between the edges of the drawing is a solid, flat area of black or dark color, leaving the inside space undefined and indeterminate. Yet because of what the onlooker brings to the viewing from memory and stored knowledge of the human figure, the blank configuration is usually quite readable. Often the silhouette is not a drawing per se but a paper cutout done directly or from a previous drawing, which is then affixed onto a highly contrasting background. The delineation between the cut shapes and the background is created by the sharp contrast between them.

Figure 12–1.
San Painting of a Dance.
Rock painting.
From a copy by G. W. Stow. South African Museum, Cape Town, South Africa.

The action of the figures is vividly communicated through the animated simplicity of this silhouette drawing. Note how the placement, relative sizes, and occasional overlappings impart a quality of spatial reality to the grouping.

In his last years, when illness confined him to bed and thus narrowed the range of materials and techniques he could use, Henri Matisse, a twentieth-century French artist, limited himself almost totally to silhouette cutouts, and he refined this art to an exquisite degree of allusive elegance (Fig. 12-2).

Modified Silhouette Drawing

Rather than confining themselves to pure silhouette, artists generally add a few details within the shape formed by the enclosing outline to give relative definition and perhaps an element of decorative enrichment to the configuration.

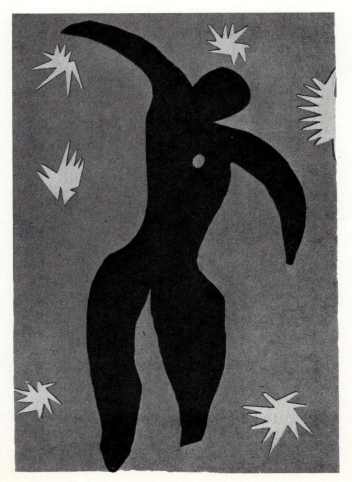

Figure 12–2.
HENRI MATISSE (1869–1954).
Icarus (1947).

From the Jazz series. Paper cutout.
© S.P.A.D.E.M., Paris/V.A.G.A., New York.

As in traditional silhouette, there are no interior details. Furthermore, since it is a frontal view, even the minimal personalization of a profile delineation is avoided. Yet the vigorous simplicity of the figure and the imaginative distortion of the contour lend the image an undeniable liveliness and energy, which relate it to San Painting of a Dance (Fig. 12–1).

Some contemporary woodcut artists, utilizing only the two contrasting flat values of the conventional silhouette, have produced a more complicated image than the traditional one by allowing not only the light shapes to enter the dark areas but also the dark shapes to enter the light areas (Fig. 12-3).

It is certainly possible to draw in silhouette or in modified silhouette from the model; however, with few exceptions, artists who choose the figurative mode in silhouette work conceptually rather than perceptually. On the other hand, Ben Shahn, a twentieth-century American artist, worked in a somewhat more perceptual vein, using a modified silhouette approach to figurative work done from memory or from his own photographs, for a greater, though limited, personalization of the model (Fig. 12-4).

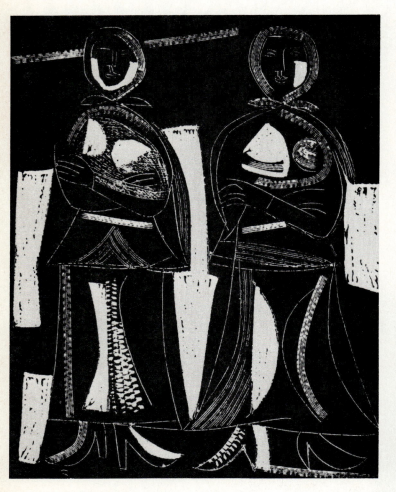

Figure 12–3.
LUIS SEAONE.
Woodcut.

In this conceptualized modified silhouette, the figures are described in thin white lines against a black background. Several flat white areas help reveal and define the configuration while establishing a strong and simple value pattern.

Figure 12–4.
BEN SHAHN (1898–1969).
Artists and Politicians (1954).
Brush drawing.
Private collection.

This silhouette contour is probably based on memory rather than on immediate observation. The stylized distortion gives the drawing an expressionist imprint.

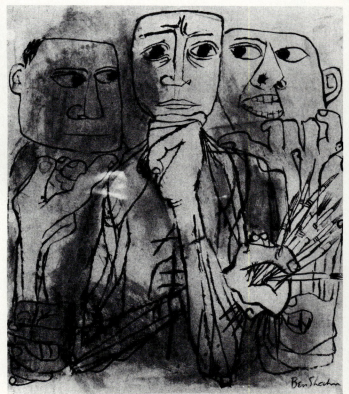

Contour Drawing

Contour drawing is a special way of perceiving and drawing the object or figure. When moving from gesture to contour exercises, a shift in concept and technique is necessary since gesture drawing depends on seeing the axial line or core of the figure; in contrast, contour drawing requires definition of the subject matter through its outer boundaries.

As the name implies, the contour delineates the figure through an almost tactile tracking of the visible outer and inner edges as they enclose the form in its natural space. It is easy to confuse modified silhouette drawing with contour drawing because there is an area where they seem to coincide: Both modes concern themselves with the edge of the form and are linearly conceived, but in contour drawing, there is always an indication of three-dimensionality, no matter how slight: a turning in of the line, a suggestion of the thrust or twist of the body, or a more naturalistic description of the figure and its relation to the space around it (Figs. 12-5 and 12-6). These basic differences are due to the fact that a contour drawing is a perceptual drawing; in fact, it is usually a very careful drawing, based on intense observation, whereas the silhouette drawing, as was noted, is usually a conceptual image done from imagination or memory and following certain traditional patterns, which give it a stylized appearance.

Figure 12–5.
HENRI MATISSE (1869–1954).
Study of a Nude.
Private collection.
©*S.P.A.D.E.M., Paris/V.A.G.A., New York.*

This study reads as a rapid silhouette contour. The line is beautifully sure, direct, and sensually expressive. Despite its delicacy, the drawing conveys a monumental quality. This is undoubtedly due to the composition itself, in which the figure fills most of the space, almost touching the edges of the picture plane on three of its sides.

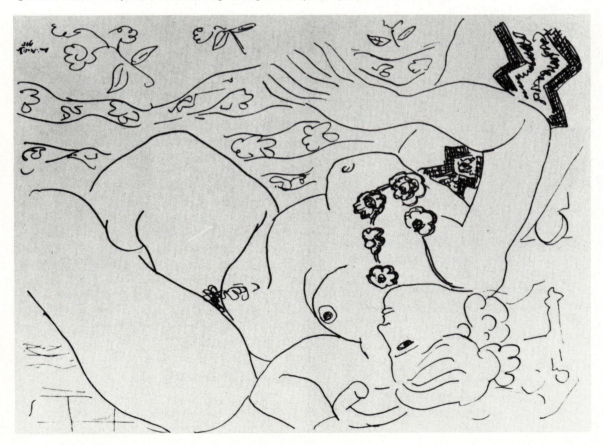

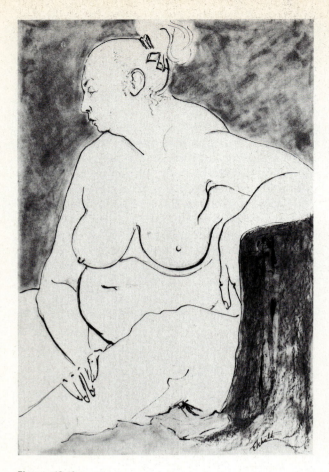

Figure 12–6.

M. ELSHETH, student.

This silhouette contour illustrates the skillful and sensitive definition of the figure by its outer contours. The line is sparingly and effectively used, and the presence of the figure is made more tangible by the importance given to the negative space that surrounds it through a simple tone contrast.

GENERAL CHARACTERISTICS OF CONTOUR DRAWING

Outer and Inner Tracks

The three-dimensionality of the figure is described in linear terms by tracking and tracing every directional change and turning of its edge as well as the perceived demarcations. This is done by enclosing the inner and outer contours of the form.

Looking Only at the Model

The artist looks at the model and not at the paper while drawing; in fact there is a quasi fusion of the process of seeing with that of drawing. If artists wish to verify their sketch, they should stop drawing to assess it and resume the visual and graphic tracking only when they look up again.

The Eye and the Hand

To insure a smooth, unbroken flow, the eye and the hand must be synchronized—moving at the same rate of speed—thus assuring the artist of a greater sense of perceptual unity.

One Part at a Time

Unlike gesture drawing, contour drawing is perceived and drawn one part at a time. This piecemeal approach makes it imperative to work with a method that is conducive to a smooth coordination between the eye and the hand.

The Tactile Sensation

Artists imagine that their charcoal, pencil, or pen are actually touching the contours of the figure as they sketch.

TWO BASIC TYPES OF CONTOUR DRAWING

There are two types of contour drawing—the analytical and the expressionist—with many subdivisions within these two broad categories. Although related to each other in that they both rely on the linear depiction of the form through the edges of its surfaces, they differ in intent; and this difference in intent dictates a difference in perceptual emphasis.

The analytical contour is generally methodical, is painstakingly observed and drawn, and requires great objectivity on the part of the artist. It is a slow process, requiring a sustained pose: at least thirty minutes and often much longer.

The expressionist contour is more spontaneous and more subjective. Unlike analytical contour, it allows the fusion of what is seen and what is emotionally felt. But the lines between the two categories of contour drawing are not hard and fast; in fact, an analytical contour drawing can convey great sensitivity, just as an expressionist contour can include much objectively observed information (Fig. 12-7).

Analytical Drawing

Depending on the emphasis given, contour drawing offers many variations, each representing a different way of perceiving and depicting the

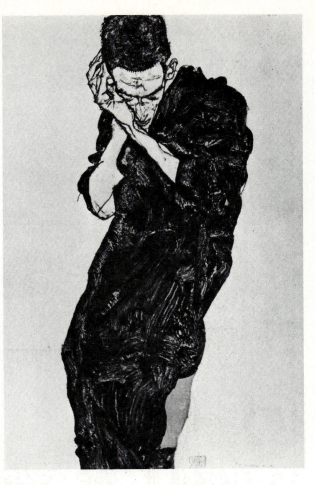

Figure 12–7.
EGON SCHIELE (1890–1918).
Young Man in Purple Robe (1914).
Gouache 12×19".
Mr. and Mrs. Hans Popper, San Francisco.

*This is an eloquent example of expressionist silhouette
contour. The diagonal slope of the figure adds to the
tension of an essentially very stark composition. The
disproportionally large hands supporting the angular
downcast head contribute to the emotional impact of
the painting.*

figure. The following, although far from exhaustive, is a brief overview of the basic types of analytical contour drawing.

Silhouette contour. It emphasizes the careful, slow, accurate, linear tracking of the outer contours of the form, combining it with an occasional inner contour, that is, a tracking of the form within the silhouette. As with all contour drawing, the artist does not look at the paper while drawing in order to keep the coordination of the eye and hand unbroken. The artist can check the accuracy of the completed drawing by going over it a second time in the same careful manner, perhaps in another color.

Cross contour. In addition to tracking and drawing the outside contours of the form, the artist defines the figure by the contour that moves across the form. This is accomplished in a series of zebralike lines that follow the directional changes across the whole surface of the visible form. It must be done slowly, methodically, and analytically in order to insure accurate observation and recording, thus avoiding the tendency simply to decorate the surface with inauthentic markings.

Compartmental contour. This kind of drawing concentrates on the large planes—frontal, side, top, bottom, and so on—by surrounding each with an outline. Even when there are no clearly defined lines on the figure, lines should be used to reveal the large planes (Figs. 12-8 and 12-9).

Figure 12–8.
ALBERTO GIACOMETTI (1901–1966).
Seated Nude from Behind (1922).
Kunsthaus, Zurich.

*This early drawing describes the body through
compartmentalized planes. Each plane has been
carefully scrutinized and delineated. Shading was
added to clarify the plane directions further.*

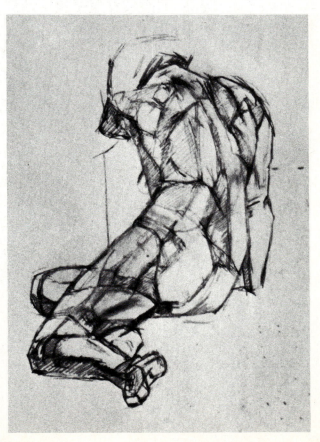

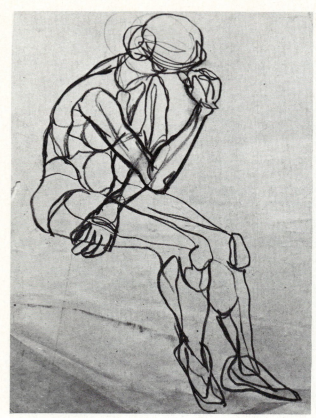

Fig. 12–9A

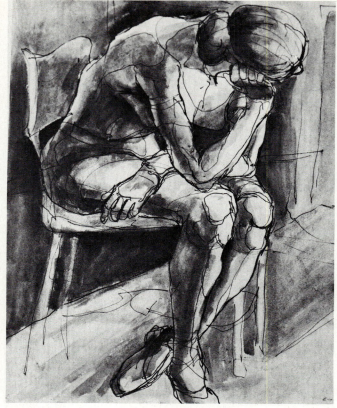

Fig. 12–9B

Figure 12–9.
EILEEN MATHENY, student.
These two compartmentalized contour studies were drawn from related poses. Figure 12–9a is a twenty-minute pose realized in charcoal; 12–9b, in pen, ink, and ink wash, was a one-hour pose.

Terrain contour. This is a drawing that follows the depths and projections of the surface of the figure through a series of concentric ovals, a kind of mapping of the figure.

Interlocking vertical and horizontal contour. This contour drawing utilizes an interlocking vertical and horizontal line to describe the basic protruberances and indentations of the form. This method was used very effectively by the British sculptor Henry Moore in some of his drawings (Fig. 12-10).

Extended contour. This is a highly detailed drawing of all the outer and inner contours, including the minor as well as the major ones. This form of drawing is done as if seen through a magnifying glass; it is executed slowly and analytically, taking at least an hour or two.

Expressionist Contour Drawing

Blind contour. This type of drawing is done quite rapidly, from a few minutes to five or ten minutes, without once looking down at the paper. Sometimes these drawings are executed with a blunt tool. Since the emphasis is not on objective and methodical analysis, the artist allows his or her feelings and reactions to infuse the quality of the line and the character of the drawing.

Gestural contour. This form of drawing combines the qualities of gesture and contour. It is related to gesture drawing in that it is done very rapidly (five minutes or less), freely, and spontaneously; but it remains a contour in that it seeks to define the figure through its enclosing lines and contours (Fig. 12-11).

Figure 12–10.
HENRY MOORE.
Family Group (1948).
Chalk, ink, and wash drawing.
Courtesy of the artist.

*In this contour drawing, the figures are stated through
interlocking planes.*

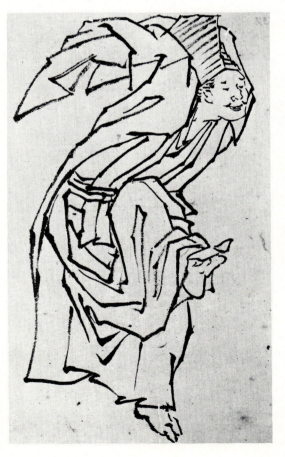

Figure 12–11.
A Sambaso Dancer.
Japanese painting, Edo period, Ukiyoe school,
Hokusai.
Courtesy of the Freer Gallery of Art, Smithsonian Institution,
Washington, D.C.

*In this contour drawing, the boldness and vigor of the
stabbing lines emphasize the animation of the gesture.*

Alternating contour. This exercise, suggested by Philip Wigg in *Introduction to Figure Drawing,* represents a challenging way of modifying the perception of the figure. Whereas traditional analytical contour requires an unbroken eye flow along the outlines of the form, coordinated with an unbroken line flow, this exercise demands relating one edge of the form to the other. It is done by stopping the process of drawing along a given edge, shifting the tool without looking to the opposite side of the form, continuing the drawing, and then switching back to the original side to complete the drawing. This process permits some portions of the outline to remain open, giving the onlooker the opportunity of connecting the gaps visually.

OBSTACLES AND SOLUTIONS

The tracking of the outer silhouette is not too difficult because there is a definite edge between the figure and the background that can be seen and recorded clearly. The tracking of the form within its outer edges is not so simple because the inner contours are not always clearly legible. However, there are some visual clues: The planes or surface directions are delineated by the muscle structure as well as by highlights and shadows, and the folds and creases of the body can be tracked linearly. The artist needs to observe and record all the subtle clues and to guard against the tendency to resort to the unauthentic solution of putting down lines haphazardly.

I have found that an effective transitional solution to this problem is to clothe the model in striped leotards and tights, which I also use to facilitate the understanding of foreshortening. The lines of this outfit follow the contours of the body and delineate them, also following the cross contours. The artist is better able to follow the directional changes within the figure. Great care must be taken to stay in constant visual and manual coordination between the line that is tracked visually on the body and the line that is drawn (Fig. 12-12).

Another leotard and tights can be modified with a series of thin vertical and horizontal lines or stripes, forming a grid. This helps the artist track and draw the subtle changes in direction on the figure, both horizontally and vertically. After these costumes have been used as clarifying devices, the same exercises are done without them, keeping in mind that all visual aids are only a means to an end, like the training wheels of a bicycle.

When engaged in blind contour drawing, the temptation is to look down at the drawing while sketching. To block this tendency, it might be a good idea to draw on the second sheet of the sketching pad, with the cover sheet shielding the drawing from view. Another safeguard may be to draw with a white wax crayon on white paper so that the drawing is not easily decipherable. After completion, a wash of India ink is brushed over the drawing, thus revealing it more clearly.

Since the artists cannot look at their drawing, problems of faulty proportion often arise. These can be avoided to some degree by making and using a light preliminary core line as a substructure, which can be referred to from time to time

Figure 12–12.

Student work.

Cross contour in charcoal and ink.

The observer can follow the surface directions of the figure by tracking the horizontal stripes of the leotard worn by the model. Soon the beginner is able to understand and describe the curvature and directional shifts without the help of any such devices.

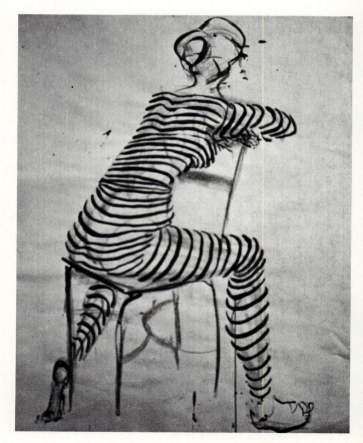

during the process of drawing. However, if the artists are trying to break loose and become freer, the core line is not necessary; the very act of drawing without looking at the paper can elicit a more forceful expression.

The curious thing about blind contour drawing is that not only does the beginner often obtain encouraging results but also the same activity can loosen the technique of the practiced draftsman who wishes to work in a less restrained manner.

SUGGESTED EXERCISES

Exercises in Silhouette

The light from behind. The model poses with a strong light coming directly from behind. This light tends to obscure the detail between the two outer edges of the figure, reducing it to a silhouette. Make a series of sketches in charcoal on bond paper from different poses; fill in the silhouette so that it appears as a simplified dark shape.

A day in your life. On a sheet of nongrainy white paper draw two concentric circles with a compass, using the same central point. Space the circles 2½″ apart; the inner circle is to have a 2″ radius. Using the inner circle in your baseline, draw a series of figures in silhouette describing a day in your life. The format will emerge as a circular band of figures. Looking at a book of figure silhouettes such as those used in the Olympics may be helpful before embarking on this assignment. Blacken the silhouettes for strong dark and light contrast between figures and ground. Or ink in the background, leaving the silhouettes white.

Light in dark, dark in light. Draw a three-quarter length costumed figure with a vase of flowers near by. Place the emphasis on patterning with large, flat black-inked areas within the figure. Introduce some white linear patterning in the black areas and some black linear patterning in the white areas. The result should have a woodcut quality. A study of woodcuts before starting the exercise may clarify the desired effect.

Preliminary Exercises in Contour

As a preparation for analytical contour, the beginner may wish to try the following exercises which are executed on top of magazine photographs.

Compartmental contour. Find three large and clear photographs or reproductions of heads with strong shadows and highlights. Using pen and ink, outline the principal planes or surface directions in space. In the shadowed areas, white ink could be used for greater clarity.

Do the same exercise with a photograph of a figure. If drawing on the photograph itself is precluded, the exercise can be done on a very thin sheet of transparent paper placed over the photograph.

Cross contour. Using another or the same photo of a head, carefully and slowly draw a series of horizontal lines across the form, following the surface contours as faithfully as possible. Be aware of all the subtle changes in the surface directions. The lines are to be spaced about ¼″ apart.

Do the same exercise with a photo of a nude figure. Refer to the explanation and illustration.

Terrain contour. Find a large, clear photograph of a face in a photography magazine. Use a series of concentric ovals, each one overlapping the other, to suggest progressive depth. Each projection of the form is depicted through another series of concentric ovals; it is a kind of mapping of the hollows and protruberances of the form.

Do the same exercise with a large photographic reproduction of a full figure.

After having worked *on* photographs, do the same exercises *from* the photographic reproductions.

Exercises in Analytical Contour

Traditional contour. Using a relatively nongrainy paper, place the pencil or pen on the drawing surface and fix your eye on one part of the figure; then, slowly and methodically, try to coordinate the hand, moving the pencil on the paper, with the eyes, carefully following the contours of the figure. The emphasis is on the outer edges so that the result is a carefully detailed silhouette. Occasionally, there is a slight turning of the form and the line, suggesting an element of depth, but the general effect is that of a relatively flat image (Fig. 12-6).

Again, do not look at the paper while drawing. You can stop and look down to relocate the pencil or pen point, but you must resist the temptation to look and draw in a piecemeal, fragmented fashion. It is beneficial to draw in as continuous and unbroken a line as possible, with an unbroken eye flow. This type of drawing is done slowly and searchingly. The more analytical the contour drawing is, the more time you need for a searching and probing tracking. The time for the

exercise may vary, but a half-hour is the minimum. Some participants may need two hours for such a study. Occasionally, you may backtrack over the same drawing, still without looking, as a further check for accuracy and control. It is good practice to do contour studies not only of the full figure but also of parts of the body—hands, feet, arms, and so on—for detailed linear analysis.

Cross contour. In addition to drawing the outer contour of the figure, track the inner contour, which runs counter to the form, to describe all the subtle concavities and convexities that are part of the surface of the body. Line by line, the cross contour is carefully recorded, imparting a zebralike effect to the drawing. Take care to ensure that each contour line is as authentically descriptive as possible, and guard against an easily attained, decorative, nondescriptive line. This requires careful observation recorded by a slow and methodical linear tracking. The cross-contour line, which does not represent the demarcation line between the form and the space next to it, as a silhouette drawing does, requires a particularly searching kind of observation; to a degree, it is an arbitrary line, but it follows and maps the subtle changes of the surface of the body.

As described on page 182, a very effective device to acquaint the student with the perceptual concept and method involved in cross contour is a horizontally striped leotard and tights worn by the model. This type of garment helps the beginner understand the point of the exercise since the stripes wrap themselves around the body, following the cross contours of the figure and making them readily visible. After some preliminary drawing exercises with the leotard, the participants can work from the nude model, the leotard having served its intended purpose. Occasionally, the artist finds it valuable to build first a wire sculpture of his model by following cross-contour outlines and then translating this sculpture into a cross-contour drawing (Figs. 12-13 and 12-14).

Figure 12–13.
KIM RECTOR, student.
Wire sculpture.
The model stand was partially rotated every twenty minutes so that the participants were able to see all sides of the figure while they were constructing a thin wire sculpture based on cross-contour definition.

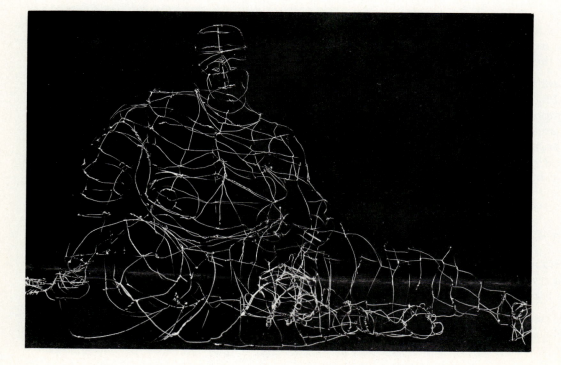

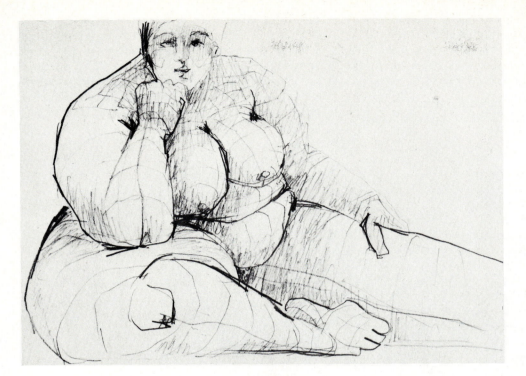

Figure 12–14.
PATRICIA TREMBLAY, student.
This drawing was executed from a wire sculpture that was used as a preliminary study of the cross contours of the figure.

Compartmental contour. Analyze the figure of a nude model in terms of the large planes: top, sides, front, and bottom. These are to be enclosed in line, even if the lines do not actually appear on the model. Folds in the flesh, an appearance of the bone or muscle structure, shadows—all help to delineate these basic changes of direction. Since the figure is complex, made up of small as well as large planes, the artist must make a few arbitrary decisions. In this exercise there is a tendency for students to "box" the figures in, taking their first faltering steps in "cubifying" the figure.

Terrain contour. After drawing in the main outlines of the figure, concentrate on the "mapping of the figure"; that is, the declivities and projections are analyzed by a series of concentric overlapping ovals. Wherever there is a projection, there will be another series of concentric ovals; the areas between the projections become the valleys.

Interlocking vertical and horizontal contour. After studying some of Henry Moore's contour drawings, make a standard contour drawing of the model. Then analyze the inner contours through a series of vertical and horizontal, shinglelike, interlocking contours within the boundaries of the figure. Use a white wax crayon on these inner contours and then throw a wash of light grey over the top of your drawing. Refer to the illustration on page 181.

Magnified contour. This contour study emphasizes detail. It is to be done as if looking at the model through a magnifying device, trying to depict every detail of the boundary lines of the outer and inner contours, including minor lines and textures. This study, which can easily take two hours to complete, can be done in pen and ink.

Exercises in Expressionist Contour

Blind contour. Make a series of three- to five-minute drawings in continuous line, emphasizing the outer edges. Draw in pen and ink without once looking down at the paper during the whole drawing process.

Gestural contour. Do a series of contour drawings of the model, five minutes each, emphasizing the expressive body features. Do not hesitate to exaggerate the main characteristics, even to the point of slight caricature (Fig. 12-15).

Alternating contour. Although not a true contour, this exercise still relies on a careful tracking of the outer edges of the figure, but the line that defines this edge is stopped at arbitrary points and is continued in the same direction on the exact opposite side of the body or limb. Then again, it switches back to the original side. Draw this open-and close-edged form without looking down at the paper.

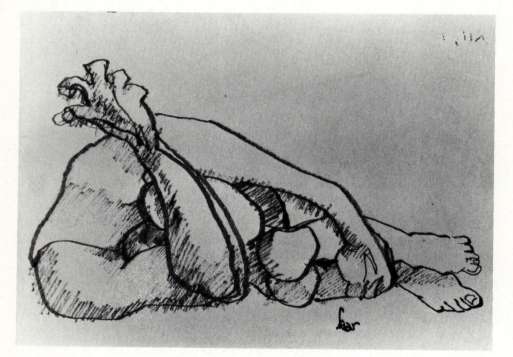

Figure 12–15.

Student drawing.

Expressionist contour, five-minute study.

Exaggeration was purposefully used to heighten the emotional response.

CHAPTER THIRTEEN

Indeterminacy:
Seeing by Masses,
Blurring and Dimming,
and Incompletion

A STATE OF MIND

A Kind of Metaphor

My drawings inspire and are not to be defined. They determine nothing. They place us, as does music, in the ambiguous realm of the undetermined. They are a kind of metaphor. . . .

<div align="right">Odilon Redon</div>

Should Be Suggestive

I do not believe that art should be explicit. It should be suggestive and ambiguous so that the viewer has to enter in.

<div align="right">Balcomb Greene</div>

Indeterminacy is a state of mind and a way of visual representation that views the figure or subject in a general state of flux—in the act of forming, moving, growing. Therefore, the forms are somewhat underdefined and not fully crystallized.

Through poetic evocation, the artist attempts to define the undefinable, using blurred, vaguely suggested forms, incompleteness, and partial concealment.

When viewing and interpreting such works, onlookers are called on to project their own imagination and sensitivity in order to complete the incomplete, define the blurred or dimmed, and uncover the concealed. However, the indeterminate quality of the configuration should not be too

extreme, lest the visual clues become so hidden and tenuous that the composition loses its coherence and meaning for the viewer.

In this chapter, some ways and means of perceiving and drawing the figure through indeterminacy will be introduced: seeing and drawing by masses, blurring and dimming, and incompletion.

SEEING AND DRAWING BY MASSES

No Lines in Nature

. . . but where do they find these lines in nature? I can only see luminous or obscure masses, planes that advance or planes that recede, reliefs or background. My eye never catches lines or details. . . .

<div align="right">Francisco Goya</div>

The most basic of these means is the perception of the human body by its mass, by its inside core rather than by its edge. Thus, the figure is drawn from the inside outward, from its skeletal core to its fleshy exterior.

Drawing the figure by its mass is often associated with the painterly approach because the figure is modeled in gradations of light and dark, whereas drawing by the edge is usually associated with a draftsmanlike quality. When working in masses, the artist soon becomes aware of the figure's weight, volume, and three-dimensionality.

Open Form

Through this type of perception and execution, the edge, of necessity, will be somewhat indefinite; this quality often helps to achieve greater unity with the space surrounding the figure. In contrast to contour drawing, where a continuous line surrounds the form, in mass drawing, portions of the outline are omitted, creating what is called *open form*.

When the light areas of the figure (such as the highlights) merge with the light areas of the background, and the dark areas of the figures (such as the shadows) merge with the darks of the background, new shapes are created through the mergings, adding a pattern of lights and darks that is both part of and yet independent of the figures.

This leads to a greater awareness of the interrelationship of form and space and to a greater consciousness of structural elements than does the purely linear approach.

There is a distinct affinity between gesture drawing and perceiving and drawing through masses. In fact, the extended gesture exercise leads directly to drawing by masses since it usually starts with the core of the figure, and the volume is superimposed by various nonlinear means.

Drawing by masses is unquestionably related to the works of certain baroque, romantic, and impressionist artists. Among the numerous masters who worked in this vein are Rembrandt, Tiepolo, Goya, Delacroix, Daumier, Seurat, and, closer to our times, Hyman Bloom and Rico LeBrun (Figs. 13-1 through 13-4).

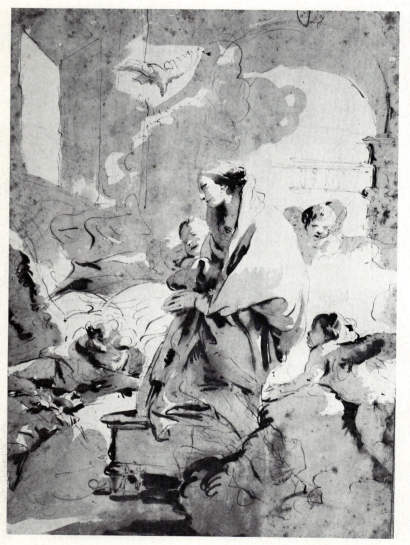

Figure 13–1.

GIAMBATTISTA TIEPOLO (1696–1770).
Annunciation (c. 1750).
Cooper Musem, New York City.

The composition allows for blank or open spaces that act as restful areas, much as silences do in music. Sometimes this compositional device is referred to as "letting the paper breathe." The open spaces of the background combine with the lightest areas of the figure, forming larger shapes that straddle the figures and the background. This also happens with the middle tones, whereas the darkest tones serve as accents.

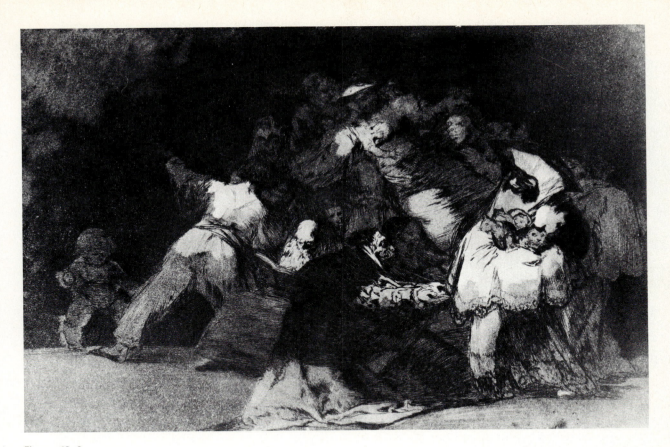

Figure 13–2.
FRANCISCO GOYA (1746–1828).
Disparate General.
Etching and aquatint.
Norton Simon Museum, Pasadena, Madrid.

A tightly knit conglomeration of seemingly unrelated, floating, standing and kneeling figures, infants, and cats. This indeterminate mass of figures forms a compact circular composition.

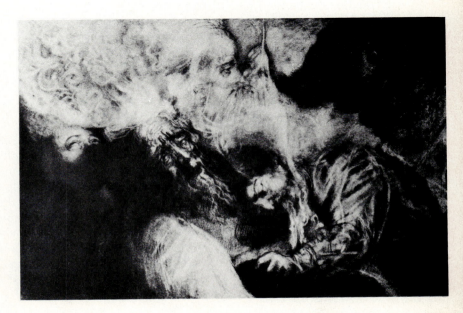

Figure 13–3.
HYMAN BLOOM.
The Seance (1954).
Charcoal and white chalk.
Philip and Deborah Isaacson Collection.

These merging, indeterminate, mystical heads emerge from deep shadows and misty lights like images appearing and disappearing in moving clouds.

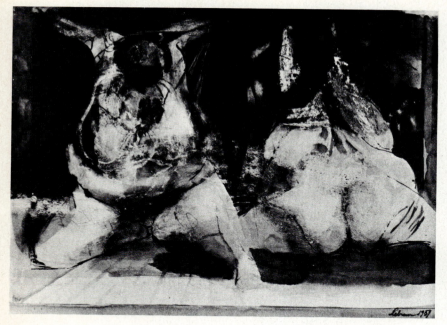

Figure 13–4.
RICO LEBRUN.
Casualties (1959).

Ink wash and wash resist.
Collection of William H. Lane Foundation.

This is a powerful study of two massive bodies trussed up like the carcasses of slaughtered cattle and slumping under their own dead weight. The composition, which fills the frame with these undefined but disturbing figures and excludes relieving background props or any other visual distractions, intrudes forcefully on the consciousness of the viewer by intensifying all the dramatic elements of the configuration.

The drawing techniques most commonly used in this approach are the fine scribble, wash drawing, crosshatch, and pointilism. It is undoubtedly wise to do some preliminary practice with these techniques before starting the suggested exercises.

Suggested Exercises

Merging figure and ground: modeled drawing. With charcoal, mass in a figure on 18 × 24″ grey charcoal paper. Use the side of the charcoal stick rather than the point, pressing gradually harder to obtain the darkest areas. Add dark areas in the background space next to a shaded area by the edge of the figure, combining dark areas of figure and space into a larger indefinite shape. Lighten the background space adjacent to some highlights in the figure with chalk or white pastel, creating additional mergings of figure and ground (Figs. 13-5, 13-6, and 13-7).

Modeled drawing of head: crosshatch. Draw a portrait lightly in pencil on illustration board or moderately grained paper. Starting in the negative space behind the shadow areas, crosshatch in pen and ink. The darkest tone (therefore the most dense crosshatching) will be closest to the outline of the head, and it will be less dense (therefore lighter) as it moves farther from the head. Use pen and ink to model the head, still crosshatching in the shadow areas, gradually building a three-dimensional quality.

Merging figure and ground: crosshatch. On moderately grained 18 × 24″ paper, make a light gestural drawing of the model in pencil. Start with the negative space behind the shadow areas of the figure, crosshatching in pen and ink. As in the preceding exercise, the darkest crosshatch will be closest to the figure, and it will become less dense and lighter as it moves away from the figure. Again, use pen and ink to model the figure through crosshatching, building a three-dimensional quality through the controlled gradation of its density. Allow the highlights of the figure to combine with the light areas of the paper, thus forming new and larger shapes of light areas.

Modeled wash drawing. Set up a strong light source emanating from one side in order to create a definite light and dark pattern. Using a mirror, block in lightly a self-portrait in pencil.

Mix water and India ink in a small, shallow container to produce a light grey tone. Brush in all areas that are to be middle-toned and dark. While the paper is still wet, add a slightly darker wash tone where needed; continue the process, keeping the paper moist. If the paper dries, add a wash of plain water and continue to add the dark areas. This is the wet-into-wet process, which produces graduated tones with very few hard edges. If so desired, a few ink lines for accenting may be added.

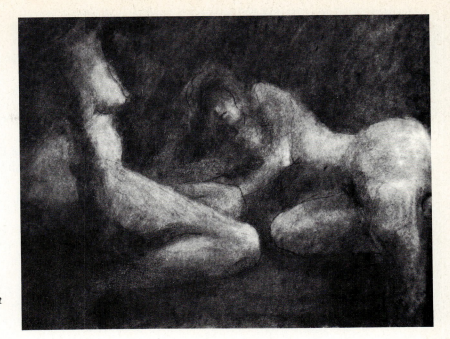

Figure 13–5.

TOM HUGHES, student.

Figure Composition

Charcoal and ink.

This study accentuates the sense of mass and weight through open form, blurred edges, and partial mergings of form and space.

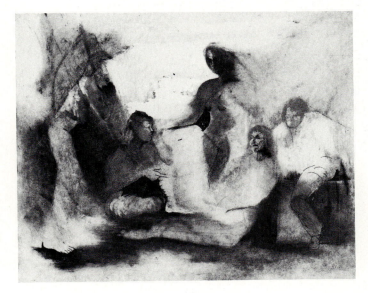

Figure 13–6.

CYNTHIA ROGERS, student.

Charcoal and ink.

This multifigured composition was conceived and stated in open form, with partial fusions of figures and ground. The poetic mood evoked by the subtle value blendings and mergings is one of mistiness and serenity.

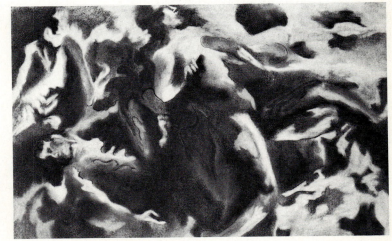

Figure 13–7.

CYNTHIA ROGER, student.

Charcoal and ink.

Turbulent though unified, this composition is based on a flamelike pattern, whereby the figures seem engulfed by violent natural forces. The dynamic and contrasting overall value pattern emphasizes the interchangeability of form and ground.

After having mastered the wash drawing self-portrait (or portrait of a model), try the same technique with the figure.

The wash drawing technique requires preliminary practice and great care in handling; however, the rich results possible make the effort quite worthwhile and rewarding.

Note: In each of the preceding exercises, I suggest that the beginner have the figure touch the edges of the paper on three sides; this tends to ensure filling the space more effectively and counters the tendency of the beginner to use too little of the drawing surface.

BLURRING AND DIMMING

Artists who squint their eyes when looking at a subject before drawing or painting it are, in effect, simplifying the image they see by eliminating the details and blurring the edges. In this way, they are able to see the inherent unity in the composition more readily.

A number of devices can help artists blur the image, for example, translucent screens placed in front of the model, dimming of lights, and out-of-focus slides.

A Symphony in Grey

The figure seen in a misty environment is similar to that seen in semidarkness. One is a symphony in light tones; the other, in dark tones. The simplification of the forms and the fusion of figure and space in some areas combine to impart a mysterious and evocative quality to the composition, an overall unification, reminiscent somewhat of ancient Chinese landscapes. Because the demarcation line between figure and ground is not quite clear, a greater demand is placed on the viewers, thus engaging their own creative imagination in the process of perception (Fig. 13-8).

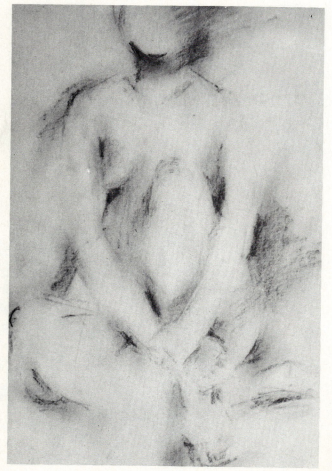

Figure 13–8.
SHARON MILAN, student.
Charcoal.

Without any hard edge or enclosing lines, the configuration is indicated through its "passages" (the negative spaces between parts of the body and the spaces contiguous to it). Suggested rather than fully stated, it allows the viewer to complete mentally the poetically undefined image.

The Common Denominator

When the image is seen out of focus, whether by blurring, dimming, or squinting the eye, it is reduced to its common denominator—light and dark patterns—regardless of the subject matter, which is partly obliterated. An indeterminate screen is formed, which allows the artists to project whatever forms they wish into the vague tonal configurations, creating new images from the original visual stimulus.

Suggested Exercises

Magic doors. One very effective device for creating a blurring effect is the shower door. The more such doors one can find and collect, the more interesting the possibilities because of the great variety of glass textures available. The pattern in one type of glass changes the appearance of the figure into a series of small planes, reminiscent of Cézanne's work, whereas another presents a small beady texture, which breaks up the figure into a pointilist blur; yet another is composed of vertical parallel stripes, which fragment the image into a series of vertical lines of varying widths. This is just a partial description of the various types of shower doors available, and each one seems to transform the figure differently (Figs. 13-9 and 13-10).

If glass shower doors are used in a classroom or studio setup, it would be advisable to have three shower doors and three models, each facing in a

Figure 13–9.
Student drawing.
Brush and ink.
The impressionistic blur is caused by the interposition of a textured glass shower door between the model and the artist.

Figure 13–10.
Student work.
Pastel.
Viewed through a textured shower door, the model is perceived as made up of a series of small facets. Interpreted in this manner, the technique is somewhat reminiscent of Cézanne's approach.

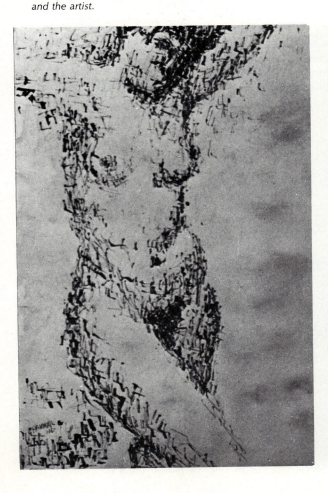

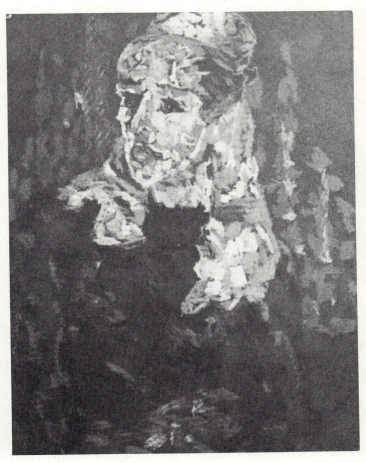

different direction, so that every participant may readily see the subject. The alternative is to have only a few participants working on this exercise at one time.

Translucent overlapping screens. Occasionally, a series of overlapping translucent screens made of thin cloth, clear plastic, or wire mesh can be suspended from the ceiling, with enough space for the model or models to pose between them. This results in a kind of spatial ambiguity, rich in potential variations of the human figure.

An interesting variation can be achieved by suspending a cycloramic cloth from the ceiling. (Cycloramic cloth is an opaque material used in the theater as a frontal- or rear-projection screen.) Models and students can create grouping close to and behind this curtain, while colored spotlights are placed about three feet behind them. The artists position themselves in front of the screen. When correctly arranged, this setup projects very exciting overlapping colored silhouettes, which the artists sketch in pastels or wax crayons or photograph for subsequent drawings. The fact that the models appear as overlapping reflections of silhouettes allows much freedom in the drawing and elaboration of the figure (Figs. 13-11 and 13-12).

When the person or persons responsible for this kind of setup have become familiar with it, additional elements, such as large scraps of open-weave material, can be partially draped over the

screen and props can be placed between the models in order to add to the spatial interest and the enigmatic quality of the projected configuration.

Out of focus. If good slides of models are available or can be prepared, they can greatly facilitate the understanding of the concept of indeterminacy through blurring. Simply project the slide on the screen and then take it out of focus; draw the resultant blurred image in tones of grey.

Metamorphic interchange. Sometimes, to make the problem more challenging, the slide of a still life or landscape is projected and put out of focus. Make a value analysis in charcoal; then after looking for hints of suggested figures in the pattern, transform the out-of-focus image into a figure composition, using charcoal and eraser. This problem helps you to see how the indeterminate screen can be transposed, how one subject matter can become another without losing the unity of the original light and dark pattern.

To the point. Because of its inherent smallness, the point lends itself very well to the application of the concept of indeterminacy and suggestion. The concentration of dots in a given area and the sparse use of them in others creates value gradations and three-dimensionality. The overall use of points or dots imparts not only a misty, open quality but also a vibrating surface, as evidenced in the drawings of Seurat (Figs. 7-25 and 7-26).

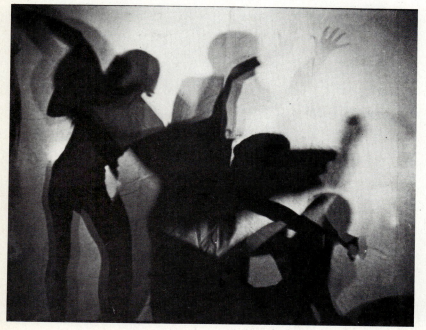

Figure 13–11.

Photograph.

A group poses behind a rear projection screen. Indeterminate configurations are produced by the utilization of overlapping silhouette forms and blurred edges. The blurring is achieved by placing some of the models farther than others from the screen.

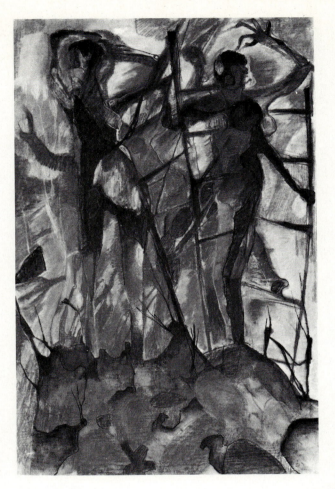

Figure 13–12.

Student work.

Pastel.

This study is based on a rear-projection setup. The proportions of the figure are purposefully exaggerated; except for a few details within the silhouettes, the general impression of indeterminacy is maintained. Brilliant colors are used.

Make a pointilist study directly from the model, using a series of dots stamped with a small dowel stick and a stamp pad. Pay attention to the graduated concentration of dots to obtain the illusion of three-dimensionality.

It may be profitable first to practice the technique in itself, then in a portrait or self-portrait, before attempting a full figure or figure composition. Any technique involving the point as a unit of drawing may be used: brush, pencil point, stamped impressions, and so on.

A paper mosaic collage made from small pieces of torn or cut paper or from paper confetti obtained with a punch is a variation of the

problem. Better results are obtained in this technique if the paper mosaic is based on a fully developed drawing, already well modeled in black, white, and grey.

The impressionist scribble. Like the dot, the scribble technique is well suited to the application of indeterminacy. In both cases, the emphasis is on mass rather than on definition of edge. Delicately handled, with conscious care given to the reflected light on the subject, the result is reminiscent of a modified impressionism and can serve as an excellent prelude to painting.

As an initial exercise to become acquainted with the technique, draw a portrait or self-portrait in Conté crayon or charcoal on middle-tone charcoal paper and define the shadow areas and middle tones with a fine scribble of varying density. Indicate the highlights with a delicate scribble in white chalk or white Conté crayon. This problem can be followed by similar studies of the partial or full figure (Fig. 13-13).

Figure 13–13.

Student work.

Pen and ink.

This impressionistic scribble was made with diluted ink and accented with stronger solution ink.

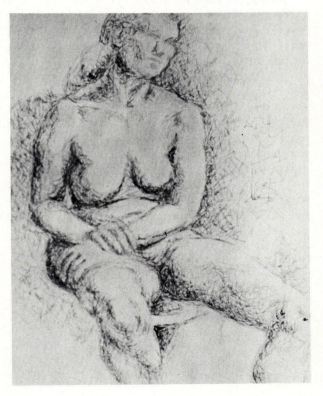

Sensitizing the eyes to darkness. In order to break the habitual pattern of seeing and drawing, occasionally I ask my students to work in semidarkness. At first, one sees very little, but as the eyes get accustomed to the dimness, the image emerges more clearly, and with practice, visual perception is dramatically increased.

Utilizing a dimmer, direct a light on one side of the model. The model is enshrouded in a curtain of semidarkness, except for the glowing highlight, the total effect being a dramatic and mysterious mood. With the dimmer, progressively lower the light with each exercise, until there is just one faint light on the model. In order to see the drawing surface better, especially for longer poses, attach small, long-lasting flashlights to the easels. Tone the drawing sheet with charcoal, use an eraser to pull out the highlights, and add charcoal in the shadow areas.

By now, the reason for working in semidarkness must be fairly evident. It seems to induce a more creative twilight atmosphere, giving the imagination a freer rein.

Through a glass, darkly. It is most interesting to draw while wearing dark glasses or to look at the model reflected in a dark mirror. Such mirrors are available in most department stores. In both cases, viewing through a dark glass tends to reduce the colors to greyish tones and to simplify the value pattern, creating a ready-made tonal harmony. The American artist Balcomb Greene occasionally drew from the reflection of the model in a dark mirror for this very reason.

You can also use juxtaposed mirror squares glued to 1' boxes. Arrange the boxes to reflect part of or the whole figure. This setup represents a further means to view the figure in unaccustomed ways. It is even possible to use regular mirror squares along with black mirror squares to further estrange the familiar look of the human figure.

Again, remember that these devices, although creative in themselves and sometimes very helpful in the realization of a given pictorial problem, should be used sparingly. The devices are just what they are: a means to an end.

INCOMPLETION

The Haiku of Drawing

The objective of incompletion is to say the most with the least, to suggest and evoke rather than define, to simplify, to extract the essence of the form and meaning. In choosing to express themselves through poetic evocation, the artists severely limit their means to a highly concentrated statement, in a kind of haiku of drawing.

Simplicity is beguiling. It is extremely difficult to achieve, and it involves a complex process of elimination to retain only the most significant. However, when successfully achieved, the very incompleteness invites viewers to complete the image in their mind. Therefore, the image is constantly changing, depending on the experience, the sensitivity, and the mood of the viewer almost as much as on the skill and sensitivity of the artist (see Figs. 8-23 and 13-8).

Many laypersons and would-be artists, conditioned by the need to identify and categorize, might find these concepts somewhat upsetting. The first question that might come to mind would be this: What is it supposed to be? In order to get into the proper frame of reference, one should be concerned first with a personal response to the forms themselves rather than with categorizations. The image will eventually emerge, provided the artist has left the significant clues.

Restraint and Understatement

Although there have been instances to the contrary, by and large most visual statements made with the concept of incompletion in mind illustrate the use of restraint and understatement: in the number of lines, the use of empty space, the number and subtleties of values, the limiting of colors, and sometimes even the understatement of emotion (Figs. 13-14 and 13-15).

The Ancient Chinese and Cézanne

Whenever we study indeterminacy in relation to incompletion, the ancient Chinese painters, who were masters of evocation and suggestion, come inevitably to mind. In times closer to our own, we can think of Cézanne who was a consummate master of these means (Fig. 13-16).

When individuality and originality are prized as ultimate artistic goals, it may disturb some people to rely so heavily on the study of one master: Paul Cézanne, in this case. Yet such a study can be an effective shortcut to learning and understanding, and as Picasso often said, we should not be afraid of copying, because we can't, anyway. Almost every serious artist started by studying the works of other masters (Fig. 13-17).

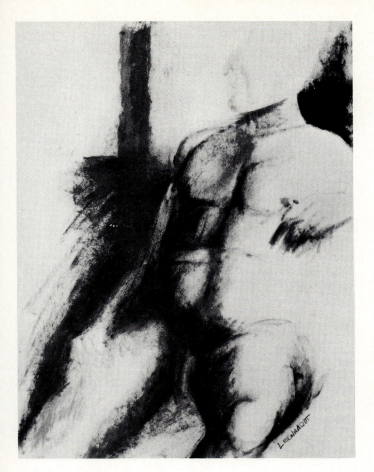

Figure 13–14.
JAMES LEONHARDT, student.
Charcoal.

This is a successful example of incompletion. Although parts of the form are stated through modeling and a tonal treatment of the volumes, others emerge from the definition of adjacent negative spaces; still others are left indeterminate and open, to fuse with the background. Paradoxically, the total configuration imparts a sense of volumetric solidity.

Figure 13–15.
ADRIAN SANTANA.
Ink.

This illustrates incompletion and closure: A few minimal linear suggestions, a few darker accents, and the figure is legible and evocative.

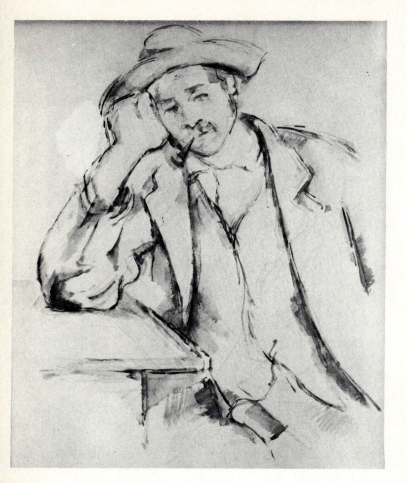

Figure 13–16.
PAUL CEZANNE (1839–1906).
The Smoker (1895–1900).
Barnes Foundation, Merion, Pennsylvania.

*With minimal visual clues and a segmented outline
that does not enclose the form, Cézanne has intimated
both the solidity of the figure and the spatial
transitions or "passages" that indicate spatial
relationships. There is something quite magical in the
volumetric presence and sense of completeness
expressed so elliptically.*

Figure 13–17.
ELIZABETH TOKAR, student.
Watercolor.
*This is an attempt to understand and apply Cézanne's
use of incompletion in formulating the image.*

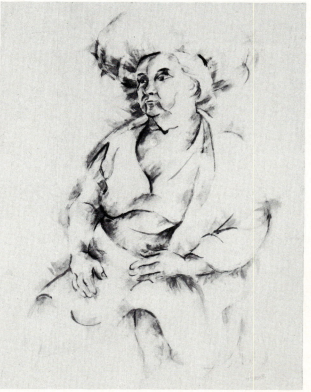

The Substance and the Shadow: Positive and Negative Form

In the spirit of the best examples provided by the exponents of masterful incompletion, a continual effort is made to stress the unified totality rather than the isolated object and to reveal the positive force of the negative space. Like an electric charge, both the positive and the negative currents are necessary to make the picture complete. The nonexistent in things is just as important as the tangible in creating a state of balance and equilibrium. Some contemporary artists, like Larry Rivers, stress the negative spaces that surround the object and allow the positive forms to be basically revealed through the negative spaces.

The definition of form through incompletion raises the problem of transitions—also called *passages*—from the positive shape to the adjacent negative space because these transitions between object and space are the means by which the form is incorporated into the picture field.

All at Onceness

Simultaneity

I advance all of my canvas at one time, together.

Paul Cézanne

Working with the concept of incompletion in mind requires particular subtlety. It is often difficult to know at which point of the process the image is suggested enough and the whole composition balanced enough for the artist to consider the drawing or the painting finished. One good working rule is to bring up the whole composition simultaneously so that it emerges as a whole, even though many parts of the working surface are left purposefully untouched. As we have seen when discussing the principle of unity, such a method also helps establish the rhythm, unity, and total equilibrium of the composition. These qualities are more difficult to attain if one works on one part of the composition at a time.

Suggested Exercises

Erasing the unnecessary. After making a contour drawing in pencil, use the eraser to eliminate those portions that do not seem totally essential to the comprehension of the figure. The result will be a contour drawing with large parts of the boundary line missing, but with an immediately "readable" subject.

Discontinuous contour. First, with the side of a charcoal stick, indicate broadly the negative space around three areas of the body: head, legs, and middle. Then draw the outline of the figure in charcoal, fitting it to the negative spaces previously massed in. Whenever a part of the figure can be left undefined without hampering the comprehension of the image, lift the charcoal from the page and start the line again farther on; the result is a discontinuous contour drawing. Continue this process of starting, stopping, skipping, and starting again for about ten minutes. It is best to vary the length of the segments and that of the spaces between them in order to keep the configuration dynamic and visually exciting. Again, the purpose of this problem is to make the incomplete drawing appear complete despite the large breaks in the outline.

The negative as positive. The object of the following two exercises is to formulate the figure through its shadows or through its highlights only. Again, it is a matter of saying the most with the least, allowing the eyes and mind to complete the image.

In the first exercise, project a spotlight on the model from one side, creating strong contrasting lights and darks on the figure. Execute the drawing by massing in the shadow areas of the figure with ink and brush, leaving the light areas implied (Fig. 13-18).

For a variation, use white poster paint or white chalk on black or dark-colored paper to indicate the highlight areas, causing the surrounding dark background to appear as the shadow areas.

Suggested planes: parallel strokes. In this study, view the figure in terms of large planes. First, very quickly and lightly mass in these planes with the broad side of the charcoal stick to suggest the shadow areas. Then add parallel strokes in the shadow areas to denote the surface directions. Do not define the rest of the figure, which remains suggested only. This exercise is based on a five-minute pose (Figs. 13-19 and 13-20).

As a variant, start directly with the parallel strokes indicating the surface directions of the planes, without first blocking in the shadows.

Suggested planes and volumes. Using Cézanne as a guide, view the figure as a series of volumes made up of larger planes or surface directions, which in turn are made up of smaller planes or patches.

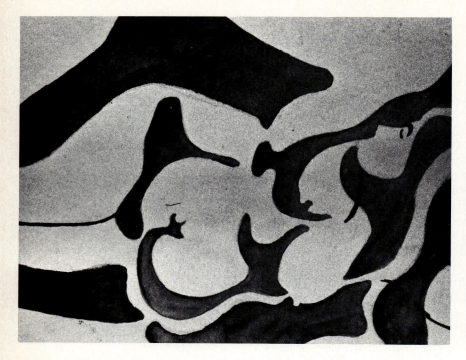

Figure 13–18.
ELIZABETH TOKAR, student.
Ink wash.
The problem was to state the figure through the interplay of positive and negative shapes: Shadow areas of the figure were combined with negative space areas, creating a strong contrast with the light areas within the body configuration and the light areas of the background. At first, the sinuous flowing shapes seem more abstractly suggestive than descriptive of the figure, but soon the viewer mentally connects and coalesces the abstract shapes into a decipherable human image.

Figure 13–19.
Student drawing.
Charcoal.
Parallel strokes are used to indicate surface directions.

Figure 13–20.
Student drawing.
Charcoal.
The parallel strokes defining surface directions are combined with massed-in shadow areas.

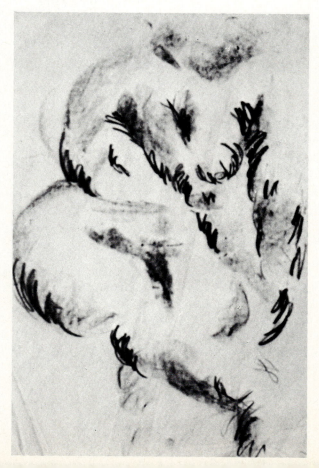

Start with a lightly penciled drawing of the figure. Dip a small wooden wedge (such as those that reinforce the corners of stretcher bars) into a highly diluted solution of blue-grey ink or watercolor. Drag this edge over a small area of the paper, starting in the negative space adjacent to the figure; this forms a small patch or plane. Repeat the process until there is a series of small planes tangent to the darkest areas of the figure, and sometimes in the spaces behind the light areas as well. When the first series of small patches is dry, superimpose additional small planes, overlapping the first ones patch over patch, the darkest ones closest to the figure, getting less dense and therefore appearing lighter as they are farther from the form. The shadow areas within the figure are treated in the same manner, patch over patch, forming small planes. Allow each series to dry fully before applying the next one.

Put the greatest concentration of patches in the transition areas—the passages—between the figure and the space behind it and in those areas that you wish to be the darkest. Leave the lightest areas totally untouched. In fact, leave much of the paper blank, the image being defined mostly by patches of suggested planes and volumes, which the eye then connects. This exercise, as it is executed here, is a direct prelude to painting.

Note: As always, the suggested problems are offered as possible springboards for further personal experimentation. In many instances, the combination of seemingly incompatible concepts and techniques yields unexpected and exciting results.

CHAPTER FOURTEEN

Indeterminacy:
Revealing by Concealing

The undraped figure can be beautiful and intriguing to work from, but too often the beginner tends to neutralize the image of the model into an academic sameness and uniformity.

Covering the figure in some unusual way, in whole or in part, can give it a kind of magical quality because our sense of imagination is brought into play. Thus, by concealing the form in different and uncommon ways, a new quality is revealed, not only in the model but in the artist as well.

As a teacher, I discovered the magic of the clad human figure through another art form, the dance, and I am especially indebted to the choreography of Alwin Nicolais. His dancers, clothed in imaginative costumes and coverings, which both reveal and conceal the figure in a most provocative manner, gave me the idea to experiment with similar qualities in the life drawing studio.

The physical means used are extremely simple: The model slips into a stretch sack, submerging him- or herself totally, and stretching the fabric tightly from elbows to head and from knee to knee.

The model has been instantaneously transformed into a strange, new, and ambiguous form, and the artist is confronted with an image known to be a person but not conforming to the archetype of the human figure. With dramatic one-sided spotlights, the figure appears disquietingly different—like a piece of living abstract sculpture,

creating a sense of visual and psychological disorientation (Figs. 14-1 through 14-5).

SUGGESTED EXERCISES:
HUMAN PACKAGES IN MOVEMENT

All participants are encouraged not only to sketch from the figure in the sack but also to take turns in shaping the bag. They sit in it, stretch, kneel, twist, lie down, and so on. They give free play to their imagination, as they evoke tree forms, amoebas, pieces of sculpture, and animals. Sometimes they remain stationary and sometimes they move, slowly changing the shape of the sack as they do so.

This active participation of the artists as models amuses and relaxes the group and also gives them the opportunity to be creatively involved in a total sense. Drawing, which too often is reduced to a kind of clinical discipline, becomes charged with an atmosphere of excitement. The hidden figure is now a hidden package, with lines of force, dramatic planes, and suggestive imagery, lending itself easily to breaking conventional modes of perception.

Within the basic setup, many variations are possible, depending on the ingenuity and the originality of both the artists and the models. The addition of background sounds, music, and readings can intensify the mood and inspire the models.

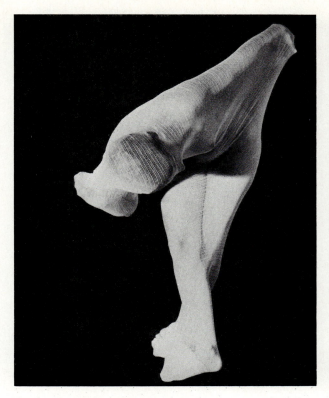

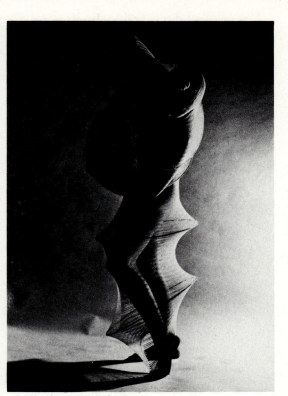

Figures 14–1 (left) and 14–2 (right).
Photographs of model in semitransparent stretch tubes.

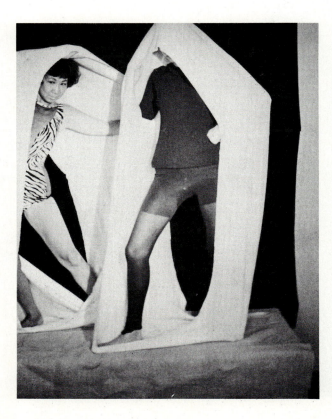

Figure 14–3.
Photograph of students in open stretch sacks.

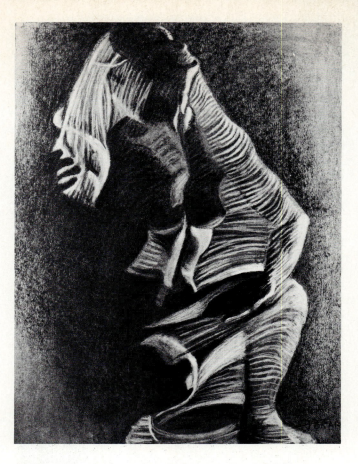

Figure 14–4.
ELIZABETH TOKAR, student.
Charcoal.
The crouching figure enclosed in netting is described in strong lights and darks and accented with cross-contour lines.

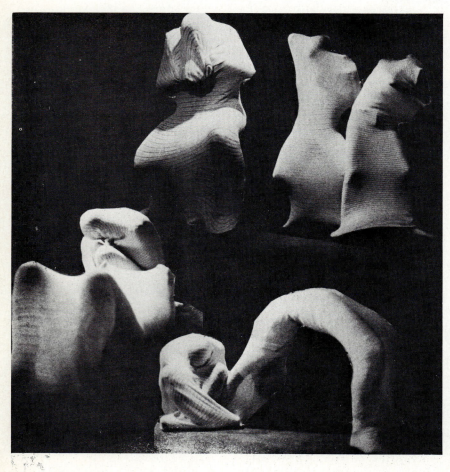

Figure 14–5.
Photograph.
Students in stretch sacks resemble living sculpture.

More than one model can be used at one time: two or three, for example, each in his or her own sack, reacting to the others, in a kind of bizarre dance.

Occasionally, two participants get into one larger stretch sack at the same time, leaving arms and heads exposed. This incongruous image looks surrealistically nightmarish (Fig. 14-6).

Instead of using sacks, a kind of dance can be performed by four people under a flowing sheet, leaving only the heads exposed; they can either move in unison or pull in different directions, while remaining connected by the flowing sheet.

In all these exercises, the artists sketch directly or take snapshots to be developed later into drawings. The drawings can be extended studies in any of the contour or volumetric approaches, paying close attention to the composition as a whole: the layout of the figure or figures to the page and to the total unity. The very fact that the figure is no longer seen as the expected body configuration allows the artist to be less intimidated, less bound by a preconceived image, and therefore more aware of form and feeling.

Drapery and Mood Evocation

A one-sided, dimmed spotlight is projected on one or more participants draped in black, flowing material with their heads hooded. Immediately, a dramatic, somber, mysterious mood permeates the setting (Figs. 14-7 and 14-8). Blank white masks further intensify the mood.

Make an extended ink study in continuous line of the draped figures, emphasizing the large planes; the changes of direction in the drapery; and its folds, hollows, and protruberances. Use a variety of line qualities: thick and thin, light and dark, multiple and singular, and so on. Then apply tones in charcoal to give the drawing greater depth and intensity.

Wet Drape

Occasionally (on a very hot day), a cotton sheet is soaked in water and wrapped around the model. The wet sheet sticks to the figure and reveals it in a sensual manner, and the artists try to capture this quality in their drawings.

Forms Within Forms

Another aspect of revealing by concealing deals with the concept of forms within forms: A model gets into a stretch tube, which is closed at both ends but open vertically in the front and back. The model can therefore be partially seen from the front of the sack and from the back. One or more participants, each in his or her own stretch tube, takes a gestural pose that is different from but related to the first. A few easels or other large

Figure 14–6.

Student drawing.

Charcoal.

Drawn in 10 minutes, this composition is based on figures encased in stretch bags. The emphasis is given to the abstract quality suggested by the planes.

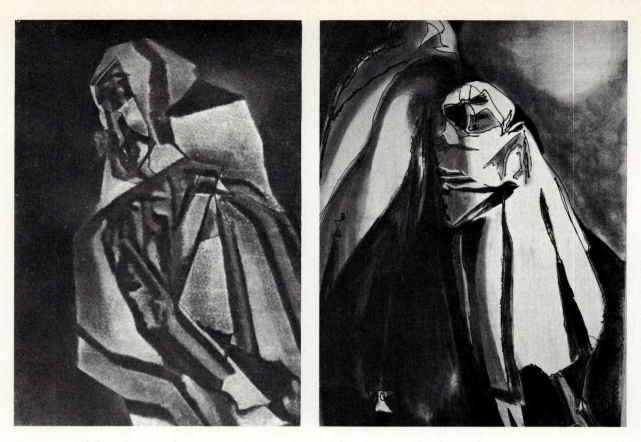

Figures 14–7 (left) and 14–8 (right).
Student drawings.
These were drawn from a model covered with sheets and spotlighted in a way that emphasizes the angularity of the drapery planes and creates a somber tonal quality, which imbues the image with a mysterious mood.

stationary props are placed around the models, and a piece of perforated translucent material is thrown over the props, forming a tentlike curtain. Sketch from this setup, which is composed of forms within forms: the bodies partially revealed by the vertical apertures of the stretch sacks, which are in turn partially concealed by the translucent tent.

A variation is to concentrate first on the spaces between and around the figures and stretch tubes and then on the figure itself, trying to use the negative space as a positive and tangible force. Continual awareness of the unified totality rather than of the individual object is stressed.

Forms Within Forms: Self-Portrait

The composite self-portrait is yet another variant. First establish a background in charcoal, including various symbols and images that have a particular meaning to you. Using a three-sided mirror, draw a self-portrait from different views, one view overlapping the other to create double or equivocal images. These drawings can be executed in differ-

ent sizes, suggesting closeups or distance. To integrate the background image with the multiview self-portrait, draw the self-portraits in continuous line contour, using pen and ink or brush with ink.

You may devise many more problems to investigate forms within forms, as it is a most intriguing area, suggesting many layered meanings, like worlds within worlds, seeds within seeds, metaphors within metaphors. As always, you must guard against being too illustrational, too contrived, too literal.

Instant Body Transformation

Desire for body painting and body transformation harks back to primitive times and cultures, when early humans believed that they could identify with spirits and deny their own vulnerability through special visual signs. Thus, with such body and face markings, they tried to endow themselves magically with strength, courage, and protection.

A particularly productive visual experience in the studio is to project color slides of nonobjective

206

paintings on the nude body of the model. The results are electrifying, as the model is instantly camouflaged with brilliantly colored shapes that seem to wrap themselves around the body and spill over into the background. With each new slide, the mood changes. Sometimes, especially when the slide of a figure is projected over the model's own, it evokes surrealistic moods (Figs. 14-9 and 14-10).

Work with pastels on black paper, using a tiny flashlight attached to the easel as a source of light.

Perhaps through some sort of romantic primitivism, artists seem to respond very positively to this kind of instant body painting. It often helps them to see the possibilities in the figure as a design, which the usual frame of reference may obscure.

Figure 14–9.

Photograph.

Slide projections on the nude body of the model create spectacular patterns, which both camouflage and reveal the figure while creating ambiguous and incongruous imagery.

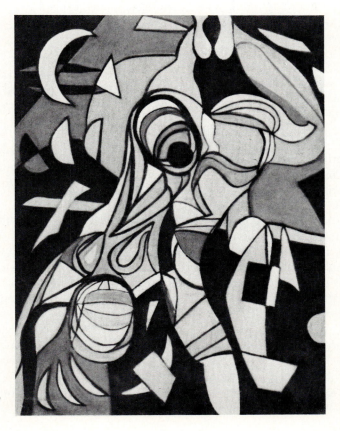

Figure 14–10.

Student drawing.

Pastel and ink.

The model was posed with colored slides projected on the body. Emphasis is on abstract rhythms.

EVOCATIVE SCREENS AND THE JUMBLED MASS

With just the slightest hint of a suggestion, it is possible to discover and reconstruct familiar forms in a nonobjective mass: clouds, stars, rock formations, driftwood, bark, wood grains, weatherstained walls, and so on. The discovery of imagery in these masses is a form of play for us now, but to early humankind it was a more serious matter, when survival could depend on one's ability to pick out the concealed object—beast or man, friend or foe, food or nonedibles—from its surrounding environment.

In the art studio, the ability to find or create this undefined imagery can be used as fertile ground for new configurations and figure compositions. It not only requires fresh perception and imagination but it is also a practical application of the principle of visual closure, whereby the mind gives boundaries to implied forms to make them legible.

Some participants may object to procedures that depend greatly on accidental effects. However, after a few experiments, they can increase the amount of control used in the project so that the results are no longer purely accidental. Moreover, the accidental can be a potent means of shaking loose from conventional ways of seeing and doing.

SUGGESTED EXERCISES

Found Imagery in Found Objects

Make rubbings or drawings in charcoal from evocative screens, such as bark, wood grains, marbleized surfaces, crazed pottery, and so on, and study them from all directions for suggested human forms or groupings. Draw figures made from the model or from imagination on the indefinite screen; accent or modify certain lines to fit the figures into the perceived composition, and add masses of dark values to create a tonal pattern. Leave much of the original rubbing intact, giving the figure a kind of disconcerting camouflaged look while providing the middle tone.

Accidentally on Purpose

Through a series of experiments in which the materials and techniques suggest evocative screens, you can learn how the ink spreads irregularly upon contact with a wet surface and what happens when the ink is puddled on dry paper and then strawblown. Such modified paper surfaces can then serve as evocative screens, where you can find vague figures that you can develop and incorporate into a total configuration, again using models or from imagination.

In one experiment, crumple the paper, and then slightly smooth out and totally dampen it with a sponge. Drop ink, full strength or watered down, with an eye-dropper at random into the network of grooves. After the paper has dried and been ironed, spatter more ink in areas with a toothbrush to add to the pattern of lights and darks and to enrich the textural variety. Then, as before, look for figurative clues in the random designs, and develop the images as figure compositions, following the procedure already described. The process may be reversed and be more perceptual, by starting with a contour drawing in India ink and then crumpling, wetting, inking, spattering, and so forth.

Printing textures with wadded-up paper or string can also produce exciting evocative screens. These, and many other prepared ground techniques, can serve as springboards for the development of suggested or superimposed compositions.

Linear Patterns as Evocative Screens

A variety of linear patterns can also serve as evocative screens: vertical and horizontal, curvilinear, opposing diagonals, dominantly vertical with minor horizontals, dominantly horizontal with minor verticals, and so on. As in the previous exercises, search for hints of human figure configurations, which you develop from imagination or with a model.

Incongruity of Figure and Ground

In this exercise, make a nonobjective study in charcoal in grey light masses, without defined edges. Superimpose a drawing of the model, realized in dark masses, on the nonobjective ground. In some areas of the study, where one might logically expect a light area, a dark one appears instead from the composition underneath. This accidental merging of two incongruous compositions creates ambiguous new shapes that become part of the integrated new totality (Figs. 14-11 and 14-12).

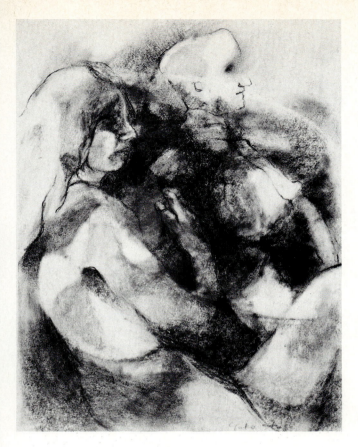

Figure 14–11.
YUKO ITO, student.

These figures show the serendipitous meshing created
by a nonobjective tonal pattern on which a linear
figure study has been superimposed. Some areas have
subsequently been erased and others have been
darkened in order to blend the originally disparate
configurations into the syncretic new image.

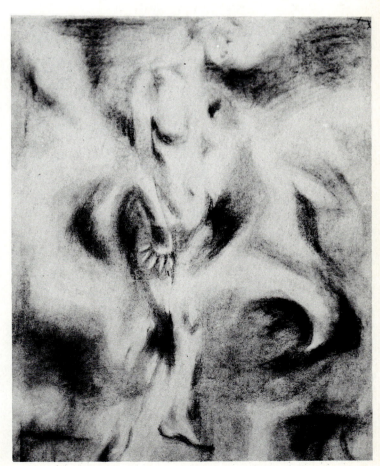

Figure 14–12.
Student drawing.

The Camouflaged Figure in Decorative Elaboration

Here the figure is seen as an assemblage of decorative shapes camouflaged within a decorative background. In some instances, it is so much part of the background that it is difficult to recognize it at first.

Start with a series of quick contour drawings done from the model without looking down at the paper. Do each new drawing on the same page, one figure slightly overlapping the preceding one. Since you have not looked down on the paper while drawing, the proportion may be somewhat exaggerated. When you have done enough drawings on the page, elaborate on the figures with doodles and decorative patterns. Designed words, letters, numbers, and so on may be incorporated into the patterning. Continue the decorative elaboration into the background, where it serves both as a unifying element and as a partial camouflage of the figures. If the camouflage is too effective, that is, if it hides the figures beyond legibility, add a slight ink or watercolor wash over the figures or in the negative spaces to denote a subtle tonal demarcation between figure and ground, thus making the image more decipherable.

Fragmented, Twisting, Overlapping Forms

The model takes a series of extremely contorted, twisting poses. Draw these in ink in a continuous line contour, taking about twenty minutes for each drawing. Turn the board each time a new figure is started, and overlap each figure on the preceding one, allowing some of the figures to go out of the frame. Concentrate on the whole composition. Add dark values to create a tonal movement pattern (Figs. 14-13 and 14-14).

Figure 14–13.
C. JONES, student.

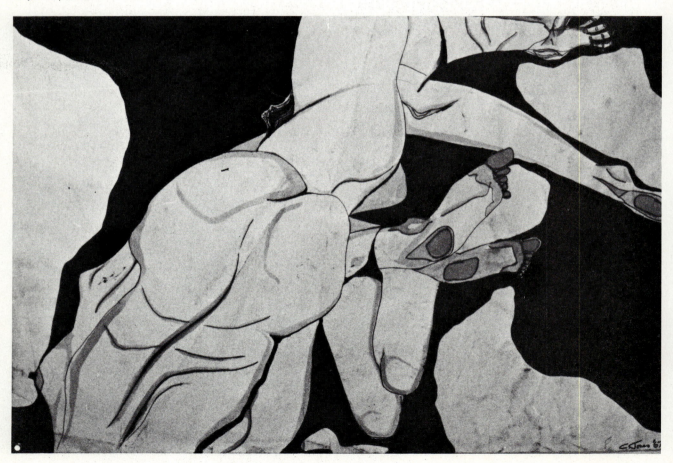

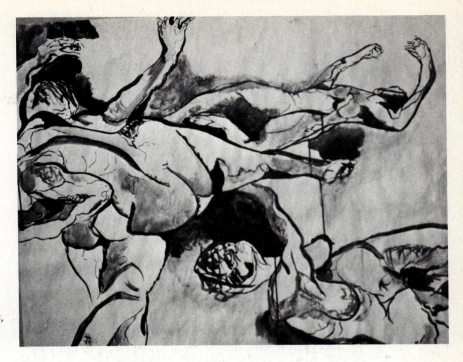

Figure 14–14.
DAN YORK, student.
The twisted, fragmented, disarticulated overlapping figures are accented by dark contrasting tonal values, which dramatize them and intensify the emotional content of these compositions (see also Fig. 14-13).

All these devices—twisted bodies, overlapping figures, and obscuring the form through mixed directional references—help to heighten the dramatic and sometimes nightmarish mood.

The Jumbled Mass

Photographs of interconnected masses of bodies on the beach or football field or engaged in any group athletic activity or dance provide an excellent point of departure for figure compositions based on indeterminacy because these photographs are often first perceived as stimulating dark and light patterns. The forms, enigmatic and scrambled at first sight, are only later deciphered as human figures (Fig. 14-15).

One possible technique, which beginners usually enjoy, is to make a collage of the dark and light pattern, using tissue paper, rice paper, and newspaper want-ads, after having turned the photograph upside down to dissociate the pattern from its original subject matter. When the tonal pattern has been established, draw in ink lines a new configuration of interconnected human figures into the collage.

If you find it difficult to apprehend the basic tonal pattern of the original photograph, view the photograph through an opaque projector purposefully set out of focus so that you will see the essential pattern of lights and darks more readily.

The purpose of the particular technique used in this problem is to dissociate the subject from the tonal composition so that more freedom in conception, execution, and expression is fostered.

Calisthenic Ambiguity

Ambiguous imagery with the human form can be achieved in many other ways. If gymnasts, dancers, or athletic models are available, a number of setups can be explored. For example, three or four models or volunteers clad in black leotards take active calisthenic poses. One can be lying down with legs in the air, another with head and arms down and one leg projected, a third with arms in the air and legs astride, and a fourth stretching arms from the shoulders and bending the knees. The variations in poses, of course, are infinite.

The models take their poses close together to form an overlapping unit. The poses, which may be difficult to keep, are held for a few minutes only, while the artists take snapshots. The negatives of the photographs are particularly interesting because of the inversion of the lights and darks. The artists draw from the negatives as well as from the photographs, sometimes putting them in a slide projector. The overlapping of two negatives in the projector can create particularly interesting and incongruous human configurations and combinations.

Artists can derive much inspiration for original pictorial compositions from the imaginative choreographic groupings created by a number of inventive contemporary dance companies.

211

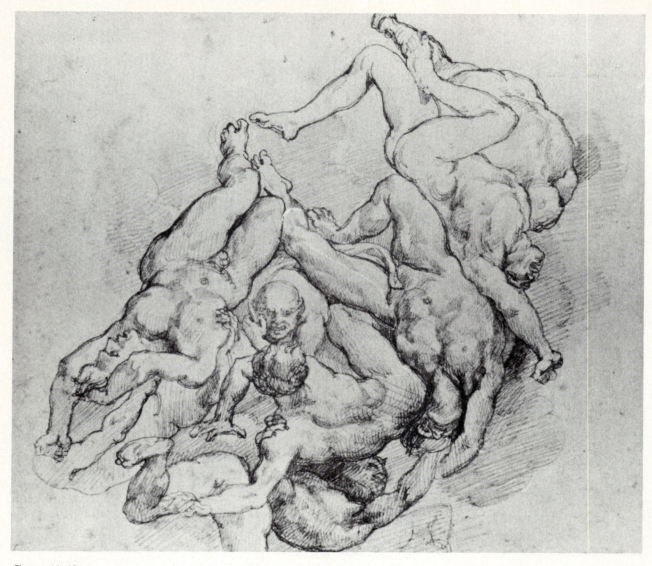

Figure 14–15.
THEODORE GERICAULT (1791–1824).
Fall of the Damned.
Pencil.
Stanford University Museum of Art, California. Gift of the Committee for Art at Stanford.

The tumbling, falling figures form a merging, indeterminate mass. Despite the clarity of the drawing, the details of the configuration are somewhat unintelligible at first until the eye and the mind sort out and decipher the individual figures within the larger shape formed by the jumbled mass.

CHAPTER FIFTEEN

The Many Faces
of Reality

Everything is happening at a furious, unprecedented pace, with new events, knowledge, theories, and problems pouring in on us like an avalanche. Our whole way of life is being shaped and reshaped; and long before we have adjusted ourselves to these changes and have had an opportunity to ponder their significance, they have already been superseded by new ones. Moreover, as mass media have facilitated communications, the notion of reality has become more relative and less insular.

THE SURFACE, THE SUBSURFACE, AND THE INTANGIBLE

With ever more sophisticated probing, recording, and measuring devices, our concept of reality has expanded to include not only the superficial skin level but also the X-ray level and the microscopic level; there is the realization that the "skin envelope" is, as Alan Watts has stated, as much a bridge as it is a barrier between the body and the space that surrounds it (Figs. 15-1 and 15-2). The impressionist paintings, done in dabs of vivid colors, and the pointilist works of Seurat (Fig. 15-3), with their close juxtaposition of dots, seem to illustrate this concept by blurring the demarcation between the object or figure and its space, except for the basic color or tonal differentiation. In all likelihood, most artists rarely study new theories in physics, but they reflect ideas and concepts that are in the air.

In addition, the findings of psychology have further confirmed that the subconscious world of dreams, phantasms, obsessions, and fantasy is part and parcel of human reality, forming an integrative whole with objective reality; this, too, was claiming its right to esthetic representation. It may be that the scientific intimation of the unity of the universe, when it is reduced to its basic components, is a validation of the Eastern philosophical and artistic concept that all things are interrelated and in process—a philosophical conclusion of vast implications for the Western artist.

THE SORCERER'S APPRENTICE

To Chart the Uncharted

In general, modern art, in spite of its strangeness and obscurity, has been inspired by a natural desire to chart the uncharted. If, in such an attempt, it produced symbols that are unfamiliar, that was only to be expected, for the depths it has been exploring are mysterious depths, full of strange fish. . . . But if we persist in our restless desire to know everything about the universe and ourselves, then we must not be afraid of what the artist brings back from his voyage of discovery.

Herbert Read

Figure 15–1.
X-ray view of head in profile.

Figure 15–2.
Pathways of subatomic particles.

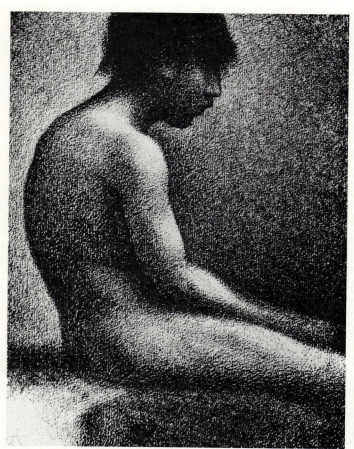

Figure 15–3.
GEORGES SEURAT (1859–1891).
Study for *La Baignade*.
Charcoal.
Private collection. The Tate Gallery, London.
The coarse surface of the paper gives the overall effect of dots, producing a pervading textural unity. This textural unity of figure and grounds intimates the oneness of all things.

Is it any wonder then, that these new developments have fascinated artists, some of whom have felt the need and the challenge to incorporate aspects of changing reality into their works—or simply to express their reactions, fascination, or repulsion? As new realities became part of our collective knowledge and consciousness, artists instinctively searched for new forms to express them.

At the same time, artists were also discovering the arts of other cultures, those cultures hitherto considered primitive and barbarian but which now seemed endowed with a simplicity, directness, vitality, and power that Western artists seized eagerly as a source of renewal—as well as a form of reaction against the increasing complexities and treacherous sophistications of our technological culture—a kind of blood transfusion.

In a flurry of esthetic search, one art movement has quickly followed another since the middle of the nineteenth century; three or four movements occasionally coexisted for a relatively short period of time, while the preceding ones were still affirming their viability. Neoclassicism, romanticism, realism, impressionism, postimpressionism, and synthethism appeared in rapid succession, each movement defining itself in relation to the preceding or contemporary one, and each claiming to be the new artistic reality of the times. Since the beginning of the twentieth century, the tempo has accelerated, as fauvism, expressionism, cubism, Orphism, dadaism, and surrealism quickly followed one another or coexisted on the Western art scene. The splintering accelerated even more as the century progressed, with the appearance of abstract expressionism, op art, pop art, and conceptual and minimal art, in a kind of *Sorcerer's Apprentice* frenzy. And with the profusion of art concepts came the utter confusion of the layperson and even the art lover.

FROM ONE TO MANY

Realities

The history of drawing is a history of "realities." Every age has its own conceptions, held to be true at that time, believed to be true for all times.
 Howard Warshaw

No longer was the original vision of a master or a group of masters part of the common values of a given time and place. When Michelangelo created his world of sinewy and brooding giants, his images found a ready counterpart in the Renaissance's elevation of man to demigod status. His artistic conceptions were eagerly recognized by his contemporaries as the noble embodiments of mankind as they dreamt it. Perhaps he did not so much impose a vision as give form and substance to the yearnings of his Florentine and Roman contemporaries. His work was a magnificent fusion of unique perception, vision, sensitivity, genius, and shared values.

It is more difficult for today's artist to think and work in terms of a shared world. The art scene is so fragmented, the imagery so diverse, that the figure seen and expressed by an artist such as Andrew Wyeth (Fig. 15-4) hardly seems to belong to the same world as the human configuration seen by Richard Lindner (Fig. 15-5). It is not only a matter of artistic idiom and techniques but certainly a question of perceptions and world views as well. There are simply more accepted realities today in our Western culture—or in Westernized cultures—than there were in former centuries.

THE PRESSURE FOR CHANGE

In fact, since there no longer is a prevalent conceptual mode, many artists do not even adhere to a particular group or branch, and each feels compelled and sometimes pressured into making stylistic changes regularly for each major exhibit. Often this self-generated or commercially generated pressure, and the fear of being accused of repetitiveness or of being out of touch with the new realities, do not allow the artist to investigate fully a creative avenue or to allow a given style to mature. The artificial pressure leads to a frantic search for novelty and change as the major criteria of style, and such a view is, in the long run, as constricting and as limiting as the old stranglehold of academic canons.

THE PREDICAMENT

The layperson, as well as the beginning artist, finds himself or herself in a predicament: If there are no longer commonly accepted esthetic realities, if the esthetic range is so wide and so diverse, if art movements succeed one another so rapidly, what constitutes the basis for study, investigation, and appreciation? The metamorphoses and, in some cases, the disintegration of the human figure as subject of the artist's perception and reflection

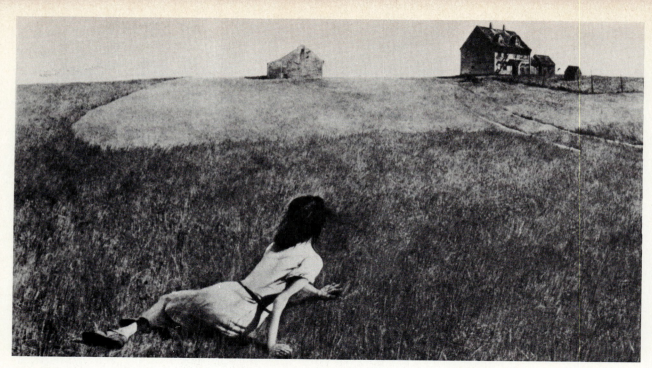

Figure 15–4.
ANDREW WYETH
Christina's World (1948).
Museum of Modern Art, New York City.

This is a sober and realistic rendition of a private drama in which all the pictorial elements contribute to the psychological impact: the solitary figure set on a wide field, straining toward a distant house set high on the horizon. The visual statement carries poignant overtones but is devoid of obvious sentimentality.

Figure 15–5.
RICHARD LINDNER
Disneyland.
Private collection, Paris.

Although contemporary with it, Lindner's Americana is far removed from Wyeth's bucolic setting. A slick, metallic, slightly threatening, stylized female figure, with exaggerated proportions, seems to stand guard before a machine-made world of deadly games.

216

have often been felt to be disorienting and even insulting. In reaction, many people refuse to see any validity in a new visual representation that does not conform with naturalism or imitation of nature, or even preferably, an idealization of nature. Most newcomers to the art world feel that art should be informative, readily legible, and in a world of constant permutations, a haven of reassuring immutability. Overwhelmed by the conflicting and sometimes antihumanist images that the contemporary art scene offers, the layperson and the fledgling artist may retreat to past traditional esthetic concepts, selecting nostalgic, comforting images of a sentimental, fictionalized reality, one that does not touch life or reflect it.

THE MAJOR NEW REALITIES

Yet in the plethora of art movements that have emerged in this century, it is possible to discern those that have proven to be watersheds in the art consciousness of our times, and which have indeed imposed new, basic visual esthetic realities. This book is certainly not designed as a history of art, or even as an art appreciation manual, but it seems to me that problems in figure drawing that are devised and presented with a rationale and a conceptual background can be more meaningful and helpful than those that are not. With this in mind, I feel that although many artists and art connoisseurs may have other personal choices, few would argue with the contention that expressionism, cubism, and abstraction, along with dadaism and surrealism, have been essential catalysts in shaping the contemporary sensibility in the realm of representational art and in the ways in which we view the human image (see Chapters Seventeen, Eighteen, and Nineteen).

Not only were these art movements large events in the Western esthetic consciousness, but also they really represent major areas of figurative

perception and expression in exploring different aspects of reality. Realism and expressionism deal with recognizable subject matter as it is perceived and felt in varying degrees of objectivity and subjectivity; cubism investigates more formal esthetic problems, using the tangible as a point of departure for formal analysis, abstractions, and variations; and surrealism revels in giving shape to the personal and collective unconscious. Each of these major art strands is an affirmation of the relativity of reality and of the many valid esthetic modes to perceive, record, and express it, as well as encouragement for artists constantly to search and fathom their own reality and find effective esthetic means to give it form and share it. Therefore, these movements, vital to a beginning artist's esthetic background, will be summarily reviewed against the continuing concept of realism.

REALISM: CONSTRUCTING ONE'S OWN REALITY

Reality Is Man-Made

Reality is man-made and the maker is the image-maker, the poet. Reality accords with the images the artist makes, and derives its validity from such values as integrity, self-consistency, vitality, pragmatic satisfaction, aesthetic satisfaction, etc.

Herbert Read

It is my hope that the introduction to these basic esthetic realities and modes, along with related problems and exercises in figure perception and depiction, will not only offer a variety of concepts but also will help students discover which mode is closest to their personal conception and iconography. As with all problems and setups, those that follow are only offered as "starters" for further investigations, modifications, and departures in the artist's search for originality and one's own signature.

CHAPTER SIXTEEN

Realism

As an esthetic language, realism has been the most widely practiced and accepted idiom in the Western art tradition. Certainly, the concept of art as imitation or representation of nature has been a common basic criterion of the skill, if not the artistry, of the painter, especially since the high Renaissance, that is, the sixteenth century. Even the two basic currents of art, the defined and the undefined, were both within the broad umbrella of realism, allowing for a comprehensive and flexible interpretation of the term, so that it can encompass the baroque and the romantic veins along with the classical and more objectively realistic ones.

REALISM DETHRONED

Yet when the advent of photography in the mid-nineteenth century and its subsequent popularity relieved artists of one of their functions—that of graphic chroniclers of physical reality—many artists felt they could investigate new avenues of visual expression, including nonrealistic ones, if they so wished.

Progressively, more and more major artists and art critics rejected realism as an exhausted, sclerotic form of art, no longer able to reflect the realities of the times. Their contention was that a search for pure form being the ultimate object of art, any concern with realistic representation was a

trivialization of the esthetic purpose. Others felt that traditional realism was too circumscribed, too limiting, too superficial a goal, and that it could not take into account the many levels of reality revealed or intimated by science, by psychology, or by the unconscious. Still others simply revolted against the absolutist, authoritarian philosophy of art, which decreed that reality was one and that the academic canons were its credentials and its guarantors.

Interestingly enough, the advent of photography, which played such a direct role in liberating the artist from the function of graphic recorder, had the opposite effect on the general public; people became fascinated and enamored with the photographic image and embraced it as the ultimate form of visual representation, confusing verisimilitude—relative though that may be even in photography—with artistic realism.

UNINSPIRED REALISM

The arguments set forth by the artists in search of new esthetic realities were undoubtedly well founded. It is true that academic, uninspired realism—realism by the rules—is often the refuge of the mediocre, unimaginative, uncreative artist, whose only talent is skillful naturalistic representation. It is also true that each age needs to discover

its own esthetic realities; and there is no doubt that the uninformed person, layperson or artist, needs to differentiate between representational skills and esthetic vision.

A SENSE OF ACCOMPLISHMENT

The continuing preference of many artists and laypersons for realism reflects a deep-seated need. Perhaps it is connected with the profound, almost metaphysical desire to understand oneself and to assert one's humanness by creating and projecting a recognizable human configuration and investing it with personal significance. On a more modest level, there is great satisfaction and a gratifying sense of accomplishment in drawing realistically. This satisfies the urge of most beginners to draw the figure with obvious control and to obtain a likeness of the sitter. This sense of accomplishment is all the more pleasurable in that it is usually rewarded by general approbation and admiration, derived from the fact that a realistic composition is more easily understood and shared, at least superficially.

ALWAYS A SEARCH FOR FORM

But it takes only a short exposure to art to realize that those realistic works of art that have stood the test of time are far more than skillful representations of anatomically correct figures or anecdotal scenes, and the serious artist soon learns that realism is indeed a very demanding form of expression—all the more demanding in that the elements that give it esthetic validity need to be totally integrated with the subject matter. To be lifted above the merely skillful or illustrational requires not only highly developed visual perception, technical skills, and control but also subtle, crucial formal choices, rearrangements of shapes and emphases—which is to say that the work must be imbued with a strong sense of composition. One only needs to examine the art of a neoclassical realist such as Ingres to see the subtle shifts and rearrangements from objective reality (Fig. 16-1).

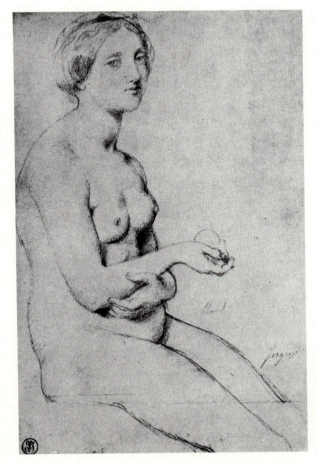

Figure 16–1.
DOMINIQUE INGRES (1780–1867).
Seated Nude (c. 1841–1867).

Graphite pencil.
Baltimore Museum of Art. Cone Collection.

In this drawing of great classical restraint and pristine clarity, the figure is established through its outer contours and reinforced with slight chiaroscuro.

A WIDE RANGE

As a term, *realism* encompasses a wide range of visual and philosophical concepts and therefore allows many choices. Yet in all these concepts, the common factor is carefully observed subject matter expressed in a recognizable visual image. However, although remaining basically anatomically correct, the composition and the execution may be classical, baroque, romantic, clinically objective, idealized, lyrical, two-dimensionally linear, or illusionistically three-dimensional with highlights and shadows. It can be emotionally neutral or charged with feelings, highly descriptive or simplified (Figs. 16-2 through 16-12). The styles and techniques are virtually innumerable, as a very limited random sampling of works spanning a few centuries of Western art quickly shows.

Some modern artists have shuttled back and forth between relatively realistic and nonrealistic art, Picasso being a brilliant and outstanding case in point. Throughout his long career, he often felt the need to revert to various forms of realism even after he had become a trailblazer and the best-known exponent of new esthetic realities through nontraditional modes (Fig. 16-2).

Among contemporary artists, there has been a positive reassessment and reinstatement of realism as a valid mode of expression. For example, Jim Dine, an American artist, has made a dramatic comeback to realism (Fig. 16-11). Others, like Philip Pearlstein and David Hockney, have been in the vanguard of this new realism—a realism that sometimes vies with the photographic image for objective truth while attempting to convey a highly charged, contemporary, formal significance through unconventional poses, placement, and cropping of the model (Fig. 16-12).

Figure 16–2.

PABLO PICASSO (1881–1973).

Portrait of Amboise Vollard (dated Paris, August 1915).

Graphite pencil.

Executed in fine crosshatching, the drawing is done in a beguiling realistic style that admits very subtle distortions.

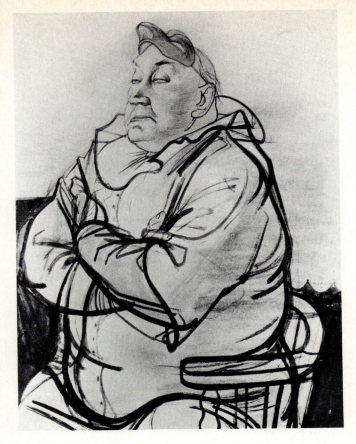

Figure 16–3.
RICO LEBRUN.
Clown (1941).
Collection of Santa Barbara Museum of Art. Gift of Mr. and Mrs. Arthur B. Sachs.

This firmly anchored drawing emphasizes the massive weight of the sitter, whose folded arms add to the blocky image. The configuration is stated through an animated interplay of vigorous, dark, heavy lines and lighter ones. The self-assured expression is masterfully defined with a few decisive lines.

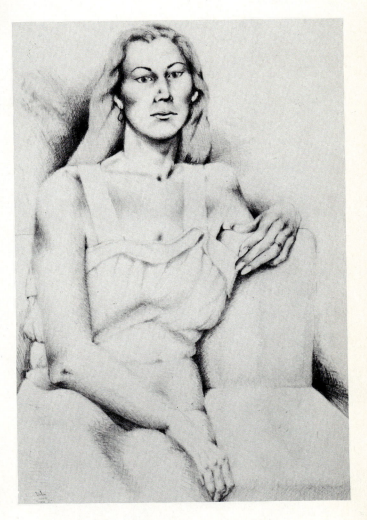

Figure 16–4.
DALIA ULMER, student.
Pencil.
Precise, detailed, and delicate, the image emerges through careful formulation of the negative spaces.

221

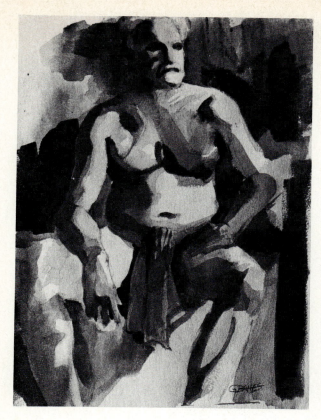

Figure 16–5.
G. BATTES, student.
Watercolor.
This is an objective, controlled statement.

Figure 16–6.
JACQUELINE HASLITT, student.
Charcoal and eraser on a toned surface.

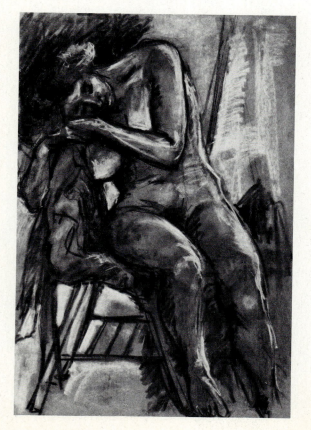

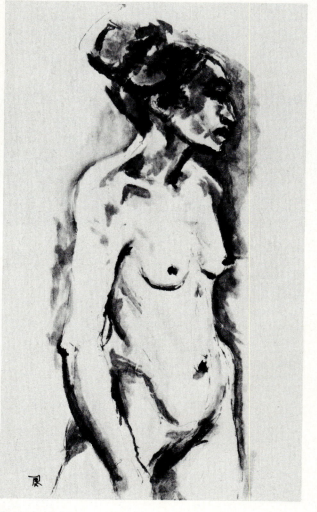

Figure 16–7.
SHARON ROSEN, student.
Ink wash.

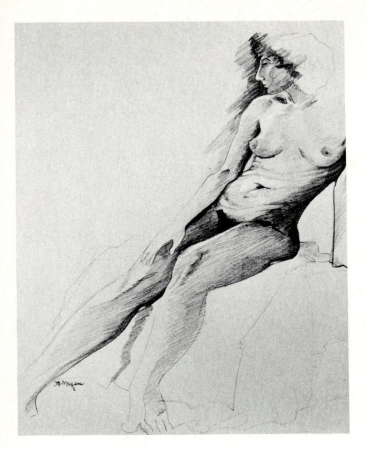

Figure 16–8.
BARBARA MYERS, student.
Pencil
The placement of the figure emphasizes a diagonal axis.

Figure 16–9.
PEGGY KAWASAKI, student.
Charcoal.
Despite the strong diagonal axis of the composition and the relative massiveness of the figure, this study evokes poise, serenity, and delicacy.

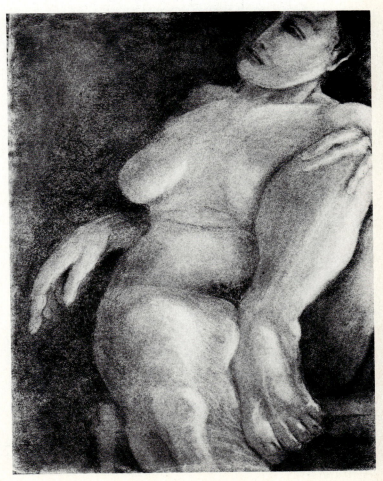

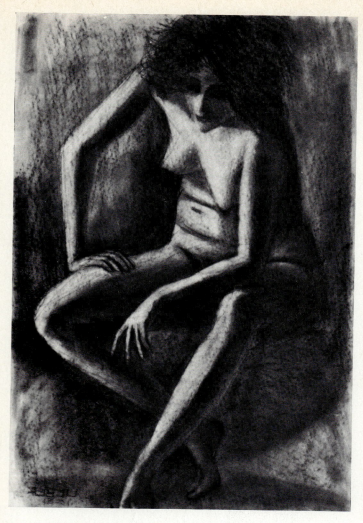

Figure 16–10.
BRAMWELL LIEBER, student.
Interpreted in a romantic realistic idiom, the figure is clearly defined in space through its placement and modeling.

Figure 16–11.
JIM DINE.
Blond Runner n. 2.
Pastel.
Pace Gallery, New York.
The artist chose to develop the upper half of the drawing more than the bottom half; yet the drawing bespeaks of close observation of the subject and feels complete.

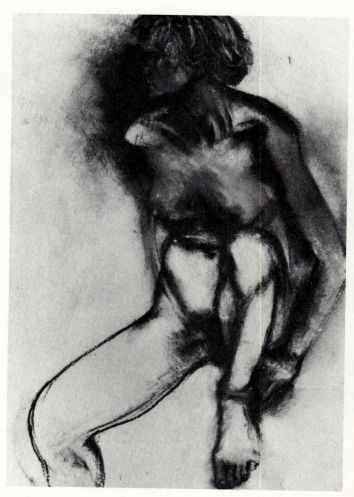

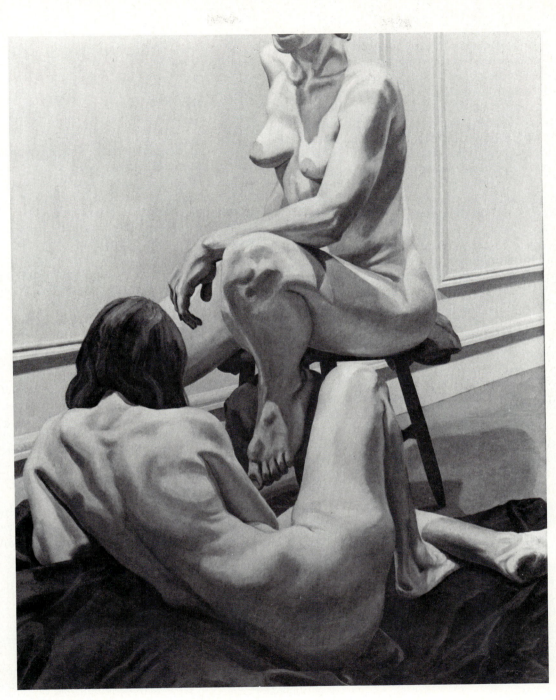

Figure 16–12.
PHILIP PEARLSTEIN.
Two Nudes (1964).
Courtesy of the Archer M. Huntington Art Gallery, The University of Texas at Austin. James and Mari Michener Collection.

The figures are developed in stark, dramatic photorealism; the cropping of what would have been the facing head adds to the impression of the depersonalization of the image, whereas the compositional device of having the figures touch the edges of the picture plane on all four sides adds to the immediacy and impact of the configuration.

A FOUNDATION

As beginning artists investigate the different art concepts and hone their skills, they most often start with a form of realism. So much of our Western art tradition is rooted in this mode, so many of the major artists who have highlighted our culture have worked within the broad definition of realism, that students *do* need to steep themselves in the esthetic tradition that has formed and conditioned their vision and thought. It is a rich and multifaceted tradition; to bypass it would be to deny one's roots. Even for artists who wish to explore other directions, a firm foundation in creative realism provides a rich and solid basis from which they can eventually depart. In a way, artists first learn their basic language: observe and study objectively the physical characteristics of the human body, investigate the many possibilities that the figure offers as a means of objective and subjective expression, gain understanding and skill within the traditionally accepted norms, and then either develop a vision and style within this mode or choose other avenues. Meanwhile, they have learned their craft: They know and understand the human figure as a subject and have proven to themselves and to others that they have mastered the traditional concepts and skills as well as the principles of composition; thus their eventual forays into non-realistic expression stem from an esthetic choice and do not represent a side-stepping from an exacting discipline.

But even as we accept realism as the usual and logical launching pad, it may be salutary to remember that if mastery of accurate realism were an absolute requirement in determining the skill of an artist, such masters as Van Gogh and Cézanne would not have passed the test. Although grounded on patient observation of the model, their work with the figure never had the anatomical accuracy and polish associated with traditional realistic art. In one case, subjective, emotional reality, in the other, formal imperatives, took precedence over objective depiction. One needs to remember that the parameters of creative realism are wide and allow much more latitude than may first appear.

To study realism, then, is to go back to Western roots, so to speak, and many artists and student-artists shortchange themselves by circumventing this part of their training; in so doing, they narrow their range of expression or appreciation, just as they would if realism were the only avenue they investigated. However, the realistic artist must be wary of the temptations of his own skills and guard against the seduction of mere shallow facility.

THE CHOICE

Exactitude is not truth.
Henri Matisse

If after a period of esthetic investigations, beginning artists choose to stay with realism, it simply means that they have opted to remain within the main currents of Western art; and if they are perceptive, talented, patient, original, and creative, they may find that this mode, far from being passé and sclerotic, can be constantly renewed and infused with new formal and emotional significance, and that the human form can be rediscovered and reinterpreted anew, as it has been through the ages.

SUGGESTED EXERCISES

The aim of most of the exercises described in the previous chapters has been to develop perceptual acuity, drawing skills, and a sense of pictorial composition, all within a realistic frame of reference. In a sense, they all have been exercises in realism, spanning the analytical, linear, contour approach and the volumetric, tonal study of the figure, with variations of the two modes.

A more systematic investigation of the variety of options possible within the broad category of realism would be to use one model and one pose and to interpret this subject matter in four or five realistic approaches.

It may be useful to explore some of the basic realistic approaches:

Classical realism is generally basically linear, explicit, idealized, and restrained.

Romantic realism is often soft-focused, more somber in tone, and may display explicit, exaggerated gestures.

Baroque realism offers a more turbulent, swirling composition than either classical or romantic realism. Its emphasis is more on mass than on line.

Clinical objective realism is photographic in the accuracy and precision of the details; it strives for verisimilitude and for a slice-of-life approach to subject matter.

The broader the initial range of exploration within a given mode, the more chances artists have of finding the one that comes closest to their needs and within which they can develop their own idiom.

After studying the figure compositions of a number of realistic artists whose idioms and styles are widely different from one another, such as Rembrandt, Ingres, Delacroix, Van Gogh, Fuseli, and Carrière, draw four versions of one pose:

1. A sustained analytical contour drawing in pencil on 18×12″ bond paper.
2. A freer, more tonal and romantic version of the same subject, using pen and ink and wash on watercolor paper.
3. A carefully worked out volumetric study of the figure and its relationship with the space around it, with emphasis on the definition of the figure through its lights, highlights, and shadows. Outline and crosshatch on watercolor paper in pen or pencil.
4. Another version of the realistic volumetric study, massing in the lights and darks in charcoal on charcoal paper. Model the form by starting with the middle tones, adding the stronger shadows, and erasing the highlights. Although the drawing may have been blocked in faint outlines, the outlines are no longer visible in the finished drawing.

Note: For all the drawings just described, you may find it useful to apply the devices of figure construction, such as sighting lines and blocking in the figure, which are described in Chapter Six. The figure construction guidelines will not appear in the finished sustained realistic drawing.

CHAPTER SEVENTEEN

Reality and Distortion: Expressionism

Reality and realism are very slippery terms, very difficult to define, since reality itself is such a relative concept. The reality in which people of different cultures and periods believed has constantly shifted, and those forms of art that differed from it were considered distorted. Thus, reality in one culture can be deemed distortion in another.

For our contemporary Western culture, distortion infers a deviation from the photographic realistic norm. The word *distortion* itself is loaded with negative connotations, and an art that uses distortions as a means of expression is not easily accepted by the general public or the conventional beginner in art. There seems to be a built-in resistance to distortion. The average person may even feel more comfortable with total nonobjectivity than with distortion. Disproportion, twisting, deformation, mutilation, and exaggeration are difficult to tolerate, especially when applied to the depiction of the human figure. Perhaps there is such a strong identification with the human image that distortion is viewed as a threat to the integrity and wholeness of the human configuration that each one of us carries in our mind's eye as the archetypal human mold. The realistic configuration, especially the idealized classical or neoclassical one, or even the romantic one, is a reassuring affirmation of our physical reality.

Yet purposeful distortion for the sake of heightened expression is not a new phenomenon in Western art. In pre-Renaissance art, it was part of the medieval esthetic tradition. Caricature, which is usually satirical, is widely accepted and enjoyed today. Eye-catching, humorous distortions are also quite acceptable in the advertising arts. It seems that only when the distortion is highly individual and personalized does it become uncomfortable or even threatening to the unprepared viewer.

For the average beginner in art, expressionism, with its reliance on distortion of form—twisting, elongating, exaggerating, adding, subtracting, squashing, and dislocation—is akin to a kind of frozen sideshow of freaks. It is also reminiscent of a mysterious carnival, where grotesque, masklike heads and figures, which border on the hideous and the repulsive, project a mood of disquietude. Often the energy released by the composition itself evokes emotional turmoil.

But we remain ambivalent toward distortion, and it evokes both repulsion and fascination. There is a part in many of us that is strongly attracted by the so-called ugly, abnormal, or grotesque. If it were not so, there would not be Halloween masks, circus freak shows, or horror movies.

NEED FOR DISTORTION

Disfigured/Transfigured

. . . I wanted to remember that our image, even when disfigured by adversity, is grand in meaning . . .
Painting may increase it by changing what is disfigured into what is transfigured.

Rico Lebrun

Just as realism is prized for its depiction of what we call recognizable visible reality, distortion answers another need of the artist: that of expressing one's own subjectivity.

To express this subjective reality takes courage and trust on the part of artists who have stripped themselves to reveal their deepest emotions. This is not to imply that objective realism lacks expression; all art that has significance conveys feelings: The form itself, the composition, is a vehicle of feelings. It is a matter of emphasis, selectivity, and intensity in the pictorial configuration.

As our world has become filled with more complexities and contradictions, as the optimistic belief in progress has often given way to doubt and an anguished reevaluation of past comforting concepts, this anguish has found its way into art. Our great expressionist painters—such as Van Gogh, Edvard Munch, the German expressionists, Chaim Soutine, and more recently, José Luis Cuevas—used distortion to convey powerful emotions: alienation, loneliness, anxiety, violence, instability, pain, anger, and despair (Figs. 17-1 through 17-5). These are feelings that we prefer to circumvent and hide rather than confront; and many artists and art movements have traditionally seen them as being outside the realm of art in the belief that art should only reflect beauty and nobility and present an idealized and uplifting image, rather than reveal, however powerfully and artistically, the dark underbelly of humanity.

But this dark underbelly exists, and it has to find its imagery. Perhaps because powerful and raw feelings can find an effective visual projection only when they have been personally experienced, expressionist art, by its very nature, is highly subjective: It is frequently the visual equivalent of an outcry, sometimes muted, sometimes strident. The distortions or the deviations from the idealized norm are the reflections of the emotional turmoil that generated them and are one way to touch and move the viewer with greater impact. It

Figure 17–1.
VINCENT VAN GOGH (1853–1890).
Dr. Gachet (1890).
Etching.
Courtesy of the National Gallery of Art, Washington, D.C. Rosenwald Collection.

The inconsistencies in the direction of the features—such as the eyes in relation to the slant of the head—prove once again how certain distortions may heighten the emotional impact of a configuration.

Figure 17–2.
EDVARD MUNCH (1863–1944).
The Cry (1895).
*Courtesy of the National Gallery of Art, Washington, D.C.
Rosenwald Collection.*

Figure 17–3.
DAVID ALFARO SIQUEIROS.
Echo of a Scream (1937).
*Museum of Modern Art, New York City. Gift of Edward M.
Warburg.*

Figure 17–4.
PABLO PICASSO (1881–1976).
Crying Woman (1937).
© *S.P.A.D.E.M., Paris/V.A.G.A., New York 1986.*

*The violent distortions of the features seem to extract
the very essence of agonized sorrow. The three works
by Munch, Siqueiros, and Picasso are powerful images
of the anxiety, alienation, pain, and anger that are part
of the human condition.*

Figure 17–5.
JOSÉ LUIS CUEVAS.
Actors Rehearsing Richard III (April 1964).

Ink.
Courtesy of the artist and Tasende Gallery.

*This is a highly personal graphic expression of a world
inhabited by dwarflike, misshapen figures. Although
executed in a powerful individual style, the distortions
and proportions may remind the viewer of the stylized
squattiness of medieval European sculpture as well as
central American pre-Columbia Tarascan ceramic
sculpture.*

should be noted that although expressionism often deals with painful subject matter and emotions, it can also express joy, love, celebration, and ecstasy, as the works of Marc Chagall and others well illustrate (Fig. 17-6).

Distortion, then, is a powerful visual means. It is not pleasant, serene, or restful, but when it is purposefully and sensitively handled, it has great impact and a beauty of its own. The distortion can be relatively subtle, as in the works of Oskar Kokoshka; more obvious, as in the works of Egon Schiele (see Figure 12-7); or violent and quasi caricatural, as in the works of Chaim Soutine,

Francis Bacon, and Richard Lindner. Although we usually associate the twisted line and the swirl as best conveying the graphic image of the artist's anguish, some artists, like Lindner, use totally different means; they may translate their sense of alienation and the incipient violence of a dehumanized world through a hard-edged human configuration, as smooth and cold as the barrel of a gun (Figures 17-7, 17-8, and 17-9). In dealing with such heightened and intense feelings, a fine line separates great expressive pictorial power from the ludicrous—a very difficult balancing act for the artist.

Figure 17–6.
MARC CHAGALL.
The Green Violinist (1918).
Oil.
Guggenheim Foundation, New York.

An amalgam of cubist, expressionist, and fantasist elements, this work shows the lighter side of expressionism with great verve and poetic imagination. The imagery is drawn and stylized from cherished recollections of the artist's childhood.

Figure 17–7.
CHAIM SOUTINE (1894–1943).
The Madwoman (1920).
The National Museum of Western Art, Tokyo. Presented by Mr. Tai Hayashi, 1960.

Figure 17–8.
FRANCIS BACON.
Three Studies for the Human Body (1967).
Private collection. Photo Galerie Claude Bernard, Paris.

These misshapen acrobatic figures are starkly set against a plain, dark background. They are the casualties of a mad and dangerous circus world and present an image that is freakish, disquieting, repulsive perhaps, yet strangely fascinating.

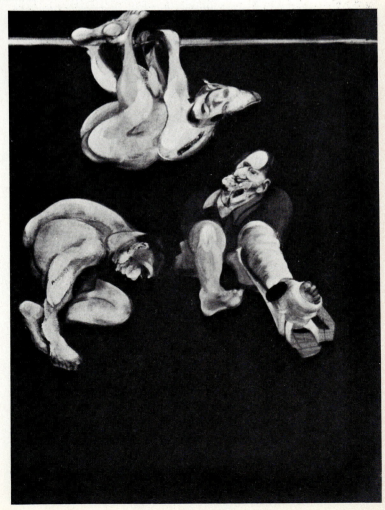

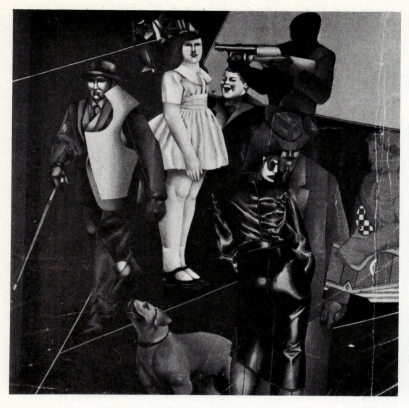

Figure 17–9.
RICHARD LINDNER.
The Street (1963).
Oil.
Kunstsammlung Nordhein.Westfalen, Düsseldorf.
This composition is based on sharp oppositions: bright color and value contrasts, highly realistic rendering juxtaposed with simplified, geometric flat surfaces. The fragmented, arbitrary background, the faceless gunman, the hard-edged configuration, and the metallic look—all evoke the violence and terror lurking in the city. Even the girl and the boy in the center seem to convey an image of tainted innocence in this urban nightmare.

NOT FOR EVERY ARTIST

The life of the consciousness is boundless. It interpenetrates the world and is woven through all its imagery. . . . Therefore, we must harken closely to our inner voice.

Oskar Kokoshka

Images of the Soul

A work of art can come only from the interior of man. Art is the form of the image formed from the nerves, heart, brain, and eye of man. . . . Nature is not only what is visible to the eye—it also shows the inner images of the soul—the images on the back side of the eyes.

Edvard Munch

Because each of us has a different emotional tone, it is obvious that not every artist can or should be a bona fide expressionist. Some artists feel reticent in exposing their strongest feelings; others fear the consequences of such baring of the soul; still others reject the graphic exteriorization of emotions as indicating a lack of measure, self-control, and objectivity, which are qualities highly valued in our culture.

Yet there have always been those artists whose need for personal expression has poured into their works; the best and strongest among them are certainly those who have been able to find a style and a format that served and enhanced both the expression and the esthetic statement.

Few of us are devoid of strong feelings, and most of us can benefit from a study of the great expressionist works as a way to increase our sensitivity to the world within and as part of our search for what constitutes personal expression; then if that modality suits our temperament and esthetic needs, we can forge our own style to express it.

NOT BY EXPRESSION ALONE

In most cases, anguish and emotion, however sincere, are rarely sufficient to confer strength to a work of art. First and foremost, the work has to stand on its own esthetic merits as a composition, as an effective assemblage of its components, the emotion and distortion being an integral part of the whole. This requires both involvement and a certain detachment, which allow artists to consider their work not only as a subjective outburst but also as a composition that must "work" in the skillful orchestration of all its elements. For the newcomer to art, this distancing is not an easy

matter; often, the desire to express supersedes all esthetic considerations. It is only with practice, control, and artistic maturity that artists reach the point where their feeling for form has become instinctive enough to serve their need for subjective expression, so that their choice of compositional scheme, concept, materials, and techniques all concur to the effectiveness of the whole.

SUGGESTED EXERCISES

Several of the exercises suggested here are conceptual. However, it seems wise to start from a perceptual vantage point because such an approach sensitizes beginners to the fact that what they see is influenced by what they feel when they have taken the risk of divesting themselves from neutralizing formulas. To start from nature, that is, to work from the model or even from a photograph, with a close conscious convergence between emotional apprehension and visual perception, will usually elicit an expressive drawing; and the step from expressive drawing to expressionist drawing is a fairly natural one, if that is the esthetic direction that the artist wishes to follow.

Modifications of Photographs

Modifying photographs taken from old magazines is a technique used in many of the exercises in almost any chapter. The availability of instant images to work with is a distinct advantage.

Furthermore, the student can experiment with perceptual distortion without having to draw yet. The suggested exercises are just a beginning. Many more variations are possible, and the student can easily devise additional ones. For example, the cut and pasted rearrangements may be combined with drawing, or they may serve as a basis for subsequent drawings.

As always, I would like to stress that when modified photographs are used as a transitional means to understand a device rather than as an integral part of the composition, the ultimate goal remains to understand the principle well enough so that the student can eventually draw directly, without having recourse to photographs, unless that is an esthetic choice.

Folding and Cutting

Choose a large photograph of a head or figure. Fold portions of it in such a way as to create unusual or interesting distortions that evoke an emotional reaction in you. Paste down the modified configuration (Fig. 17-10).

Cut an old photograph or an illustration of a head or figure into vertical or horizontal strips. Place these on a separate page, slightly staggered, and either contiguous or with some space left between them, as wished. Paste down the strips. The slight staggering of the strips displaces the elements of the figure enough to produce a mild but jarring distortion.

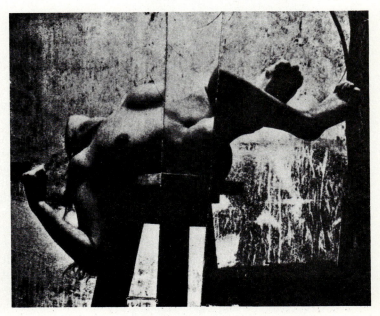

Figure 17–10.
Student work.
Photo modification.
By folding portions of a photographic reproduction, the artist has produced a most provocative variation on the human figure, akin to abstract sculptural forms.

Concentric Circles

Draw a number of concentric circles on a large photograph or magazine illustration, using one central point. Cut the concentric circles and move each one slightly before pasting down the strip, creating a mild distortion of the configuration, as in the preceding exercise.

Elongation

Find two or three identical photographs or illustrations of a head. Cut each into horizontal strips ⅛" in width. Splice the strip from the two or three sets, taking one from each picture until the image is completed. The configuration appears elongated since its elements have doubled or tripled. Paste the strips down carefully and in order. If you wish to exaggerate one portion of the configuration more than another, add more strips in that area and less in another (Fig. 17-11).

Figure 17–11.
Student work.
Photo modification.
The elongation of the image was produced by combining the horizontal strips cut from two identical photographs. The repeat and ripple effect introduce an element of movement in the image.

Horizontal Stretch

If you want a horizontal stretch rather than elongation, cut and paste the strips vertically rather than horizontally. In both cases, you will notice that the stretching of the image also leads to a flattening of the form.

Polymer Transfer Stretch

Prepare a colored photo illustration of a figure from a magazine by coating it with polymer glue. Let it dry overnight; repeat the process three or four times, allowing the glue to dry overnight each time. Run warm water on the back of the picture, until the paper can be easily peeled from the polymer "skin." The transferred image will appear on the transparent plastic skin. By applying heat, the film becomes softened enough so that it can be stretched, producing interesting distortions of the image. The polymer film can be affixed to a sheet of paper with Elmer's Glue-All and the image may be further modified with the addition of ink lines to emphasize the expressiveness of the distorted configuration.

Any of the exercises involving photographs or illustrations may be used as the basis for drawings; these may be executed in crosshatch, dots, or fine scribble. The drawings can be combined with elements of the photograph if the combination serves the esthetic and expressive ends of the artist.

The Photomat Show

For those who want, but find it difficult, to express their feelings in their work, a transitional exercise may be helpful. It uses a kind of playacting as a means to exteriorize emotions before dealing with highly charged personal responses. To do this, consciously express various emotions through facial expressions in front of a mirror in the privacy of your home or in an automatic photography booth. If in front of the mirror, draw directly; however, the sketching process requires a certain freezing of the expression, which may or may not deter from its immediacy. It is easier to draw from photographs taken in a booth. Although there is an amusing and light-hearted aspect to this approach, you will soon discover its validity as a source of investigation of the self through the playacting of emotions. Often, what starts as playacting opens the way to authentic self-discovery and a graphic recording of this investigation (Fig. 17-12).

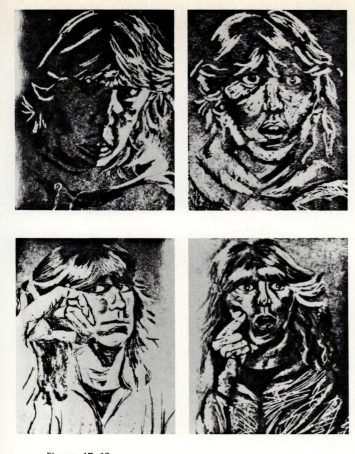

Figure 17–12.
DEBBIE LIVINGSTONE, student.
White chalk on black paper.
Hamming it up in a spirit of fun, and then sketching from the resulting photographs, can serve as an early step in loosening up and becoming expressive. It is a preparatory activity for more serious and introspective pictorial expression.

Register your re-created expressions of fear, anger, pain, anxiety, joy, or sorrow. Exaggerate the expressions as in early movies or old-fashion melodrama. Then translate the photographs into 9×12″ drawings executed in compartmentalized contour.

Masquerade: Improvisations

The mask, more than any other human covering, has been a popular means of embodying emotions: the emotions of the bearer and the emotions of the onlooker. The ambiguity of the mask is an added factor in the fascination that it holds, for while it hides the wearers and conceals their features, it often reveals more about them than their real but controlled features ever disclose.

Almost all cultures, ancient and modern, have used the mask in rituals and festivals. In rituals, it is often endowed with quasi-magical powers, lending

its attributes to the wearer: the strength or cunning of an animal or the power of a fierce deity. It is easy to fall under the spell of masks and to accept that the wearer becomes a temporary incarnation of what the mask represents.

In preparation for the exercise, you are encouraged to study the masks of various cultures: African, Oceanic, American Indian, Eskimo, pre-Columbian, and so on, as well as some of the more contemporary masks used in religious or secular pageantry. Having studied originals in anthropological museums if possible and in specialized books, you can proceed to study the masklike heads of some contemporary sculptors like Henry Moore. This preliminary research helps you to accept the mask as a means to heighten the depiction of human expressions, and it also acquaints you with some of the various distorting devices used to intensify the depiction of human expressions and emotions (Fig. 17-13).

After studying the masks of various ancient and contemporary cultures, as well as those works of Moore, Picasso, Gordon, Munari, and Rötger, which show the influence of primitive masks, invent a series of masklike heads—at least twenty-five—trying to adapt creatively and with originality as many stylistic devices as you can remember from your research: dislocation of the features, exaggeration of proportions, composite heads, multiplication of certain features, subtraction of others, flattening, decoration, and so on. Use colored inks applied on an illustration board.

A follow-up to the exercise is to create a series of conceptually designed figures to "fit" each head in a stylistically consistent manner. When the proportions are not logically consistent, there should be an esthetic consistency even in the disproportions.

Obviously, the two exercises just described are conceptual rather than perceptual. However, a fascinating variation is to move from the conceptual to the observed by tailoring and personalizing a mask and a body configuration for a specific subject or model, stylizing his or her distinctive features into a decorative but strongly expressive design.

Caricature

Most people expect, accept, and even enjoy the distortions and exaggerations of an effective caricature. Essentially, the caricaturist exaggerates the characteristics of the model; and because caricature

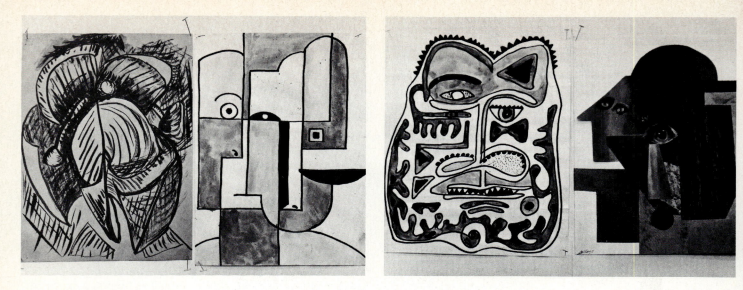

Figure 17–13.
Student work.
Masklike head improvisations inspired by primitive arts.

is used to depict celebrities whose features are well known, the exaggeration of salient features hastens the immediate recognition of the subject rather than hinders it. Depending on its purpose, the distortion can be gentle, good-humored, or savage and brutal.

Certain artists have used mild caricatures to depict their models, especially some socially conscious artists. Artists like Toulouse-Lautrec and Goya made very effective use of caricatural elements to convey their feelings about a model, or to create a kind of complicity between the observer and the artist, by exaggerating what is already a salient and therefore unharmonious feature in a subject (Figs. 17-14 and 17-15).

Exaggerated portraits. A gestural drawing of a head requires the artist to make a quick decision about what feature is salient and should be emphasized.

A quick linear drawing can clarify the image, and since line is the element most readily deciphered, most caricatures are linear.

Choose a person who has characteristic, rememberable features and draw a rapid linear depiction that emphasizes the salient features and characteristic expression (Fig. 17-16).

Make a quick wash drawing of the model, combining the gestural approach with mass and clarifying the features while exaggerating them, using a pentel brush or a pen (Fig. 17-17).

Exaggerated contour. We have seen earlier that a contour drawing can be objectively precise and analytical or passionately permeated with the feelings and emotions of the artist.

Figure 17–14.
HENRI DE TOULOUSE-LAUTREC (1864–1901).
Yvette Guilbert.
Toulouse-Lautrec Museum, Albi, France.
The element of caricatural distortion vitalizes the portrait and gives it a forceful and unforgettable emotional impact.

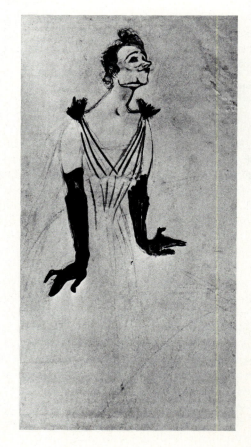

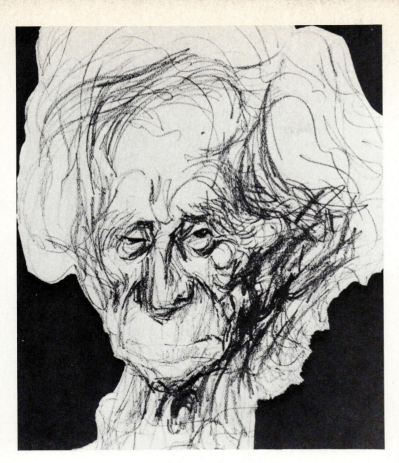

Figure 17–15.

FELIKS TOPOLSKI.

Head of Bertrand Russell.

In Face to Face.

Published by Jonathan Cape, Ltd., London, and Stein and Day Publishers in New York.

Courtesy of the artist.

The artist extracts the very essence of his subject by exaggerating the characteristic features. He does so with lively, scratchy, multiple lines, which dart, leap, and intertwine into an expressive tangle. He defies the conventional human proportions with impunity in his search for a more forceful and more truthful image than objective, realistic portrayal would convey.

Figure 17–17.

TOM HUGHES, student.

Pastel.

Drawn in masses of grey, black, and white pastel, the drawing exudes a kind of romantic expressionism.

Figure 17–16.

JOAN LANO DE SIO, student.

Charcoal.

For this problem, work from a character model whose features are somewhat askew or whose expression bears a hint of melancholy. Since the long pose does not lend itself to mercurial changes of expression, the model almost automatically assumes a serious expression; it may be an expression of boredom, but you can read into it what you wish (Figs. 17-18 through 17-22). The model may be nude or in costume, but the costumed model provides an easier point of departure for textural and tonal variations. Using 9× 12" all-purpose watercolor paper and pen and ink, do a contour drawing of the three-quarter figure, outlining the model through its edges. The drawing is to be interpretative, that is, allow your feelings and empathy to enter into play as you seek to emphasize the distinctive features and body personality of the model, paying close attention to the inherent expressive qualities of the hands and feet.

When the linear configuration is finished, work within the areas, adding various textures: clusters of dots in one area, dashes in another, and so on, taking care that the textured areas do not detract from the directness and strength of the exaggerated contour.

Figure 17–18.

TONY GALT, student.

Ink.

This expressive drawing extracts a strong emotional quality from the pose itself. The bulky figure in its prone position reminds the viewer of the helplessness of a tortoise lying on its back. The vigorous line quality and the simplified tonal pattern are very effective in conveying the image without any visual distraction.

Figure 17–19.
Student drawing.
Charcoal.

Figure 17–20.
THERESA FURGOL, student.
The mild but selective distortion and the free linear quality impart a special vitality to Figures 17–19 and 17–20.

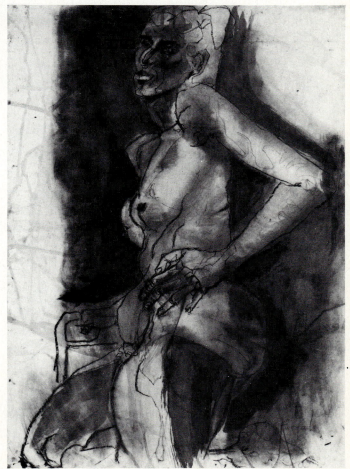

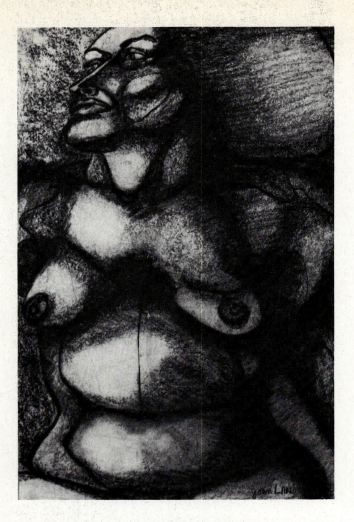

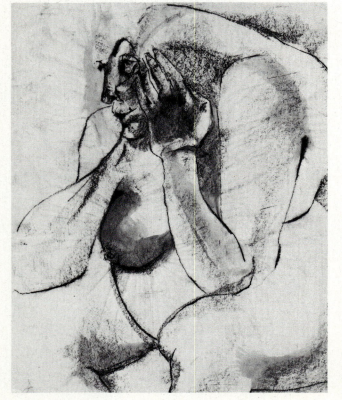

Figures 17–21 (top) and 17–22 (bottom).
JOAN LANO DE SIO, student.

These two drawings denote a strong personal vision translated in an expressionist style. At first glance, there is a close connection between caricature and expressionism. Both often exaggerate the characteristic features and proportions of the subject, but for different purposes: Caricature aims at immediate recognition—sometimes ridicule—whereas expressionism aims at emotional impact. Moreover, although the caricature is rarely conceived as a compositional whole, the expressionist work, to be valid as an esthetic statement, concerns itself with all the factors that are part of significant form.

Exaggerated tonal drawing. In this drawing, the emphasis will be on the elongation of the figure and a dramatic interplay of strong lights and darks. It is preferable to find a tall, thin model so that the elongation of the drawing exaggerates what you already see. A costume or covering forming long and deep folds, such as a monk's robe or makeshift equivalent, accents the angular quality of the subject and provides the basis for strong light and dark contrasts.

Tone an 18×24″ charcoal paper evenly, so that the lightest tones of the drawing will already be greyed down, imparting a dark atmosphere to the composition; the toning is accomplished by covering the surface with charcoal and smoothing it with tissues or chamois cloth to an even middle tone. Then mass in the shapes with charcoal, including only three-quarters of the figure. Let the darks be very dark, and bring out the highlights by erasing with a charcoal eraser. Be aware of the linear and tonal rhythms that emphasize the elongation of the shapes and features (Fig. 17-21).

Expressionist Wash Drawing

Using a 12×18″ or 18×24″ watercolor paper, apply a wash to block in the seated figure of a character model directly, without any outline. With pen and ink or a pentel color brush, draw the features, exaggerating them even more than in the previous exercise. Intensify every aspect that makes the particular model recognizable as an individual: characteristic facial traits, body configuration, wrinkles, expression, "personality" of the body and of the hands and feet. With the wash, accent the dark areas, working wet-in-wet at the beginning to obtain soft mergings; then allow the wash to dry somewhat before clarifying the features with pen and ink. It is helpful to build the image from lights to darks and from the general to the specific.

Reflections on Reflections: Mirrors

There is something magical about the mirror. Just as with photographs, we equate the reflections we see with reality. But as we know, human reality is informed and sometimes distorted by subjective interpretations. The images we see in the mirror appear attractive, plain, or repulsive, depending on the way we happen to feel.

In my classes, I use distortion mirrors of various kinds to give the students an opportunity of perceiving and drawing the figure in ways that are not experienced in daily life; yet the elongation, horizontal stretch, proportional distortion,

fragmentation, and dislocation retain credibility because they are the result of mirror reflections. The students draw the reflection as they see it, and they attempt to make a realistic drawing of a reflection. But very often, the objective distortion that they perceive arouses emotional reactions, so that the end result may combine the objective depiction of a distorted reflection and the subjective reaction to it. Once the initial fear of distortion has been overcome, students are usually more willing to distort without resorting to the use of mirrors.

Draw a series of self-portraits in contour, in pencil or pen, from your reflection in a shiny curved surface such as a toaster or a coffeepot.

Collect a number of various mirror surfaces: fragmented mirrors; cylindrical mirrors for vertical and horizontal distension; and a large sheet of mirrored Mylar, which can be bent into several concave and convex curves to create twisting and other deformations of the reflection. Place the model in front of any one of these surfaces, and sketch the reflection of the model (Figs. 17-23 and 17-24). It is useful to record and interpret the same pose reflected by various surfaces in order to study the different kinds of distortions created by these mirrors.

The model or subject may be nude or costumed; the reflections may be photographed for subsequent drawings or for combinations of reflections.

Place two large mirrors vertically touching along one edge at right angles to each other, the mirror surfaces forming the 90° angle.

The model poses facing the mirror surfaces in such a way that the single image reflected by the two mirrors represents interesting contractions and fusions. The model may first experiment with moving the hands and projecting them in front of the mirrors until they appear and disappear as disembodied images that seem more like strange animals. Afterward, the model may better understand what angles, what moves, and what positions will produce those strange and provocative reconfigurations of the human image. The projected image is sketched directly or photographed for later use.

A variation of the problem is to use smaller mirrors (approximately 8 × 10″) and glue them along one edge at right angles to each other, as in the preceding project. Place a photograph of a person or a realistic drawing in front of the double mirror and move it until you obtain a visually exciting contracted reflection of the image. Draw from this reflection.

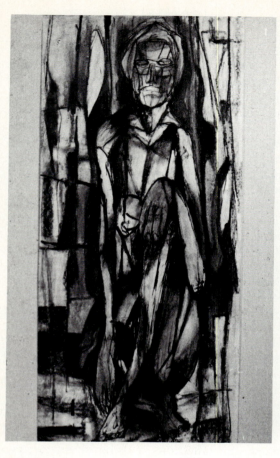

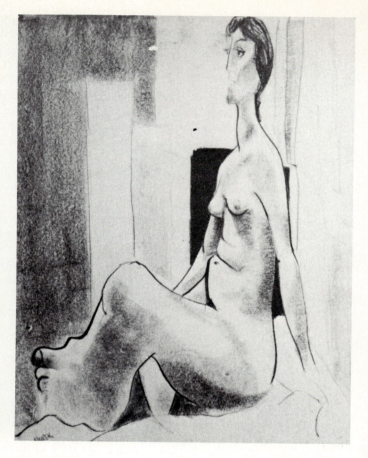

Figure 17–23.
Student work.

Figure 17–24.
M. MAREK, student.

These were drawn from the reflections of the model in distortion mirrors: For Figure 17–23, the model was placed in front of a vertical distortion mirror, which elongates the figure, and the artist fragmented the form for greater expressiveness. Figure 17–24 was derived from the image reflected in a parabolic mirror.

CHAPTER EIGHTEEN

Reality and Abstraction

HISTORICAL PRELUDE

From the end of the nineteenth century, the idealized reality of neoclassicism and romanticism had already largely given way under the onslaught of impressionism and postexpressionism; but the coup de grâce was delivered in a two-pronged attack, first by the works of Matisse (which were labeled fauvism—that is, the works of wild beasts) and more dramatically, with the appearance in 1907 of a single, strange, shocking painting by Picasso: *Les Demoiselles d'Avignon,* which came to be known as the first cubist painting (Fig. 18-1). This painting—in which the arbitrarily geometricized background was peopled with odd, expressionless, distorted, ungraceful, stylized, and unrealistic figures, some wearing awesome African masks—was to represent a watershed in occidental art: a revolutionary break with the past, a new perception of esthetic reality, and a new and vivid iconography.

Shocking though this new painting was, it did have roots; almost all art does, and somehow each radical movement is both a break with the past and a renewal of it. But this time, the roots were not part of the classical Renaissance tradition; the artist felt free to be eclectic, to include elements from unrelated cultures and traditions: medieval Catalonian, El Greco, late Cézanne, African, and even Egyptian. It should also be noted that long before Picasso burst upon the scene, pre-Renaissance artists such

as Albrecht Dürer, Giovanni Bracelli, and Lucas Cambiaso had in the sixteenth century done studies that by their geometrizations and stylizations could be considered prototypes of cubism and abstraction in general (Figs. 18-2 and 18-3). But in these cases, the intent was different, and they represented no more than excursions into the analysis of form rather than new directions.

ROOTED IN REALITY

The term *abstraction* can be confusing; some people use it loosely enough to include nonobjective art, that is, an art of purely formal arrangements, with no conscious relation to nature. For the purpose of this book, we shall adopt the more restrictive definition of an art that remains rooted in nature, even if it fragments, rearranges, and transforms it. The degree of abstraction and geometrization can be relatively subtle, as in the late Cézannes (Fig. 18-4), or quite extreme, as in the analytical cubist compositions of Braque and Picasso (Fig. 18-5)—where forms are barely recognizable, where the figure or the object seen in multiple views has become dislocated and fragmented into slippery, shifting planes in ambiguous, flattened space; yet no matter how extreme the abstraction, there remains a recognizable though tenuous vestige of its origin in the natural world, in this case, the human figure.

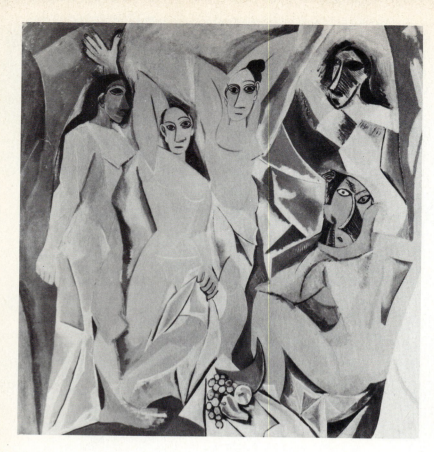

Figure 18–1.

PABLO PICASSO (1881–1976).

Les Demoiselles d'Avignon (1907).

Museum of Modern Art, New York City. ©S.P.A.D.E.M., Paris/V.A.G.A., New York.

This seminal composition is bristling with intensity, energy, and expressiveness but has an overwhelming emphasis on form. It is angular and schematized and combines figures and ground in nonrepresentational, compressed space.

Figure 18–2.

ALBRECHT DÜRER (1471–1528).

Two Faceted Heads (1512).

Sachsische Landesbibliothek, Dresden.

Figure 18–3.

LUCAS CAMBIASO (1527–1585).

Drawing of Men in Action.

Uffizi Gallery, Florence.

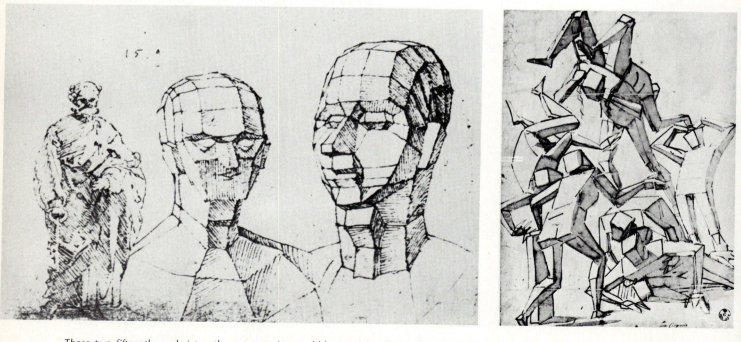

These two fifteenth- and sixteenth-century artists could be considered precursors of abstract art because each did a few studies in which they cubified the figure, either as a way to analyze it or as an arbitrary geometrization.

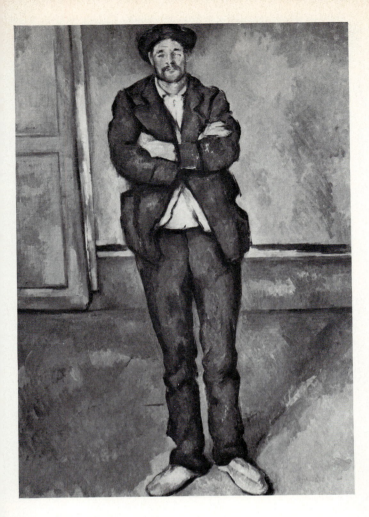

Figure 18–4.
PAUL CÉZANNE (1839–1906).
Standing Peasant (c. 1895).
© *The Barnes Foundation, Merion, Pennsylvania.*

Figure 18–5.
GEORGES BRAQUE (1882–1963).
The Portuguese.
Kunstmuseum, Basel.

RELATIVE AND EXTREME

As an artistic mode, abstraction should not intimidate beginners since they can acquaint themselves gradually with the concept and the experience. It may be reassuring to realize that any graphic representation, even the most naturalistic one, is abstracted to some degree: A tangible form in the round has to be abstracted in order to be translated as a two-dimensional form. But often, when the degree of abstraction and manipulation of form interferes with the instant legibility of the work, when formal esthetic considerations have superseded those of clear communication, laypeople feel that a violation of nature itself has been perpetrated and that such art, instead of fulfilling its function as a source of pleasure and as a solace, has become an arrogant formal riddle and a phenomenon as bewildering as the constantly shifting reality around us: the very instability that art should keep at bay. Abstract art is then viewed as an assault on our sensibilities and as a further dehumanizing factor in an already dehumanized world.

Actually, in many ways, the abstract quality of cubism may be more easily accepted by the neophyte than expressionism because cubism is basically an orderly and highly formal, unemotional manipulation of planes, with a *parti pris* of anti-illusionism and antirealism: unlike expressionism, it does not engage the onlooker at the "gut level." Yet *Guernica* (Fig. 18-6), a major painting of our century, again by Picasso, allied cubism and expressionism to create a haunting graphic statement of the artist's reaction to the Spanish Civil War. However, although not unique, this combination of cubism and expressionism is not too frequent, and the generalization that cubism and abstract art are basically formal quests is a workable one.

PERCEPTUAL AND CONCEPTUAL

Although there are abstract works that straddle and transcend the boundaries between expressionism and abstraction, most abstract art is above all a formal arrangement of shapes that originate in nature but have been transformed to fit the

Figure 18–6.
PABLO PICASSO (1881–1976).
Guernica (1937).
Mural.
Prado Museum, Madrid. © S.P.A.D.E.M., Paris/V.A.G.A., New York.

architectonics of a given composition. The expressiveness that exists in the finished work is conveyed through formal relationships, to which the artist or onlooker may unconsciously add the emotional connotations that the still recognizable subject matter retains for them (see Figs. 18-1 and 18-6).

As in expressionism and fantasy, abstraction of the figure can be approached perceptually and conceptually. The perceptual mode, as always, is based on an initial reliance on the observed model, which is then subjected to a series of formal transformations within the composition. These transformations of the observed subject result from a number of voluntary perceptual shifts and from graphic devices such as simplification, geometrization, flattening of the form, spatial manipulation, interchanges of form and space, arbitrary light and dark patterns, arbitrary colors and textures, linear or edge emphasis, plane shifts and dislocations—devices that, when used judiciously and tastefully, should contribute to the order and effectiveness of the composition.

The abstract artist commonly combines the perceptual and the conceptual approaches—flattening large observed volumes, overlapping transparent planes, using multiple perspective and multiple views, adding realistic and invented textures, and so on. The mixture of these graphic notations helps to obscure somewhat or almost entirely the legibility of the subject matter. Instead, the artist emphasizes the autonomy of the composition as resulting from the manipulation and placement of shapes originally derived from nature but transformed into effective pictorial elements.

One of the great problems in introducing abstracting devices is that they can be used almost mechanically, producing conventional, facile, and mediocre graphic configurations, such as one sees only too often in the many art works mass produced for a pseudosophisticated public. The devices should be used as part of a coherent personal esthetic statement within a chosen idiom, style, and medium. Used mindlessly and without integrity, they deprive the work of any sincerity or originality.

FORM, NOT FORMULAS

If beginning artists need to steep themselves in the classical and baroque-romantic perceptions of the figure, and if they need to experience the expressionist approach, they certainly can also greatly benefit from applied experiences in formal abstraction as a means to expand their field of perception and expression, even if abstraction is not going to be their eventual iconography.

The exercises that follow may be viewed as a basic introduction to some of the ways, means, and devices that have been effectively used by major abstract artists to project their formal concerns; they are designed to help beginning, searching artists—or artists who wish to expand their graphic representational experience—to recognize, study, apply, adapt, and transform some of these devices to their own perception and to manipulate and reorganize the planes of the figure and its surrounding contracted space into a satisfying and effective abstract composition—all while retaining contact with the figure, so that the image that emerges is not only a formal interplay of shapes but also a distillation of observed reality.

FROM REALISM TO ABSTRACTION

> If the artist copies mere nature, the natura naturata, what idle rivalry!
>
> S.T. Coleridge

> The goal is not to be concerned with the reconstitution of an anecdotal fact, but with the constitution of a pictorial fact.
>
> Georges Braque

Preliminary Exercises: Photographs

My old standby of using magazine illustrations as a shortcut to the understanding of a concept is used here. If for some philosophical reason you object to this transition and prefer to omit it, the problems can easily be translated into direct exercises in drawing.

Geometrical reduction. Choose a large and clear photograph of a head from a magazine. With a black felt marker, analyze its large planes and geometricize them by outlining them with straight lines.

Straight and curved. Do the same exercise with the same head if possible, using straight and curved lines in the analysis of the planes.

Geometricized mask. Geometricize another large head by reducing the features, planes, and lights and darks to squares, rectangles, triangles, circles, and so on, still using a black felt pen. Develop the resulting image into a mask.

Simplification: tonal. Develop a simplified and dramatized light and dark pattern of the photograph of a head by consolidating the dark values while reducing the light values to a single very light tone, excluding all tonal transitions and nuances within the areas.

Layered head. For a more elaborate exercise, take a large, clear photograph of a head from an old magazine (or sketch such a head with careful indications of lights and darks) and analyze its major directional planes by outlining them with pencil or pen. Then cut the outlined planes with a stencil knife and paste them down on sheets of clear acetate—thus, the planes that recede most into space are on the bottom acetate sheets, and the planes that appear closest to the observer are pasted on the top sheets. Affix narrow strips of balsa wood or cardboard to the edges of the sheets so that there is some space between the layers when all the sheets have been reassembled. The reconstituted image conveys a realistic configuration abstracted through simplification, fragmentation, and arbitrary physical space (Fig. 18-7).

For an interesting variation, slightly shift some of the acetate layers so that some of the features are subtly displaced. When a satisfactory combination has been obtained, trim the acetate sheets to fit the original rectangular frame pattern despite the shifts.

The problem lends itself to many more variations: combination of photo and drawing as part of the configuration, expressionist or surrealist distortions and dislocations through shifts, and so on.

Note: All the exercises based on the analysis and rearrangement of a photograph may serve as a point of departure for subsequent drawings or collages.

Realistic Abstractions:
Abstract Costumes

As part of the introduction to perceptual abstraction, I sometimes rely on a method that invokes realism as a transition—but also realism with a twist. For example, the model is dressed in a highly abstract, geometricized costume inspired by

Figure 18–7.

JOHN BENICKI, student.

The photograph was analyzed and the major planes of the face were defined, cut, and placed on separate sheets of clear plastic, which were then superimposed, thus reassembling the features in their original position. The spatial depth created by the thickness of each plastic sheet of the assemblage and the play of lights and darks these spaces cause, along with the linear definitions of the cut edges, present a completely new image—a layered appearance that is disquietingly surrealistic.

well-known abstract sculptures or paintings. The students are asked to draw the model as they see it. The more realistically they draw, the more abstract the figure emerges. The interaction of life and art provides a helpful transition to those students who feel uncomfortable in modifying the perceived human form. By translating one art form into another and by using their prized skill at realistic depiction, the students end up with an abstract image; and while working in this manner, they have been exposed to a number of abstracting devices without verbalizing or analyzing. Frequently, this is a painless breakthrough for students in their passage from realism to the investigation of abstraction through personal experience (Figs. 18-8, 18-9, and 18-10).

Figure 18–8.
PABLO PICASSO (1881–1976).
Three Musicians (1921).
Museum of Modern Art, New York City,. Simon Guggenheim Fund. ©S.P.A.D.E.M., Paris/V.A.G.A., New York.

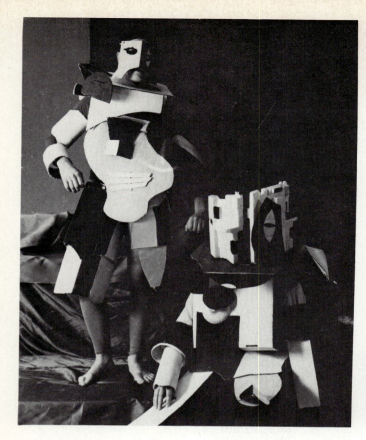

Figure 18–9.

Photograph.

Students are wearing abstract costumes inspired by paintings of Picasso and Juan Gris. The costumes were designed and executed by Bonnie Kaplan.

Figure 18–10.

ELIZABETH TOKAR, student.

Based on the setup in Figure 18–9, this exercise helps the student make the transition from realism to one kind of abstraction quite painlessly, since the figure has already been restructured abstractly with the addition of cardboard shapes. Then the student can work more directly and conceptually and find a personal figurative abstract imagery.

Realism and Abstraction: Substructure

Although a drawing or painting in process frequently undergoes compositional changes between its inception and its completion, most abstract compositions are carefully thought out, even when executed from a basically perceptual mode.

Many artists approach abstraction in a manner similar to the first stages of a realistic drawing: In either case, the artist may indicate a preliminary scaffolding or substructure before defining the shapes. This gives an embryonic compositional and abstracting scheme while serving as reference in the elaboration of the drawing.

After studying the model carefully, the core line of the figure is indicated on the paper, and sighting lines—usually slanted horizontals—are added to establish the relationship of the parts and the basic proportions of the figure: shoulder line, rib cage line, pelvis and knee lines. Sighting diagonal or vertical lines suggest the outer edges of major parts of the figure. By adding sighting lines, sometimes referred to as tangent lines, the student may align the edges of several parts of the form along one straight line, allowing some lines to meet and cross, so that there is an intersection of sighting and tangential lines at major articulation points such as the ankles, knees, and elbows.

The Fork in the Road

So far, the preparatory scaffolding is no different than the substructure for a realistic figure drawing. But at this point, the approach to abstraction differs radically from that of objective realism. Whereas the artist who wants a realistic drawing would continue by sketching the figure over the guiding substructure, the artist who wishes to abstract from the observed figure has a number of options.

252

For example, the artist may pursue the composition with more straight and intersecting lines, extracting the large planes or surface directions of the figure as well as those of the space around the figure. The composition may proceed along basically straight lines, or some curved lines may be introduced. The structure lines may be purposefully extended beyond their visual reference points, projecting into the negative space that surrounds the figure and tying the form to a shallow broken space—thus unifying the figure and the background.

SIMPLIFICATION

The most instinctive and logical approach to perceptual abstraction is to simplify the observed figure by eliminating many but not necessarily all details, reducing the configuration and its surrounding space to its main geometric planes and volumes; the abstraction may also be achieved by flattening the form through the omission of light and shade and by incorporating the resulting shape into compressed space.

Interestingly enough, the very analysis and reduction of the forms to volumes and planes may lead away from simplification to the multiplication and fragmentation of the planes, thus helping to destroy the element of realism and recognition (Fig. 18-11).

The simplification or reduction of the figure to planes may be perceptual—based on initial observation of the model—or it may be conceptual—a remembered form simplified by memory to its main components or features—or a combination of remembered forms and invented shapes for the necessity of the composition.

Suggested Exercises

Rectilinear geometrization. Draw the model from life, using only straight lines. Keep the geometrization closely related to your visual perception of the figure, emphasizing the large planes, volumes, and space (Fig. 18-12).

Figure 18–11.
PHYLLIS KUSSMAN, student.
This compartmentalized contour emphasizes the abstract quality of the planes.

Figure 18–12.
TERESA PIETRASANTA, student.
Pen, brush, and ink.
These are simplified cubed figures. The extension lines are used for space definition.

The exercise may be carried further by developing the simplified shadow areas and extending these into the background, so that figure and background are united through a geometricized network of lights and darks.

Rectilinear and curvilinear. This is related to the previous exercise, but includes simple curvilinear clean edges, including shadow areas. Jacques Villon's *Les Haleurs* can be used as reference (Fig. 18-13).

Volumetric simplification. As you draw from the model, depict the forms as simplified volumes, as if you were drawing from a model constructed of simple wooden or smooth metallic parts: cylinders, cubes, and spheres. Add strong shading to convey the three-dimensionality of the form. Geometricize background shapes also, so that the total composition is conceptually and stylistically integrated (Figs. 18-14 and 18-15).

Multiplications of the planes. Observe carefully the model as you draw, analyzing and defining the planes that make up the body and the planes within the planes, so that the small planes are depicted as shingles, with both mergings and hard edges. Use pencil or pen and ink wash.

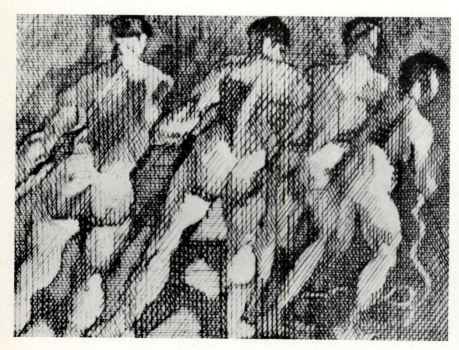

Figure 18–13.
JACQUES VILLON (1875–1963).
Les Haleurs.
Mr. Hubert Prouté, Paris
Etching.
The diagonal, straining figures of the men pulling on a rope are described through a network of carefully modulated, wide, regular crosshatch; they are further defined with a few blank areas and a few smaller darker accents. This linear-tonal technique produces an abstract screen, which unifies and subtly geometricizes the whole configuration while infusing it with a sense of dynamic, but harnessed, movement.

Figure 18–14.

TONY GALT, student.

The figure is seen in its larger planes. The execution is limited to straight lines and dramatic edges as a way to understand one basic form of abstraction.

Figure 18–15.

DEBBIE FRIEDMAN, student.

Charcoal.

In this compartmentalized contour, the planes and plane facets have been geometricized. The extended construction lines contribute to the overall angularity of the image.

The same problem can be treated conceptually rather than perceptually by adding planes and shingles to connect figure and space in areas where they are needed for the logic of the composition.

Rearrangements. A recurrent motif of abstract artists is the fragmentation of the human figure and the rearrangement of its parts, along with the flattening of the shapes and the use of transparent superimpositions. A number of views are frequently used for conceptual and esthetic purposes.

Bits and pieces. Draw a realistic figure in pen and ink or pen and ink wash, with lights and darks defined through fine scribble, crosshatch, or dots. Tear the figure into uneven parts and rearrange the scrambled pieces on a second sheet into a satisfying composition, without regard to the realistic connections of parts. When the desired composition is attained, paste the pieces down. Complete the arrangement by creating a spatial background, using the same techniques as in the drawing of the figure, and unify the background and the collage through arbitrary shapes that straddle both (Fig. 18-16).

The same problem may be attempted with a multifigure composition (See Fig. 18-21).

Selected fragments: closeups. Look at the hands or feet of a model, concentrating on the configuration itself, without reference to its human context or its function, until the forms are simply read as forms—something akin to the oddly shaped stones that have been modeled and polished by nature over millennia. Draw these in pen and ink, using very small dots and simplifying the details.

Enlarged Fragments

Enormous enlargements of an object or a fragment give it a personality it never had before, and in this way, it can become a vehicle of entirely new lyric and plastic power.

Fernand Léger

A related version is to execute the drawing from a design approach, stylizing the shapes by reducing the subtleties in plane directions to a simplified decorative pattern. Develop the drawing in wax crayons as a hard-edged design, in large format, emphasizing the dramatic impact of the image.

Figure 18–16.
THERESA FURGOL, student.
This is a highly abstract, rhythmic, exciting, fragmented, multifigure composition, bristling with movement and energy.

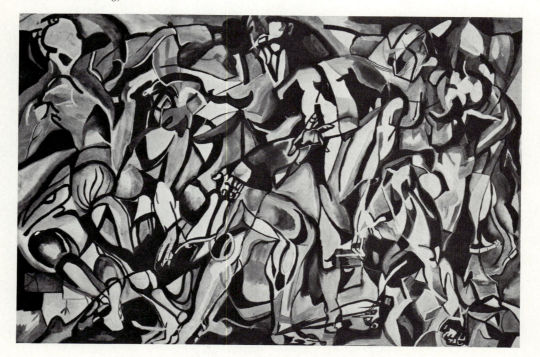

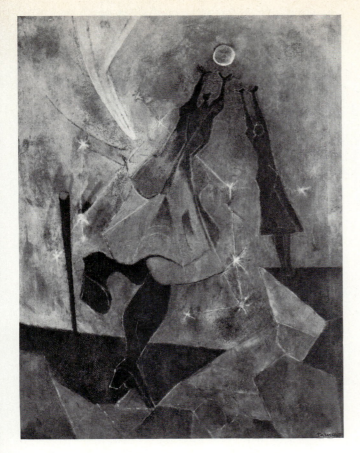

A more ambitious project involves the selection of a detail of the body, which is cropped in such a way as to render its immediate legibility enigmatic. Ask the model to take a pose in which the limbs are folded: head reclining on a folded arm, leg tucked under other leg or buttock, arm folded toward back, and so on. Study the model carefully, paying particular attention to points of junction of body parts and points of articulation. Select one single part, as if you were cropping that configuration from an existing photograph. At first, you may want to use a viewfinder, which you move as you look at the model until you find the most interesting partial configuration. Later, as you become more able to dissociate form from practical references, you may prefer to isolate the fragment without the viewfinder (Figs. 18-18, 18-19, and 18-20). As in the previous exercises, first draw the detail close up in areas of small ink dots with subtle chiaroscuro. Later, you may develop this preliminary study into a design, simplifying the basic shapes and patterning the structural lines so that the result is decorative.

Figure 18–17.
RUFINO TAMAYO.
Women Reaching for the Moon (1946).
Collection Cleveland Museum of Art.

As in Picasso's By the Sea *(Fig. 5—9), the exaggerated foreshortening of the figures seen in frog's view adds a dramatic sense of the fusion of time and space to the image.*

Figure 18–19.
CYNTHIA ROGERS, student.
Pen and ink.
Illustrated are two series of studies of parts or details of the human figure: a kind of cropping which tends to abstract the configuration by isolating it from its context. When the fragments are placed strategically next to each other, they may form an interesting positive and negative grouping. Figure 18—18 is depicted in silhouette, whereas Figure 18—19 is a simplified and modified cross contour.

Figure 18–18.
ELIZABETH TOKAR, student.
Pen and ink.

SPATIAL REPRESENTATION

The abstraction of the figure implies the manipulation of form in space, so that we cannot speak of abstraction without addressing the notion of spatial representation. Flattening and compression of form and space, transparent overlappings and interpenetrations, unusual angles of vision, multiple perspective, and simultaneous views all concur to depict the subject in an arbitrary spatial context. These devices may be considered variations of the concept of perspective: Where Renaissance perspective attempted to create the illusions of deep space, these devices aim at introducing the elements of movement and simultaneity in the essentially two-dimensional depiction and composition (Fig. 18-17).

Suggested Exercises

Bird's-eye view. Draw the figure as seen from above, looking straight down or from a slight angle. The depiction will require extreme foreshortening; the top of the head and the shoulders will assume greater visual importance than the other visible parts of the body. Use pencil or pen and ink.

Frog's-eye view. Draw the model placed on a high platform or ladder, so that the figure is seen from below. Again, extreme foreshortening will be necessary; here, the legs will loom much larger than the rest of the visible body, whereas the torso and head will appear relatively small.

X-ray view. Draw a simplified contour outline of the model. Add parts of the viscera or parts of the skeleton or muscular structure, using simplified anatomical diagrams.

Simultaneous views. Draw three or four contour drawings of the same figure in related poses in the same scale, each on a separate sheet of transparent or tracing paper. Superimpose the sheets and shift them slightly. Study the multiple-view image and select the salient aspects from each one until you have a new configuration that combines elements of all the original drawings. This rearrangement is definitely derived from a realistic study of the figure but departs from it through the use of combined views, elimination of some parts, and slight shifts that alter the relationships of the parts (Figs. 18-21 and 18-22).

Draw the new configuration in pen and ink on a separate sheet. An arbitrary tonal pattern may be incorporated to further abstract the figure.

Before attempting the abstract figure exercise just described, some students prefer to start with contour drawings on transparent paper of different views of the same head seen from various angles and eye levels; they proceed as indicated to draw a composite head.

Figure 18–20.
MARY HOLLANDS, student.

The model took a supine pose with a strong twist of the torso. By carefully choosing a fragment of the configuration, the artist drew a composition that suggests a figure-landscape.

Figure 18–21.
MILTON HALBE.
Photograph.
Portrait in the Round (1942).
(*In* Vision in Motion, *by Moholy-Nagy, Theobald Publisher.*)

The photograph is made up of three views of the head, presenting an odd, surreal image through a classical abstract device.

Figure 18–22.
Student work.
Charcoal.

In this study, two related views of the same figure were combined into one configuration, creating an impression of dislocation and distortion of the figure. The compartmentalized treatment adds to the abstraction of the image.

CHAPTER NINETEEN

Reality and Fantasy

DADAISM: DOWN WITH EVERYTHING

While the expressionists, cubists, and other abstractionists were still engaged in their various quests for the depiction of nontraditional artistic realities, another breed of artists burst on the scene. It is undoubtedly no accident that they appeared in 1916, in the midst of World War I, which was convulsing Europe and marked the end of an age. For these new artists, even the works of the nontraditionalists were still pursuing new versions of old values. Considering themselves the real revolutionaries of art and true iconoclasts, they stridently announced the bankruptcy of society, reason, and art and set out to destroy all the cherished pictorial conventions—all the shibboleths of composition, form, and meaning—through a concerted program of shocking art events and outrageous exhibits. Declaring themselves antiart, they vociferously and irreverently threw all art principles overboard and proclaimed the reign of irrationality. *Dada*, a nonsense word meaning "hobbyhorse" in French baby talk, was the name they chose for themselves, for its very unrelatedness to an art movement and its derisive connotation.

Dada had a very short but stormy life: By the mid-1920s, it was virtually ended as an official movement. But by then it had managed to shake the very foundations of Western art and had left an indelible mark. Although some of its followers went on a wantonly destructive artistic rampage and retained a fascination with a form of nihilistic art, most of its practitioners were simply too gifted, too creative, too profoundly—though unwillingly—"art conscious" to remain mere agents of destruction. Their short-lived and outrageous movement succeeded in sweeping the cobwebs from art, and when they were through with the wreckage, the buried treasure of nontraditional art, which lay hidden under the debris of academicism, could be rediscovered and reinterpreted in a spirit of freedom. By fostering a climate of creative chaos, they had helped expand the range of possibilities in art, and in fact, influenced *all* the arts, including the applied arts and the theater. However, the final balance sheet is ambiguous: The positive contribution was the ferment, the questioning, the new directions it allowed. The negative side is that the more nihilistic practitioners left the art scene in shambles, a kind of scorched-earth policy in art, which saw both the artists and the public in complete disarray.

IRRATIONALITY AND THE UNCONSCIOUS: SURREALISM

There are other relations besides reality, which the mind is capable of grasping and which also are primary, like chance, illusion, the fantastic, the dream.

Louis Aragon

All our interior world is reality, and that, perhaps, more so than our apparent world.

Marc Chagall

The dadaists' refusal of logic, reason, common-sense reality, and realism; their reliance on the shocking, the accidental, and the irrational, were major factors in ushering in yet another esthetic reality: that of the subconscious. Fortuitously perhaps, this occurred at the very time that Freud's seminal conclusions on the irrepressible primacy of the subconscious were being popularized. The surrealists, who followed the dadaists, were their most direct inheritors; in fact, some had started as dadaists. Like their predecessors, they rejected the controlled, measured world of logic, reason, and idealized reality. Their territory was the subterranean, mysterious, disturbing reality of our dreams, obsessions, fears, and phantasms: a graphic universe that is not measured or measurable through logic and realistic objectivity, but

where time and space become merged and are both limitless, where reality and dreams are bridged, where landscapes can turn into figures and figures into landscapes in a constant interchange and transformation of forms and realms.

The imagery and style of the surrealist artists varied greatly, from the hauntingly realistic description of unreal phantasms set in infinite space of Dali (Fig. 19-1), to the quasi, nonobjective, amorphous shapes of Miro. Some artists used automaticism—a trancelike, unconcerted, free manner of drawing—as a technique to allow the unconscious to guide their hand and, in the process, release their uncontrolled, unplanned, unedited inner imagery. Others enjoyed a whimsical approach, using found objects to create new configurations: the result of creative perception,

Figure 19–1.
SALVADOR DALI.
The Burning Giraffe.
The Emmanuel Hoffman Foundation, Kunstmusem, Basel. ©
S.P.A.D.E.M., Paris/V.A.G.A., New York.

This is a dream fantasy replete with classical surrealist visual devices: eerie, maimed, disproportionate, mannekinlike figures propped against a barren desertlike landscape of infinite vistas; visual games played with relative proportions and distance; odd images and enigmatic symbols of a private inner world.

Figure 19–2.
MAX ERNST. (c. 1891–1976).
The Attirement of the Bride (1940).
Peggy Guggenheim Collection, Venice, Italy (The Solomon Guggenheim Foundation).

With exquisite precision and clarity, Ernst depicts an exuberant fantasy in which woman and bird are in the process of fusion; human-limbed birds grasp broken arrows, and scale, anatomy, and perspective escape the norms of physical reality to create a magical, disquieting, yet strangely seductive world.

free from percepts and conventions. Others yet, like Max Ernst, found exciting and poetic imagery in experimental materials and techniques (Fig. 19-2).

PERSONAL IMAGERY AND COLLECTIVE IMAGERY

Obviously, imagination, fantasy, phantasms and nightmares, and a playful, topsy-turvy world were not born with this century. If virtually all art,

however revolutionary in approach, is born from other forms of art, then certainly surrealism and fantastic art can claim filiation with great masters of the past, whose works reflected similar concerns: above all the wonderfully imaginative or nightmarish compositions of Hieronymus Bosch (Fig. 19-3), the composite configurations of Giuseppe Arcimboldo and Larmessin (Figs. 19-4 and 19-5), and in the early nineteenth century, Francisco Goya's last works, his monstrous nightmarish visions. But with the exception of Goya's art, most of these works depicted themes that were part of a common religious cosmogony or were playful, intellectual, imaginative compositions. Of these great precursors, only Goya took the risk of utter subjectivity to give form to his nightmares and inner torment.

The surrealists of the early 1920s could indeed say that they were linked with arts that had held a minor place in the grand Western rationalist tradition, but their great contribution was to tap the sources of another hitherto neglected rich and mysterious reality, that of the personal and collective unconscious. The surrealists and the fantasists explored, and are still exploring, mind states. Some have created magic gardens of the mind, whereas others like Max Beckman (see Fig. 9-30), portray their mind states as a theater of marvels in which life's metaphors, similes, and charades are played out: a theater of illusions and mirages, where it is difficult to distinguish where absurdity leaves off and meaning begins or whether they are interchangeable. The privileged space of the paper or canvas becomes the special arena where strange mind games find their visual exteriorizations— where dreams, fantasies, mutations, and incongruities have found their pictorial shape. There are no walls or airtight chambers between realms, and modes of expression dissolve into one marvelous circus of the mind in which anything can happen.

Today's inheritors of Dada, surrealism, and fantasy are still plowing the fertile loam that their predecessors uncovered, and some produce works of imaginative and sometimes awesome beauty; but too many others are mired in imitating the imitators of the innovators.

In the spirit of freedom that the dadaists, surrealists, and fantasists have wrested, the problems, exercises, and devices suggested here are only temporary directional guides, possible starts for those students who wish to incorporate their personal mythology into the experience of figure drawing. The devices may be obvious, perhaps elementary, but the purpose is to prime students to

262

Figure 19–3.
HIERONYMOUS BOSCH (c. 1450–1516).
The Temptation of St. Anthony (1500).
Detail of central panel (The Alchemical Child).
Museu Nacional de Arte Antiga, Lisbon.

Astride a huge tame rat, a tree spirit cradles an infant, while a creature that is half knight and half bird rides an animal that is part horse and part jug.. These are just a few of the strange apparitions that inhabit Bosch's rich and inventive world of nightmarish fantasies.

Figure 19–4.
GIUSEPPE ARCIMBOLDO (1527–1593).
Autumn (1573).
Louvre, Paris.

The head is a composite of realistically painted fruit, vegetable, and grain, all products of the harvest. Arcimboldo's composites have inspired many subsequent artists in their own imaginative configurations.

Figure 19–5.
LARMESSIN.
(Eighteenth century).
These are fanciful depictions of various occupations and crafts.

bridge the gap between cerebral analysis or even emotional apprehension to the full use of their total consciousness—which includes the subconscious.

SUGGESTED EXERCISES: FANTASY

Before embarking on the suggested exercises, it may be of value to underscore the chief characteristics of fantasy. For the sake of convenience, dada, surrealism, and fantasy are all grouped under the heading of fantasy—a broad heading, which includes varied approaches and styles as well as indefinite imagery and invented configurations. Some fantasists, like Paul Klee, view their world as a magic forest, a desert, or an undersea-scape, which they populate with their personal flora and fauna.

In a related spirit of banishing the planned and the concerted, some artists looked for forms and configurations to emerge from the accidental; to this effect, they developed many techniques that were, in fact, setting up "happy accidents," which may give forth unexpected imagery. In their rejection of the conventionally acceptable, useful, or beautiful, these artists often looked to the trash heap as a source of exciting found objects, which they modified or to which they assigned a new validity and significance.

In this kind of fantasy, things often appear strange yet disquietingly familiar, or their familiarity has a kind of eerie strangeness, which may not even be immediately perceptible. Fantasy is dreamlike; metaphoric; symbolic; imaginative; spontaneous; sometimes mildly, sometimes powerfully shocking; and above all, freed from the constraints of common sense and reason.

Mutations and Metamorphoses

This category of exercise emphasizes the process of change from one state to another, from the human to the animal or plant, from the young to the old. The mutations of the form may include additions, subtractions, or fragmentations.

Flora and fauna. After studying previous contour drawings done directly from the model and consulting a reference file of plants, animals, and birds, combine elements into a new imaginary being that partakes of two realms: human and bird, or animal or plant and human. The combination may include any part of either realm (Figs. 19-6, 19-7, and 19-8).

Figure 19–6.
Photograph.

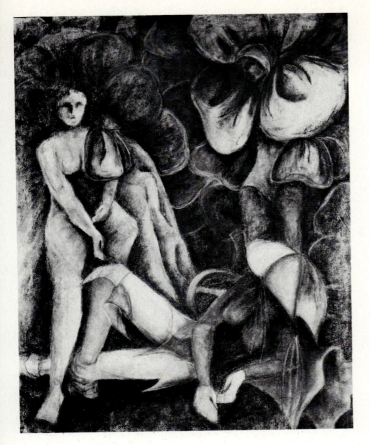

Figure 19–7.
JUDITH HARRIS, student.
Pastel.
Models and props form an unusual grouping, which serves as a basis for a fantasylike interpretation wherein the head covering of the standing figure on the right suggests a flower motif for the composition.

Figure 19–8.
Student work.
Collage.
This collage is based on Arcimboldo's work (see Fig. 19–4). The head is made up of seashells.

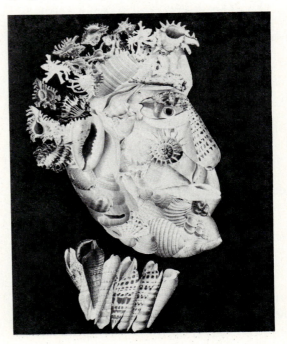

Execute the new combination as a collage from tracings of parts of contour figure drawings or cutouts or tracings of parts of the animal, bird, or plant. When a problem of scale of the parts arises, derive the solution from attempted juxtapositions and then execute the new drawing into one connected configuration, where the parts are brought into relationship with each other. Use pen and ink for the linear part, and add watercolor, pastel, or crayon.

A personal bestiary: man and beast. This is a variation of the previous exercise. Here, create an imaginary beast by combining three different animals—including the human—into one.

The figure as landscape. Seeing the figure as landscape is not new. The visual pun was, as we have seen, a common surrealist device. Here, however, I would like to approach the concept from another viewpoint: that of the isolated closeup of a detail of the human body. Disconnected from its usual context and considered as an entity, such a fragment takes on a dramatic and abstract visual presence. Despite the realism of the depiction, it loses its immediate legibility and often resembles rocks or topographic details more than it does the human body. The ambiguity in the legibility of the image blurs the boundaries between realms, and the initial perception can be disconcerting and disorienting enough to foster a fresher view of the subject matter. With this end in view, look at the model with an eye for analogies between the human figure and landscape (Figs. 19-9 and 18-20).

Landscape as figure. Analogies between figure and landscape can be made from either direction: from the figure to the landscape and from the landscape to the figure.

Draw images in nature that, by chance, evoke the human figure in whole or in part. Emphasize the pictorial kinship to the human figure, but respect the original characteristics of your primary subject, so that the drawing strongly suggests the human figure while retaining its significance as a detail from the natural world. Draw in pen or pencil on all-purpose 11×17″ watercolor paper.

Incongruities

A bizarre and often significant image frequently results from assembling forms in unusual and unexpected ways: odd substitutions, grotesque visual connections, absurd juxtapositions, whereby

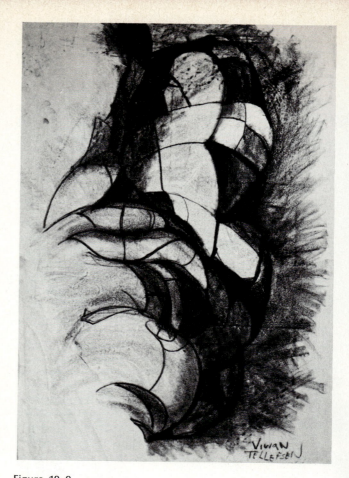

Figure 19–9.
VIVIAN TELLEFSON, student.
Charcoal.
The figure is seen as a stony landscape and drawn in compartmentalized contour.

the absurdity itself carries a meaning—a meaning so undetermined that it may be different for every observer.

Substitutions, subtractions, additions, and fragmentations: "Mad Anatomy." An old standby of incongruous juxtapositions is the substitution of the head of one subject for that of another. In order to be more effective, the choice has to be particularly ludicrous or outrageous: Charlie Chaplin and Queen Victoria, Freud and Marilyn Monroe, for example. The material is easily obtained from magazines or book reproductions, which can be reproduced in halftone.

Again, using a photographic reproduction of a full figure or head, create a mildly disconnected or inconsistent configuration by eliminating parts of the image—eyes, mouth, a breast—by erasing, cutting, or blotting out with ink. Then make a collage by gluing in drawings or segments taken from other drawings or reproductions in the appropriate blank spaces. The resulting image,

while reconstituting the human anatomy, is disharmonious enough to have a slightly disconcerting or jarring impact.

In a related vein, it is also sometimes both shocking and confusedly meaningful to unite human configurations that are ordinarily perceived as opposites or as contrasting entities, yet which possess an underlying bond that the invented image reaffirms: combining the young and the old, male and female, naked and clothed, for example. This can be done by collage juxtaposition, combining photographs and drawings with invented background forms. Along with the straight collage, ink or pastel drawing may be used (Fig. 19-10).

Figure 19–10.

Student work.

Collage.

The artist combined a portrait by the French nineteenth-century painter Edouard Manet with two photographs of the model who had posed for that portrait: one portrait taken when the model was young, the other when she was old. The juxtaposition produces an effective image on both the pictorial and the emotional levels.

The range of possibilities in creating unexpected pictorial reconfigurations and reassemblages is limited only by one's imagination. Mad anatomy projects are challenging to invent, and the successful combinations can have great visual impact.

One favorite surrealist recombination scheme is a drawing or a drawing and collage in which shocking anatomical incongruities are invented: an eye in the mouth, teeth in the eyes, a mouth in the hand, and so on. Such images can carry a powerful psychological impact.

A more whimsical approach is suggested by Saul Steinberg's witty and significant cartoons and by Tomi Ungerer's assemblages, in which the figure is integrated with a common object.

Role reversals. The portrayal of role reversals is part of the tradition of visual incongruities: the donkey riding the man, the infant carrying the adult, and so on. These might be executed in black and white or brightly colored with crayons or felt pens, in the spirit of the *Images d'Epinal* (Fig. 19-11).

Visual Games

The fantasists, particularly the dadaists and surrealists, had a sense of humor and loved to play games; they were particularly fond of the visual pun, that is, an image that can be read in more than one way, with hidden images within the primary configuration.

Hide and seek: composites. Using pen and ink, draw a large head made up of connected smaller figures. The edges of these figures also form part of the enclosing boundary line of the head. Add fine crosshatch to the ink drawing to hide partially its component images and make the reading of the general configuration more ambiguous.

The head can also be a composite of seashells and sea life, vegetables and fruit, utensils, or machine parts. Arcimboldo, in the sixteenth century, and Dali in the twentieth, were fond of these assemblages (Figs. 19-4 and 19-8).

Seeing double. Draw a large head, which when turned on its side reads as a landscape, rock formation, or another head (Fig. 19-12).

Photo-drawing head. Draw a head or figure from imagination and substitute details such as eye, mouth, and hand from photographic portions.

Figure 19–11.

Spanish (nineteenth century).
The World Topsy-Turvy.

An early version of the comic strip were the popular and inexpensive nineteenth-century broadsides and variations of the Images d'Epinal. One of the recurring themes of these illustrations was that of the world turned upside down. These charming illustrations, done in naive style, must have delighted the surrealists.

Figure 19–12.
TOM HUGHES, student.
In this exercise, the heads read as heads whether they are viewed right side up or upside down.

Grounds for Fantasy

In their desire to limit the interference of learned percepts, and to connect directly with the unconscious in order to express it through graphic imagery, some artists relied on automaticism: a kind of mindless doodle or drawing that apparently allows the hand to follow the meanderings of the unconscious.

A pen and ink doodle can serve as a point of departure for many figurative compositions. The point is to doodle with no graphic preconception, preferably while engaged in another activity, such as conversing or watching television. This may neutralize the habit of conscious control. When you stop doodling, look for imaginative groupings hidden in the aimless pattern and fill them in with ink to clarify them, or fill the spaces around them for the same purpose, depending on your preference for defining the figure through negative or positive space (Fig. 19-13).

The doodle may be used as an imaginative and poetic enhancement to an existing sketch or reproduction. Doodle with your pen on top of the head or figure, using grey ink in the light areas and white ink in the shadows or dark areas. The resulting webbed image transforms the known into a new, unexpected, and challenging image.

Evocative Images

Although artists can try to recapture and express their dreams, phantasms, and personal fairy tales on a blank surface, it is sometimes easier to do so by using evocative and diffused textural grounds as points of departure. We can either project our own imagery onto these, or by squinting or working in low-intensity lights, find in them the imagery that corresponds to our needs of the moment. Perhaps the best time for this activity is the twilight zone of half-sleep, half-wakefulness,

Figure 19–13.
CYNTHIA ROGERS, student.

In this developed doodle, the juxtaposition of different scaled units treated in op and contour creates an image of fantasy.

when we are most receptive to our own creative fantasies. The elements of chance and imaginative subjectivity play important parts in this process.

There are countless ways to produce evocative grounds into which to project, or from which to derive, figurative and imaginative configurations unbound by naturalistic settings or frames of reference. The following are a few among many.

A rich ground is produced when a coat of black fingerpaint is rolled onto a 9×12" poster board with a brayer; while the paint is still wet, press a loosely crumpled sheet of bond typing paper onto the surface, picking up the paint in an irregular pattern. Do this over most of the surfaces, keeping a few areas untouched, that is, evenly black, as contrasts with the exciting textures created by the crumpled paper lift off. If you want to work on a larger scale, 18×12", for example, it is more practical to obtain the textures with crumpled all-purpose watercolor paper, which is larger than typing paper. After the board has dried, allow your imagination to find faces or figures or combinations of species in the textures. Then simplify or elaborate the images with black fingerpaint applied with a watercolor brush without any liquid.

The same basic process of looking for images can be pursued by crumpling a sheet of all-purpose watercolor paper and spraying it with acrylic black and light brown spray paint from different angles while it is still loosely crumpled. You may want to examine the paper after it has dried and has been uncrumpled, and if you want textural enrichment, repeat the process, keeping some irregular areas untouched. When the paint is totally dry, smooth out the paper with a heavy weight or with a cold iron. Compressed pastel can be used in the definition of the configuration.

A softer background is obtained by wetting a sheet of watercolor paper and immediately dropping some colors into various parts of the paper, allowing the wet colors to intermingle on the wet surface. When the paper is dry, examine the soft color mergings for accidental imagery, and once found, reinforce the imagery with pen and ink.

Night Fishing

Convinced that the subconscious is a rich mine of personal and collective imagery, the surrealists opened wide the gates of the unconscious in an attempt to allow that subterranean quality to infuse, extend, and perhaps illuminate our limited objective reality.

Often, the dream quality is very subtle, and the unsettling details are not immediately apprehended: It may be a clock without hands, an overall tilting of the ground and the figures on it, a mild discrepancy of scale between parts or a manipulation of perspective.

Dream paintings or drawings can emerge from undefined, evocative grounds, or they can stand as startling visual statements against a simplified background that is often depicted in exaggerated deep perspective. In either case, the undefined shallow space or the exaggerated depth enhances the impression of timelessness and limitlessness of the dream world. But this can also be conveyed by a nearly naturalistic setting with discrete incongruities, which are insistent reminders that the dream world permeates our reality. The stylistic language can be classically linear, romantically diffused, expressionist, abstract, or nearly realistic. What consigns the imagery to a form of surrealism is the combination of objectivity and irrationality into an effective visual statement.

Persistent image. Graphically depict a persistent dream or a recurrent image that is part of your life. Draw on an evocative ground, such as those described in this chapter. The images can be left unclear or can be sharpened by the addition of boundary lines and light and shade. The dream or recurrent image can derive from the nightmare or the pleasant daydream, as your inclination directs. Better yet, both can be depicted in different compositions.

Nightmare. Draw in one composition what you consider to be your personal phantasms, demons, or anxiety-producing imagery. Include persons who make you uneasy. You may incorporate symbols, words, or props that relate to your nightmare (Fig. 19-14).

A personal fairytale. It is sometimes quite revealing to oneself to draw a frozen image of a crucial moment in a personal fairytale in which we depict our fears or wishes. This can even be depicted in a small triptych, each part showing an important moment of the tale, including, if possible, its end. Some artists prefer to portray their tale in a series of related images, horizontally or vertically.

An effective technique for this project is to work in a simple linear manner, perhaps voluntarily naive or childlike, as described in silhouette drawing. However, the stylistic choice need not be

Figure 19–14.
DAN YORK, student.
Pipe-cleaner figures serve as a basis for this multifigure study of dancing mannequins come to life.

restricted to this idiom. In something as personal as one's own fairytale, it is certainly advisable to choose a style that feels comfortable and authentic.

The Figure as Metaphor

Like the verbal metaphor, the visual metaphor unveils a new meaning in an unexpected combination of images. If it is not treated too literally or too narrowly, it adds a poetic and evocative dimension to the human configuration, which then becomes open to several interpretations beyond the immediate reading. When the delicate balance between form and content is successfully managed, the human figure as a metaphor becomes a very effective vehicle for esthetic, emotional, and intellectual communication, ranging from the light and whimsical to the brooding and enigmatic.

Following are a few suggestions for human metaphors. The list is partial, and the possibilities can be as numerous and inventive as the imagination and the creativity of the participants will allow.

Each member of the group selects one metaphor from the list, or devises one of his or her own, and develops it as a costume and human environment so that other members of the group can sketch or photograph it for later reference. It may be profitable for several participants to choose the same or a related metaphor, so that they share a common experience to which they will bring different solutions.

The figure is viewed as

machine:	cardboard and styrofoam shapes added and attached to the body, suggesting machine parts and cyborgs
metamorphosis:	a combination of parts: human, beast, machine, tree, and so on
incongruity or absurdity:	unusual juxtapositions, use of visual puns, or two or more figures locked in strange configurations; best done with students who are young enough to be conversant with gymnastics or dance
sorcerer:	suggesting magic and illusion
time:	portraying obsessions with the past and future with surrealistic interpretations
its own environment:	such as variations on astronauts or aquanauts; even more effective when reflected in distortion mirrors
figure turned inside-out:	perhaps showing some muscle structure, skeletal parts, and/or viscera as part of the configuration

Development of a Metaphor: The Figure Contained

The concept of forms within forms is an exciting visual concept, esthetically and emotionally. On the formal level, it creates unusual and complex relations between figure and space; and on the emotional level, it layers the image with ambiguous meanings, sometimes suggesting shelter and protection, sometimes suggesting imprisonment, or both (Fig. 19-15; see also Fig. 1-13).

Boxes, tunnels, and enclosures. Select a cardboard box taller than a kneeling figure and shorter than a standing one; its width should accommodate one figure. Remove one side of the container. The model is asked to fit himself or herself into the available space, touching all sides, and to hold the pose for five or ten minutes. Draw with charcoal on 11×17" charcoal paper.

The setup can be modified to include more than one model: Procure a large cardboard box such as those used to store or transport major appliances. After removing one side of the box, ask two or more participants to crowd into the enclosure, creating a complex, cramped figure assemblage. Take photographs or sketch directly from the configuration. Since the pose is obviously uncomfortable and difficult to hold, the direct sketch has to be done rapidly; more detailed drawing can be done from the photographs or from a combination of direct drawing and reference to the snapshots. Draw from three such groupings and develop one of the sketches into a sustained project. Use charcoal or pencil on 18×24" paper (Fig. 19-16).

Tunnel. Request the model to slip into a long translucent stretch sack, which has been fitted with hoops on the inside and is closed at one end. Photograph or draw the setup. As in the previous exercises, the figure is studied in relation to its container and the compressed space that defines it (Fig. 19-17).

String enclosures. String bound around the figure accents its three-dimensionality and gives a "human package" quality to the figure. When string is used on the head and face, it creates patterned proclivities and declivities, which suggest ritualistic markings and impart a mask quality to the face.

Figure 19–15.
JAN STUSSY.
Transformation, A Trance for Information (1981).
Courtesy of the artist.

This is an imaginative and provocative image of a figure contained in a box. The muscle structure, freely rendered to resemble armor, emphasizes the abstract quality of the figure, which though seemingly prisoner in a constrictive box projects an image of coiled power.

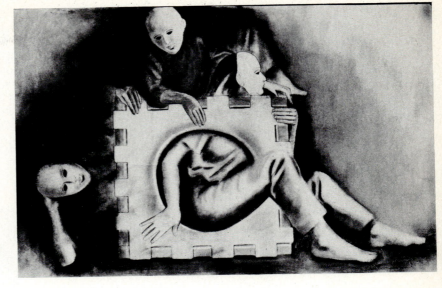

Figure 19–16.
CAROL PATE.
Charcoal.
The participants had been asked to take poses with large construction cubes in a manner that would create visual variations on the theme of crowding and containment. Masks were added to suggest an incongruous and depersonalized quality.

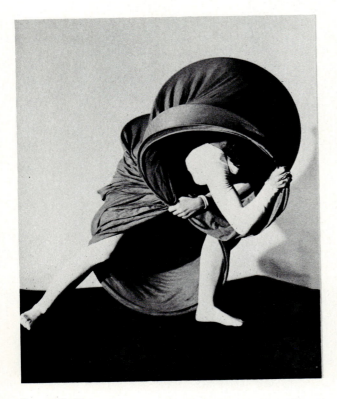

Figure 19–17.
Photograph.
Figure in tunnel.

If you wish, cordon off the immediate environment with string and create a network or a web of crisscrossing lines by fastening the string to props around or near the model.

Draw the setup in contour, in pencil or pen.

Costumes from Fantastic Art

Using examples from artists who have used fantasy in their work, improvise imaginative costumes to be worn by students or models. If more than one costume is available, the participants can pose as a tableau while the rest of the group photographs and draws.

You may find it valuable to study the works of the following artists to find inspiration for inventive and odd coverings:

l'Armessin	Picasso
Bracelli	Miro
Arcimboldo	Dali
Bosch	Ernst
Louis XIV pageants	

Whenever a project includes the design and improvisation of costumes, it is likely that some participants will find it impossible to help in the realization of the costumes. However, the activity can be carried out with makeshift means and very simplified props. Participants may also choose to work from imagination.

Models and Mannequins

The mannequin is a fascinating implement. The window mannequin exerts a psychological attraction not limited to its utilitarian function of displaying fashion. The attraction is difficult to explain. Perhaps it is due in part to a psychological ambiguity between the animate and the inanimate. As humans become more integrated with mach-

ines, and as machines becomes more humanized, the blurring of the two realms is an intriguing thought, raising the problems of reality and illusion and identity and conformity. A number of artists have used the mannequin as subject matter: Kokoshka, Chirico, Marisol, Kienholz, Belmer, and Clavé come to mind. One immense practical advantage of the mannequin is that it can be positioned in poses impossible for the live model to hold or even to take.

Several types of mannequins are available, and each type can serve a different purpose. The most traditional and readily available is the small articulated mannequin made of wood or plastic, which is found in all art stores. It can be used singly or in multifigured poses and is easily stored. Some of the conventional window mannequins have limited flexibility; however, these can be modified with draperies and surface decorations. Like the small articulated models, some large mannequins are made up of movable parts, which can be turned and twisted at the neck, waist, elbow, and knee (Fig. 19-18). More expensive than the other types, these are the most serviceable. A soft rag mannequin can be constructed with pillows, a styrofoam head, and stuffed gloves. The life-sized mannequin can be used alone or in conjunction with the live model.

Foreshortened views. Position a life-sized articulated mannequin across two straps suspended from the ceiling by ropes. Find the angle and level of vision from which it presents the most dynamic and visually exciting foreshortened view. Draw in pencil or pen and ink on all-purpose watercolor paper.

Suspended mannequin. Use either a soft cloth mannequin or a life-sized articulated one; suspend it securely by the waist, by one arm or one leg, or upside down from the ceiling, and draw it from different angles in charcoal or soft pencil.

Soft mannequin. Use a mannequin made of cloth stuffing. Cover it with paper. Truss and tether it so that it resembles a mummy or evokes a symbol of captivity. Create a dramatic, high-contrast lighting. Draw in Conté crayon on toned charcoal paper.

Mannequins and models. Design a setup in which models pose with life-sized mannequins. The setup should emphasize the ambiguity between the animate and the inanimate. Take photographs to use later for drawings or draw directly from the setup. The drawing should be a sustained study and may incorporate a number of techniques: crosshatch, wash, pointillism, and so on.

Figure 19–18.
Photographs.
Mannequin designed and constructed by Irene Nye.
The mannequin affords the opportunity to work with a configuration that is in the ambiguous realm between the human and the inanimate. It lends itself to surrealist visual metaphors and possesses the practical advantage of holding poses that the human being cannot hold—or take.

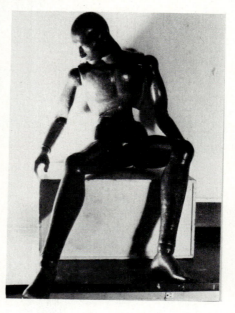

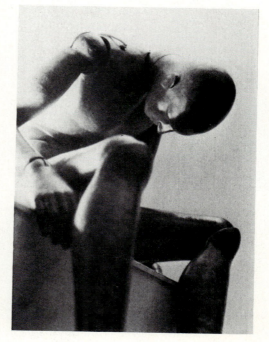

CHAPTER TWENTY

Some Challenging Questions, Some Tentative Conclusions

After the students have endeavored to sharpen their visual perception; to understand and practice different esthetic approaches; and to master a variety of materials, tools, and techniques, many of their questions may still remain unanswered—questions that, perhaps, have as many answers as there are artists; questions that may have only partial or tentative answers; and questions that may not have any definite answers at all but still need to be asked.

FACILITY AND TALENT

One of the questions often asked by beginners or near beginners is whether they are justified in going on with an art program on the basis of their talent. It seems to me that drawing skills can be acquired with effort and practice, but sensitivity to form has to be present, at least incipiently. Sometimes, too great a facility in drawing is an impediment to the real growth of the artist, who becomes satisfied with easy flashy results, whereas a person who appears to have little facility in drawing may have strong potential for the creative graphic experience and only needs to develop skills. Facility is not necessarily talent, although one certainly can have both. Some great artists such as Van Gogh and Cézanne never had facility in drawing—yet, they were geniuses at seeing and expressing creatively, and the drawing skill, which came to them with

difficulty, evolved into a masterful instrument of their compelling vision. Talent presupposes a growing awareness and sensitivity to form, and it implies the ability both to see uniquely and to express that vision through a finely honed skill that is gradually perfected.

CONCEPT, METHOD, AND STYLE

How does an artist develop an individual style? There are so many choices of artistic idioms that the range itself presents a dilemma. Certainly, one's past and present experiences, one's personal philosophy and world view, the artistic influences to which one is exposed—all play a role. But more practical considerations, such as one's predilection for a given material, technique, or format or the purpose of a given drawing, may also play a part in determining a concept and a style.

The evolution of an artist toward an original style implies a number of choices that are both conscious and unconscious, intellectual and emotional. Artists who recognize and respect their basic leanings usually choose intuitively those methods and even those influences that lend themselves more readily to the artists' preferences. This does not mean that artists never try approaches and techniques foreign to them; it only means that after trying, they will discard some and adopt or adapt those that are in keeping with their

needs. In fact, even when artists have found a direction and a style they can call their own—that is, an awareness of their artistic tendencies and a knowledge of the media and techniques that suit them best—it is wise for them to explore other artistic concepts and methods in a kind of general approach, which through trial and error, may eventually enrich and modify their work.

SERIOUSNESS AND PLAY

Anguish and Wit

> . . . it is sometimes forgotten how much wit there is in certain works of abstract art. There is a certain point in undergoing anguish where one encounters the comic. I think of Miro, of the late Paul Klee, of Charlie Chaplin, of what healthy and human values their wit displays. . . .
>
> Robert Motherwell

Many artists and laypeople view the act of artistic creation as something akin to a religious rite. They regard it with such reverence that they cannot tolerate a sense of play, a spontaneous happening, or occasional humor as part of the process. For them, the artist is a kind of seer, someone who unveils beauty and truth, and they look on the lighter approach as shallow, superficial, and showing a lack of commitment.

It is true that some artists' way of working cannot—and should not—admit the light and the humorous touch. It is difficult to imagine Michelangelo, Van Gogh, or Lindner approaching their work in a spirit of spontaneous playfulness. Yet such an approach is right for other artists; it certainly did not detract from the expressive qualities of a Klee or a Miro, whose works could be whimsical and significant at the same time. The serious and reverent approach is totally valid and fruitful, and it has acted as midwife to much of our artistic heritage. I simply would like to suggest that creativity is not incompatible with the spontaneous, the whimsical, and even the accidental. A creative person can often recognize, transform, or incorporate even the most commonplace into a meaningful visual configuration.

Play is not superficial per se. In some cases, it is part of the investigation and discovery process. It may also be part of the expressive quality of the work, just as absurdity may be the other face of significance. In any case, depending on the personality of the artist, the playful and the accidental can be factors in disarming the artists of a constricting self-consciousness and providing other avenues of access to significant form.

More often than not, we grasp the shadow rather than the substance. The strange irony of the situation is that when we try too hard, too self-consciously, too directly, the substance eludes us, and it may come forth when we least expect it. It is not only *what* is said but *how* it is said, and I do not mean simply the technique. For what is expressed can be disarmingly unpretentious, and how it is said implies sensitivity of expression and uniqueness of concept, as well as the appropriate technique.

PRODUCT AND PROCESS

There is an obvious connection between the approach to an artistic project and one's method of working. Those artists whose approach is intellectual and analytical are more likely to place more emphasis on the end product than on the process. Indeed, this is the view favored by our Western society, and at its best, it has encouraged the formulation of standards and the creation of many masterful and technically flawless works. Artists who focus on the end result are concerned with the planning and careful execution of the project. If they are working on a sustained, ambitious project, they often do preliminary drawings to ensure a minimum of trial and error on the final product, which is usually executed in dependable, traditional, or quasi-traditional materials that present minimal technical risks.

Process-oriented artists are rarely oblivious of the end product but regard the creative process as meaningful in itself. They may be neither more nor less creative than their product-oriented counterparts, but they are willing to accept the accidental, to take conceptual and technical risks, and to surprise themselves with the unexpected results of their more venturesome approaches.

The pleasure of a nonintellectual technical approach should not blind the artist's critical sense, so that when the work is completed, he or she should still be able to judge whether the product is a valid esthetic expression or simply an experiment that may or may not bear fruit for later projects.

A DUAL NEED

Certainly no two artists have exactly the same needs or the same methods of working, yet it is common for artists of vastly differing styles and philosophies to voice similar concerns. They often speak of their dual need for investigation into or

search in depth for a given theme or style; on the other hand, they voice a compulsion for exploring new concepts, styles, and techniques. Perhaps this dual need is not the dilemma it appears to be. Perhaps it is mainly a matter of timing and emphasis. All artistic activity represents a search and a temporary solution. But it may be that the search needs to be modulated differently at various points of the artist's development: There is a time for probing development in depth within set limits of themes, techniques, and styles, so that each variation represents another facet of the probing; and there is a time for radical plunges into new artistic means, concepts, and techniques.

In my contact with art students, I have tried to address this dual need by alternating problems that reflect these two attitudes. For the first, the emphasis is on a sequential approach; the second entails rapid-fire changes, from one concept, technique, and environment to another.

IN THE SAME VEIN: THE SEQUENTIAL SERIES

With More Feeling

When I have a model who is quiet and steady and one with whom I am acquainted, then I draw repeatedly till there is one drawing that is different from the rest, which does not look like an ordinary study, but more typical and with more feeling. All the same it was made under circumstances similar to those of the others yet the latter are just studies with less feeling and less life in them.

Vincent Van Gogh

Involved in a Theme

I worked a great deal then, as you can do only on a set theme, absolved from the obligation to find a new fact, a new subject every day. This cancels the tragedy of the blank canvas and relegates it to the realm of ridiculous dilemma, for day and night you are involved in a theme and its variations.

Rico Lebrun

To work in a series—from the same models or subject, the same theme, the same concept, or the same materials and techniques—gives the artist the opportunity of exploring and interpreting in depth and with increasing assurance. There is a moment in the process when the artist hits optimum stride, and it is at that point that the best results are likely to come forth. Such a series may consist of a number of sketches, a few sustained drawings, or a combination of both. Sometimes the series is used as preparation for a more sustained work, which represents the culmination and the synthesis of the experience. Sometimes one of the variations leads to further investigations along a given conceptual or stylistic line, and sometimes the series itself stands as an organic esthetic whole. Examples of sequential series abound: Goya's *Disasters of War*, Degas' *Ballet Dancers*, Picasso's *Tauromachia*, among others.

The sequential approach tends to force artists to push their interpretative versatility to its limits; it may also help them discover the richness of their own artistic and imaginative resources, as well as a unifying thread beneath the multiplicity of images.

FROM ONE TO THE OTHER: CHANGES, CHANGES, CHANGES

The great dangers that threaten the serious student as well as the full-fledged practitioner are mediocrity, banality, facile and uninspired work, lack of authenticity, and a repetitiveness that is a form of artistic sterility. One of the antidotes against the occasional ruts that befall the artist is to make a series of concerted changes: perceptual, conceptual, environmental, stylistic, or technical.

Throughout this book, many techniques have been offered with the intended goal of helping the student break through old patterns of seeing and drawing the figure. There has been a consistent effort to challenge students through contrasting changes and even contradictory approaches, in the hope that the diversity of concepts, methods, and techniques would help them gain fresh insights and avoid the morass of the overly facile and falsely reassuring. Yet they must also guard against the seduction of change for its own sake, which is another trap, perhaps more dangerous than repetitiveness, robbing them of authenticity and preventing them from probing in depth.

Changes can be subtle or radical. They can involve one element or several factors simultaneously. The variations possible are enormous. Imposing some limitations on oneself is often more beneficial than harmful, for freedom can easily slip into lack of continuity and chaos. And so, a fine balance between continuity and change seems helpful. Perhaps the best safeguard an artist has against discontinuity and chaos is to introduce changes after having already gained a solid and even quasi-traditional grounding, so that the changes are transformations, mutations, and metamorphoses rather than destructive or frivolous. In the long run, the artist's growth reflects his or her response to the need for renewal and breakthrough.

STANDARDS

The Higher You Jump

We Catalans believe you must always plant your feet firmly on the ground if you want to be able to jump in the air. The fact that I come down to earth from time to time makes it possible to jump all the higher.

Joan Miro

In some ways, the matter of standards is one of the most difficult and controversial questions because it is so personal; sooner or later, each artist takes a personal stand and works within the parameters he or she has chosen. Certainly, it is helpful to be conversant with the grammar of the visual language; and just as certainly, one cannot depend on this knowledge to ensure sensitivity and originality of vision and pictorial expression: One must also learn to trust one's own feelings and sense of form. One must decide individually what to keep, what to change, and what to discard in the body of transmitted standards and canons.

In the final analysis, a work of art is a distillation of what the artist has learned and what he or she sees, knows, and feels, expressed through a personal and effective pictorial language.

It would be a mistake to consider the preceding questions and issues as either/or propositions. Even when we are more inclined toward one approach than the other, we should be open to alternatives, especially at the beginning of our explorations, when we are searching for approaches that reflect our personality and artistic needs. What is right is usually what *feels* right, but we can only know what feels right if we have tried a number of approaches and solutions.

As an artist evolves a personal style, it may even be healthy occasionally to punctuate one's development with conscious departures from it, to be sure that the style one has found is not a security blanket and that one is capable of opening new doors and exploring side paths, even within a main line of development.

ORIGINALITY

Originality is certainly a goal toward which every artist strives; but I am afraid that many beginners are obsessed with it too early in their development, to the point of avoiding the study of previous works of art for fear of being unduly influenced. Sadly enough, this *idée fixe* of originality, and its concomitant distrust of previous art

forms, may lead the artist to embrace the artistic fad of the moment, which is, in fact, the farthest thing from originality.

It seems to me that originality, when it is not immediately evident in the first attempts of a beginner—and it rarely is—can evolve through sustained search for a personal and meaningful pictorial expression, whatever the first source of inspiration may have been. Since originality comes from within, we do not have to be afraid that early influences will prevent its flowering. As the skill, personality, talent, assurance, and philosophy of an artist gradually emerge and assert themselves, the influences that have helped to shape the artist are eventually absorbed, channeled, and transformed into his or her own vision and expression.

EXPRESSING THE INEXPRESSIBLE

The inexpressible is the only thing that is worthwhile expressing.

Jerome Frank

Every serious and committed artist, it must be assumed, has a profound need to communicate, through the most effective visual means possible, something profound and meaningful that may be revealing and significant to others. When we are in the presence of a masterful visual statement, we instinctively recognize its uniqueness. It seems to bathe its surroundings with an aura of energy and power that is truly magical. It is these rare and masterful works of art that give shape and meaning to the art experience and to the existence of the artist.

Perhaps the aim of the artist is nothing less than to express that which usually cannot be expressed; not too modest an aim, but the creative act is not a modest one. That is why artists constantly hone their skills so that they can be prepared for those rare and precious moments when form and substance magically merge in a work of unique, original, and compelling significance that truly defies explanation.

THE FINAL CHALLENGE

Into the Fabric of Existence

Someday when I understand many more things than I I do now, the fundamentals of my drawing will be so tightly woven into those of existence that I will easily and naturally find the design which is the answer to many questions. Meanwhile, I draw continuously.

Rico Lebrun

However, the art experience exists on many levels and is not limited to professional artists or to art students who expect to become professionals. In many cases, it is a way to add an esthetic dimension to one's life, to enrich the quality of one's daily visual and emotional experiences, to express oneself and one's world through nonverbal means. The study and the experience of drawing the human figure can be a deep source of joy and self-realization for both the enlightened art connoisseur and the committed artist.

The final challenge, then, is to make the gradual transition from student to independent artist on any given level. But there are pitfalls: If the break is made too soon, the artists may lack the necessary solid grounding in basics and the assurance that the possession of one's métier gives. However, if the break is delayed too long, they may not ever be able to wean themselves from the direct tutelage of those who set problems before them and propose their own solutions.

As they develop their skills, artists have to be aware of their personal artistic leanings and develop an expressive pictoral language in harmony with their unique vision. To help them achieve this, this book has proposed a program filled with seeming contradictions and paradoxes, reflecting the fact that art itself is a grand paradox.

The contradictions and oppositions abound indeed, and each has validity, depending on the timing, the emphasis, and the temperament of the participant: tradition versus innovation, the analytical and intellectual versus the emotional and subconscious, clarity versus indeterminacy, observation versus invention, realism versus abstraction, flat versus three-dimensional, understatement versus overstatement, preconceived versus accidental—to mention just a few. It is my hope that a nonliteral, nonlinear, nondogmatic approach to the problems suggested leads the participants to devise an individual program of study and pictorial investigations of the human configuration by choosing their own emphasis at different stages of their artistic development and constantly observing, outwardly and inwardly, objectively and emotionally. This approach presupposes that the participants will select, omit, modify, adapt, complement, combine, expand, or change the order of the exercises according to their needs of the moment. They will take from the old as well as from the new, assess, discard, or keep, as they assume the responsibility of making the crucial passage from art student to creative artist; that is, they have to become constant but independent seekers of images and form. It is to be hoped that this search will ultimately lead them to the unique calligraphy that will best express their vision through the most effective compositions.

In the course of a student's growth, as in the course of an artist's development, there are plateaux, ruts, even blockages. These are the times to investigate different approaches and techniques, and the momentary setback may be the pause before a significant breakthrough or renewal.

In the end, no art course, no seminar, no lecture, no book, no change of environment and technique can replace the patient, sometimes discouraging, sometimes painful, but often exhilarating experience of drawing the figure, and by so doing, learning about oneself as one draws, and draws, and draws.

Bibliography

GENERAL

ALBERT, C., and SECKLER, D. *Figure Drawing Comes to Life*. New York: Reinhold Publishing Co., 1957.

BERRY, WILLIAM A. *Drawing the Human Form: Methods, Sources, Concepts*. New York: Van Nostrand Reinhold, 1977.

BETTI, CLAUDIA, and SALE, TEEL. *Drawing: A Contemporary Approach*. New York: Holt, Rinehart and Winston, 1980.

BINYON, LAURENCE. *The Flight of the Dragon (Wisdom of the East Series)*. London: John Murray, 1st edition 1911, reprinted 1948.

BLAKE, VERNON. *The Art and Craft of Drawing*. Dover: 1926.

BRIDGMAN, GEORGE B. *Bridgman's Complete Guide to Drawing from Life*. Edited by Howard Simon. New York: Sterling Publishing Co., 1952.

BRO, LU. *Drawing: A Studio Guide*. New York: W.W. Norton and Co., 1978.

CAMP, JEFFREY. *The Drawing Book*. New York: Holt, Rinehart and Winston, 1981.

CHAET, BERNARD. *The Art of Drawing*. New York: Holt, Rinehart and Winston, 1978.

CODY, JOHN. *Atlas of Foreshortening: The Human Figure in Deep Perspective*. Photographs by Leon Staab and Greg Matlock. New York: Van Nostrand Reinhold Inc., 1984.

GOLDSTEIN, NATHAN. *The Art of Responsive Drawing*. Englewood Cliffs, NJ: Prentice Hall, 1973.

————. *Figure Drawing: The Structure, Anatomy, and Design of Human Form*. Englewood Cliffs, NJ: Prentice Hall, 1976 and 1981.

HALE, ROBERT BEVERLY. *Drawing Lessons from the Great Masters*. New York: Watson-Guptill Publications, Inc., 1964.

HENRI, ROBERT. *The Art Spirit*. Philadelphia/London: J.P. Lippincott, 1923.

HILL, EDWARD. *The Language of Drawing*. Englewood Cliffs, NJ: Prentice-Hall, 1966.

KAUPELIS, ROBERT. *Experimental Drawing*. New York: Watson-Guptill Publications, 1980. London: Pitman House, 1980.

————. *Learning to Draw: A Creative Approach to Expressive Drawing*. New York: Watson-Guptill Publications, Inc., 1966.

LEBRUN, RICO. *Drawings*. Berkeley and Los Angeles: University of California Press, 1961.

MENDELOWITZ, DANIEL M. *A Guide to Drawing*. New York: Holt, Rinehart and Winston, 1967.

————. *Drawing*. New York: Holt, Rinehart and Winston, 1967.

MOSKOWITZ, I., ED. *Great Drawings of All Times* (4 volumes). New York: Sherwood Publishers, 1962.

NIKOLAIDES, KIMON. *The Natural Way to Draw*. Boston: Houghton-Mifflin Co., 1st edition 1941.

ORSINI, NICHOLAS. *The Language of Drawing: Learning the Basic Elements*. Garden City, NY: Doubleday and Co., Inc., 1982.

PURSER, STUART. *The Drawing Handbook*. Worcester, MA: Davis Publications, Inc., 1976.

RAWSON, PHILIP. *The Art of Drawing: An Instructional Guide*. Englewood Cliffs, NJ: Prentice-Hall, 1984.

TOMASCH, E. J., and LARMER, O.V. *A Foundation for Expressive Drawing*, 2nd edition. Minneapolis, MN: Burgess Publishing Co., 1969.

WARSHAW, HOWARD. *Drawings on Drawing: Graphic*

Reflexion on the Language of Drawing. Santa Barbara, CA: Ross-Erikson Publishers, 1981.

WIGG, PHILIP. *Introduction to Figure Drawing*. Dubuque, IA: William C. Brown Co. Publishers, 1967.

WILLIAM, HIRAM. *Notes for a Young Painter*. Englewood Cliffs, NJ: Prentice-Hall, 1963.

SETTING THE STAGE

BARNES, CLIVE. *Waldman on Dance*. New York: William Morrow Inc., Co., 1977.

————. *Waldman on Theater*. New York: Doubleday and Co., 1971.

CREELEY, ROBERT. *Presences: A Text for Marisol*. New York: Charles Scribner and Sons, 1976.

Farrallones Scrapbook: Making Places, Changing Places, in Schools, at Home and Within Ourselves. New York: Random House Inc., 1971.

GOLDBERG, ROSELEE. *Performance: Live Art 1909 to the Present*. London: Thames and Hudson, 1979.

ISSEY, MIYAKE. *East Meets West*. Tokyo: Heibousha Lt Publ., 1978.

JOHNSON, PAULINE. *Creating with Paper*. New York: Doubleday and Co., 1971.

LA LIBERTE, NORMAN, and MOGELON, ALEX. *Masks, Face Coverings and Headgears*. New York: Van Nostrand Reinhold, 1973.

MATSON, TIM. *Pilobolus*. New York: Random House Inc., 1978.

ROOSE-EVANS, JAMES. *Experimental Theater: From Stanislavsky to Today*. New York: Universe Books, 1973.

STEINBERG, SAUL. *The Inspector*. New York: The Viking Press, 1973.

Unique Lighting Handbook. Barrington, NJ: Edmund Scientific Co., 1969, 1977.

MATERIALS AND TECHNIQUES

BRIGADIER, ANNE. *Collage: A Complete Guide for Artists*. New York: Watson Guptill, 1970.

CHAET, BERNARD. *Artists at Work*. Cambridge, MA: Webb Books Inc., 1960.

LALIBERTE, NORMAN, and MOGELON, ALEX. *Painting with Crayons: History and Modern Techniques*. New York: Van Nostrand Reinhold, 1967.

————. *Collage, Montage, Assemblage*. New York: Van Nostrand Reinhold, 1975.

————. *Drawing with Ink*. New York: Van Nostrand Reinhold, 1970.

————. *Drawing with Pencils*. New York: Van Nostrand Reinhold, 1969.

————. *Pastel, Charcoal and Chalk Drawing*. New York: Van Nostrand Reinhold, 1973.

————. *Silhouettes, Shadows and Cutouts*. New York: Reinhold Book Co., 1968.

MAYER, RALPH W. *The Artist's Handbook of Materials and Techniques*, revised edition. New York: Viking Press Inc., 1970.

REID, CHARLES. *Figure Painting in Watercolor*. New York: Watson-Guptill Publications, Inc., 1972.

SIUDSINSKI, PAUL. *Sumie-e: A Meditation in Ink: An Introduction to Japanese Brush Painting*. New York/London: Drake Publishing, Inc., 1978.

WATROUS, CHARLES. *The Craft of Old Masters Drawings*. Madison, WI: University of Wisconsin Press, 1957.

PERCEPTION

ADAMS, JAMES L. *Conceptual Blockbusting: A Guide to Better Ideas*, 2nd edition. New York/London: W.W. Norton & Co., 1980.

ARNHEIM, RUDOLF. *Visual Thinking*. Berkeley, CA: University of California Press, 1969.

BLOOMER, CAROLYN M. *Principles of Visual Perception*. New York: Van Nostand Reinhold Co., 1976.

BRUNNER, JEROME S. *On Knowing: Essays for the Left Hand*. New York: Atheneum, 1973.

EDWARDS, BETTY. *Drawing on the Right Side of the Brain*. Los Angeles: J. P. Tarcher Inc., and New York: St. Martin Press, 1979.

FRANK, FREDERICK. *The Zen of Drawing*. Vintage Books, Random House.

GOMBRICH, E.H. *The Image and the Eye: Further Studies in the Psychology of Pictorial Representation*. Ithaca, NY: Cornell University Press, 1982.

GREGORY, D.L. *The Intelligent Eye*. New York: McGraw Hill, 1970.

HUXLEY, ALDOUS. *The Art of Seeing*. New York and London: Harper and Brothers, 1942.

KOBERG, DON, and BAGNALL, JIM. *The All New Universal Traveler*. Los Altos, CA: William Kaufmann Inc., 1972, 1973, 1974, 1976, 1980, 1981.

LINDEMAN, EARL W. *Invitation to Vision: Ideas and Imagination for Art*. Dubuque, IA: William C. Brown Co., Publishers, 1967.

McKIM, ROBERT. *Experiences in Visual Thinking*. Monterey, CA: Brooks-Cole Publishing Co., 1972.

ORNSTEIN, ROBERT. *The Psychology of Consciousness*. Freeman Press.

SHERMAN, HOYT. *Drawing by Seeing*. New York/Philadelphia: Hinds, Hayden & Eldridge, 1947.

VISUAL COMPONENTS: ELEMENTS AND PRINCIPLES

ANDERSON, DOUGLAS M. *Elements of Design*. New York: Holt, Rinehart and Winston, 1961.

ARNHEIM, RUDOLF. *The Power of the Center: A Study of Composition in the Visual Arts*. Berkeley, CA: University of California Press, 1982.

GRAHAM, DONALD W. *Composing Pictures*. New York: Van Nostrand Reinhold.

HOFFMAN, HANS. *Search for the Real.* Edited by Sara T. Weeks and Bartlett H. Hayes, Jr. Cambridge, MA: M.I.T. Press, 1967.

KEPES, GYORGY. *Language of Vision.* Chicago: Paul Theobald, 1947.

LORAN, ERLE. *Cezanne's Compositions.* Berkeley, CA: University of California Press, 1947.

MOHOLY-NAGY, L. *Vision in Motion.* Chicago: Paul Theobald, 1947.

SCOTT, ROBERT G. *Design Fundamentals.* New York: McGraw-Hill Book Co., Inc., 1951.

SHAHN, BEN. *The Shape of Content.* New York: Vintage Books, Alfred A. Knopf, Inc., and Random House, 1957.

FACES OF REALITY

ARNASEN, H. H. *History of Modern Art,* 2nd edition. Englewood Cliffs, NJ: Prentice-Hall, and New York: Harry N. Abrams, Inc., 1983.

BARR, ALFRED, JR. *Cubism and Abstract Art.* New York: Museum of Modern Art, 1936.

————. *Fantastic Art, Dada and Surrealism.* New York: Museum of Modern Art Publications, distributed by Simon and Schuster, 1946.

CHENEY, SHELDON. *Expressionism in Art.* New York: Liveright Publishing Corporation, 1934.

CHIPP, HERSHEL B. *Theories of Modern Art.* Berkeley, CA: University of California Press, 1969.

GOLDWATER, ROBERT, and TREVES, MARCO. *Artists on Art.* New York: Pantheon Books, 1945.

GORDON, STEPHAN F. *The Contemporary Face.* New York: Van Nostrand Reinhold, 1972.

HERBERT, ROBERT L. *Modern Artists on Art: Ten Unabridged Essays.* Englewood Cliffs, NJ: Prentice-Hall, Inc., 1964.

HUGHES, ROBERT. *The Shock of the New.* New York: Alfred Knopf, 1981.

HUNTER, SAM, and JACOBUS, JOHN. *Modern Art: Painting. Sculpture. Architecture,* 2nd edition. Englewood Cliffs, NJ: Prentice-Hall, and New York: Harry N. Abrams, Inc., 1985.

KUH, KATHERINE. *Art Has Many Faces: The Nature of Art Presented Visually.* New York: Harper and Brothers Publishers, 1951.

LONGMAN, LESTER D. *History & Appreciation of Art.* Iowa City, IA: The State University of Iowa.

MAISON, K. E. *Art Themes and Variations: Five Centuries of Interpretations and Recreations.* New York: Harry N. Abrams, Inc.

READ, HERBERT. *The Philosophy of Modern Art.* New York: Meridian Books, 1955.

RODMAN, SELDEN. *Conversations with Artists.* New York: Capricorn Books, 1957.

RUBIN, WILLIAM S. *Dada and Surrealist Art.* New York: Harry N. Abrams, Inc.

WÖFFLIN, HEINRICH. *Principles of Art History.* New York: Dover Publications, 1932 (from the German 7th Edition, 1929).

Index